Mind and
Context
in the Art
of Drawing

Mind and Context in the Art of Drawing

An Empirical and Speculative Account of the
Drawing Process and the Drawing Series
and of the Contexts in Which They Occur

KENNETH R. BEITTEL

Pennsylvania State University

HOLT RINEHART AND WINSTON, INC.
New York Chicago San Francisco Atlanta
Dallas Montreal Toronto London Sydney

Cover drawing by Christina Sandblade Mesmer

Copyright © 1972 by Holt, Rinehart and Winston, Inc.
All Rights Reserved
Library of Congress Catalog Card Number 71–184950
ISBN: 0–03–086045–8
Printed in the United States of America
2 3 4 5 038 9 8 7 6 5 4 3 2 1

Preface

This book reports on some of my research over the last ten years. It has more of a historical flavor than I originally intended, doubtlessly because my own mind has been changing over the years along with my studies. As I began to write, it seemed that a unified point of view would be possible, but I eventually had to admit that the unity, if it exists, is one of contradictions.

In this book I have focused on the empirical study of the art of drawing. The reader will learn that my usage of empirical is extended to inferred behavior, to first-person-singular reports, and to interpersonal modes of knowing. In addition, I eventually attempt to speculate on the emergence of the creative and the artistic within the life of a given person, and I even dare to use words like *dialogue* and *community* in the latter chapters. Nevertheless my effort is directed toward knowledge and understanding of the art process and the art series and, as such, is *scientific* although my expanded usage of this term will hardly please the neopositive behaviorist.

I have added to my speculations concerning the art of drawing by

ranging through three kinds of literature: that of psychology of higher mental processes, of thinking, problem-solving, and the like—literature that almost, but not quite, comes to the art process; that constituting the philosophy of art, especially as it is concerned with the making of art; and that growing body of literature of a psychological, philosophical, and critical nature which probes the limits of a narrow, verificationist empiricism and discusses the indeterminate, fallible, and personal aspects of all knowing. This last literature has been essential to my cognitive grasp of the meaning of my own transition within the course of my studies. The use to which I put these three kinds of literature probably strains the intentions of the writers, but an effort at synthesis through imagination seemed the only path to my problems.

The literature on art education is likewise utilized, but more sporadically. At bottom, however, I remain an art educator. But I must also try to be an amateur artist, psychologist, and philosopher to confront the task of this book. To those who are specialists in any one of these three realms of human experience, my apologies in advance for my inability to be what I cannot be but would need to be to do this task better. Yet I remain unapologetic in the face of the scope required for the task: nobody's "specialty" would suffice.

This book is intended for that interdisciplinary audience interested in the psychology of art, at professional, graduate, upperclass undergraduate, and lay levels. Seminars devoted to cognitive psychology, higher mental processes, and art and art education theory should likewise find it useful. It should be appropriate for classes on research, especially in art education, because differing research methodologies are used and discussed with reference to a single subject. So-called "methods" courses in the teaching of art might also do well to turn aside momentarily from all-purpose books to one which attempts, as does this one, to treat a topic in depth, thereby raising questions of ends and means simultaneously.

I cannot acknowledge every one of the many works and persons who have helped me, but I need to reveal the scope of my indebtedness. I do not consider my mind to be an unusually creative one nor a widely experienced one in the world of action. Rather I have merely recognized that my mind does play at putting together and carrying into limited action the many influences washing over me.

First, I would like to acknowledge the influence of Viktor Lowenfeld, who provided me with a personal model for inquiry and concern in art education. Second, I cite the climate that Edward L. Mattil, Head of Art Education, and A. W. VanderMeer, Dean of the College of Education at Penn State, established which nurtured and rewarded my efforts at research in the decade 1961–1971. After this, I must refer to a lengthy list of graduate students and research assistants who have directly aided me in my research and indirectly provided me with mental stimulus through continuous discussions. Of these, Robert C. Burkhart should be singled out, since over a period of six or more years we worked actively together, especially on the research discussed in Chapters 4 and 5 of this book. During the period 1962 to 1964

Gloria Bernheim, Earl Nitschke, Layman Jones, and Anneke Prins worked as graduate research assistants with me. Within the period of 1964 to 1966 the following assistants should be mentioned: Ruby C. Ball, James J. Johnson, Jr., Larry Kantner, Daniel Kuruna, and John Mahlmann. For the years from 1967 to 1971 I must especially single out Charles S. Steele, who worked closely with me in the drawing laboratory, with and without an assistantship, and participated directly in the development of many of the concepts in the last four chapters of this book. The graduate students who have helped my thinking through open discussion with me are too many to list, but I will mention James Srubek, Diane Fetter, Barbara White, Richard Munson, and David York, and thank all others anonymously.

I have also been fortunate at having available funded research grants from the National Science Foundation and the U.S. Office of Education during the years 1961–1966. Such funds are now tighter or have gone the way of bureaucratic management into centralized laboratories or into priority guidelines of what can be studied. The demise of the unsolicited research grant I take as a bad omen. But then the kinds of inquiries I now envision, lacking a priori detailing of procedures and mathematical analyses, would not likely be funded were there uncommitted funds available. This is another instance where history was kind to me, for when I did my experiments they fit the funding requirements and funds were available.

Finally, that I have undertaken this book under some conception that I could do it owes much to the encouragement and helpful criticism of Dale B. Harris, Professor of Psychology at Penn State, and to my wife, Esther. Both have believed that I could and should undertake it, and both in their own ways have done much to bring it about. To Irvin L. Child, June K. McFee, and Dale B. Harris, my gratitude for their careful reading and constructive criticism of the manuscript. My thanks also to Thelma Allyn and Janie Burns, who helped in the typing and preparation of the manuscript.

K. R. B.

Contents

Figures

Tables

This book is about how drawings get made. More specifically, it is concerned with the thought processes, conscious or not, that underlie the stage-to-stage operations comprising a drawing. It asks about conditions that effect subtle or severe change within a drawing and from one drawing to the next.

It will be helpful to try to position this study within the literature of drawing. Thus it will be necessary to review child art in general terms. Some attention will also be paid to the work of mature artists, past and present, wherever this is likely to further understanding. In addition, there is a voluminous interdisciplinary literature having some influence on the assumptions underlying the author's experiments: from the social sciences, in particular psychology, from the philosophy of art, and from such interdisciplinary fields as cybernetics. This is indeed a large order. It would be a rash man who felt that he could fully comprehend such diverse sources. This background literature is in itself inconsistent and full of gaps, so that any point of view claiming to be comprehensive remains in great part speculative.

The author's orientation inclines him toward the things we do not know but need to know that arise to consciousness in the process of empirical inquiry. The research conducted becomes a sieve which allows some facts and speculations to pass through but excludes others. It simultaneously tests and extends theory.

Except where there is knowledge arising from research, the role played by the drawing medium itself will be minimized. This is not tantamount to the conclusion that the medium is unimportant; rather it is an acknowledgement that these factors are so important that they need direct and detailed study. In the research the author conducted, medium and tool were held constant. This is admittedly a limitation since the symbolic transformations in one medium will rarely be translatable into another.

In like manner a multitude of other considerations of probable importance to drawing are beyond the scope of this book. These omissions and limitations are explicitly acknowledged and are felt to be an artifact of the kind of approach employed. Alternatives to the present approach are numerous. The reader can easily consult sources where less control has been attempted.

Emphasis on drawing strategies and styles and upon changes from drawing to drawing has encouraged a focus upon process data and the neglect of the qualitative assessment of finished art products. Since the author is an art educator, however, he felt it would be misleading and improper totally to ignore qualitative comparisons of products, difficult though these comparisons may be.

The function of this work will be fulfilled if it stimulates further inquiry and experimentation on the part of art educators and others interested in the psychology of art. The word *art* remains troublesome. It would be lacking in humility to assume that what is here written will be of interest or help to the esthetician, the art critic, and the artist. For this reason, it may be said that the emphasis is not on art in the honorific sense, but on a broadly interpreted base of esthetic behavior and on its dynamics. This formulation is not meant to be an academic circumlocution of a difficult problem; instead it reveals the assumption that art is properly thought of as a contested and undefinable concept, and that the best of theories will only succeed in limning one of its many faces.[1]

A considerable portion of this book will be devoted to several interrelated experiments, performed with college undergraduate art majors and nonmajors, that deal specifically with the nature of drawing styles and strategies and the conditions affecting these from one drawing to the next.[2] Photographic records of drawing processes from this research will be used to furnish illustrations of the points and concepts discussed verbally. The experiments themselves were so designed that a reasonable amount of control of conditions affecting drawings was possible. The nature of the design of these experiments allows the author to control for both subject or classification variables as well as treatment conditions. The symbolic or representa-

tional utility of the methods employed are herein held up for evaluation and criticism. It is important, at least to the writer, to try to find how such an approach fits within the entire body of knowledge concerning drawings.

It was felt that drawing processes, drawing styles and strategies are a fruitful point of departure for inquiry because of the very ambiguity attending these terms. In both definition and placement, it is not clear whether they belong in art criticism or art history, in psychology or in art education. For these very reasons, they make an interdisciplinary attack a necessity.

The latter part of this book will describe a transition which has taken place in my research, which has moved from emphasis on the experiment with its external controls and manipulations of the environment to in-depth case methodology utilizing first-person-singular reports of the artist in artist-researcher dialogues during the production of an extended series of drawings. Though this transition has been a natural one, the reader will sense, as I have, the great difference between the two approaches as well as how they complement one another.

A word should also be said about why the focus of this study is on the art of the adult rather than that of the child. Suffice it to say that those studies which have taken the opposite route have not, by and large, increased our understanding of mature art although some have claimed to do so. In fact, many writers on child art make a clean break between the art of the child and the adult, assuming that they are of different kinds. Such an assumption has not been made here, but it has seemed wise to take the alternative route even though at times this leads to complications. Cognitive theorists have attempted to define the nature of thinking involved in a subject area such as mathematics or science and to deal with these formulations in the developing thought of the young child. It is in this spirit that a study of adult thinking and art might well precede a closer look at the drawings and art behavior of children. Then, too, art educators, artists, and adults generally are inclined to entertain unsupported and romantic notions about the child's art that are really more a function of a metaphysical position than of educational, psychological, or artistic theory as such.

So vast remains the area of what cannot now be known by such methods as here employed that the author has no fear of having to submit to the self-immolation which his former teacher, Viktor Lowenfeld, felt in describing the nature of creative activity.[3] These meager scratchings will scarcely molest the muse.

NOTES

1. For further discussion of art as "logically indefinable" and as a "contested concept," see Morris Weitz, "The Role of Theory in Aesthetics," *Journal of Aesthetics and Art Criticism* 15 (1956): 27–35; and W. B. Gallie, "Art as an Essentially Contested Concept," *Philosophical Quarterly* 6 (1956): 97–114.

2. These drawing-learning experiments, supported by grants from the U.S. Office of Education, are reported in Kenneth R. Beittel, "Effect of Self-Reflective Training in Art on the Capacity for Creative Action," U.S. Office of Education Cooperative Research Project No. 1874 (The Pennsylvania State University, 1964); and Kenneth R. Beittel, "Selected Psychological Concepts as Applied to the Teaching of Drawing," U.S. Office of Education Cooperative Research Project No. 3149 (The Pennsylvania State University, 1966).

3. Viktor Lowenfeld, *The Nature of Creative Activity* (New York: Harcourt Brace Jovanovich, Inc., 1939), p. xvii.

chapter 2

Backgrounds, Limits, and Definitions

What kinds of assumptions do we need to have to discuss how a drawing gets made? This disarmingly simple question will assuredly bring us to grief, but let us ask it anyway.

How have various writers approached this topic? Since the clarification of one's basic assumptions may be the motive in writing a book or essay, it is often necessary to abstract from the writing what seems to be a writer's basic position. In the literature on child art in particular, certain assumptions about the child and about art or creative activity can often be teased out. The arguments of innocence, innate rightness of action, the given within perceptual processes themselves, or the nature of what is sometimes called the creative or originative instinct will be found to guide the course of an entire work. It is not really possible to separate these emphases from each other, but it may be helpful to discuss them separately.

FORMAL VIEWPOINTS

In one sense the making of a drawing can be considered a game of its own. With such a focus, formal aspects of drawing come to the fore. Closely tied with the formal are both what I will call repetitive or process dynamics and also characteristics of medium. While formal emphases lap over into developmental and perceptual approaches, the process dynamics and characteristics of medium are typically treated as secondary. Seen from this point of view, a vocabulary of form and method with or without common symbolic reference is held to develop from drawing to drawing. The assumption underlying an approach like Kellogg's[1] in her study of the young child is that this process unfolds organically and rightly without influence other than time, encouragement and medium. There is the further assumption that one formal stage or form family should precede those that have been identified as logically later ones. Motor aspects, perceptual processes, temperament or personality, and the desire to communicate, while not ignored, are given secondary importance in such approaches.

While only a few studies have done so, it is possible to take what I will call a *dynamic* formal point of view in which one pays closest attention to changes arising within the drawing process itself, or occurring from one drawing to the next. Alexander and Morris,[2] for example, emphasize this explanatory mode. The approach is formal precisely because it deals with the variation of given or observable elements with little consideration of forces outside the drawing act itself.

Writers such as Arnheim,[3] who base their approach to drawing upon assumptions about the nature of perception, are not precisely formal. Although the role of medium and the drawing process itself are acknowledged to be important, the given in this case is largely to be found within claims about the nature of perceptual processes per se.

More broadly conceived is the approach of the developmentalist. Here drawing behavior is likely to be positioned within all that is known about the maturing child in a cultural setting. Such studies, represented by Goodenough and Harris,[4] focus particularly on the concept of the development of intellectual maturity of the child. More recently, writers dealing with the cognitive processes and problem-solving behavior of children discuss the emergence of strategies for processing information, thus ushering in a dynamic developmental concern.[5] Furthermore, experimentation with early infant learning leaves one with the impression of the extreme plasticity of human learning and therefore of the tentativeness of developmental schedules.[6]

While centered more upon art, an approach like McFee's[7] attempts to integrate all of the forces that might operate upon the child in the production of a drawing. Thus, close attention is paid to socio-cultural factors as well as perceptual processes and qualities of medium and tradition within the arts themselves.

ART EDUCATION CLASSICS

The most ambitious attempts to explain the art of the child have doubtlessly been made by Lowenfeld, Read and Schaefer-Simmern. Since these men are art educators, they attempt in their writing to do more than describe the child's art. Their assumptions are directly tied to the importance of art and creative activity itself. Lowenfeld,[8] for example, begins with the conviction of the primacy and accessibility of the creative instinct in all human beings. He centers upon the role that affect and experiences of the self, physiological or otherwise, play in shaping the child's drawing. Imaginatively trying to enter the mind of the young child, he assumes that there is always meaning or intent present and that what is read by the adult as error or chance was in fact clearly guided by the bodily sensations, feelings and thought processes of the young child. It is by making contact with the child at the level of his ongoing experiences that his drawings may both be understood and enriched. The child's self-expression has a rightness about it and is not to be tampered with directly. In later development, this rightness has to do with what might be called perceptual types, and again the assumption is made that understanding and proper enrichment will only come from identification with the experiencing child. The role of medium, artistic conditions, or formal aspects within and between drawings, while acknowledged, is not emphasized.

Read[9] attempts to account for the importance of art in the total scheme of education and culture. The metaphysical position is perhaps more clearly acknowledged in Read than in other writers. He has tried, in fact, following Plato and Schiller, to put forth the premise that the arts of rhythm and form engaged in at a tender age will not only preserve the sensibility and artistic powers of man, but will lead to ethical or moral perfection. This argument is based upon the assumption that the arts draw upon rhythmical processes and wholeness exemplified in all organic and natural processes, forming thereby the child's behavior during what Rousseau called "the sleep of reason," so that in later life one's acts will possess grace and measure. The importance of artistic activity continues throughout life in that the arts give man the prime chance to experience unity and wholeness. This comes about by engaging the will in spontaneous activity in concrete situations requiring the manipulation of sensuous qualities for symbolic meaning. The child is not to be imposed upon; rather it becomes important to recognize the diversity of temperamental and artistic types that can rightly unfold toward this ethical perfection.

Lowenfeld, especially in his later writings, saw art in similar ethical dimensions. He emphasized how art embodied the creative process most purely and how it led to various sensitivities that could be applied in terms of a general creativity. Thus both Read and Lowenfeld developed an art education taking into account the part which art was assumed to play in the good life. It is not my intent to criticize these inclusive, coherent and impor-

tant views of art in education. In this context, it will not be necessary to follow completely their assumptions about the nature of art in education in order to discuss how drawings get made. Rather their works will be examined for what they have to say about the drawing act itself.

Schaefer-Simmern[10] is perhaps both purer and more lopsided than other theorists discussed so far. In the process of what he calls "visual conceiving," an activity peculiarly different from other cognitive processes, both child and adult, primitive and modern artist, develop their drawings in a similar organic manner. In this development "intentional figures," that is, those clearly set off as figures on ground, often indicated in the drawing of the young child as circular form, give way to a horizontal and vertical stage (elongation of the earlier figures). From this they pass to less than right angles, to maximal variability or acute angles in the intersection of lines, all the while maintaining the clarity of figure and ground found in the earliest intentional figures. All forms are heavily outlined, without a break. Overlapping does not occur in the usual sense. Shading and color bear no relation to naturalistic illusion but obey laws of their own. The purpose of the artist is always apparently to clearly separate form from form or segment from segment for the greatest clarification of figure on ground. Illusionistic space, as we have come to know it in the Western world, interferes with this orderly, organic unfolding, for such devices represent abstract thinking or a type of external imposition of technique. As in medieval work, that of primitives or of much of the East, upper position on the picture plane (sometimes with smaller size) represents distance. This is achieved with minimal overlap. Often a huge foreground figure is set off against the distance which is conceived almost like a stage backdrop.

Schaefer-Simmern speaks of more complex drawings following this route as being more "vital." To this observer, at least, there is not one vital drawing in his book — at least not as compared to what might be called "action" or "vitalistic" styles implying motion or gesture through open lines and ragged edges as opposed to concentration on slow, fully bounded contour. Spatial treatment in the examples given is limited to the flat plane and not to penetrations within the plane, conveying in like manner a more static, shallow space — perfectly compatible with one family of styles.

The curious thing is that Schaefer-Simmern sees this distinctly one-style, one-method mode of drawing as being *the* natural, organic unfolding of the drawing process. It is apparently true that some young children and primitives do often draw in this manner.

Alexander,[11] previously referred to, makes the child's tendency to separate forms for clear differentiation and perception of them the root of a kind of unity. By trying to keep things apart to make them readable, the child forces his forms into some organized relationship, one to the other. How this comes about is still mysterious. Alexander would make it a byproduct, not something intentionally sought.

Schaefer-Simmern makes much of the process of visual conception as being one in which a synthesis of immediately digested visual experience

takes place. Here we are plunged into a logical problem, for we are not at all sure how forms become synthesized. By claiming that visual experience, set off from other experience, becomes synthesized in the act of drawing, we are still left in doubt as to what occurs. More comprehensible is Schaefer-Simmern's insistence on the differentiation from drawing to drawing. Perhaps this is what he means by "unfolding." The virtue and possibly the horror of this approach is that taking the tendency toward simple, outlined forms as a beginning, as often found in children's, untrained adults', and primitives' drawings, the logic of development in this style is relentlessly pursued. A severe screen is thus set between the artist and the rest of the art world, past and present. Both by method and reinforcement, Schaefer-Simmern keeps his subjects or his students to this more or less coherent but one-dimensional development. Methods of criticism, even though drawn from the student, are led carefully toward the reinforced style. Techniques, such as blackening within the outline of a figure and seeing the drawing from a great distance, are meant to direct aspects of this development. As will be discussed later, any emphasis on shading as opposed to flat plane, black-white, or patterned texture is historically inconsistent with this stylistic mode. Consequently, in Schaefer-Simmern's students, when shading is used, it is not for naturalistic effects, but for a more complex rendering of figure-ground relationships.

It has seemed worthwhile to spend time with Schaefer-Simmern's approach, even though his terminology is psychologically and logically impenetrable, because his method and the coherence of the style purveyed thereby are clean and clear. Thus, for the first time in our discussion to this point, and without consideration of therapeutic and self-actualizing advantages which Schaefer-Simmern claims for his approach, we are given an exposition of how a drawing develops, or perhaps I should say how drawings develop from one to the next. More importantly, we are given some hint of how a style is learned, beginning with what seems to be a commonly found base in children's and untrained adults' schematic drawings and patiently developing from this meager base greater and greater complexity in one stylistic mode. It is interesting to note that Schaefer-Simmern uses pictorial examples to make sure the style gets off on the right foot. It does not necessarily follow, however, as Schaefer-Simmern suggests, that greater complexity and greater quality should be equated, nor that using approaches found earlier in time constitutes a regression.

CHANGE IN STYLE

Perhaps at this point we are brought to the issue of development and learning or change in style. Certainly, in the Western culture, the child's drawings show a rather linear development in their spatial conceptions. Not all of these developments would fit Schaefer-Simmern's stylistic mode. Aerial perspective, perspective in general, overlapping, foreshortening, and so forth, are inconsistent with it, as is therefore much of Western art. For examples, the works of Rubens, Rembrandt, Leonardo, Daumier, among

many who come to mind, would not fit into his approach. Many of my students point out the primitive or the medieval look of drawings made by this method.

The virtue of Schaefer-Simmern's attack, however, is that he has focused on the drawing act and drawing-to-drawing change much more than other writers so far considered. It is assumed in this book that drawings ordinarily take on directionality and complexity, that is, follow a stylistic development, by a subtle process of clarification, reinforcement, and control of elements found in the most rudimentary drawings. This history is akin to the process of individuation in an organism.

It is also assumed that some elements within a drawing have in their handling and interrelationships a kind of logic about them which can in fact be clarified from drawing to drawing. It is as though a network of interwoven constraints effectively screen out some kinds of development, some kinds of informational experience or inputs, or even affect and symbolic expression, while encouraging or easily letting others through. This internal logic need not be verbalizable or even clearly formulated in the child's or artist's mind; but the logic of a drawing is as much an example of mind, and of logic, broadly understood, as is the usage of language, though the two differ markedly.

As in Read and Lowenfeld, Schaefer-Simmern's use of art is for the good life. It is, perhaps, these extra artistic uses of art which have constantly and throughout history revitalized art itself, or at least been partially motivating of art activity. In the case of Schaefer-Simmern, his very narrowness and his strict adherence to the drawing act and method as he conceives them make it easily possible to separate the extra-artistic from the artistic development. There can be no doubt that his subjects or students did develop and find their lives enhanced by his teaching. These uses and outcomes of artistic activity, however, are not the central topic of the first five chapters of this book, although they gain in importance in the last four chapters.

Lowenfeld does not present us so much with development in drawing, as does Schaefer-Simmern, as with the effect of experience upon drawing. He does, however, talk in great detail about a child's drawing, indicating how we might read it in experiential, affective, and somatic terms. Even more, and despite the fact that his method is mostly one of case study, he exhibits an experimental frame of mind by setting up ingenious topics and problems which tease out the very characteristics of children's drawings which interest him most. Examples come readily to mind, as in the road which goes up or downhill and over a bump, or as in searching for a lost pencil in the dark and in broad daylight. The child's schema, particularly of the human figure, becomes a benchmark for interpretation, and the procedure for this interpretation is found in departures from the schema brought about by such topics. This method is applied again and again, with fruitful and provocative results. Changes from drawing to drawing are described mostly from this point of view, in terms of a given case or series of cases. The description and the series terminate when the topic or experience has run its course. Generalizations to the art of children are then made.

We are left with a clear image of the likely psychological state of mind attending certain pictorial outcomes and how activating this state of mind aids in the general development of the child. It is as though the impulsion toward the drawing sets its process and fixes its form. (In nature and organic life we think of form as the correlate of growth, or in abstract terms as the action of forces on a relatively homogeneous field.) This known impulsion then becomes explanatory of what is to be seen in the child's drawing, when manipulated through concepts such as affective distortion, autoplastic sensation, and perspective of value. Developmental stage and psychological type (visual or haptic), also described in terms of the child's state of mind, further explain the drawing. It is easy to see why Lowenfeld fought against any emphasis on the "how" in drawing since in his system it is the experience, the impulsion itself, which determines how things will fall in the drawing process. When we lack information on this impulsion, his method encourages us to infer it from the drawing. The method focuses stricter attention on concrete experiences than on symbolic transformations of experience. But its virtue lies in its attention to environment-organism interaction as a source of meaning. As a method, it thereby provides a corrective to strictly formalistic approaches by insisting on situational factors. The limitations of the method increase as the child develops—that is, as his knowledge of tools, medium, and art increase, and his thinking, in general, becomes more abstract.

Read, in contrast, does not give us much detail about a drawing or a connected series. He is more content to delineate the logic of a system for categorizing the variety of forms a child's drawings can take. The form of a drawing is the fruit of a psychological predisposition. "Mind pictures" and "mandalas" are possible exemplifications in art of something akin to the collective unconscious described by Jung. There are "primordial images" available to the young child. Unconscious modes of integration underlie these processes.

While Read does not give us detailed information about how drawings come about, he does something equally valuable. He lays the philosophical framework for connecting child art and adult art by his insistence that drawing is a process in which we observe "the spontaneous association of a symbol with an experience," in which the symbol need only represent the "affective component"[12]—which it can do arbitrarily and idiosyncratically. We need not follow his belief that this process is purely a function of the subconscious.

Read's basic point of view, as here described, connects drawing behavior to central problems in the philosophy of art, particularly as these are faced by thinkers like Dewey and Langer. Langer's "new key" in philosophy[13] describes "mind" as larger than what is commonly called thought, and sees, even before the dawn of speech, evidence of the basic need of symbolization, in which experiences are transformed as "an act essential to thought." If we follow Langer's lead, we will profit more from an epistemological stance emphasizing medium and meaning—as exemplified in the symbolic transformation of experience—than the traditional epistemology of percept-concept.

PERTAINING TO THE NATURE, GROUNDS, LIMITS, CRITERIA, OR VALIDITY OF HUMAN KNOWLEDGE

And when we apply this stance to the arts, to visual forms in this case, we find the articulation of forms not discursive (i.e., their constituents are not presented successively, as in language) but "presentational" (i.e., presented simultaneously). Structure in presentational forms can be as complex as in discursive forms, but meanings reside in the "sensuous construct" itself. In the world of presentational symbols, all is connotative, nothing is denotative (the latter being the chief virtue of language) significance. By way of symbolism, the life of feeling attains its own rationality. Presentational symbols, as already hinted, are earlier in occurrence than discursive ones. Langer says that the earliest symbols were not invented but were ". . . *Gestalten* furnished to the senses of a creature ready to give them some diffuse meaning."[14] And among these early meanings are found "aesthetic attraction" and "mysterious fear." Moreover, earliest symbolic behavior is seen as "purposeless" and not "ways to means."[15] Without detailed pursuit of Langer's concept of the course of cognitive growth, suffice it to say that early examples of symbolic transformation are those in which vague and basic feeling, often of what she calls an aesthetic character, reads meaning into or from visual and auditory forms.

In terms of drawing behavior, Langer's assumptions largely circumvent the arguments about whether a child draws what he "knows" or "sees." They even circumvent the question of why he draws, for "images" are already "symbols" whereby things are conceived, available for transforming experience into "meanings." They are, in short, ". . . our readiest instruments for abstracting concepts from the tumbling stream of actual impressions."[16] Furthermore, Langer describes presentational symbolism as showing its own characteristic development: (1) single and static images (single concept), (2) images taken together, having reference to each other, (3) "stories," and (4) possible inclusion of more than visual components, what she calls "fantasies."

In this setting, however, it is enough to say that Langer offers us a rationale for seeing drawing behavior as part of man's basic need for symbolic transformation of experience, an essential process in conceiving the meaning of that experience. Such symbolism is presentational, its structure grasped in one act. The work of art articulates the idea of feeling, not through a synthesis of elements, but as a nonadditive, emergent quality, as organized feeling. The work of art as a whole is symbolic, for it is ". . . an expanded metaphor of feeling."[17]

By presenting art as essentially qualitative and following a "logic" unlike the logic of discursive symbols, but just as rigorous, Langer has much in common with Dewey. To Dewey,[18] the world of lived experience is primarily qualitative. "Situations," as contrasted with "objects" (abstractions from situations), are not only qualitative but regulated by an underlying "pervasive quality." Situations can only be handled abstractly by making them elements (objects) in more comprehensive situations—that is, by moving up the ladder of abstraction and, ostensibly, into language.

Following Dewey, it is fair to suggest that the creative process itself

evidences a dynamic pervasive quality. As with all experience, it has purpose and an emergent direction. It has pattern, structure, and boundaries. It is a microcosm of the life of the "live creature," a transaction, in which essentially unpredictable, irreversible events are harmonized toward a fulfilling and inclusive close. From this stance, the drawing act becomes imbued with the drama and the dynamics of "an experience," as Dewey means this term. But, under its critical phase, the drawing act becomes not a "situation" only, but also an "object" in the larger situation which is comprised of a series of drawings—perhaps even "all of the drawings I have made, seen, or imagined." And yet its quality cannot be accounted for directly by the application of any principles existing through the generalizing abstraction of language.

CONTINUITY AND CONSISTENCY

What factors, however, explain the consistency sensed between the drawings of a given person? Some would say that this has to do with the connections between art and personality. Passing reference has already been made to those put forth by Read and Lowenfeld. Both men define temperamental and artistic types. Lowenfeld talks about the visual and the haptic, equating these generally with impressionistic and expressionistic art styles. Read bases his approach on a more complex system taken from the work of the psychologist Carl Jung. Four types, the thinking, feeling, intuitive, and sensation types, are identified along with an objective or subjective emphasis in each, yielding thereby eight categories. Read also connects these types with artistic styles past and present. He even creates divisions of the curriculum to match the four basic types.

Schaefer-Simmern, in a disarming manner, ignores completely the hypothetical impact of temperament upon style, so single-minded is his belief in one manner of developing one's art. This very neglect is significant, in that it indicates the operational utility of suppressing the emphasis on personality as necessary to the explanation of style.

Alschuler and Hattwick[19] discuss art and personality directly, in their case dealing with art of the preschool child. In their approach to the study of personality through art, they make a valuable point about the possible connection between medium and the projection of personality characteristics through drawings. They state, in fact, that the pointed instruments commonly used for drawing are more likely to emphasize the cognitive rather than affective life of the child. Arnheim and Schaefer-Simmern show the reverse concern, fearing that broad brushes and dripping paint, as espoused in the name of "free expression," will curtail the child's ability to "conceive visually." The writer feels that it is unnecessary to make the assumption that there is any direct relationship between art expression and personality types. Slight, if any, explanatory power will result from assuming that drawings get made a certain way because certain personalities are that way a priori.

In the romantic image the conceptual, rational side of man is played down in favor of the vitalistic, image-making, dream-like, and magically

based side.[20] The work of art becomes not only unique, with a life of its own, but is not open to study or dissection. Science, in fact, became the "tree of death" insofar as art is concerned. By this argument we must leave to the arts what cannot be described discursively but what can only be "known experientially." A further point of view, developed through Eliot,[21] is that of the dissociated sensibility in which the modern preference for the intellect and science has resulted in a shrinkage of the imaginative powers of man. By this view, man must retreat into organic wholeness, away from lopsided society, to regain balance and innocence. By such formulations art becomes off-limits for scientific discussion. This same inheritance would further bolster, however, the expectation of a connection between art and personality although admittedly from this vantage point, the connection would be a dynamic, transactional one. The point of all this discussion, however, is to say that such assumptions about art and culture are not felt to be essential to this work, resting as they do more upon a mystique than a theoretical or factual base.

Perhaps the practice of art, at least as we can now see it as inheritors of the romantic age, suggests to the artist that he needs to have ideas about art which place it out of the realm of ordinary experience. At other times and places, when the power of myth, tradition, and ceremony was more felt, art may have infused daily life more deeply. In this subjective quest for significance, artistic activity may be little different from creative work generally, whether in science, art, or other areas of living. For such a mind set, man has historically called upon divine or even demonic powers. In a more sophisticated time he calls upon the creative process itself. There is always a turmoil of fresh or recovered ideas (possibly crackpot, but who could tell?) which help set off new activity in the arts. The artist may believe himself specially called or entertain notions about his own or his work's importance, or about his state of mind, the only purpose of which is to get him into the proper creative mood. What an artist needs "to art" is meaningful to a psychology of art, but it must not be confused with an effort at rational explanation of what actually takes place. This is likewise true for concepts presented in critical writing concerning art, which help us to comprehend its complexities and its qualities but which are beyond logic and verification. Such a distinction as Jung's[22] between the psychological and visionary modes of art, for example, will not help us in trying to comprehend the making of art, because by definition his visionary mode transcends the bounds of psychological intelligibility.

There is, however, a proper region of mystery to our inquiry, and this will expand as the book continues and the transition from the nomothetic to the idiographic frame of reference occurs. Such a shift induces the researcher to assume naturally a more phenomenological method. There is a centering on experiencing and a philosophical drift toward the existential. It has been alleged that the researcher comprehends phenomena somewhat as a reflection of his own image, through the questions his intuitive side allows him to ask. If so, I have been guilty of using both of these approaches and hope still others will come to me.

It is indeed easier to state what is not assumed than what is. Perhaps as Alexander[23] indicates, this is the only route for definition open to us when considering complex phenomena. It is clear, however, that whatever the impetus toward a drawing, the act of drawing itself is a directed thought or "mind" process and, though covert in nature, is open for inquiry and description. Thus it is unparsimonious to assume without evidence that the thought processes involved are greatly different from other thought processes except as these differences can be clearly demonstrated. The forming of any tangible product, and now we turn from the realm of a verbal product, takes its orderly course, and this course involves means-to-end control, in the dialogic sense where we deal with dynamic processes that are, to the participant, partially unpredictable and irreversible,[24] but which, nonetheless, move toward "end" structure and organization, albeit of a nature traditionally described as vital or organic. This control is learned through drawing itself, and we will make no effort to separate means and end herein. It will be admitted, as in the "perception delineation" theory and model of McFee,[25] that there are many factors, many influences which potentially impinge upon the drawing act. Thus it is impossible to separate drawing from the cultural context in which it occurs. It should be fruitful, however, to concentrate largely on the drawing act itself and upon drawings made in sequence in order to further our understanding of drawing. This is not to ignore the other forces, but to point out that they are so many that, unless they are part of controlled observation, it will be impossible to state what is operating. In an approach like McFee's, where these many forces are detailed under readiness, psychological environment, information-handling abilities, and delineation skills of the child, we are still not enlightened about the drawing act itself. Indeed, many things condition drawing, but drawings nevertheless get made and they show surprising similarities in method and style. It is these which are the focus of this work, in both their generic and individual manifestations.

STYLES AND STRATEGIES

By concentrating on the art of the adult, it will not be necessary to become partisan to the various points of view about how the art of the young child develops. Although at times reference is made to the art of the child, this will be where points in common with those developed in the art of the adult occur and where they may perhaps be seen more clearly in a simpler drawing. It is acknowledged that the drawing of the adult not only is more complex but is manipulated much differently than is the child's drawing. The shift from concrete operations to formal operations emphasized by Piaget and corresponding to the cessation of increments on the Goodenough and Harris Draw-A-Man Test, corresponding with the ages of 11 or 12 to around 15, is significant in this context.[26] It is assumed that what might be called formal operations analogous to, but not identical with, those we know in logic do in fact occur in making drawings. These operations might be referred to as transformational habits developed within sequential drawings and loosely bound together in packages called styles and strategies. Whereas

some of these processes which obtain from drawing to drawing may be slightly idiosyncratic, others will be found to relate to various style and strategy families. The meanings or qualities which a particular drawing conveys will indeed be found to be above and beyond these styles and strategies, but they will nonetheless be circumscribed by a certain style and a certain strategy. Thus, to be sure, following the concepts from Dewey and Langer as previously presented, we cannot speak discursively of the pervasive quality of a drawing, locked in the connotations we sense from that presentational symbol of shaped feeling; we can, however, speak of the drawing as an object in the larger perspective of a series, or of a style. If I am pressed about the pervasive quality of a style, of a series, I will have to back up still further.

In a sense, my primary focus on strategy and style, the two words I have been using loosely and together up to now, blinds me from the effort to talk about drawing as a whole. Further definition of these terms is therefore now in order.

Style, a key concept in art history, will be used to refer to discriminable unities ascribable to a time, a place, or a person, or all of these. It will be taken to imply conventions or habits of how the art work is put together or of the "appearance" of the forms, e.g. whether they are clean and bounded with a hard precise contour or whether they are diffused, rough, with open and ragged contour. While it may interact with what is symbolized by a work, it is not the source of the meanings experienced with that work. Thus the style and the quality of an art work are not to be confused. The latter is to be found in the gestalt, the sensuous context of the unique work itself. Style is "coded" and capable of generalization to a fair degree in discursive thought. The quality of a certain work is not.

Strategy may indeed overlap with style, but it will be profitable to use these words differently. Strategy is taken to refer to "regularities in decision-making,"[27] or as mental schemata for processing the "pieces" with which the work is constructed. Such schemata undoubtedly arise from repetitions into complexity from meager beginnings. Strategy is a concept which is more general and abstract than style, and less attached to art than style, but like style free from directly controlling individual quality. I would like to call it "the way a mind works" at the task of putting together art objects. It happens also to be true of other ways mind works, as in solving problems of all kinds. A synonym of use may be found in the concept of "plan" (to be discussed in detail in the next chapter) taken as a program for a course of behavior, (acts, purposes), guided by feedback loops in time, in context, in process.[28] If *plan* seems too structured a term, it should be said that it does not necessarily imply conscious or clear preconception. Certain plans or strategies, in fact, appear to be very fuzzy as to the sequence of behavior which will follow beyond a certain point. But that is the character of this class of strategies. A full discussion here, however, of kinds of strategies is premature. It is the basic concept and its differentiation from style that is our concern.

While in general there is a correlation between strategy and style

in many periods and places in art history, the same strategy can result in different styles. Evidence for this will be cited from experiments where the "plan" of attack and development remained essentially the same, but the style of the works were different. Such changes within sameness of strategy may appear where subjects were asked to switch styles or where they were directly instructed to do so. For most subjects, it would appear to be easier to change style characteristics than strategy.

It may be asked how mind can work in only one way and forms come out in generally different styles. Apparently this is, at its simplest, merely a matter of envisioning the gross appearances of a conventional style. In making pottery my method of throwing could remain essentially the same and yet differing styles be apparent in the outcome. In Japan, where many traditions of pottery remain intact, potters such as Hamada have worked in the styles of the places they have visited, but they have probably not greatly changed their basic method of throwing. The fact that this is rarely done is beside the point. (It is often done by students when they change from one art class to another.) In practice, however, it will be admitted that strategy and style are apt to accommodate each other.

Much more mysterious is the way in which apparently similar or even ostensibly identical strategy episodes can eventuate in greatly dissimilar works or gestalts. Again, the narrow range within the work of a Japanese potter working in a coded style and even using the same basic form, materials, decorative motif, and firing method will contain individual pots far different in expressive character.

This latter qualitative individuality of a work is thus more properly toward the core of art than are strategy and style. It is also more of the "mystery" of art. Discussions of strategy and style, however, are more possible at present. Knowledge of these may bring us closer to talk of the qualities of a work because ordinarily the range of means, materials, and processes will not be as narrow as in the example above nor will the outcomes be as seemingly different. We are more apt to see strategy and style not as explanatory of qualities but as shifting some of the frames which allow particular qualities to be cognized at all. They are thus among the gradients of plan and appearance within which the unique work occurs. (Strategy and style are indeed analogous to plan and appearance.) By learning what these are, we may learn better what quality is not. And the feeling cannot be suppressed that they usually help set the range of the qualities which can be projected. They cannot be said to constitute or explain art, but they are of the dynamic that is art, as essential ingredients in the mind producing it.

In a way, the approach in this book should underline the plasticity of some of the components of drawing behavior. By doing so, it cannot be claimed that our understanding of learning or growth in art will be complete. Rather we may have a context within which to conceive of changes, from drawing to drawing, in the things that do not directly count in the achievement of aesthetic qualities but that from time to time will illustrate, *post hoc* to be sure, the process of individuation which seems to eventuate in sensed

qualities of the work. In one way dynamics of strategy and style will often explain the emergent route toward a quality but not account for its achievement. This is not strange, for the perception of qualities in art is in itself an open, unfinished process.

Let it be said that beyond the differentiation of strategy and style, there is the differentiation between often confused kinds of development: child development, artistic development, and representational development (this latter refers to the quest for realistic representation in the Western world). It will be to our advantage to work at keeping these separate conceptually, even though, like strategy and style, they will often occur together.

OBJECTS AND IMAGES

Emphasis on processes may help prevent us from starting with the object, or the idea, or "perception." As Britsch[29] foresaw, it is not what is perceived that is represented (or symbolized) in a drawing. "Visual experience" is the stuff on which art feeds, but it is the images arising from this stuff, this funding, this exercise and transaction, that linked with "effort" of imagination sets the art process going. Then it is that process itself which would seem to hold the secrets we need to probe. As already indicated, the "new key" which Langer[30] has grasped intuitively in her philosophy of art fixes us on image, medium, process, and meaning, not on the older percept-concept epistemology. It is on this loom we would weave.

Indeed, to Langer, in her most recent work[31] the art object, as the projected form of feeling, as the organic process by which imagery is transformed to signify in sensuous materials, is the paradigm for "mind" in its broadest reach. Pribram,[32] from his study of the brain and how it functions, goes even further in his discussion of "meaning."

Evoking images, he says, involves "a less constrained, more primary process," a path to meaning necessary for the second- and third-level processes he calls "indexing" and "symbolization."[33] Neurologically, coding operations are the key to the determination of meaning. A code is described as ". . . a set of signals or signs which allows ready manipulation." A code transforms a complex series of very simple elements into "a simpler series of patterns of more complex elements."[34] As an example, Pribram illustrates how a line of twelve on-off switches requiring varied settings can be transformed into a more manipulable code. A given sequence: UUDDUUUDUDUD becomes: 7463, through the assignment of Arabic numerals to patterns of triads of on-off elements (there are eight such triads for on-off elements, or 2^3). Thus UUD is the seventh possible triad pattern, DUU the fourth, and so forth.

In imaging, an elementary coding system already occurs in the nervous system itself.

Composed as it is of few elements arranged in complex series of patterns, the image thus resembles, as it should, the uncoded pattern from which it originates. This is a resemblance only, however; . . . the elements composing the image are

relations between events rather than events *per se*. . . . The image is thus a sign of relationships. In this way, imaging provides internal meaning to signs. Imaging is therefore the first of several ways by which meaning can be achieved.[35]

The constructed mental image and uncoded "reality," however, are similar enough that the internal meaning which images possess cannot easily be communicated. Higher order "denotative signs" are constructed by the mind to handle relationships within the image. Perhaps, says Pribram, "one or another relationship may be enhanced to stand for the whole." This might be like a pervasive qualitative or so-called physiognomic qualitative relationship. This second-order process of coding is one of "indexing by means of signs the universe which generated them."[36]

At the first level, imaging, meaning is "internal," at the second, indexing, it is "intrinsic." In indexing, meaning would seem to be imposed on events; but "the imposition is derived from relationships between the events themselves," and thus is not of an arbitrary character.[37]

Symbols, or "tokens" as Pribram also calls them, function as a third-level process. Symbols are neither internally nor intrinsically related to the events to which they give meaning. Language, for example, is ordinarily symbolic, except in poetry, where it signifies (stands in some intrinsic relationship to imaging). Symbols

. . . are *not* isomorphic with the events they symbolize. For the most part symbols are constructed arbitrarily through use, i.e., through the operation of feedbacks from the consequences of prior actions, the process of reinforcement. . . . Symbolic meaning is thus paradoxically primarily external to the events to which meaning is given and it leads to externalization in a form different from the original events. Yet a relationship is maintained between all of these processes—they are, as it were, grafted one upon another to produce a various and abundant crop.[38]

The last sentence above suggests the interaction of these various coding processes. As Pribram puts it: "The Act, the external representation, takes form from an organization of neural signs, a Plan."[39] The communication of meaning, or expression, depends on a coordination of the three levels of coding: from the relationship of events in constructed images, to the manipulation of relationships within the image, to action and output through "useful symbols." Visual art, like poetry, must certainly be involved with all three of these levels, but it is based primarily on the second level. In other words, there is an attempt to use symbolic elements (arbitrary, impersonal) for communicating (or expressing) intrinsic meaning based on decoding (via indexing) the internal meaning of constructed mental images themselves. Pribram thus conceptualizes these functional relationships:

. . . the importance of the phrase "what one means to do" centers on the fact that the interaction of doing lies in the attempt to form, through action, an external representation of one's *imaging*. . . . I would suggest therefore that both indices and symbols derive meaning to the extent that they evoke images.[40]

In Pribram's usage, signifying would rather well coincide with Langer's nondiscursive or presentational mode of symbolizing. A kind of abstract thinking would be involved, for which the terms abductive or analogical reasoning are proper, while Langer speaks of "abstractive specification" as a form of thinking different from "generalizing abstraction."[41]

Such concepts would explain the artist's actions as constructing abductively (i.e., by leading back to the base) the form of feeling from elements analogically comparable to the imagery which is its source—the whole, as Langer well knows, suffering its own history of acts, individuation, and whatever metaphors match aspects of organic life as it unfolds in time and context. To repeat, this abductive process, which Pribram calls signifying, in visual art thus involves externalizing, through partially conventionalized symbolic elements, intrinsic meaning imposed upon but derivable from the constructed mental image itself. Since nondiscursive symbols are here functioning, it would seem—and I believe both Langer and Pribram suggest this—that the transformational process underlying visual expression is more closely allied to its source in imaging than are the processes leading to expression in discursive symbol systems. Nondiscursive symbols are flexible, fluid, ambiguous, and context-locked to an amazing degree, as compared with discursive symbols. The former are therefore ideally suited to do "directly" what language must always do at least partially indirectly.

EXPERIENCE AND EXPRESSION

Yet our prior discussion, following Pribram, has stressed the interaction of "neural signs" of all levels in the act of communication or expression. It would nonetheless seem that the response or action side is more social in character, the imaging side more private and nonsharable. That these poles can move apart in experiencing is attested to by the frustrations often attendant upon our efforts toward "expression" and "learning." On the action side, we are all too easily influenced away from our internal base of meaning in imaging. On the other hand, our symbolic expressions and the feedback they give us are most likely prime shapers of the kinds of indexing operations we choose to emphasize in decoding our images.

From Piaget,[42] we find a hint that the young child and the artist have in common the set toward abductive reasoning, whereby imagery and idiosyncratic subjective life are transformed by whatever is at hand that is not strictly a part of the collective life only. According to Piaget, thought and affective life are far apart in the child. "Symbolic play" is not yet art, he maintains, but becomes so when reconciliations take place as ". . . syntheses of the expression of the ego and submission to reality."[43] It is the discipline necessary for this reconciliation that is apparently the undoing of child art in our culture (and in general throughout the world), since emphasis on the ". . . world of objective and communicable realities which is the material and social universe"[44] cuts short the symbolic play in which early abductive reasoning is a natural but highly idiosyncratic thing. But the synthesis of

affect and reality are not a problem in symbolic play. (In passing, it should be pointed out that Piaget's term "symbolic play" is confusing because "symbolic" suggests an arbitrary, socialized, and conventional meaning which is absent from his usage. The reader may profitably substitute "imaginative play" for this term.) Maybe, even as Grossinger insists,[45] affect is reality to the young child, since he almost knows no other way to "think," and it is we adults who read in all sorts of nonsense, even when "identifying" with the child (as Lowenfeld said we must) and trying to "think childlike."

As Gombrich has indicated, the stick *is* a hobby horse.[46] It is precisely because the child has no powers of reflection (is "unaware" as Lowenfeld would say), has ". . . no second order thoughts which deal critically with his own thinking"[47] that child art and adult art part company. The basic activity is the same, but the lack of this reflective thought makes the synthesis of which Piaget speaks unlikely. On the other hand, we know all too well how this same critical ingredient vitiates adult art by its overabundance, which stifles the very "expression of ego" (I would prefer "transformation of imagery," with Langer and Pribram) which is its apparent source of power.

These concepts lead to a speculative hypothesis concerning child art. In our own culture, after Peirce and James, and now with cognitive theorists like Bruner, the growth of the mind is away from the subtle and initially subjective reasoning by analogy (for which the term abductive reasoning was proposed) and toward pragmatic, scientific kinds of reasoning, toward induction, deduction, discursive thought, and symbolic logic. Thus just because a hierarchy is implied, the emphasis is on what Bruner and Pribram call symbolic thought, and away from signifying, or reasoning by analogy, abductively representing the internal meaning of one's imagery. In mature art, the traditions and operations of a particular medium and style intervene before we say a person "thinks like an artist." What is clear in child "art," however, is not tradition or medium, but the crudest and most concrete thinking by analogy in terms of the internal meaning of imagery. This unaware process is the source of directness, power, and simultaneous ambiguity and transparency in child art. The acts of the drawing situation are composed of manipulations and extensions of available drawing schemata for this end. It is probably helpful that the schemata are impoverished, relatively undifferentiated, and ambiguous for such direct matching, where the schemata at hand *are* the image they represent, without undue regard for collective meaning. All images are "wrested" from the mind and transformed in the art process, but not this simply; although, to borrow a term from Langer,[48] the match is always "overdetermined" (as indeed are all metaphors). The erosion that affects child art is brought about by the gradual shift from what is at first basically the only way of thinking in children to the "submission to reality" or collective, symbolic logic, which, for a while, makes child art less ambiguous, less idiosyncratic (and, bit by bit, less powerful) but ends up by swallowing up the "affect" pole for that of "thought."

The adult must suppress the emphasis on the arbitrary, conventionalized aspect of symbolic modes and utilize artistic tradition, medium, technique,

and the ambiguities of all these for abductive, analogical thinking. Through the critical power of reflective thought unavailable to the child, he must bring about that synthesis which makes both expression and meaning equally possible and equally problematical. And here I follow Langer's most recent writing[49] for the form of feeling which is the work of art embodies the history of that dialectical situation, that sequence of acts in which abductive and critical reasoning struggle with physical stuff of medium, the appearances of traditions and styles, and the techniques and operations of an art, in the effort to clarify (virtually, to create) the image-meaning germ which is its impetus and rudder.

It is for this reason that we begin with the next chapter the study of the drawing process itself, for its situational and sequential history are a neglected and unknown side of aesthetics and the psychology of art.

NOTES

1. Rhoda Kellogg, *What Children Scribble and Why* (Palo Alto, Calif.: N-P Publications, 1955).

2. Christopher Alexander, "The Origin of Creative Power in Children," *British Journal of Aesthetics* 2, no. 3 (July 1962): 207–26; Desmond Morris, *The Biology of Art* (New York: Alfred A. Knopf, 1962).

3. Rudolf Arnheim, *Art and Visual Perception* (Berkeley: University of California Press, 1954).

4. Florence L. Goodenough, *Measurement of Intelligence by Drawing* (New York: Harcourt Brace Jovanovich, Inc., 1926); Dale B. Harris, *Children's Drawings as Measures of Intellectual Maturity* (New York: Harcourt Brace Jovanovich, Inc., 1963).

5. See, for example, Jerome Kagan, "Impulsive and Reflective Children: The Significance of Conceptual Tempo," in *Learning and the Educational Process,* ed. John D. Krumboltz (Skokie, Ill.: Rand McNally & Company, 1965); Michael A. Wallach and Albert J. Caron, "Attribute Criteriality and Sex-Linked Conservatism as Determinants of Psychological Similarity," *Journal of Abnormal and Social Psychology* 59 (1959): 43–50.

6. J. McV. Hunt, *Intelligence and Experience* (New York: The Ronald Press Company, 1961).

7. June King McFee, *Preparation for Art* (San Francisco: Wadsworth Publishing Co. Inc., 1961).

8. Viktor Lowenfeld, *The Nature of Creative Activity* (New York: Harcourt Brace Jovanovich, Inc., 1939); Viktor Lowenfeld, *Creative and Mental Growth,* 3d ed. (New York: Crowell Collier and Macmillan, Inc., 1957).

9. Herbert Read, *Education through Art,* 3d ed. (New York: Pantheon Books, Inc., 1956).

10. Henry Schaefer-Simmern, *The Unfolding of Artistic Activity* (Berkeley: University of California Press, 1961).

11. Alexander, op. cit., n. 2 chap. 2.

12. Read, op. cit., n. 9 chap. 2, p. 137.

13. Susanne K. Langer, *Philosophy in a New Key* (original ed., 1942; reprint ed., Baltimore: Penguin Books, Inc., 1948).

14. Ibid., p. 89.

15. Ibid., pp. 95–96.

16. Ibid., p. 117.

17. Susanne K. Langer, *Problems of Art* (New York: Charles Scribner's Sons, 1957), p. 180.

18. John Dewey, *Philosophy and Civilization,* "Qualitative Thought" (New York: Minton, Balch & Co., 1931).

19. Rose H. Alschuler and La Berta W. Hattwick, *Painting and Personality, A Study of Young Children,* 2 vols. (Chicago: University of Chicago Press, 1947).

20. Frank Kermode, *Romantic Image* (New York: Random House, Inc., Vintage Books, 1957; reprint ed., 1964).

21. Ibid.; see chap. 8, "Dissociation of Sensibility," pp. 138–61.

22. Carl G. Jung, *Modern Man in Search of a Soul* (New York: Harcourt Brace Jovanovich, Inc., 1933), p. 155.

23. Christopher Alexander, *Notes on the Synthesis of Form* (Cambridge: Harvard University Press, 1958; reprint ed., 1966) pp. 22–26.

24. Hannah Arendt, *The Human Condition* (New York: Doubleday & Company, Inc., Anchor Books, 1959), pp. 212–23.

25. McFee, op. cit., n. 7 chap. 2, pp. 40–42; 147–51.

26. Harris, op. cit., n. 4 chap. 2, p. 4.

27. Jerome S. Bruner, Jacqueline J. Goodnow, and George A. Austin, *A Study of Thinking* (New York: John Wiley & Sons, Inc., 1956), pp. 54–55.

28. George A. Miller, Eugene Galanter, and Karl H. Pribram, *Plans and the Structure of Behavior* (New York: Holt, Rinehart and Winston, Inc., 1960).

29. Gustaf Britsch, *Theorie der bildenden Kunst,* 2d ed., ed. Egon Kornmann, (Munich: Bruckmann, 1930); p. 13.

30. Langer, op. cit., n. 13 chap. 2.

31. Susanne K. Langer, *Mind: An Essay on Human Feeling,* vol. 1 (Baltimore: The Johns Hopkins Press, 1967).

32. Karl H. Pribram, "Meaning in Education" (Paper presented at a meeting of the American Educational Research Association, Chicago, 1960).

33. Ibid., p. 14.

34. Ibid., p. 5.

35. Ibid., p. 7.

36. Ibid., p. 8.

37. Ibid., p. 9.

38. Ibid., p. 10.

39. Ibid.

40. Ibid., p. 13.

41. Langer, op. cit., n. 17 chap. 2, pp. 177–80.

42. Jean Piaget, "Art Education and Child Psychology," in *Education and Art,* ed. Edwin Ziegfeld, (UNESCO, 1953), pp. 22–23.

43. Ibid., p. 22.

44. Ibid., p. 23.

45. Wolfgang Grozinger, *Scribbling, Drawing, Painting* (London: Faber & Faber, Ltd., 1955).

46. E. H. Gombrich, *Meditations on a Hobby Horse* (London: The Phaidon Press, Ltd., 1963).

47. Barbel Inhelder and Jean Piaget, *The Growth of Logical Thinking* (New York: Basic Books, Inc., 1958), p. 340.

48. Langer, op. cit., n. 31 chap. 2, p. 103.

49. Langer, op. cit., n. 31 chap. 2.

The Drawing Process and the Drawing Series

In this chapter the general nature of the drawing process will be explored and concepts "drawing sequence" and "process feedback" introduced. It will soon be apparent that there are unsettling dilemmas attendant upon any effort at consistent thinking on these matters.

In earlier writing[1] Burkhart and I tried to make explicit our assumptions about the typical situation in which the artist is involved in picture-making:

1. Drawing is a "dialogue" between the artist and his drawing.
2. Thus drawing is essentially a covert and private affair.
3. Self-direction is a natural consequence of a drawing series, especially where there is relatively little change in the medium, theme, or stimulus, the procedure for self-evaluation, (i.e., where attention is fixed upon comparable qualities of drawings themselves). Such conditions occur within an artist's discipline in his own studio.

4. A "value neutral field" surrounding the picture-maker, removing extrinsic rewards, emphasizes "self-rewarding activation," a principle which Morris[2] finds basic to picture-making (even among apes).

The artistic dialogue, that is, must be intrinsically rewarding and all-absorbing, not diverted by strong external criteria, especially if these interfere with the artist's imagery and feelings. The "value neutral field" is, put positively, a supportive and a nurturant, but a relatively passive one, inviting the artist to work from and to embody values inherent in his own dialogue.

CONTRADICTION OF OPPOSITES

The notion that the art process is a "dialogue" or a "crazy game of strategy" is commonplace in art writing. "Crazy" means that there are something like rules, but that they are free to change in process and are peculiar to each game. A "game of strategy" is one in which one's own move is countered by one's opponent's move. As Black[3] puts it:

> There is . . . in all artistic creation a characteristic *tension* between the man and the material in which he works . . . the artist literally *wrestles* with his material, while it both resists and nourishes his intention. He finds himself constantly excited by the qualities objectively present in the material which it is his aim progressively to discover.

In short, the art process is one of dialectic, energized by the contradiction of opposites. Whence come these opposites? Are they a kind of mental pattern-matching of the remembered with the on-going, allowing us to attend to qualitative aspects of experience, an essential ingredient in conscious imagination? In the on-going artistic dialogue, the line which creates on a pregnant ground gives way to the remaining ground opposing it, which evokes a new contrasting figure. A simple form prompts development or elaboration. White demands black. Precision evokes spontaneity; struggle, grace; restraint, passion; theme, variation. Examples are endless.

What I have termed dialogue is more like what Langer calls a "dialectical rhythm," where a series of actions ". . . consists of alternating contraries, such as rise and fall, push and pull, suction and expulsion, and each element in spending itself prepares and initiates its own converse. . . ."[4] The merit of her conception in this regard resides in its pervasive abstractness, for she applies it to living form in nature and to form in art (which is to her the model through which vital systems can be cognized).

The basic element, in art and in living systems, Langer calls the "typical act form," expressed as a parabolic curve, operating on myriad levels of structure, and composed of ". . . main phases of inception, acceleration, consummation, and cadential finish."[5] Langer's concept of the 'act form' is exceedingly complex. Acts occur within a "situation" (a term she sometimes qualifies as "the prevailing situation," and again refers to as "the entire situa-

tion"). 'Situation' includes what are often called the "internal" and the "external environments" of the organism. The important variables in any given situation may be present or past, environmental or internal.[6] (In my present thinking, I sometimes refer to the "bounded context" as equivalent to the artist's external environment, and to the artist's "situation" as encompassing his perception and action within that context. Langer, however, prefers to have the single global term "situation" cover both of these concepts, a usage which a focus on the artist as agent would seem to support.)

The "inception" of an act, says Langer, is also its "impulse," and it contains the germ of the total act form. The impulse arises from the situation, and the "substance of a situation" is "the stream of advancing acts" from previous situations.[7] The prevailing situation thus cannot be separated from the total life of the organism. It cannot be described as a thing-in-itself.[8] A causal relation is held to exist among acts, for "one act, or a complex of acts, may be said to induce a new act."[9]

The effective variables within an organism's situation are "acts of perception" and "traces of former acts." Langer finds utility in the concept of the "impulse" or initial phase of an act, because it allows her to talk of "potential acts" and thus to deal with "choice" and "intent," terms denied within the traditional language of natural science[10] but extremely important for discussing "mind." She feels that the artist's symbolic projection

> . . . provides a principle of analysis applicable to the actual living form his work reflects: the principle of distinguishing, within a dynamic whole (i.e., a whole held together only by activity) articulated elements, which nonetheless are indivisible in themselves, and inalienable from the whole, if they are not to give up their identity . . . artistic elements are "act-like." Their biological analogues in the world of nature are acts.[11]

I conclude several things from these difficult concepts. The artist's product may be defined as the result of a series of motor acts, one inducing the other, contingent upon former acts, dependent on on-going perception, a process in which (to hark back to Pribram[12]) choice in relation to intent (or meaning) occurs at the level of transformational operations. At this level of choice and meaning the artist continuously decodes his imaging in terms of its potential for expression. The product would then seem to reinstate these acts in a kind of psychophysical parallelism, not so much in an "objectified" form but as a potential "work" within the perception (the "situation") of another person.

I see great utility in the above ideas. For one thing, they form a bridge between psychology and art, putting them both back into the same world again, without a softening of the one side or a hardening of the other. For another, analytic elements not only connect to but are a part of the situation. And while the complexity of Langer's system is staggering, it nevertheless provokes imagery which unites ideas otherwise hard to reconcile. Whether this imagery is more of a solace than a trustworthy guide in the labyrinth

ahead remains to be seen. Though it will seem hopelessly subjective to admit, it better fits the art process as I know it than other theories I have studied.

On the surface, it may appear to relate to the so-called vitalistic or spontaneous styles more than the classic, formal or geometric, but I think that this confusion arises only when strategy and style, or plan and appearance, are confused. My position will be that strategies of drawing, while they differ from each other and typically relate to different families of styles, nevertheless all eventuate in a "whole held together only by activity," the "articulated elements" of which are "act-like."

OBJECTS OF COMMUNICATION

Art forms, however, are man-made, and they are made as a special kind of communication. Insofar as self-communication is partly social and perception is open and transactional, it is impossible to understand a work of art in a static, finite way. In short, the form that eventuates from a situational process is grasped through a similar process once it has arrived at "objecthood." The object is thus known only as an ingredient of a new situation or as a part of another entity.

The Japanese have ritualized the perception of common objects and life events in their tea ceremony. They seem to realize, in general, better than Westerners, that the object made by a human needs situational and symbolic boundaries for the human perceiving it. Whitehead[13] speaks of the importance of "positioning" the self to see even the beauty of a sunset. I raise these issues now to protect against the tendency to "objectify" the object apart from the human uses and intercourse which constitute its proper ambience.

Polanyi[14] has recently shed light on this "tacit dimension" of all knowing by his many examples of how we grasp "more than we can tell." The universe itself is seen as ". . . filled with strata of realities, joined together in pairs of higher and lower strata."[15] It is in our grasp of "comprehensive entities" that we experience these different levels of reality. An entity is a Gestalt. (Polanyi's position is a recasting of Gestalt psychology into a logic of tacit thought, his argument based on a connection between subception—or perception without awareness—and the formation of Gestalt.[16]) To know an entity, we are aware of its particulars, not directly, but as a function of focusing on the higher strata of the entity. Thus we know the tool through our using it, as a "probe," as Polanyi puts it. "We are attending to the meaning of its impact on our hands in terms of its effect on the things to which we are applying it."[17] There are thus two terms to tacit knowing, and they are such that "we know the first only by relying on our awareness of it for attending to the second."[18] Thus we do not attend *to* particulars but *from* them *to* the higher-level term. The feelings in the hand become meaningful, in learning to use a tool, as we lose the sense of them as particulars, and even as we become unable to specify what these feelings are. In the case of the human physiognomy, ". . . we are attending *from* the features *to* the face,

and thus, may be unable to specify the features." We thus, through the features, arrive at their meaning taken together. Nevertheless, ". . . we may know a physiognomy without being able to specify its particulars."[19]

In each instance, then, of what Polanyi calls tacit knowing, two levels of reality are involved, each with its own laws governing its elements, but also with ". . . the laws that control the comprehensive entity formed by them."[20] "The relation of a comprehensive entity to its particulars is . . . the relation between two levels of reality, the higher one controlling the marginal conditions left indeterminate by the principles governing the lower one."[21] These "levels" Polanyi sees as stacked hierarchically one on the other. Taking his cue from the structure of the inanimate and animate world and from the theory of evolution in the latter, he defines "emergence" as the action producing the next higher level.[22] Mind thus makes "ever new sense of the world by dwelling in its particulars with a view to their comprehension."[23] It is what Polanyi calls "emergence," a thrust producing the next level of reality, that is the "creative" or innovative aspect of mind, and the outcome of its exercise in knowing "comprehensive entities." Thus we tacitly know a thing by what it leads to.

This seeming digression has the function of rendering more precise the excessively abstract concepts we have borrowed from Langer. It may help explain how "particulars" in the drawing process are not known meaningfully except in terms of their mingling with higher levels of organization into situational acts, entities, from which still higher levels "emerge," often into minor or major innovations for the particular mind in action.

Still more to the point is the impact of Langer's and Polanyi's constructs on the conceptualization of the drawing process and the drawing sequence. Their influence should lead us away from a false exactitude and impoverished certainty about what is taking place.

There is a proper boundary to both a drawing that achieves objecthood and to a drawing sequence or series which has been set off in space and time from the rest of life. The boundary of the drawing is readily apparent. It runs its course. Our scrutiny of the process of its making leads us to conceive of mind in one way. The boundary proper to an isolatable sequence of drawings directs our attention *from* the individual drawing *to* the higher levels of meaning to which the mind inclines as it strives to know the drawings as a group in space and time. Thus the artist knows where he is by directing his attention *from* his drawings *to* his direction—toward emergence, that is.

We have no term for a bounded run of drawings. In education they might arbitrarily be defined as a "course." Perhaps we could call them a "drawing affair." In practice, however, the bounded quality is easily generated by foreknowledge of a regular time and place to work, and by a "contract" to have the drawing sessions go on for so many days or weeks. The artist may engage upon a bounded run by setting arbitrary limits or purposes for it, or he may approach it as an open "affair." The people with whom I have worked have been in formal experiments or in regular individual drawing sessions. In either case, these have been arbitrarily bounded in time.

DRAWING AS A PRIVATE AFFAIR

In my general psychological position, I am siding with such men as Tolman; Hebb; Miller, Galanter, and Pribram; Chomsky; and Berlyne. The basic Tolmanian position is that ". . . the organism learns paths in a cognitive space, i.e., behavioral rules for transforming one input into another."[24] Perhaps all the other psychologists mentioned may be said to be in Tolman's lineage. It is to Miller, Galanter, and Pribram,[25] and to Berlyne,[26] however, that I will turn for most of my guidance. To these sources will be added, later, the computer simulation work of Newell, Shaw, and Simon.[27] Behind the scenes will be the influence of Dale B. Harris,[28] by definition a developmental psychologist, who also has the broadest grasp of the literature on child art and is a person capable of seeing psychology as one science despite its many factions and fashions.

But first let us return to the previously stated assumption that drawing is essentially a covert and private affair. In the still earlier discussion at the close of Chapter 2, we drew upon Piaget and Pribram in exploring "imagery" and "imaginative play" and the forms to which these may give rise—namely, "signifying" (Pribram) or, with Piaget, art, if the "subjective expression of the ego" is synthesized with "submission to reality." Pribram, like Langer, would seem to make no clean break between image and its transformation through analogy or some structural equivalence into an artistic symbol. But Piaget makes a clean break between "imaginative play" and art. Imaginative play is the necessary but not sufficient source for art. Perhaps Pribram and Langer would concur requiring that analogy and transformation via media enter in. Nevertheless, Piaget's distinction is important. To him:

> Symbols . . . are more or less private, noncodified signifiers which . . . bear some physical similarity to their referents.[29]

Interestingly then, Piaget speaks against the application of his work on social, moral, and logical development to matters aesthetic. His peculiar use of *symbolic* is one which closely parallels Pribram's term, *level of signifying*. To avoid confusion, I will turn the term into *idiosyncratic meaning*. Certainly this suggests what is covert and private, what is a movement from the lone center outwards.

This usage may be confusing if it is taken to stand for more than the full meaning existing for the artist at any given moment in the art process. Idiosyncratic meaning is that unsharable base which to some unspecifiable degree is worked over into materials in an effort to represent it through a structural equivalent or substitute. That this base is not static but changing does not contradict the sense of guiding rightness which belongs to the artist. It is true, in a very real sense, that the work expresses the process itself, the situation of its articulation; and all the forces and factors of which we speak move upon what was unstructured to give it form.

The term *idiosyncratic meaning* is not meant to be a ghost in the ma-

chine. It is the best I can do to give the drawing back to the artist (it is an unsought outcome of method that once the researcher has taken it away from him, the artist never gets it back). From within, it is like a mode of guidance via apprehension through qualitative feeling. This kind of meaning is both situationally and personally unique, I believe, and hence I call it idiosyncratic. At various levels of abstraction or interpretation, there are indeed regularities and family resemblances between drawing processes of a given artist; but in the act of drawing use of such a term stresses that in *this* drawing, *this* image, *this* feeling impels and guides, moving toward one equivalent over some other. This is held to be equally true when the process is claimed to be all discovery, where "one line leads to another."

Gombrich comes close to this same meaning in his search for the "roots of artistic form." Aesthetic creation is not ". . . representation, image-forming, or abstraction, but simply the *making of a functional substitute,* an object which can serve in place of an original (or desired) experience in respect of some function or need of the individual."[30] This formulation is relatively simple; it suggests that something is freely shaped, found, or used which to the self echoes the idiosyncratic image, feeling, or need it represents.

Idiosyncratic meaning is assumed to exist at all levels of art expression, but there are many gradations of synthesis with convention, the collective, or "submission to reality." In the last analysis, this usage of *idiosyncratic meaning* is synonymous with *imagery* and *signifying* or *abductive reasoning* (Pribram) and with *feeling and symbolic transformation* (Langer), but the separation of the idiosyncratic from the collective is not made explicit in the latter.

It may be argued that Piaget's clean break between idiosyncratic meaning and art is an unfortunate semantic lapse, but I believe the distinction worth preserving. To Pribram and to Langer, the image is already symbolic, but it is likewise private. The work of signifying or symbolic transformation into medium makes it into art. So these three thinkers appear to be in basic agreement about that base in image and feeling I have termed *idiosyncratic meaning.*

The connection and assumption I wish to make is that the impulse for the art process is very often just this idiosyncratic meaning discussed above, elicited by the prevailing situation. In stating this opaque concept, I do not imply a ruling intent on the artist's part. Here Collingwood[31] is a fair guide, for the artist clarifies ("constructs" would be better) the feeling which was his impulse only through the conscious work of the process itself. *The artist's intent, therefore, is a situation: it is what the history of the process reveals.* What he "intends" or what anyone says he "intends" is only misleading whenever it moves us away from our interaction with the product as the embodiment of its own organic evolution.

This is why the artist stands outside his completed work even as another observer of it does. And just as autobiography is a special kind of history, so the artist's recall of the acts comprising his work (and of how one act induced another) must also be called a special kind of history. Since the

sequence of acts of a drawing process ("a whole held together only by activity") is both situational and unique, it is not at all strange that an artist does not want to say why he did something, for he literally cannot do so. Like an observer, he can only try to describe his memory of what took place. Certainly there is a lot of "tacit knowing" here in which particulars lose their meaning if we focus on them exclusively and fail to attend from them to the entity of which they are a part.

Perhaps it should not be surprising, therefore, that in an earlier experiment which Burkhart and I did[32] the use of process feedback, in the form of time-lapse photographic samples of the evolution of a given drawing, led to improved quality in subsequent drawings much more than did attention to the completed product only; for while the qualities of a given work must be grasped from the work itself, we are left in unending speculation about how they got there even when we are "expert" in the art form in question. Therefore, process feedback renders more precise such speculation; and where an open evaluation situation prevails, it should be more helpful in stimulating plans for comparable works.

PLANS VERSUS PROCESSES

There is, of course, surface contradiction between "plans" and unique processes and situations. It is to the matter of "plan" that I thus now turn.

Miller, Galanter, and Pribram[33] have offered the concept of "plan" as a useful alternative to the atomism of stimulus-response behaviorism in accounting for the "structure of behavior." Before discussing "plans," however, let us make a digression to consider changes taking place within the psychology of thinking.

Piaget treats thought as internalized action. As such, it developmentally precedes and remains broader than language. It most certainly includes images. Bruner[34] has discussed the "course of cognitive growth" from this base, postulating a developmental and functional hierarchy of modes of representation, leading from enactive to iconic to symbolic (the latter represented by language primarily and by arbitrariness of designation). Developmentally, the shift is from "stimulus-bound" behavior to "associative principles" (at work in perceptual organization) to "denaturing" through abstract rules for ordering phenomena. All levels of cognitive representation remain in use, but it is the symbolic one which frees mind. When blocked at the symbolic level, Bruner allows for the merit of rich imagery at the iconic level for reconstruction of new abstract rules or principles.

How does this postulated hierarchy of modes of cognitive representation relate to Langer's conceptualization of mind? It would seem that the two can be compatible if one allows for the progressively greater role that internal processes developmentally play in that prevailing situation which is said to determine a given sequence of acts. In short, these modes of representation are a fundamental proportion of the "situation of the organism," so that it is necessary to fight constantly against the organism-environment

dichotomy which stimulus-response psychology and common sense language encourage. In these contexts, it can be argued that dwelling on the feelings and imagery always incipiently present, "the mind is its own place," as Milton put it, and constitutes the king's share of the prevailing situation. The artist's habit of mind inclines him to fight against that stifling of idiosyncratic meaning conditioned and encouraged by continual "submission to reality" and collective meaning. So seen, we might risk the generalization that for the artist the prevailing situation is one in which internal processes at the iconic and enactive levels (and at the verbal or symbolic level as related to these and as metaphor) are literally the impulse, which moves to bend whatever is available outside the organism to its incipient form. There is thus nothing adjustive about the process, in the usual sense, nor need it require any Freudian overtones. *It is a reflexive process: mind as context,* freed of syntax and rule as they occur at Bruner's symbolic level.

Here we are merely saying in different words what earlier was referred to as centering on the level of signifying or abductive reasoning, where the artist accentuates or chooses aspects of imaging with an eye for their potential for action. Polanyi would confirm this view. He states: "The casting forward of an intention is an act of the imagination," and adds that "we can trust the powers of our imagination . . . to evoke from . . . available resources the implementation of our purpose."[35] (It appears that we cannot talk of a person drawing without using words like plan and intention, even allowing for the situational and bounded character of our usage of these terms.)

It matters little that artistic traditions of form and medium are a part of this prevailing situation because these have nothing like the collective meaning and arbitrary power of language and logic—since the former are shot through with ambiguities and are context determined to a degree that even artists are slow to comprehend. And I do not think the artist sets out to perceptually disorient the person playing the perceiver's role by contradicting expectations, as Peckham maintains in his refreshing analysis of "artistic behavior."[36] This, indeed, should be the outcome to some degree, but it need not be the impulse and in fact is not typically held to be by our analysis. Idiosyncratic and collective meaning can never be completely separated, but any situation which works at their separation is bound to be somewhat disorienting. There is nothing regressive about this process and the reflexiveness of mind which attends to its own situation. It is the transparency and nakedness of the self attested to by poets and philosophers throughout recorded history, and it attends us from birth through grave with variable but continuing poignancy. Nor would I like to suggest that in this process the locus is entirely internal. As Dewey suggests, *any* prevailing situation is dominated by a pervasive quality, the meaning of which is to some degree idiosyncratic and indeterminate.

To return to our analysis of psychological sources, Berlyne[37] offers further delineation of Piaget's concept of thought as an internalized action. He reasons that between two successive states in thinking ". . . must come another kind of symbolic response representing a *transformation* that would

turn the first state of affairs into the second."[38] Transformations are of two kinds: one "transformation applying," where the presence of a first situation and a transformation elicits the second situation, and the other "transformation selecting," where a first situation paired with a second elicits the transformation that would lead from the first to the second. "Opposite of white" as a problem would correspond to transformation application; whereas the presence of "white-black," if "opposites" were elicited, would correspond to transformation selection.

In more molar terms involving goals and given situations, transformational concepts might be applied to art processes. In our later discussion of drawing strategies, transformational concepts will be seen as fitting the global analysis of the two strategies described, for Burkhart and I said that one strategy kept processes open but held to a clear goal (transformation selection), whereas the other held process under control but kept the goal open (transformation application).[39]

Here, an example may be in order. In Figures 1 and 2, the reader can see the beginning, the "tangible impulse," if you will, of a drawing, and the last or end photograph of the same drawing. In the middle drawing will be found samples of the drawing's evolution between these end points. In the first example, we have a global case of transformation selection in which the in-process operations are selected through an open search to bridge the image gap. In the second, we have a case of transformation application in which operations are performed, as it were, to define or piece together an end-image not well known at the start (a comparison of beginning and end suggests this). Feedback from the drawing process, as later analysis will try to show, is handled differently in these two strategies.

In passing, it should be pointed out that Piaget[40] uses the concepts "operation applying" and "operation selecting," and Spearman[41] speaks of the "eduction of relations" and the "eduction of correlates." All of these are terms of which Berlyne is the inheritor. I will pick up this line of reasoning in the next chapter when drawing strategies come under scrutiny. For the focus on process, it is the general concept of transformational modes of thinking that is important.

Consideration of computer-simulation work in problem-solving will also be held off until later. In developing the context for discussing the drawing process, however, it is necessary to mention these currents of contemporary psychological thought. In addition to those mentioned above, there is the general idea of exploratory behavior as predominant in living organisms. The organism is seen as active. As Caron[42] points out, interest has begun to shift from "response selection" to "stimulus selection" that is, to ". . . the question of which stimulus an organism will respond to when he is simultaneously being inundated with an endless variety of stimuli, as most creatures are in their natural environments." Caron further summarizes the work in computer simulation of problem-solving, that of Berlyne, and of Miller, Galanter, and Pribram, by saying that these men have been led

. . . to question certain of the most cherished behaviorist conceptions and to wonder particularly whether the reflexive notion of behavior might more profitably be replaced by an error-actuated model (self-correcting via feedback). Certainly, Berlyne's transformational concept implies that behavior is impelled and directed by observed discrepancies between desired states of affairs and given states of affairs.[43]

Berlyne sees boredom, attention, novelty, curiosity, and so forth as aroused by discrepancy or conflict. "Conceptual conflict" is said to be a function of uncertainty in a situation (number of conflicting responses and how equal in strength they are) and of importance (in general, the individual's ego-involvement in the conflict situation).[44]

The above ideas at least stimulate imagination as one tries to conceptualize the art process. Certainly the earlier reference to Langer's theory suggests, even in "the induction of acts" one from the other, a transformational chain. And her description of a work of art as symbolic transformation of feelings into materials has, at this higher level of abstraction, a comparable ring.

But whence the uncertainty, the ego-involvement that constitute the conflict from which the arousal, motivation, and the like are said to arise? The ego-involvement is simplest to present in the arts, I will assume. This is especially so if the further assumption of the base of artistic activity in idiosyncratic meaning is accepted. "This imagery, these feelings, are mine alone and have meaning" is its simplest form. Conflict dimensions are likewise close at hand in "submission to reality" or to "collective meaning," and all that these terms connote. I would certainly extend the conflicts to those stemming from media, tools, and studio traditions and habits whenever these confront that feeling base they must analogically represent; and I would expand the range of these to include the most narrow one, as in redoing (not repeating) a pottery decoration on similar forms; and the broadest, as in a truly new feeling base (a breakthrough into new forms of feeling).

But the components of the art process are not as separate as discursive thought renders them. The situational aspects that were once a source of conflict, be they from studio discipline or traditional techniques, tools, or whatever extra art ideas there may be, subsequently become displaced into the imagery and feeling, the idiosyncratic meaning, which is the impulse, the prepotent act of the next process. Thus after a resident period in Arita, Japan, where I studied porcelain-making for six months using traditional techniques and tools, the feel, the image of these as fused in living form in material did not come to me until some months following my return. The newer methods for me, in fact, seemed like discontinuities at first in my home studio. Only gradually did the environment and the foreign methods arrive at mutual adaptation.

Let us return at this point to "plans," the discussion of which we delayed for a side journey through neobehaviorism and cognitive theory in

1.1

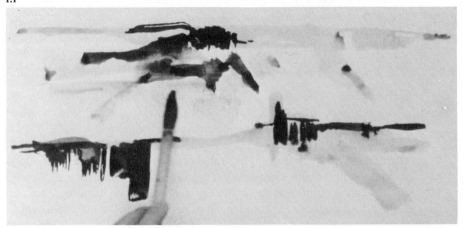

1.2

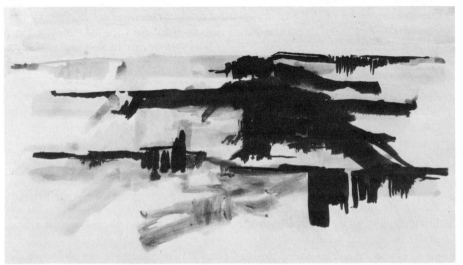

1.3

Figure 1 The drawing process as a global transformational plan: transformation selection.

2.1

2.2

2.3

Figure 2 The drawing process as a global trans-
formational plan: transformation applica-
tion.

For both Figures 1 and 2 .1 is the beginning, .2 is
the transformation, and .3 is the finished drawing.

psychology. Miller, Galanter, and Pribram in their book, *Plans and the Structure of Behavior,*[45] have offered an attractive way of conceiving of human thought and action. While they do not speak of artistic behavior, their theory connects with that of Langer concerning "mind," and she not only speaks of art but uses it as her model for mind. (We have already referred to Pribram's later report on "meaning and mind" and how his neurological analysis leads him to a symbolic mode close to art.)

Miller, Galanter, and Pribram point out that we *imagine* how something will be and make *plans* to cope with it. The authors criticize earlier cognitive theorists (with whom, however, they align themselves), finding in them ". . . a theoretical vacuum between cognition and action." Their book, they say, was written "to explore the relation between the Image and Plans," or between knowledge and action.[46]

Like Langer, they make one massive assumption, in their case about why there should be Plans (they capitalize Image and Plan) to begin with: "Plans are executed because people are alive."[47] The unit Plan is bigger by far than Langer's "act form," but it could be built up from images of situations, if I understand her. Plans would thus be internally represented models of situations fitting within Miller, Galanter, and Pribram's Image, the latter, as internal representation of one's world, becoming synonymous with "life as continuing situation." I will borrow from both Langer and from Miller, Galanter, and Pribram, and use image in the particularistic sense when speaking of an art process, and Image in the general sense when discussing which Plans are executed, that is, the problem of choice, for which Miller, et al., admit one needs some "valuational concepts."[48]

By the latter authors' definition, "A Plan is any hierarchical process in the organism that can control the order in which a sequence of operations is to be performed."[49] Plan, further, is seen as comparable to "program" as this concept is used in computer work. To further distinguish between levels in the hierarchical organization of behavior, the authors use *strategy* to refer to bigger or molar units, and *tactics* for smaller or molecular ones. They further assume that only one plan is executed at a time, that plans are storable (and thus part of the Image), communicable, and so forth.

Perhaps it would be well to present their definition of Image:

> The Image is all the accumulated, organized knowledge that the organism has about itself and its world. The Image consists of a great deal more than imagery, of course. What we have in mind . . . is essentially the same kind of private representation that other cognitive theorists have demanded. It includes everything the organism has learned—his values as well as his facts—organized by whatever concepts, images or relations he has been able to master.[50]

The basic unit of Plan is the TOTE unit, or feedback loop, a representation of which is given in Figure 3.[51] The symbol TOTE has four components. The first is *Test* and represents an incongruity between the external situation and an internal representation of it (probably the first part of an act form)

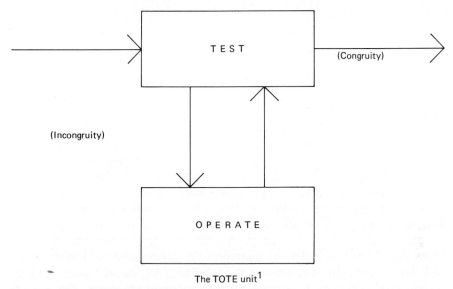

The TOTE unit[1]

Figure 3 Diagram of the TOTE Unit.
Source: Miller, Galanter, and Pribram, *Plans and the Structure of Behavior* (New York: Holt, Rinehart and Winston, Inc., 1960).

as it is cognized. The incongruity is the impulse for the act form and induces the second component, *Operation* (the acceleration of the act form). When the incongruity vanishes, as checked against the *Test* (as defined in the first component), the act form is consummated and ceases, designated by *Exit*, the fourth component.

I am trying here to relate Miller, et al. to Langer's position, for I sense few problems and many advantages in doing so. The greater abstractness in Langer's position lies in the fact that, unlike psychologists, she will not separate "mind" from "prevailing situation." While there may seem to be no immediate practical consequences at this effort to unify my sources, I foresee greater potential payoff for theory from the more abstract base.

Miller, et al. discuss what "flows" over the arrows in Figure 3. They say it could be conceived of as energy, information, or control; that is, as a neurological model, in information-flow terms, or as the more tangible "control" of the computer program "with the order in which the instructions are executed."[52] It is this latter usage that appeals in the context of this book.

TOTE units can be "nested" and detailed one within the other (actually like subprograms or routines under the Operation phase of the total Plan). The authors feel it is essential to be able to specify structure on many levels simultaneously within the hierarchical arrangement of behavior. Thus there is the total, X, its breakdown, AB, and still finer, A units into a and b, and B into c, d, and e. The Plan is thus $X = AB = ab, cde$, not to be construed as an equation but as three levels of structure. The principle can be shown by the tree form or aborization perhaps even better:

The authors feel that such breakdowns of the Plan form are possible on a number of structural levels. Their own simple, molar analysis of the "hierarchical Plan for hammering nails" foretells what grief we would come to were we to attempt such an analysis of the art process. But a like or even vaster complexity is suggested by Langer's basic act form as element. Perhaps we should take our cue from her and suggest that while there must be allowable access up and down the ladder of structure, we feel no compulsion at the present stage of speculation to attempt more than molar specifications. Plans allow us to manipulate or transform the environment by linking action with cognition, even as Miller, et al. intended. The "desired state" and the "given state" of affairs of Berlyne are not foreign to this issue. The internal representation of a future, desired situation and a Plan for its realization can be designated as prime ingredients when the situation thus symbolically prepared for actually occurs. Nevertheless, we will follow Langer in insisting that we pay attention to the pervasive situation itself in our effort to comprehend what takes place in the art process. Image and Plan, operating under feedback, can be crudely designated as Mind, but these exist only in context, that is, in some situational history of acts. And image (lower case) and idiosyncratic meaning and their simultaneous clarification and plastic materialization are overridingly situational.

Miller, et al. allow for flexibility in Plans; that is, the parts of a Plan can be performed in more than one order and are not rigidly sequenced. They also allow for substitution of Plans, or subroutines within Plans, and so on.[53] These qualifications are helpful if we try to relate Plans to art. Conflict, uncertainty, ego-involvement are easily recognized as present in the art process. But it is helpful to hold to the concept of Plan, especially Transformational Plans (my capitalization) for the basic symbolic transformation representing the art process itself. We have already, in Figures 1 and 2, hinted at two global Transformational Plans, later to be designated as drawing Strategies.

Langer has given us another cue by her insistence that the art symbol does not rest on convention. Conventions in art, she says, refer only to the ways of creating the symbol, not to its semantic function.[54] (In passing, it is admitted that there is some difficulty with Langer's usage, since "symbol" traditionally refers to some convention or commonality of meaning. This is a difficulty that can only be cleared up by further reference to Langer's definition of "nondiscursive symbol.") This concept helps explain how a clear Plan, let's say for throwing a pot on the potter's wheel, can exist, complete with hierarchical ordering of behaviors, yet not account for the qualita-

tive component. One might reply that this is a generic Plan which must sensitively be adjusted, situationally, to a guiding or evolving image. In any event, such a Plan is not, as some would make it, a technology. *It is potentially at least, an art process in which the "convention of creating" and the "semantic function" produce some tension or conflict, or form a comprehensive entity in which the conventions of creating are known only as a function of the "meaning" emerging.* But what can be a Plan for achieving quality, for transforming image into symbol, or for clarifying feeling into form?

LANGUAGE VERSUS ART

Certainly we will not be able to hold to a clear hierarchical structure of behavior for an "Art Process Plan." And even the Image is troublesome, for there may be in addition to that image with its idiosyncratic meaning (the likely situational impulse), the image of the work as "transformed," the image of the process, and the image of the work-as-process (herein favored in hand with imaging as the source of idiosyncratic meaning). And unlike language, which, says Langer, has "automatic structure" and "singleness of projection" (and arbitrariness), the art symbol is organic, situational, has multiplicity of functions, is overdetermined, equivocal, is, in short, "an image, not an index."[55] (In the latter formulation Langer concurs directly with Pribram's "signifying" and "symbolizing" levels of coding as these stand in relation to "imaging.")

There are, in effect, "rules for no rules" in the art process. Consider the following concepts: Kant[56] describes art as "telic without purpose" and as "perceptible rationality without discursive logic"; Whitehead[57] speaks of an immediate apprehension of a variety of vivid values with a minimum of eviscerating analysis. Peckham is more specific to our argument (although I cannot agree with his insistence on the primacy of convention in *all* artistic behavior), which began in the last paragraph to contrast language with art. Peckham uses the term "package" to refer to collected forms and behaviors having no apparent, generalizable, or clear structural principles for how they are put together. He points out that

> . . . configurational sign systems do not include structural signs, and are consequently much easier to handle than verbal signs. There are no rules about how configurational signs may be combined; there are very strict rules, however, about how referential signs may be combined in verbal behavior . . . Improvisation and innovation are comparatively easy in visual sign behavior, but are extremely difficult in high-level verbal behavior.[58]

Hence it seems completely reasonable to utilize very flexible Plans in the visual art process, to attend to an emerging "perceptible rationality" in the ongoing situation, and to play any conventional art Plan for making an art form against the feel and the meaning of the unique process underway.

We have thus far argued for the following concepts: idiosyncratic meaning, as arising of its own accord from imagery, and as constituting the situational impulse of the art process, activated by conflict between a desired and existing state of affairs; the likelihood of a large, flexible Transformational Plan for this process, the nature of which is dependent on the closeness and clarity of the end-gestalt (the art work) with its image base; the essential differences, without discontinuity, between this mode of reflexive cognitive functioning, and the arbitrariness, collective meaning, and syntax of discursive logic; and the necessity of attending to the ongoing, prevailing, and pervading situation to comprehend the dynamic, "vital," and "organic" component of the art process. Several additional concepts must now be introduced to round out the base being laid for a definition of the art process.

One has only to watch people in an art studio to conclude that they are highly involved or motivated. What are the signs of this? Long hours, concentration, constant "looking-in" on the studio at times when they cannot be there for work, not being able to "turn it off," and so on. Moreover, "mental workers" (those laboring with the symbol systems of discursive logic), when they have not closed out other dimensions of mind, feel inordinate attraction to art activity. In commonsensical language, they speak of a "need for balance."

Morris concludes that "self-rewarding activation" is essential to all picture-making. Whatever other extrinsic motives there may be, ". . . if the production of the picture is not also a reward itself, then its aesthetic value will be impaired."[59] This, he claims, is as true with apes as with humans. Our prior analysis suggests a possible reason for this, which would transcend Alexander's notion of pleasurable repetition,[60] Piaget's "function pleasure,"[61] or Lowenfeld's "repetition for self-confidence."[62] Picture-making should be self-rewarding activity because that conflict situation within which an impulse in idiosyncratic meaning confronts objects, techniques, and collective meanings has been resolved, transformed in the art process and symbolized in the art object. This is, simply stated, "exploratory behavior" of high ego-importance, or, as Lowenfeld implied, of high self-identification.

Berlyne, from whose work we have already drawn, suggests still more basic reasons why the art process (in fact, all "aesthetic behavior") is self-rewarding. He speaks of "diversive exploration" (as differentiated from "specific exploration") as having ". . . the function of introducing stimulation from any source that is 'interesting' or 'entertaining'."[63] Such behavior is reinforced by "biologically neutral stimulation," by which he means something akin to Piaget's "function pleasure" with reference to the nervous system and sense organs, but with absence of any other beneficial or harmful effects. For an understanding of exploratory behavior, he turns to those stimulus properties referred to earlier—novelty, surprisingness, complexity, ambiguity, incongruity, puzzlingness, and the like. He calls such stimulus properties "collative," because they depend on comparison of information coming from different parts of a given stimulus field or from stimulus fields simul-

taneously past and present.[64] He further speculates that collative properties involve conflict between incompatible response tendencies and that these could be the source of interest and drama in art. His ideas thus relate directly to the dialectical rhythms and tensions which Langer finds basic to the art process. In a still more general sense, the art object itself, as the deposit of the organic process forming it, reflects the tensions pervading the attempt to synthesize that conflict hypothesized as arising from the image-form, private-collective, expectation-experience gaps which render that process "interesting" and "self-rewarding." Seen in this context, it is not difficult to understand Peckham's argument that art provides us an education in the ". . . capacity to endure cognitive tension."[65]

PATTERNS AND THINKING

Rimland[66] feels we think in terms of patterns, analogically and not logically, by comparing new patterns with remembered ones. In mental life as I have described it, the image with its idiosyncratic meaning already arises as "interesting," as an example of diversive exploratory behavior in which some conflict is implicit between new and remembered meanings. As the "art situation" unrolls, many "interesting" levels of conflict generated by comparing new and remembered patterns occur, the foremost of which I have made the partial domestication of idiosyncratic meaning by its synthesis with materials and collective thought; but certainly many other kinds of possible conflict also enter in.

Berlyne has made still further distinctions which may aid our developing thought concerning the art process:

> By thinking, we mean any process that involves a chain (that is, a sequence of two or more members) of symbolic responses. Chains of symbolic responses can take various forms and have various functions. They can, for example, constitute autistic thinking. This is exemplified by daydreaming or by the free association that is demanded in the psychoanalyst's office. It appears to have the function of providing substitute satisfactions through reward value that is transferred from desired situations to representations of these situations. There are also chains of symbolic responses that occur when we recall, for one reason or another, a sequence of past events—'thinking of days that are no more.' Directed thinking is thinking whose function is to convey us to solutions to problems.[67]

Later, we learn that

> . . . *specific* exploration is clearly akin to *directed* thinking, which is likewise initiated by concern with a specific topic and is not successfully concluded until a symbolic formula that can eliminate specific uncertainties has been reached. *Diversive* exploration is apparently more closely related to autistic thinking.[68]

In both directed and autistic thinking we represent situations other than the one we are in. In autistic thinking, however, Berlyne points out that

we leap freely from one symbolized situation to another. Events are in an impossible order. In directed thinking the sequence of situations is represented and also the processes that lead from one situation to the next.[69]

Herein may rest a clue to the art process. It must surely include both autistic thinking and diversive exploration. But just as surely the mind must pay some attention to the sequence of operations (although this aspect can be like a flexible Plan) and also the processes leading from one situation to the next. There is an apparently unavoidable paradoxical component to a discussion of the art process. It is as though, to use Berlyne's terms, the artist engages in diversive exploration, but in conjunction with a kind of directed thinking; or, equally irrational in discursive logic, with autistic thinking in conjunction with specific exploration. There may be some resolution of this paradox in keeping with ideas previously discussed. "Imaging" and the "casting forward of an intention" (necessarily associated with it in the process of drawing) are bound to eventuate in a history of acts that seems peculiar to one outside the experience itself. The image is inexpressible. The coding which occurs to render aspects of the image mentally manipulable is Janus-faced. On the one hand it reaches toward the idiosyncratic, given, internal meaning of the image. On the other hand it must take into account the conventions and physical properties of media. The one feels more like autistic thinking, the other like directed. But the decisions made in process, the transformations of feedback, are continuous. From within the experience the paradox is dissipated throughout the situational history of the work. One literally both dreams and directs all along the line.

Such a process only by a stretch of the imagination fits under the umbrella of problem-solving. If the artist typically resolves conflicts or paradoxes, if he synthesizes the idiosyncratic and the collective, do these constitute "problems?" The play upon dialectical rhythms and tensions in the prevailing art situation is more likely a sign of diversive exploration than part of a problem-solving sequence. Conflict and "interestingness" are an implicit part of this process. Most often there is no clear problem before undertaking a work, and the main thrust encounters many decision points during the dialogue of the process. When the work has run its course, it will be puzzling for the perceiver for it will present itself as a "complete entity," one which embodies "incompatible response tendencies" and depends upon his "tacit knowing," a knowing *from* his own imagery, his own body, to the work.

I would like to offer the very real possibility, real at least to me as an amateur artist, that the adult mind may utilize directed thinking, or more conscious control, in an editorship, list-running, operation-searching function to represent "remembered patterns" (schemas, images, technical operations in media, and so forth) in one of two ways within a TOTE unit: (1) as the likely element which is incongruous with the initial Test (new image), and therefore in readiness for transformation in the Operation phase; or (2) as a selected and known beginning pattern, the initial Test for which is "not like remembered patterns." It may be evident to the reader that these are akin to transformation-selection and transformation-application situations. The

former would seem to require a strong base in idiosyncratic meaning; the latter a search for such meaning as a departure from readily accessible past patterns.

It is one of the contentions of this book that transformation-applying and transformation-selecting habits are equally important in the art process. In our analysis of art strategies in the next chapter, there will occur a preponderance of one or the other of these transformational habits in each of the two strategies to be described. I do not agree with Berlyne in his suggestion that transformation-applying habits are "completely constrained associations" since, by his reasoning, ". . . the application of a particular transformation to a particular operand must always give rise to the same transform, but several transformations may lead from a particular operand to a particular transform."[70] But this is a minor point, possibly true with discursive and logical symbols, or perhaps even with infinitesimal parts of the art process. Since the transform of one transformation-applying operation becomes the operand for the next cycle of transformation within the art process, any feeling of constraint would soon be lost in the evolving work. The initial uncertainty sparking the process is worth considering in the two instances. A clearly held transformation invites selection of an "interesting" operand (part) whereas a strongly held operand (indistinct image of a total) invites selection of an "interesting" transformation.[71]

What I am suggesting is that uncertainty can arise from the number of operands available, or from the number of transformations available, as well as from how these small units, or TOTEs, follow one another as a part of an overall flexible Plan. Anton Ehrenzweig has theorized on just how flexible the total Plan must be in art and in all creative work. If his analysis is correct, there is ample uncertainty in the art process as a whole as well as in its smaller components. The steps the artist takes must be chosen without a clear idea of how they relate to the end product.

> His lack of precise visualization is bound up with the fact that creative work opens up new avenues of further progress at each step. The endless ramifications may be astronomical in number. He cannot possibly examine all these future possibilities and make a conscious choice. Conscious visualization can only deal with one alternative at a time. Hence he must rely on unconscious intuition for scanning these many possibilities.[72]

Ehrenzweig goes on to speak of the development of a kind of perception ". . . that contains several mutually exclusive variations of a theme in a single act of comprehension." This he terms "the or-or structure of low-level vision," in which contradicting patterns are held in one glance, much as art students learn to relax their figure-ground habits to attend to positive and negative forms in relation to each other and simultaneously.[73] Autistic thinking, dreams, collative properties with their incompatible response tendencies, dialectical rhythms, and the bipolar gradients of affective phenomena and sensations would appear to be akin to these or-or structures, without the need for recourse to "dynamics of the unconscious."

Gombrich supplies us with a suggestion as to how this free and open process might be guided by a kind of directed thinking and thus even constitute a kind of problem. He describes a game of "multiple matrix matching" in which the symbol is constructed and revealed through ". . . the symbol choice from a given set of matrices of what is least unlike the referent to be represented."[74] He illustrates this process by a parlor game in which a person is to be represented through such analogical questions as: "If he were a flower, what would he be? Or what would be his emblem as an animal, his symbol among colors, his style among painters? What would he be if he were a dish?"[75] In this freer field, the person is progressively represented by the overlap of shifting matrices of analogical meaning. The player must keep open, entertain or-or structures (disjunctive, mutually exclusive possibilities), until he can form a representative image from these merging meanings. If we can remove this procedure from the parlor-game context, are we not close to the situation which is the art process and to that abductive reasoning by analogy of which Pribram spoke?

What Bartlett calls "adventurous thinking" is close to the current discussion. He says that, in an open system, the thinker searches to increase, not restrict, the number of possibilities, for ". . . it is more likely that the one sought will be found when there are a lot of chances than when there are only a few."[76] In short, the worker invites getting lost during the process; and we are close to Ehrenzweig's gradual advance through unpredictable, branching stages, and ". . . the consonance and dissonance of multiple meanings that interlink in the structure of artistic symbols."[77]

Perhaps, unwittingly, I have come close to suggesting that the art process is a special kind of problem-solving. Language which uses terms like "uncertainty, conflict, synthesis, and search" could easily take on this connotation. Only the broader view of Langer avoids this pitfall. The artist "has" problems, but the prevailing situation which is the art process is only a problem in the broader sense that the life process is a problem. (And, indeed, in that broader sense, everything is a problem.)

The confusions, thus, that attend too direct a matching between the art process and what we usually call problem-solving are so apparent that it seems better to drop the term altogether in favor of descriptions of those families of plans, those varieties of directed thinking, and those kinds of intelligence discernible in artistic behavior. A link between problem-solving and artistic creation might be forged by fixing on the gestaltists' term "productive thinking," especially if we further qualify that usage by restriction to the nondiscursive realm of symbolic process. But then one wonders why we cannot refer to the kinds of thought processes involved in art more directly, without recourse to the connotations surrounding problem-solving or productive thinking.

EVOLUTION OF FORM

Lipman has a suggestion which permits further inquiry into the kind of thinking seen in art. He states that the adaptation of means to ends is only

one form of intelligence, and that there is another which has to do with the organization of part and whole.[78] This productive hint plunges us anew into the organic nature of the evolution of form, into that covert dialogue where the patterning of things (media) in the prevailing situation is transactionally guided by and leads to those formal and tertiary qualities wherein things are experienced as feelings and thoughts.

This differentiation, however, into a kind of thinking closer to artistic creation does not go far enough. Beardsley, in review of Lipman's book, pushes further:

> 'Thinking in terms of wood' may involve something like a use of the wood's properties as a set of temporarily drafted signs, replacing words and functioning for a time as a substitute for them—so that, in fact, the basic properties of the wood are really not attended to and thought about, but used in thinking about the emergent properties (the 'tertiary' ones).[79]

In short, the properties of the wood are a part of tacit knowing in which attention is directed from them to the qualities sought after.

One qualification I would have of Beardsley's elaboration is that the basic properties of the medium, tools, and so on, and their role in the emerging configuration are really attended to and thought about but indirectly, for these continually enlarge and vitalize those properties manipulated as "a set of temporarily drafted signs." It is the last quoted phrase that I find particularly full of potential meaning. Whether these are replacements for words or not need not be argued (I would say they might be but probably are not, directly). The important point is that thing qualities, medium qualities, and process qualities are treated as the raw stuff for symbol-making in the temporary "code," and that these are pattern-bound, or configurational phenomena, built up by that form of intelligence contending with the organization of part and whole.

To anyone who has made art or tried to observe it being made objectively, the organization of part and whole and the use of sensuous properties as "a set of temporarily drafted signs" is not nearly as mysterious as *experienced* as when an effort is made to treat it discursively. For, as Lipman has also pointed out,[80] we are puzzled only in our nonqualitative thought. In responding qualitatively, the work is intelligible, and the process and organization are likewise so.

It could well be that our verbal symbols, arbitrary, collective, depending on general or class concepts, tend to elicit (apart from poetry) associations which are atomistic in the sense that they are replaceable by other verbal symbols. Thus, in attempting this writing, I am inclined to manipulate mentally the sources and concepts at my disposal (discursive material) painfully to construct the image I have of the art process. This image, covering phenomena complex and dynamic beyond representation, is nevertheless qualitatively intelligible to me (despite the fact that it can never be really complete or finished). The reader may rightly detect that I vacillate between a strict means-end approach, befitting discursive logic, and a kind of multilevel

struggle with concepts as though they were themselves qualities in a part-whole organization. It is as though all the part-truths I entertain can produce a pervasive quality as well as a logic concerning the nature of the drawing process. Yet I do not write a novel.

I have been suggesting that discursive symbols, general, arbitrary, and discrete at their start, encourage one to converge into a logic often unintended. (I have been trying to fight this premature ossification by two methods: admitting diverse concepts and theories, and holding an open, qualitative image of the art process.) On the other hand, nondiscursive symbols, specific, concrete, and interwoven at their start, encourage one to diverge continually into qualities and meanings.

While continuing speculations about artistic thought processes, it is well to recall that thought changes its shape and function at varying stages of what we refer to as one creative process. It is this realization that makes the description of the rhythm of acts within situations in Langer's recent theories of mind appealing. To be sure, uncertainties, collative properties, idiosyncratic meaning, imagery and feelings, transformational operations, traditional methods, plans, properties of media treated as temporarily drafted signs, and much more—all of these are relevant. The dynamic aspect of directed thought which links one stage, one association, one act, with another seems best thought of in terms of the pervasive quality of the prevailing situation, where mind is working at the organization of part and whole, manipulating tangible phenomena but attentive to emergent qualitative properties.[81] The artistic dialogue, thus, predisposes one to see things as qualities from the onset, but it remains alive to the qualities attending the birth of the forms themselves. It is the epitome of transactional processes. The medium is not the message. Rather, the process, projectively and reflexively, is the message. (This is equivalent to the earlier statement that the artist's intention is a situation.) The temporarily drafted signs which are impressed upon the properties of the medium are peculiarly historical or contextual; and they are utilized for the possible funding of meanings and qualities within the part-whole organization which is emerging so that organization itself gives rise to new meanings and qualities.

THE DRAWING PROCESS

By now, certainly, we should be able to return to the drawing process. To be sure, no definition of the drawing process has been presented, nor will one be attempted at this point. Processes occur within other processes and within given contexts. Langer's term "prevailing situation" seems to include process-in-context, which is the usage we will hold to.

This usage will be all the more apparent since many of the descriptions to follow will focus on the drawing processes of one person at a time, as seen over a run of sequential drawings. There are many advantages to this idiographic approach. Idiosyncratic meanings and methods can be somewhat fully extensionalized as a benchmark for reading change, elaboration, sim-

plification, introduction of new elements, etc. Thus, there is a safeguard against false generalizations and projections on the observor's part. Also, much of the motivation for drawing has seemed to me to lie close to the feelings, thoughts, experience, images and wishes of the particular person engaged in the process. These background factors will quite often not be fully conscious to the person observed. They are teased out of regularities observed across drawings and through hunches followed up in interview.

A person's drawing process is quite often unknown to him, insofar as any clear account of what took place and when is concerned. Hence I have relied heavily on time-lapse photographic records of each of the drawings I have observed. These photographic records are typically shown to the artist before the next drawing session. Thus the artist's drawing process is made accessible, abstract, conscious to him. I am certain that this modifies what he imagines and plans. Since, however, there is no process apart from context, the reader is merely warned that this is the context out of which my observations arise. In like manner, when sequential drawings are made an object of scrutiny—that is, when interviews are held about what is taking place, when works are arranged physically in time order, and when process records from one drawing can be compared with another—then I find that the artist typically develops a strong image of his own direction and learning.

An interested observer who openly interviews, keeps the setting responsive to the artist's needs, responds to changes in the artist's work, provides time-lapse process records for study, arranges works for examination, and so forth, is a strong ingredient in the drawing sequence. I cannot see this influence, however, as invalidating descriptions. It is quite often these very acts which make revelation and description possible. While speech cannot tell outright what is taking place in drawing, an open, accepting and facilitating environment encourages participation in the covert drawing dialogue. The self is not a thing, nor inviolable. The drawing makes the self quite as much as the self makes the drawing. The important thing is that context be specified.

But there is also another side to my inquiry, which will be more nomothetic. It will spring, in fact, from experiments in which every effort was made to hold to strict controls and treatment conditions. From this context will emerge generalizations about feedback, strategies of drawings, and how they change, effects of stimulus conditions, and the like. These two approaches are just different, not to be argued about as to value. I see both as necessary. Both can lead to their own kinds of hypotheses concerning the thought processes involved in freehand drawing and the ways in which these are manipulated to bring about changes in a sequence of drawings.

It might be well to point out that many kinds of feedback always occur in a drawing process, as in any ongoing situation. The overt recording, storage, representation of process phenomena for feedback and evaluation is thus an intensification and change in form of what takes place naturally. There is this important difference, however. Whereas natural feedback while drawing guides the ongoing process, stored and retrieved feedback guides

and directs the sequence of drawings. It thus participates forcibly in developing the image of learning of direction in art. It is in this sense that the reader will often be asked to consider a sequence of drawings as a learning process or episode. And the artist, in such a sequence, might be said to be involved in learning to learn in art.

SUMMARY

We have assumed that the art process is a covert and private dialogue; that self-direction is encouraged by holding down environmental noise and by implementing process feedback; and that a nurturant and supportive environment encourages the artist to explore his own imagery. There is a tension within the art dialogue between the artist and his medium which aids his struggle to find qualities congruent with his imaging.

The art process consists of wave upon wave of acts, one inducing another. Such acts occur within what Langer calls a "situation," a context including our present and past, our internal and external environment. Within any given situation, our perception and our prior acts are likely the important forces. If it is assumed that there are "potential acts," terms such as "choice" and "intent" can be legitimately used. The elements of the artist's symbolic projection are inseparable from the whole arising out of a given situation. As such, the artist's product would seem to reinstate the acts leading up to it, in a kind of psychophysical parallelism, but less as an objectified form and more as a potential work for a new perceiver.

We grasp gestalts, or "comprehensive entities" by a process Polanyi calls "tacit knowing," in which we know *from* one level of an entity (its particulars or subsidiaries) *to* its higher level (e.g., from the features to the physiognomy of a face). Such tacit knowing exists in comprehending the drawing process and the drawing series; the particulars and the entities change depending on whether we focus on specific operations, on episodes within the process, on the drawing as a whole, on the series of which the drawings are a part, or on the life of which the series is a part. The artist also operates thus: he directs his attention from his lines to his form, from his form to the organization of forms within his drawing, from his drawing to the path he charts through a series of drawings.

It is useful to separate the idiosyncratic meaning side of the art process from the collective meaning side. The former refers to the full psychologically real meaning as it exists for the artist at any given moment in the art process; the latter to the likely consensus of meaning with which viewers will react. Conflict and tension are thought to exist between these in the artist's mind. Idiosyncratic meaning is like the impulse for the art process. Though directed by intentionality, the impulse is not the intention. The artist's intention is what the situational history of the process reveals it to be. Idiosyncratic meaning is not directly communicable. The drawing process itself is its meaning (in the sense that "whatever a thing bears on may be called its

meaning"[82]). Though a privileged observer, the artist stands outside his completed work. He knows from it to some larger entity.

Transformational concepts are utilized to specify what occurs between two states of thinking. They designate the operation that turns the one state into another. Two such operations have been defined: "transformation-applying" and "transformation-selecting." These can be applied to the art process. In some drawings, for example, beginning and end appearances are similar, suggesting the drawing resulted from continuous transformation selections guided by relatively clear projections of future stages. In others, transformation applications piece together an end image which is more the result of discoveries en route. Imagery and transformational operations only make sense in terms of intentionality, or of an on-going focus integrating them in action.

Human thought and action is a kind of "planfulness" in which we imagine how a thing will be and lay plans to cope with it. A plan is like a program for a computer, controlling the sequence of operations one will do. It is comprised of feedback loops which try to remove the discrepancy between a desired and an existing state. Such loops are hierarchically organized within the total plan. Plans used in the art process reveal a flexible, changeable quality, for they are like a plan for a dialogue or a game of strategy. Such a plan must remain open and take its cues from process feedback. The needed flexibility is aided by the ambiguity and less collectivized nature of images and visual configurations as compared with verbal symbols.

Such plans are a kind of exploratory behavior akin to Berlyne's "diversive exploration," which seeks out what is "interesting" (puzzling, complex). Such thinking is related to "autistic thinking" (daydreaming, free association). In contrast, "directed thinking" leads us to the solution of problems and includes not only a sequence of situations but also how we get from one to the next. Both types of thinking are involved in the art process. While this seems paradoxical in verbal description, it seems less so as experienced within the process itself. "Imaging" and "the casting forward of an intention" seem autistic only when coldly compared with conventions or with a restricted view of media. In the art process, one dreams and directs simultaneously. Internal "meaning" becomes true meaning (or is expressed) only as it bears on media and conventions.

It is not useful to call such a process problem-solving. Steps may be taken without foreknowledge of where they will lead. Out of seeming vagueness and divergence an end form arises organic to the given process. This is no more problem-solving than is the life process itself. A kind of intelligence is involved, but it is more one of organizing parts to wholes than of means to ends. Properties of medium are treated like an *ad hoc* set of signs. The artistic dialogue inclines one to see properties as qualities from the outset, and it also incorporates emergent qualities, even errors and seeming chance events, occurring from the process itself. The medium is not the message. Rather the process, as we tacitly know it from higher level

integrations of its various subsidiaries, is the message. In our focus, we also know from it to the series. Such a process and such a series are lawful, but more in a biological than a mechanical sense, more in an idiographic than a nomothetic sense (as later discussion will attempt to show), and lead to a point of view emphasizing understanding and interpretation over prediction.

At this point it may be well to intrude one qualifier to the discussion in this Chapter. The role that art plays in imagery has not been emphasized. Because I work at pottery, I can speak of how one's imaging can already begin from properties of media and from traditions of the art. This interiorizing of past art, methods, and materials does not rule out idiosyncratic meanings, it merely is a prime ingredient in the imaging preceding a new art process. The issue raised here is beyond the scope of the present discussion, but it is pertinent to any discussion of the art process and the art series. Perhaps it is the kind of thing we can understand best in terms of case histories, a line of inquiry taken up in later chapters.

NOTES

1. See Kenneth R. Beittel, op. cit. (1964 and 1968), n. 2 chap. 1.

2. Desmond Morris, *The Biology of Art* (New York: Alfred A. Knopf, 1962), p. 158.

3. Max Black, "Education as Art and Discipline," *Ethics* 54 (July 1944): 290–91.

4. Susanne K. Langer, *Mind: An Essay on Human Feeling,* vol. 1 (Baltimore: The Johns Hopkins Press, 1967), p. 324.

5. Ibid., p. 324.

6. Ibid., p. 297.

7. Ibid., p. 281.

8. Ibid., p. 311.

9. Ibid., p. 281.

10. Ibid., p. 299.

11. Ibid., pp. 272–73.

12. Karl H. Pribram, "Meaning in Education" (paper presented at a meeting of the American Educational Research Association, Chicago, 1960).

13. Alfred North Whitehead, *Science and the Modern World* (London: Macmillan & Co., Ltd., 1925; reprint ed., New York: New American Library, Inc., Mentor Books, 1949) p. 199.

14. Michael Polanyi, *The Tacit Dimension* (original ed., 1966; New York: Doubleday & Company, Inc., Anchor Books, 1967).

15. Ibid., p. 35.

16. Ibid., p. 95.

17. Ibid., p. 13.

18. Ibid., p. 10.

19. Ibid., pp. 10, 19.

20. Ibid., p. 20.

21. Ibid., p. 55.

22. Ibid., p. 55.

23. Ibid., p. 56.

24. Edward A. Bilodeau, ed., *Acquisition of Skill* (New York: Academic Press, Inc., 1966), p. 488.

25. George A. Miller, Eugene Galanter, and Karl H. Pribram, *Plans and the Structure of Behavior* (New York: Holt, Rinehart and Winston, Inc., 1960).

26. David E. Berlyne, *Structure and Direction in Thinking* (New York: John Wiley & Sons, Inc., 1965).

27. A. Newell, J. K. Shaw, and H. A. Simon, "Report on a General Problem-Solving Program," in *Proceedings of the International Conference on Information Processing,* Paris, 1959; pp. 256–64; see also, by the same authors, chap. 3 in Howard E. Gruber, et al., eds., *Contemporary Approaches to Creative Thinking* (Chicago: Aldine-Atherton, Inc., 1962), pp. 63–119.

28. Dale B. Harris, *Children's Drawings as Measures of Intellectual Maturity* (New York: Harcourt Brace Jovanovich, Inc., 1963).

29. John H. Flavel, *The Developmental Psychology of Jean Piaget* (New York: Van Nostrand Reinhold Company, 1963), pp. 154–55.

30. Lancelot Law Whyte, ed., *Aspects of Form* (Bloomington: Indiana University Press, 1961), p. 6.

31. R. G. Collingwood, *The Principles of Art* (1938; reprint ed., New York: Oxford University Press, Inc., Galaxy Books, 1958).

32. Beittel, op. cit. (1964), n. 2 chap. 1.

33. Miller, Galanter, and Pribram, op.cit., n. 25 chap. 3.

34. Jerome S. Bruner, "The Course of Cognitive Growth," *American Psychologist* 19, no. 1 (January 1964): 1–15.

35. Michael Polanyi, "Logic and Psychology," *American Psychologist* 23, no. 1 (January 1968): 40.

36. Morse Peckham, *Man's Rage for Chaos* (Philadelphia: Chilton Book Company, 1965).

37. David E. Berlyne, "Comments on Relations Between Piaget's Theory and S-R Theory," in *Monographs of the Society for Research in Child Development, 27,* 1962; pp. 127–130.

38. Ibid., p. 128.

39. Kenneth R. Beittel and Robert C. Burkhart, "Strategies of Spontaneous, Divergent and Academic Art Students," *Studies in Art Education* 5, no. 1 (Fall 1963): 20–41.

40. Jean Piaget and P. Greco, "Apprentissage et Connaisance," *Études d'Épistém. Génét.,* 7 and 10. (Paris: Presses Universitaires de France, 1959).

41. C. Spearman, *The Nature of "Intelligence" and the Principles of Cognition* (London: Macmillan & Co., Ltd., 1923).

42. Albert J. Caron, "Impact of Motivational Variables on Knowledge-Seeking Behavior," chap. 5 in *Productive Thinking in Education,* ed. Mary Jane Aschner and Charles E. Bish, (Washington: National Education Association, 1965), p. 140.

43. Ibid.

44. David E. Berlyne, "A Theory of Human Curiosity," *British Journal of Psychology* 45 (1954): 180–91; David E. Berlyne, *Conflict, Arousal and Curiosity* (New York: McGraw-Hill Book Company, 1960).

45. Miller, Galanter, and Pribram, op. cit., n. 25 chap. 3.

46. Ibid., pp. 11, 18.

47. Ibid., p. 62.

48. Ibid.

49. Ibid., p. 16.

50. Ibid., pp. 17–18.

51. Ibid., p. 26.

52. Ibid., p. 29.

53. Ibid., p. 67.

54. Langer, op. cit., n. 4 chap. 3, p. 105.

55. Ibid., pp. 103–5.

56. Immanuel Kant, *Critique of Judgment* (1790).

57. Whitehead, op. cit., n. 14 chap. 3.

58. Peckham, op. cit., n. 36 chap. 3, p. 100.

59. Morris, op. cit., n. 2 chap. 3, p. 158.

60. Christopher Alexander, "The Origin of Creative Power in Children," *British Journal of Aesthetics* 2, no. 3, (July 1962): 207–26.

61. The term *function pleasure* really comes from K. Buhler, "Displeasure and Pleasure in Relation to Activity," in *Feelings and Emotions: The Wittenberg Symposium,* ed. M. L. Reymert (Worcester, Mass.: Clark University Press, 1928), chap. 14.

62. Viktor Lowenfeld, *Creative and Mental Growth,* 3d ed. (New York: Crowell Collier and Macmillan, Inc., 1957).

63. Berlyne, op. cit., n. 26 chap. 3, p. 244.

64. Ibid., pp. 245–46.

65. Peckham, op. cit., n. 36 chap. 3, p. 322.

66. Bernard Rimland, *Infantile Autism: The Syndrome and Its Implications for a Neural Theory of Behavior* (New York: Appleton-Century-Crofts, 1964).

67. Berlyne, op. cit., n. 26 chap. 3, p. 19.

68. Ibid., p. 245.

69. Ibid., p. 108.

70. Ibid., p. 118.

71. The TOTE unit might be called a "transformational act," and thus be seen as uniting the theories of Miller, Galanter, and Pribram; Berlyne; and Langer.

72. Anton Ehrenzweig, "Conscious Planning and Unconscious Scanning," in *Education of Vision,* ed. Gyorgy Kepes (New York: George Braziller, Inc., 1965), p. 28.

73. Ibid., p. 30.

74. E. H. Gombrich, "The Use of Art for the Study of Symbols," *American Psychologist* 20, no. 1 (January 1965): 49.

75. Ibid., p. 36.

76. F. C. Bartlett, *Thinking* (London: Methuen & Co., Ltd., 1958).

77. Gombrich, op. cit., n. 74 chap. 3, p. 49.

78. Matthew Lipman, *What Happens in Art* (New York: Appleton-Century-Crofts, 1967), p. 97.

79. Monroe C. Beardsley, Review of *What Happens in Art,* by Matthew Lipman, *Journal of Aesthetics and Art Criticism* 26, no. 3 (Spring 1968): 411–12.

80. Lipman, op. cit., n. 78 chap. 3, p. 102.

81. The term *tertiary qualities* is conventionally used to designate whole qualities, that is, those which we cannot localize but which seem to belong to situations and processes. Dewey says that tertiary qualities lack specificity. What we designate as "melancholy" or "puzzling" are pervasive, not particular, phenomena. John Dewey, *Logic* (New York: Holt, Rinehart and Winston, Inc., 1938), p. 69.

82. Polanyi, op. cit., n. 35 chap. 3, p. 29.

Drawing Strategies

Before we can look into the drawing process anew, the concept of a drawing strategy should be explored. In Chapter 2 an effort was made to distinguish operationally between style, grossly labeled "appearance," and strategy, labeled "plan." As I will try to show, this simple distinction avoids much of the confusion attending previous attempts to define dichotomous superstyles and then to stretch them to cover all the cultural, individual, and historical variants called "styles."

It has been alleged that the Western mind has long been plagued with the habit of either-or or dichotomous thinking, whereas the oriental mind has not taken as fully to a balance-beam logic. Examples of dichotomous thinking within the literature of western art are voluminous.

STYLE AND STRATEGY

In the paragraphs immediately following, I will skim across some of the literature related to style *as it appears to be pertinent to our concern with*

strategy. Style and strategy are falsely treated as the same thing in most writing. This error is understandable, since they always occur together. The claim here, however, is that many styles can occur within a single strategy, and, conversely, the same style can occur under both of the strategies to be presented in detail later in this chapter. The error in past writings, thus, has been in their inability to separate thinking processes (strategy) from conventional or habitual art appearances (style).

Some writers have the opinion that the artist's personality and even his fate are intertwined with a defined style. Huyghe,[1] for example, speaks of "vitalists" and "formalists," stressing that quality is equal in the works of each, but indicating that a "fated inner determinism" is at work in the process of selecting which style an artist will use. Itten[2] similarly believes in the "rightness" of certain temperament-form-style connections, perhaps in a manner related to the long-standing European traditions for interpretation in graphology.[3]

By admixtures of art history, aesthetics, and psychology, Read,[4] as previously discussed, connects coherent art styles with stable personality traits, based on the theories of Jung.[5] His purpose, however, is largely peda-gogical, for he wants to see pluralistic values in the classroom so that the fullest range of individual differences and potentialities can be developed in the "organic" manner he describes. In contrast, Schaefer-Simmern's[6] approach is exceedingly narrow, for he finds only *one* path of development that is "natural." Thus a value judgment is made by way of exclusion.

McFee[7] develops her reasoning in a different manner by fixing on the concept of "cognitive style," as described from the work of Witkin.[8] Here a value judgment first occurs between two types of mental functioning, field-dependent and field-independent, and carries over into the art these types create. McFee's purpose, however, is not to define art styles but to increase teachers' sensitivity to differences in students' "readiness for art." Lowenfeld[9] goes further than the above authors into detailed artistic and psychological analysis of visual and nonvisual (haptic) styles of art, as verified first in the works of weak-sighted and the congenitally blind and then ex-tended to the normal-sighted. He, too, confuses these types with art styles (impressionism and expressionism), but his psychological analysis and re-search are deeper and more closely related to the production of works of art than any of the above-mentioned authors. Knowledge of Lowenfeld's life and the stimulating Viennese world of ideas out of which he came[10] provides the setting for a full comprehension of how Lowenfeld flexibly used these types as tools for inquiry. By comparison, contemporary criticism of his typology seems thin and superficial.[11]

The extent to which styles may be based on pervasive personality traits is disputed in the literature of art education and the psychology of art. By and large, the artist's romantic inheritance from the nineteenth century inclines him to expect such a connection. This view persists in the present century even in the face of the most fluctuating stylistic dynamism in the history of art.

Some writers find style-temperament relationships even in the art of the young child. Minkowska is quoted as describing the early appearance of "separation" and "joining or connection," leading respectively to "immobility and precision" and to "movement and impreciseness of form" in the art of the young child.[12] That some credence may be placed in such generalizations is supported by studies outside of art, as in the work of Witkin[13] referred to above or as in Kagan's recent study of the "conceptual tempo" to be found in "impulsive and reflective" children.[14] Nevertheless, the connections between art styles, strategies (cognitive or artistic), personality, and development are far from clear. The reader is referred to Harris[15] for the most inclusive discussion of these subjects as they relate to child art. In the classic study of expressive movement of Allport and Vernon[16] the authors find that the "integration" of expressive movements into a common style, in the sense of highly interrelated ways of acting within a personality, is not a common occurrence although it does occasionally occur. As earlier work by Burkhart and the author shows,[17] it is likely that the more "spontaneous" or vitalistic styles—the nonvisual, the baroque, the sensational, the dionysian, etc.—correlate better with existing personality scales than their counterparts. Furthermore, where such relationships between style and personality are found, the syndromes revealed relate to findings in creativity research, thus typically introducing a value bias into discussions of styles, especially where the setting is an educational one.[18]

DICHOTOMOUS SYSTEMS

Gombrich[19] accuses German art historians of working with contrasting pairs of concepts, a method which he feels introduces a false dichotomy. He states that all of the contrasting pairs—he mentions as examples haptic-optic (Riegl), abstraction-empathy (Worringer), physioplastic-ideoplastic (Verworn), multiplicity-unity (Wolfflin)—could probably be labeled as "conceptual" and "less conceptual." While one must agree with Gombrich that terms like classical and romantic, ethos and pathos, and the like, have been unduly hypostatized in the run of writing on art, nevertheless the "conceptual" and "less conceptual" approaches have continued to appear throughout the history of man. In this book, a stand will be taken with Gombrich, Schapiro,[20] Ackerman[21] and others that style is a concept too broad and complex to be contained in a dichotomous system.

It so happens that the dichotomous systems in existence work better for strategies than for styles. It was humbling to find that the descriptive terms developed for describing art strategies (presented later in this chapter) are close in spirit and substance to those which Wolfflin coined to distinguish between classical and baroque art.[22] His terms for line quality (painterly-linear), space (recession-plane), composition (open-closed), elaboration (unity-multiplicity), and light (unclearness-clearness) are directly translatable into clusters of strategy signs describing the spontaneous and divergent working processes respectively, and soon to be introduced.

Rothschild[23] has recently codified dichotomous terms derived from the literature on style in art. His key terms are "sensational" and "analytical"; and these more or less correspond to the spontaneous and divergent strategies of this book. Unlike the position taken herein, however, Rothschild makes much of personality traits and pervasive life styles and sees them as essentially correlates, or even causative agents, of the two classes of styles. As with Wolfflin, the entries in Rothschild's "Table of the Polar Categories"[24] are almost directly translatable into some of the strategy criteria to be described.

What, then, is the difference between style systems like those above and art strategies? Primarily it is that the former are tools for the explanation, through classification and comparison, of periods of art; whereas the strategies are first steps toward understanding thinking processes occurring within the art process itself.

THINKING WITHIN THE ART PROCESS

Let us begin with a broad point of view that keeps us within the bounds of a transactional context for the art process by quoting some sweeping statements from Gombrich.[25]

> The growing awareness that art offers a key to the mind . . . has led to a radical change of interest on the part of artists. . . . The language of forms and colors . . . that explores the inner recesses of the mind has come to be looked upon as being right by nature. Our nature.

> To the artist the image in the unconscious is as mythical and useless an idea as was the image on the retina. There is no shortcut to articulation. Wherever the artist turns his gaze he can only make and match, and out of a developed language select the nearest equivalent.

It is this "making and matching" out of a "developed"—and I would stress "developing"—"language" and this tentative selection of an "equivalent" for some imagined or emerging meaning that requires "structure" in the mind, as a directing force. The term "drawing strategy" introduces a process emphasis in keeping with this global, dynamic language.

Psychologists have used the term *strategy* to describe consistent modes of processing information, usually in a problem-solving context. The term *processing information,* however, fits the productive side of art poorly. The terms previously introduced from Miller, Galanter and Pribram[26]—*image, plan, strategy, tactics,* and the *TOTE unit*—overcome some of this difficulty. Further, the analogies to computer strategies advanced by Newell, Shaw, and Simon[27] for use in simulating certain kinds of problem-solving are attractive. Both of these sources reflect more global and eclectic positions, perhaps because they deal with large and functional units of behavior on a level of complexity that invites comparisons with drawing. The computer simulation programs use:

. . . a substantive view of the nature of information as well as the cybernetic princi-
ple of a control system that is both (a) sensitive to feedback indicative of behavioral
error or discrepancy between existing and desired states of affairs, and (b) differ-
entially responds to such feedback in ways that correct the existing error or dis-
crepancy.[28]

The difficulty in speaking of a strategy in drawing is that the important
actions in the dialogue between the artist and the emerging drawing, which
is the drawing process, are covertly mediated. The difficulty existing in
describing the relationship between thought and language, between "inner"
and "communicative" speech,[29] is thus compounded when we come to speak
of thought and drawing. Can we refer to "inner" and "communicative" (or
also expressive) drawing? And how will these stand in relation to the verbali-
zations by means of which the observer and the subject refer to stages in the
drawing process?

Vygotsky[30] provides a clue and suggests a danger in too readily accept-
ing Piaget's assumptions concerning the path the child takes from the private
to the egocentric to the socialized and logical forms of language. Instead of
these stages following one another, Vygotsky feels that inner speech—think-
ing for oneself—is like egocentric speech but has gone underground. And
rather than the private, the idiosyncratic, and the autistic being early, they
are late in emerging, are in fact forms of individuation and differentiation
occurring only in maturity. This highly original and non-Freudian point of
view is worth considering. It would help prevent art education from succumb-
ing to the "cult of childhood,"[31] and from overdetermining the meaning of
the child's early art. Perhaps there is wisdom in Grözinger's[32] suggestion that
the very young child, no less than the child from 8 to 12, is trying to represent
"reality"—that is, the world as it is "real" to him.

From these bases, a line of reasoning concerning the use of the strategy
concept in relation to the drawing process begins to take form. Before, I
argued down drawing as a kind of problem-solving, and I played games with
Berlyne's[33] concepts of directed and autistic thinking. The reader may ask
why. Frankly, because my eye is on the drawing process and the drawing
sequence, and these phenomena will not allow themselves to be forced into
the neat separations that theorists of cognitive processes are prone to. Only
Langer, in her recent work,[34] treats mind both abstractly and dynamically
enough to accommodate comfortably the complexity of artistic behavior.

The argument I wish to present is that the art strategy is a more or less
implicit or emerging plan for connecting symbolic transformations of sensory
feedback. The plan is situational in that beginning drawing operations, as
much as intentionality (that is, images of what can be done arising from what
has been done) and idiosyncratic meaning, will determine what actually
occurs in a drawing. Feedback from beginning operations is analyzed for
error-reduction (what is *not* wanted) or evaluated as the base for redefining
what *can* be wanted in the given drawing process. Thus the term I prefer to
use is not *problem-solving,* nor is it *qualitative problem-solving,*[35] but *prob-*

lem-controlling. At any given point in the drawing process, the "inner" drawing and the "communicative" drawing as it actually is at its existing stage, constitute a dialectical process, a game of strategy, so to speak, for a next phase—the following symbolic transformation. This means that the artist must feel like the controlling agent, no matter how dynamic the process. This is especially so when the artist feels as though the drawing is controlling him, for in no case could he be more sensitive than he is then to the process feedback he receives. Rather than get trapped in either-or thinking that rejects outright the notion of drawing as problem-solving, let me state that problem-controlling implies that all kinds of thinking processes enter into drawing. My view is like Smith and Smith's[36] that

> . . . both communication and the verbal and nonverbal symbolic transformations used in thinking may involve many different kinds of operations. The different processes known as memory, reasoning, problem-solving, and creativity are distinctive ways of using verbal and nonverbal symbols to control adaptive perceptual-motor behavior.

There is no need to get hung up on whether drawing is problem-solving and therefore whether we have to do with only "directed thinking" and "specific exploration." Instead it will be clear that in such a dynamic process we contend with both "specific" and "diversive" exploration, in other words with both "directed" and "autistic" thinking, to use Berlyne's terms. Thereby we part company with Berlyne himself, who equates diversive exploration with "amusement," "diversion," or "aesthetic experience."[37]

CREATIVE PROBLEM-SOLVING

Since the insertion of the qualifier "creative" before problem-solving changes our whole perspective on its relationship to drawing, let us spend some time examining recent viewpoints on "creative problem-solving." In Gagné's discussion of "learning types," problem-solving is "type 8," at the top of the hierarchy (the other seven being prerequisites to it). Gagné says of problem-solving that it ". . . is a kind of learning that requires the internal events usually called thinking. Two or more previously acquired principles are somehow combined to produce a new capability that can be shown to depend on a 'higher order' principle."[38] For Getzels, the highest order to problems is one in which ". . . the problem itself exists but remains to be identified or discovered, and no standard method for solving it is known to a problem-solver or to others."[39]

Simon[40] has recently said that "problem-solving involves selective trial-and-error search in a vast space of possibilities." "Selective search" means in the case of humans usually less than 100 alternatives and not the 10^{120} choices that would have to be considered in playing chess, for example, if an algorithm were involved. Therefore, some "heuristic" hunch about short cuts is necessary. Creative problem-solving, which we have been leading up

to, is, for Simon, near the "blind-search end of the continuum." The "novel" arises for a number of reasons: the subject has a superior intelligence, a new problem, observes a new phenomenon, has a new instrument or new analytic tool, or is utilizing a mixture of cues from different fields. "Depth" in problem-solving is revealed through a tremendous preoccupation with the problem and "a long-term tolerance for ambiguity."

In creative problem-solving, as in drawing, some alternating "dialectical rhythms" (akin to those which were described from Langer[41] in the last chapter) appear to be at work. Earlier, we also viewed Ehrenzweig's[42] concept of creative thought as a gradual advance in successive stages, each opening into new possibilities, unforeseen to a degree, then closing into clarity; thence into subsequent stages, and into integration through combinations made in progress. Bruner[43] speaks of appropriately open and appropriately closed phases to ideation, and of "retreat" to personal metaphor or lower levels of representational modes for knowledge when blocked.

Similarly, Beardsley[44] analyzes "preconscious" processes (apparently the seedbed for intuitive and illuminative ideas) into gestalt strengthening and associative components which, taken together, become the preconscious and inventive phase of the creative process, alternating with a conscious and selective phase, the latter being critical or evaluative. Rhythmical cycles are thus suggested in which the entire process of making a drawing would consist of stages, each gradually advancing through preconscious and conscious phases, which would find their equivalent in more molecular structural units composed of the actual transformations or operations sought, selected, applied, compared, and evaluated.

Just what the preconscious is no one has helped me to understand. It is perhaps a retreat into the strangeness of perception that Gibson[45] speaks of (the "visual field" as opposed to the "visual world"); or Fiedler's[46] lingering at the stage of "pure perception"; or Ehrenzweig's[47] cross-eyed "unconscious scanning" or diffused attention" which is thought to lead to "or-or" structures (disjunctives, or mutually exclusive variations of a theme); or James's[48] "consciousness" which cannot be attended to directly; or Polanyi's[49] "proximal term" in tacit understanding "from" which we attend "to" a distal term and of which we cannot speak.

Perhaps the entire notion of a preconscious phase is unparsimonious and we can uncover more useful constructs. McKellar[50] speaks of an "authorship-editorship" relation which holds between autistic or free-associative thinking and directed thinking. And Berlyne too will admit, despite the split in his system which we discussed above, that ". . . transformational and free-associative thinking must usually interact and collaborate in practice." The way an artist or thinker recognizes an appropriate route or heuristic is not known. Progress may have to do with "conflict reduction."[51] And even problem-solving in computers alternates between running through lists and selecting and applying an operation.[52]

What would appear to be lacking in these formulations is the context of the drawing itself, the "prevailing situation" of Langer's[53] that we described

in the last chapter. In contemporary thought, this line of reasoning is most akin to "experimental behavioral cybernetics." According to Smith and Smith,[54] "this new approach conceptualizes behavior not in terms of discrete units of response but as the continuous activity of a self-governing system." Further, human performance can be represented as a "closed-loop" operating system. Such systems ". . . readjust themselves continuously by means of their inherent capacity to detect directional differences. They are self-regulating or feedback-regulating systems."[55] These same authors refer to thinking as "action," as "response-controlled," and also as controlled by "symbolism."[56]

> We can distinguish among concrete behavior, concrete symbolism, and abstract symbolism. Concrete symbols designate specific objects and events whereas abstract symbols denote such general properties as geometric relationships and principles, temporal relationships, force and energy requirements, and the values involved in the situation. Individual behavior is regulated by such abstract feedback transformations in much the same way as it is by the feedback from concrete symbols and specific objects; but the knowledge used to recognize and manipulate the geometric, temporal, kinetic, and other abstract properties of the situation is far more generalized than that related to concrete events. The degree of control that an individual can level over his environment increases with the generality of his symbolic understanding. Further, the evolution of knowledge in human culture has seen a gradual expansion of symbolic control from primitive spatial representations of the environment to the advanced historical, geometric, kinetic, economic, artistic, and scientific concepts of modern man.[57]

It now becomes apparent why these same authors stress "symbolic transformation of sensory feedback," and why they have espoused a "transformational theory of cognitive behavior." Thus "inner drawing" involves the kind of "abstract symbols" referred to above as well as "drawing transformations" seen in more concrete terms. Moreover, as Harris has stated (in a letter to the author) ". . . the esthetic embodies concepts, but high order abstractions, not the object concepts of the drawing test" (he here refers to the Goodenough-Harris Draw-A-Man Test). This is perhaps why Harris sees drawings of "artistic merit" as postdating childhood. As he reasons

> . . . graphic ability which achieves representative drawing of esthetic or artistic merit cannot be discerned in young children; such appears only after certain psychological (cognitive) processes have run their course, and the child has mastered techniques appropriate to the medium. Much the same can be said of graphic traditions other than the representative.[58]

In further clarifying this statement to the author, Harris said: "If a drawing is to be an esthetic object, my statement implies principles of art which maximize the likelihood of an esthetic response to the product." Verbalizations may or may not elucidate what these "high order abstractions" or "abstract symbols" related to art may be. I will argue that these are in part

difficult or verbalization in drawing and closely bound to the drawing process and sequence.

These abstract symbols and concepts help direct the problem-controlling artist in the drawing process, for they point toward the transformations of sensory feedback that the artist responds to. Even though Gombrich [59] says that all art is "conceptual," or at least "more or less" conceptual (a significant qualification), art is certainly not completely so in our ordinary usage of the word though its production may be partially mediated by concepts. The "aesthetic" as opposed to the "artistic" leaves us with the impression, however hard to formulate, that the former deals with the "sensuous" as "immediately given" in our experience.

> Art is not the expression or the embodiment of experience which is mediated by means of concepts. Such expression is reserved for language. Art is the only form of expression devised by man to embody the immediate sensuousness of his living experiences. [60]

I take this line of reasoning, in process terms, to hark back to Langer's "prevailing situation" which, in the last chapter, led me to conclude that the artist's intent is in fact a situation—it is what the process was all about to a closed-loop cybernetic system, to a problem-controlling agent. It is also akin to Dewey's "pervasive quality" which stains immediate experience and cannot be directly cognized.

My only qualification would be that even these qualities are manipulated by abstract symbols in the drawing process. Aesthetic and autistic "thinking," diversive and specific exploration, and directed thinking all occur in the drawing act. All process "mental stuff" and lead to selective acts under ongoing control, even when such mental contents "represent" what it is in immediate experience to "color," to "form," and to "move." If by dint of practice and time, I "no longer think" as certain operations are performed in throwing a pot, and even when a particular "habit family" or "transformation family" is so elided that it seems to occur between my fingertips and the clay alone, this I consider only "less conceptual" or as a nonverbalized "abstract symbol" embedded in the ongoing situation, still response directed. As Piaget argues, thinking preceded and remains broader than language, and, at base, includes those symbolic products "created almost out of nothing" from mental stuff which "supplements language." [61]

ELEMENTS OF THE DRAWING PROCESS

Having made the point that the artist is a problem-controlling, response-directed agent, operating through symbolic transformation of sensory feedback, we still have no clear language to describe the kinds of operations and abstract symbols that are chained together in any given drawing process. The language of "operations" has broad appeal today in many quarters. "Operations" are foremost in the system of Piaget [62] in his discussion of the

development of thought and logic in the child. In computer simulation of problem-solving it is necessary to stipulate the operations to be performed to transform information in one form into another closer to the solution. Berlyne speaks of "transformational chains" as the key to directed thinking. Since they are "derivatives of overt responses that regularly result in particular kinds of environmental change," it would appear that it is not at all erroneous to make a claim for drawings producing drawings, provided allowance is made for the interaction of the symbolic and operational side of drawings. As in directed thought, any one transformational chain for a given drawing must ". . . on the whole . . . depend on the information contained in the subject's symbolic structures and cannot rely on periodic replenishments of information from the outside world."[63]

Just what are the likely components of a transformational chain in the drawing process and how do these group into sufficient regularities to be honored by the term *strategy?* "Transformational chain" sounds more precise than it is. Though the term *strategy* is fuzzy, the image of cognitive structure it evokes emphasizes hierarchy, or verticality, of components as well as order, or horizontality. In this sense, a transformational chain could be a larger subpart of a drawing strategy, just as standard subroutines are utilizable in a variety of different computer programs. Let us again take refuge in the situational drawing dialogue.

> Each time the artist . . . takes a step, he adds something to what is already there *(A),* and makes another and different object *(B).* If he judges *B* worse than *A,* he must go back. If *B* is better than *A,* the question is whether it is good enough to stand alone as a work of art. If not, the question is whether *B* can be transformed into still another and better object, *C.* If this is impossible, if every attempt to improve it only makes it worse, then the whole project is left unfinished, for it is unfinishable.[64]

The first step is crucial within a strategy. Beardsley calls this the "incept." For this, any sort of thing of esthetic or psychological appeal will do, because ". . . the crucial controlling power at every point is the particular stage or condition of the unfinished work itself, the possibilities it presents, and the developments it permits."[65] Much "process talk" of artists confirms this, and later we will present case material along this same line. What we are illustrating is the way in which the artist is problem-controlling and feedback-directed in the symbolic transformations he chains together.

Valery gives another example of this when he says that poetry proceeds by means of ". . . word combinations, not so much through the conformity of the meaning of these groups to an idea or thought that one thinks should be expressed, as, on the contrary through their effects once they are formed, from which one chooses."[66] Sometimes the larger transformations a work goes through are indeed startling. In Yeats's Byzantium poems where a record of their development has been preserved, many of the original meanings are completely reversed from earlier to later versions.[67] Picasso has

said that a painting may be a sum of destructions. There are some painters whose in-process photos might be indecipherable without time-order clues. In drawings, and with a substantially additive medium, such startling transformations are less likely.

Vygotsky gives an example of how situational factors and responses to them may redirect a drawing. The incident is so charming that I wish to quote it directly:

> A child of five-and-a-half was drawing a streetcar when the point of his pencil broke. He tried, nevertheless, to finish the circle of a wheel, pressing down on the pencil very hard, but nothing showed on the paper except a deep colorless line. The child muttered to himself, 'It's broken,' put aside the pencil, took watercolors instead and began drawing a *broken* streetcar after an accident, continuing to talk to himself from time to time about the change in the picture. The child's accidentally provoked egocentric utterance so manifestly affected his activity that it is impossible to mistake it for a mere by-product, an accompaniment not interfering with the melody.[68]

With adults, an external triggering of change is not as necessary. In Figure 4 are recorded the stages of a drawing by a college student who was drawing from a complex still-life. She singled out of the still-life a ladder-back chair, whose greatly extended back, as first drawn, was then made into one section of a ladder. Off an adjacent side of the seat a new chair back was formed, and this subsequently became the back also for a rocking chair, facing in the opposite direction. Such examples of obvious transformations while in-process are far from rare. They are, in fact, common in one of the drawing strategies about to be described.

TWO DRAWING STRATEGIES

As reported elsewhere,[69] the two art strategies emerged from time-lapse photographs of drawing processes. These photographs were not taken for the express purpose of studying drawing strategies. They were process feedback material in a learning experiment involving free-hand drawing from a complex, many-sided still-life. Since this still-life became an important known stimulus from which to read subjects' drawings, a photograph of it from various views is shown in Figure 5.

How can one say that the two drawing strategies emerged before my eyes and those of Burkhart, my research associate? To begin with, our minds were prepared to see signs of spontaneity by work which Burkhart had done on his thesis and, later, in book form.[70] These signs of spontaneity, however, were not defined within the drawing process. The first analysis breaking spontaneity, as a global criterion, into components, had just been carried out by Bernheim,[71] a research assistant working with Burkhart and me. The six criteria she established within spontaneity were still end-product criteria. It took time-lapse photographs of drawings in-process plus the sudden realization that there were ways other than through spontaneity of making "good"

4.1

4.2

4.3

4.4

Figure 4 In-process transformation of subject matter.

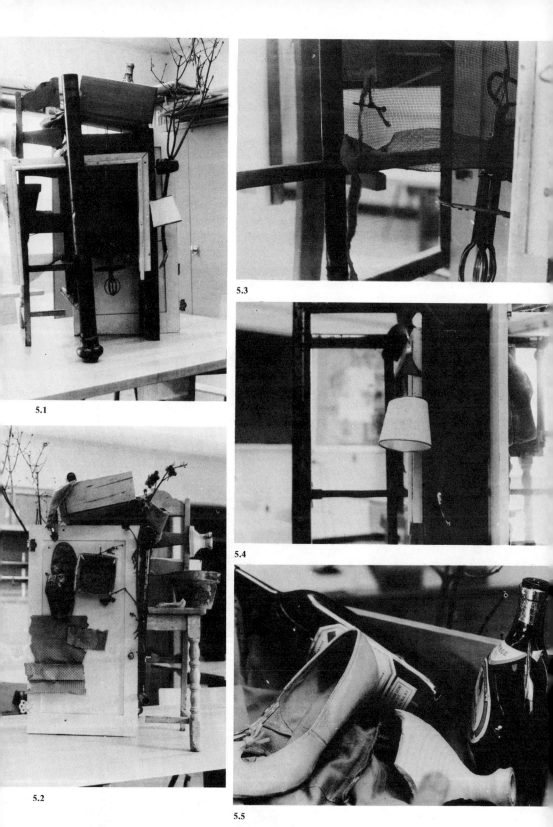

5.1

5.2

5.3

5.4

5.5

Figure 5 Assemblage-like still life used in drawing experiments.

6.1

6.2

6.3

6.4

Figure 6 Process sequences illustrating the spontaneous strategy.

drawings to allow us to cognize the concept of definite strategies which, despite their idiosyncratic embodiment in any one drawing or any one person's drawings, were general enough to cut across many different drawings and persons.

The way Burkhart and I first obtained the distinguishing signs of each strategy needs some description because it relates to the drawing sequence concept. Our grasp being global, we looked for clear exemplifications of the two strategies. For this we chose students whose entire sequence exemplified the strategy, as globally defined, and in addition showed a seeming increase in intensity or complexity of the still undefined strategy in question. By this means, we could become aware of the strategy sign because it changed from the base, or it appeared where before it had been absent. Then we sought further verification for signs thus isolated.

These strategies were originally defined as follows:

The *Spontaneous Strategy,* in broad terms, exhibits a beginning big organic statement devoid of detail but suggestive of a whole picture. Through progressive medium interaction, centralization, movement, incorporation of process-inspired accidents, and suggestion, students utilizing the spontaneous strategy focus on the whole problem as they feel it and try to solve it through procedural experimentation.

In the *Divergent Strategy,* the student typically begins by drawing with considered fine line control a single element which in some portion shows the early inclusion of relatively precise detail. As new elements are added, an alteration of viewpoint and shifting of focus is likely to occur, and the work is off-center and tensional. Through line, black-white contrasts and positive-negative figure-ground reversals, the work undergoes unexpected changes, and becomes flatter and often simpler.[72]

Examples of these two strategies are given in Figures 6 and 7. The original criteria or strategy signs which Burkhart and I identified and put to use in several learning experiments[73] are given in Tables I and II together with the percentages of the 96 art education majors in these experiments who, over a four-week period, gave evidence of the particular sign at sometime in their drawings.

STRATEGY SIGNS

Burkhart attempted to integrate these strategy signs within one description.

In art works, the most critical point of detection determinant of the strategy is the beginning stage. Spontaneous students begin with a big organic statement devoid of detail but suggestive of a whole picture. This initial statement is enriched by a diversity of strokes which allow, through media overlays, for the incorporation of accidental forms as a source of process inspired changes essential to the progressive development of the work as an organic unit. Action is evident in the brush

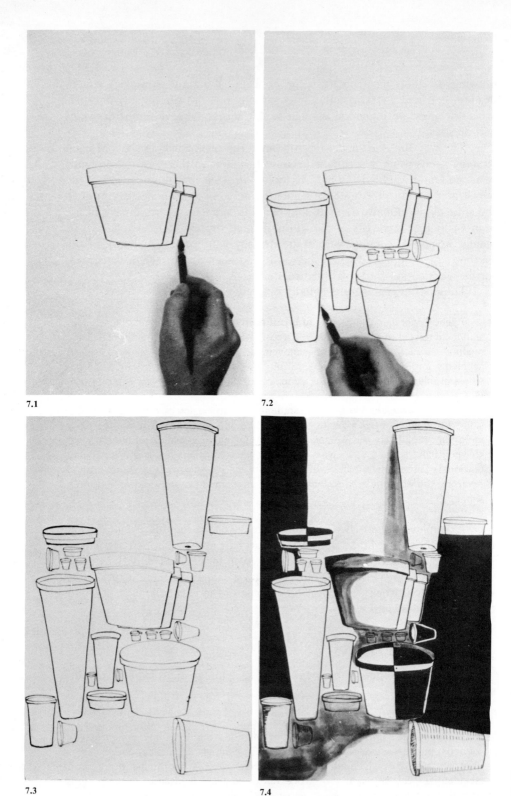

7.1

7.2

7.3

7.4

Figure 7 Process sequences illustrating the divergent strategy.

TABLE I ORIGINAL CRITERIA FOR THE SPONTANEOUS STRATEGY

	Criterion	*% (N = 96)*
1.	Progressive Development of Work as an Organic Unit	64
2.	Reliance on Suggestion for Completeness, Not Elaboration	55
3.	Movement within Shapes	54
4.	Central Emphasis (through the balancing out of the dynamic elements in juxtaposition to each other)	49
5.	Erratic Wandering Fine Lines	46
6.	Action Gestures (resulting from the distortion of the contours of the subject matter)	42
7.	Direct Abrupt Quick Motions	38
8.	Patterns of Broken Light within Darks	37
9.	Rough and Varied Edges	36
10.	Suggestive Big Organic Statement from Start (in scale) Devoid of Detail	33
11.	Open and Broken Contours (not at joints)	31
12.	Medium Overlays (interaction)	31
13.	Incorporation of Accidental Forms (Process-inspired changes)	30
14.	Enrichment through Diversity in Strokes within Picture	28
15.	Direct Forceful, Flowing Movements (circular or long)	22
16.	Web-like Solidification across Objects	21
17.	Movement across Forms and Contour	17
18.	A Spatial Network through Voids Surrounded by Dynamic Dark Forms	14
19.	Heavy Action Forms in Space (disconnected)	14

work which varied from the use of direct, forceful, flowing movements to direct, abrupt, quick motions that are usually interwoven with erratic wandering fine lines which convey the impression of movement within shapes, intensifying the action gestures resulting from the distortion of the contours of the subject matter. This freedom in procedure leads the spontaneous student to reliance on suggestion for completeness, not elaboration. As the work progresses, shapes are stated rapidly with open and broken contours and rough and varied edges, creating patterns of broken lights and darks throughout the picture's surface, which sometimes in the bigness of the forms suggests a network of spaces through voids surrounded by dynamic dark forms. It is principally by the composition's central emphasis that the picture is held together, through the balancing out of these dynamic elements, which are further integrated by the open spatial patterns of brush strokes which in their diverse movements across forms and contours sometimes achieve a fused or web-like solidification of objects into a dynamic abstract, monumental unit, or heavy action forms in space. Spontaneous students begin with wholeness and their objective is to give increasing vitality to the whole through suggestive progressive interaction.

Divergent students begin their picture by drawing with considered fine line control a single element which in some portion shows the early inclusion of detail. They sometimes draw only a single element but more often their work reveals a single element focus which when compared to the stimulus object in shape shows

TABLE II ORIGINAL CRITERIA FOR THE DIVERGENT STRATEGY

Criterion	% (N = 96)
1. Flatness (picture as a whole in pattern)	56
2. Elimination of Nonessentials (less cluttered)	55
3. Black-White Contrasts (solid)	51
4. Change in Size, Internal Scale Alteration	45
5. Variation of the Same Element Picture to Picture (form not just treatment)	45
6. Progression of Theme Picture to Picture, Period to Period	44
7. Formal Distortion (static, drawn out, elongated, abstract)	43
8. Early Inclusion of Detail	42
9. Single Element Focus	41
10. Constructed Spatial Network, Connected (welded together)	38
11. Static Spatial Suspension, Floating (no base line implied)	37
12. Begins with Single Element	37
13. Fine Line Control	37
14. Edge Contrast Edge to Edge (tensional)	34
15. Black-White Negative Reversals	31
16. Decorative Patterns (detail)	30
17. Unexpected Organizational Progression	30
18. Off-Center Composition Off Balance	24
19. Theme and Variation within Picture (same element varied)	23
20. Transparencies and Overlapping Spatial Plans	23
21. Only Single Element (for subject matter)	20

intentional formal distortion in contour which is frequently still further emphasized by the inclusion of the same object again within the composition, with further deviations from its form as a theme for variation on this specific subject matter. A closely related form of change in focus pertaining to subject matter alteration is that of changes in the internal scale of objects in their size relationships, often depicted through the use of transparencies and overlapping spatial planes. The process photographs further reveal that as the picture evolves unexpected organizational progressions usually occur, sometimes resulting in an off center composition, which is off balance, utilizing edge contrasts, from edge to edge of the picture frame, which also contains some detached objects held in a state of static spatial floating suspension. Near the conclusion of the work flatness in the pattern of the picture as a whole is frequently achieved through the use of decorative patterns and solid black-white contrasts that sometimes are in the form of black-white negative reversals of objects in space as inter-connected parts of a constructed spatial network. Over a series of works there is often some elimination of nonessentials and sometimes variations of the same element from picture to picture, which may be included as the basic elements in a progression of pictures from one work period to the next.

In their art Divergent students reveal a constant alteration of viewpoint and controlled shifting of focus within a designated framework in their persistent search for conceptual variety through their systematic openness to emerging possibilities for innovation as they work. Their divergency constitutes a synthetic,

elementalistic strategy, dependent upon conceptual flexibility, organizational clarity, and freedom for discovery.

Two attempts were made to reduce the forty strategy signs to simpler structure. In the first new grouping, Kantner, a more recent graduate research assistant of mine, collapsed the forty criteria into eighteen, and listed these under eight substantive headings. This reduction was done "cognitively," in terms of apparent meaning. Kantner's new and simplified groupings were debated and judged for "visual compatibility" by another graduate research assistant and me. Our decisions were operational in the sense that we asked the question: "Can this criterion be used comfortably and reliably in judging drawing processes?" These eighteen criteria are shown in Table III.

The eighteen criteria of Table III were then applied one at a time, and in random order, by three judges, to 480 drawings resulting from the first of two later experiments.[74] (This, by the way, is close to 26,000 separate judgments.) These judgments were submitted to factor analysis in an effort to arrive at still simpler structure, with the results shown in Table IV. (For de-

TABLE III REGROUPING AND SIMPLIFICATION OF THE ORIGINAL FORTY STRATEGY CRITERIA INTO SUBSTANTIVE CATEGORIES

Type of Line	1.	Diversity of line; open or broken contours (process related) (S)
	2.	Fine line control with limited line variation (D)
Beginning	3.	Overall early structural statement, undetailed but inclusive; central emphasis (S)
	4.	Single element focus, detailed and partial; off-center emphasis (D)
Medium Usage	5.	Abrupt medium changes (D)
	6.	Continuous medium variations (S)
	7.	Suggestion (S)
Detail	8.	Elaboration; precision; pattern (D)
Movement	9.	Direct, flowing movement; action gestures (S)
	10.	Concern for contour, formal distortion (D)
	11.	Plane: eye travels path of forms; frontal plane; position in space affirmed; floating; lateral tension; transparencies and overlapping flat planes (D)
Space	12.	Recession: eye penetrates space; many planes, not clearly separated; position in space sought; depth tension (S)
Contrast and Texture	13.	Irregular broken lights; medium as texture (S)
	14.	Solid regular areas of black and white; black-white reversals; surface patterns (D)
	15.	Emphasis on process and medium usage; objects of subordinate interest (S)
	16.	Size relationships manipulated (D)
Theme	17.	Theme and variation of same element (D)
	18.	"Organic" and progressive development; enrichment of initial overall structure (S)

TABLE IV SIX CLUSTERS RESULTING FROM A FACTOR ANALYSIS OF THE
18 STRATEGY CRITERIA LISTED IN TABLE III

Spontaneous

1. Process Dialogue (a) Diversity of line (1)* (b) Suggestion (7) (c) Action gestures (9) (d) Process emphasis (15)	2. Spatial Continuity (a) Medium variation (6) (b) Recession (12) (c) Broken lights (13)	3. Big Central Attack (a) Early statement (3) (b) Organic develop- ment (18)

Divergent

4. Controlled Detail (a) Fine line control (2) (b) Single element, off-center (4)	5. Elaboration and Pat- tern (a) Abrupt medium changes (5) (b) Pattern (8) (c) Solid black-white (14)	6. Segmented Form and Space (a) Formal distortion (10) (b) Plane (11) (c) Size manipulated (16) (d) Theme and varia- tion (17)

*Numbers in parentheses refer to the 18 criteria shown in Table III.

tailed descriptions and statistical procedures, the reader is referred to the studies listed in note 74.)

It so happens that the strategy criteria which have been presented in the first four tables of this book are highly intercorrelated. Within a strategy, the criteria are positively intercorrelated; across a strategy they are negatively intercorrelated. While they are process-related, art "experts" (operationally, faculty and doctoral art education students) can judge them quite well from finished drawings. Still, the reliability and precision of judgments has been improved by time-lapse process photographs. And even though criteria from one domain correlate negatively with those from another, criteria within a strategy cluster together in a factor analysis (see Table IV). For the latter reason, I have urged that the strategies not be judged in bipolar terms. Such an approach also conceals the fact that various mixes of the two strategies occur. These in themselves are important to investigate because the two kinds of thinking do not easily occur together, though there is no reason why they cannot. When they do, there may be a transition in the general thinking behind a drawing; or we may be seeing the residue of incompatible instructions; or an effort after a kind of style (appearance) that is ill-suited to the thinking (strategy, plan) behind it. Figure 8 shows such an example, in which there is a change in size, that is, an internal scale alteration (a divergent strategy sign), within what appears otherwise to be a drawing in the spontaneous strategy.

There is, of course, the danger that these two strategies have in themselves become unduly hypostatized, inclined, as they are, to force an unreal dichotomy. Perhaps from the start they have been overdetermined to a de-

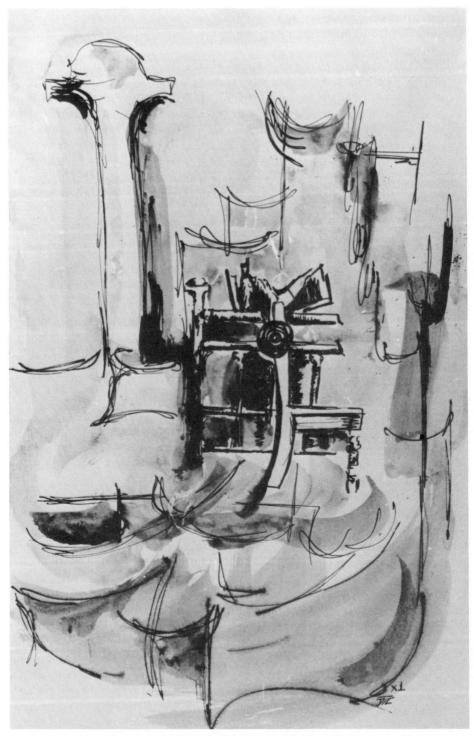

Figure 8 Mixed strategy characteristics in a drawing: change in internal scale (a divergent sign) in a predominantly spontaneous drawing.

gree. It is easy, however, to drop concepts because they have become commonplace, or have had their day, and thus misconstrue their original meaning and promise.

Langer discusses Read's contrast of what he calls the "path of vitality" and the "path of beauty." She says that the beautiful-expressive dichotomy is well established in modern criticism, the one implying works made to please the "higher senses," the other to relieve "emotional pressures." She then goes on to describe one of the errors to which the manipulation of such concepts can lead. The assumption that ". . . the ideal artistic attainment, consequently, is supposed to be a perfect compromise between these two aims, doing the highest possible justice to each," as she says Read proposed, may be misconceived, though the phenomenon of the dichotomy may be genuine. She concludes:

> I think it far more likely that every artist has only one artistic aim, whatever non-artistic interests he may also find opportunity to satisfy by his work. The sole artistic intent is to present his idea of some mode of feeling in the nameless but sensible quality which shall pervade his nascent creation.[75]

Langer points up false conclusions to which "thinking through dichotomies" may lead us. She does *not* say, however, that an artist is "fated" to stick to the same "artistic aim" or a similar one from work to work.

Illustrations attempting to show the six clusters of strategy criteria presented in Table IV are presented in Figures 9 through 14. It is highly important that the reader sense strategy components visually as well as comprehend them verbally. It is only for economy that the six clusters are illustrated rather than the 18 criteria (grouped under eight headings) of Table III, or the 40 criteria of Tables I and II. The feel of these criteria, visually, is more important than the precise criterion or sign itself, because I am not of the opinion that the "elements" of these four tables are in the right form or language to allow us to describe any given drawing process. That they have utility in this task, however, I do wish to affirm. My statement implies rather that in themselves they are not sufficient, and that the language and point of view may have to be modified to cope with what the problem-controlling agent actually does in making a drawing with some flexible Transformational Plan in mind, but with continuous adjustment to the feedback received in process.

A brief digression on value relationships attributed to the art strategies is here in order. I have already referred to some of the contradictory findings but will summarize them here. Students consistently utilizing the spontaneous strategy in our culture can be identified by means of certain personality and creativity tests.[76] Such students are also those with more art training and an identification with painting and drawing.[77] Art judges reflect these influences in that when they identify "aesthetic quality," it is biased toward students using the spontaneous strategy. Further the judge's own typical art strategy or institutional "subculture" is projected as a bias on what has "aesthetic

quality."[78] When highly rated students are instructed to make two drawings, one in each strategy (or "mode" as one study calls it), then the correlation between judgments of "aesthetic quality" and strategy becomes negligible. Moreover, the better the student (by grades, faculty ratings, etc.) the more dissimilar he can make two such drawings.[79]

The studies cited above lead me to conclude that the two art strategies under discussion are phenomena most clearly seen in advanced, trained students and artists, who can, if they desire, flexibly manipulate them. They occur, however, among untrained and beginning students as well; but at this level there is less problem-controlling ability, and there is the likelihood that strategy of drawing will correlate with certain personality and creativity measures. In a way, then, the strategy signs and the plan that controls their graphic flow, will be little available to the novice, even though, of necessity I hope to show, his thinking will approximate one or the other of these routes even though at a rudimentary level. Paradoxically, we will find the signs of the strategies less useful as a language of description with the novice, because other concepts, images, techniques, difficulties, etc. will be paramount in his mind. But the language also does not effectively describe how the more advanced student makes his drawing. What it does do well relates back to the conditions of its finding—that is, it describes the increase in complexity and differentiation (even "de-differentiation") occurring over a student's series of drawings.

In some recent case studies, I discovered, with untrained college students, that the more their art experience, the more they reported that the stages they used could be changed, but, importantly, the less they reported that the overall effect of the work they were doing was clear before the last stage (of stages they themselves designated from process photographs of their work). In other words, as art experience accumulates stage manipulation or flexibility increases and clarity of end effect is postponed until later in the process. A person who sees his stages as invariant and also knows early where he is going is hardly engaged in a dialogue. He is more like an automaton who performs regardless of his environment or the task conditions.

The reader will rightly sense my ambivalence concerning the relationship of problem-solving to drawing. In Chapter 3 I tried to disavow the utility of the concept and again, in this chapter, I have reexamined an expanded term—"creative problem solving" and the "blind search end of the continuum" that it led to. I suspect there can be no either-or here. Drawing has indeed characteristics of problem-solving, especially creative problem-solving. Perhaps my former colleague, Burkhart, was right in referring to the spontaneous strategy as a problem-solving one. In an earlier joint article, we explained our use of "divergent" (an appellation many thought unfortunate) thus:

The word 'Divergent' is employed because the objective of this strategy is primarily *discovery*, whereas the objective of the Spontaneous student is primarily *problem-solving.*

9.1 9.2 9.3

9.4

Figure 9 Illustrations of strategy factor S-1, process dialogue.

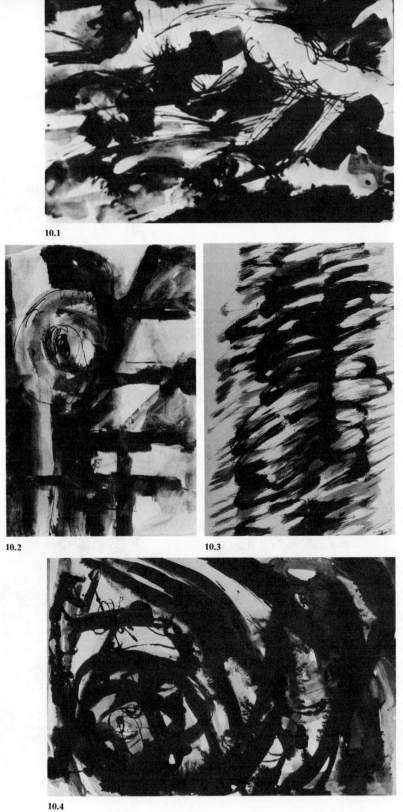

10.1

10.2 10.3

10.4

Figure 10 Illustrations of strategy factor S-2, spatial continuity.

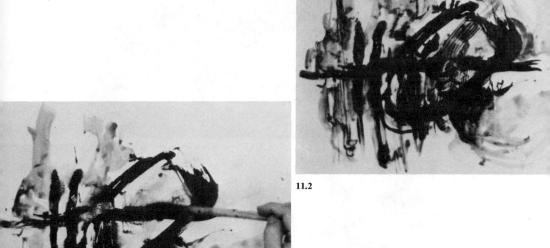

11.2

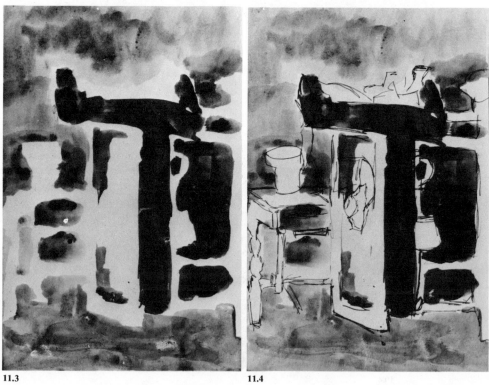

11.1

11.3

11.4

Figure 11 Illustrations of strategy factor S-3, big central attack.

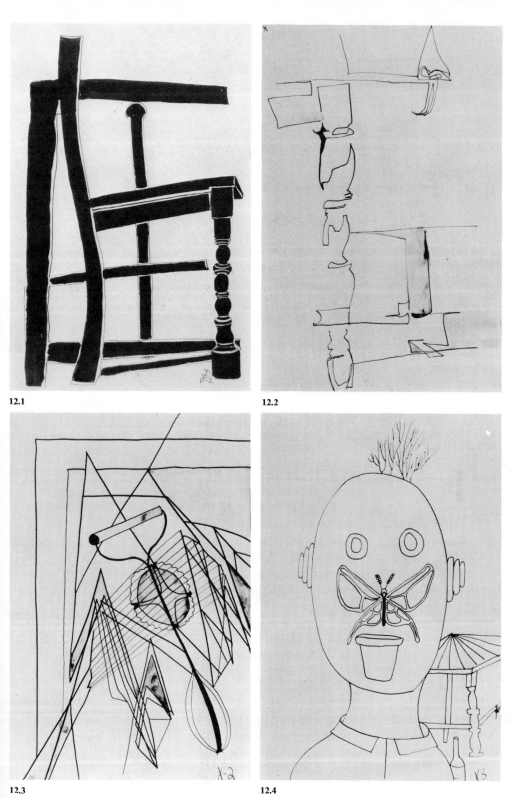

12.1

12.2

12.3

12.4

Figure 12 Illustrations of strategy factor D-1, controlled detail.

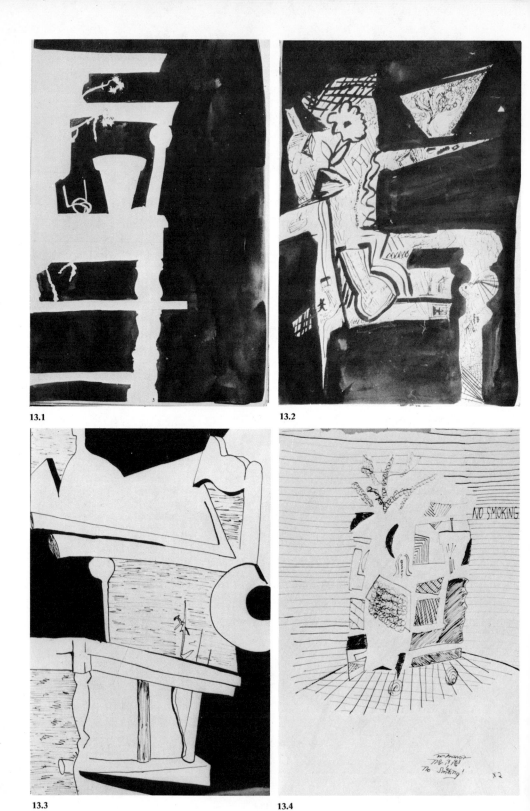

13.1

13.2

13.3

13.4

Figure 13 Illustrations of strategy factor D-2, elaboration and pattern.

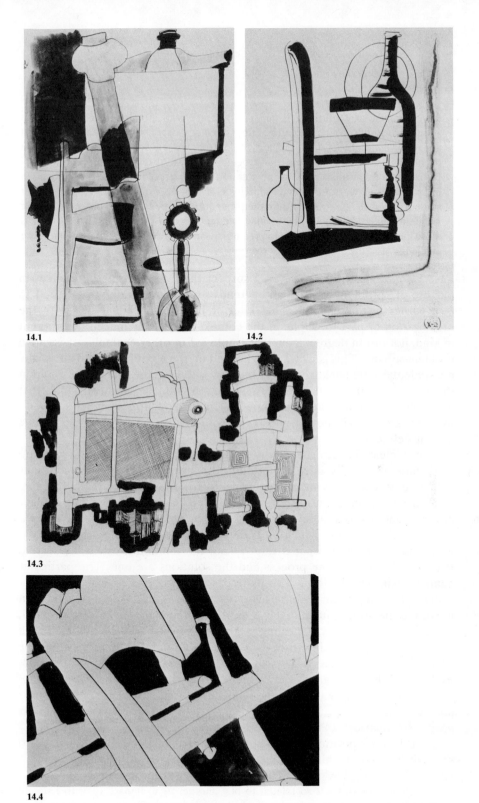

14.1

14.2

14.3

14.4

Figure 14 Illustrations of strategy factor D-3, seqmented form and space.

And again:

> In a dynamic strategy there is an open and a closed circuit to the system. The procedure and the objective can be either open or closed, but not both, as one must always be held constant as a means of control. With a Spontaneous student, the problem is held constant and the procedure is varied until an appropriate procedure emerges which leads to the solution of the problem. Thus the innovation in Spontaneous work is procedural. This is a process orientation. The Divergent student varies the goal rather than the procedure. He controls the process in order to intellectually search for ideas which will lead to new discoveries. The former is more like a trouble-shooter, the latter, the inventor. For the one the problem is the challenge, for the other, the discovery.[80]

Even at this time, however, I suspect there were prime differences in our use of "problem-solving" and "creative problem-solving" that I tried to face earlier in this chapter. That kind of intelligence concerned with the organization of part to whole, in the context of art, may indeed be different in kind, not just in degree, from that employed in other examples of creative problem-solving. This is why I have hedged on the identification. This is why my students come back from their brushes with learning theory, information theory, cybernetics, and computer simulation with the intuitive hunch that while these exciting systems of knowledge and thought have much to say to us about art, art will not fit into them *as they now exist.* And note that we cannot define art.

It is clear, in retrospect, why Berlyne lumped the esthetic in with autistic thinking and diversive exploration. It is even clearer why Langer picks up art activity as the symbolic equivalent of the emergence of the organic form in nature and as an analogy for mind. The heuristic element implicit in the Spontaneous strategy may be similar to creative problem-solving, except that the situation which embodies the solution, that is, the heuristic itself one might say, is what is valued—not the solution it ostensibly served. It might be said that the process and the solutions are one. The particular heuristic path chosen, now with its traces in the object, is what is qualitatively interesting. Is this another case of tacit knowing? Where the end is in mind, the means are qualitatively appealing. Where the means are in mind, the end is qualitatively appealing. I know I speak partly in riddles, for in both instances we have interface with an end configuration, but the situations which they envelop are differently acted. And we attend "from" the controlled "to" the free part of the "circuit," to a whole in either case held together only by activity. If these thoughts have merit, any degree of openness in either strategy must lead to the innovative and interesting (within its proper boundaries).

In this, my position is radical and like that of Peirce, who claimed to know little of art. To him an object is esthetically good if it has:

> . . . a multitude of parts so related to one another as to impart a positive simple immediate quality to their totality; and whatever does this is, in so far, esthetically

good, no matter what the particular quality of the total may be. If that quality be such as to nauseate us, to scare us, or otherwise disturb us to the point of throwing us out of the mood of esthetic enjoyment, out of the mood of simply contemplating the embodiment of the quality . . . then the object remains none the less esthetically good, although people in our condition are incapacitated from a calm esthetic contemplation of it.

> . . . there is no such thing as positive esthetic badness; and since by goodness we chiefly . . . mean merely the absence of badness, or faultlessness, there will be no such thing as esthetic goodness. All there will be will be various esthetic qualities; that is, simple qualities of totalities not capable of full embodiment in the parts, which qualities may be more decided and strong in one case than another. But the very reduction of the intensity may be an esthetic quality; nay, it *will* be so; and I am seriously inclined to doubt there being any distinction of pure esthetic betterness and worseness. My notion would be that there are innumerable varieties of esthetic quality, but no purely esthetic grade of excellence.[81]

We will have reason to refer to this radical position from time to time. Here, it effectively removes our view from essences or even any single aesthetic system, and fixes it on the context wherein we can sense such diverse pervasive qualities. (Although it is not ruled out by this quotation that a drawing mode where both procedure and goal are controlled can possess a pervasive quality, I will argue that in an "art knowledge" context or in the context of a series of drawings by one person, judgments about how much "interestingness" is required for sensing esthetic qualities are constantly being made.)

SIMULATIONS OF PROBLEM-SOLVING

To back the claim that the two art strategies are really thinking strategies existing in comparable form elsewhere, let us turn to the computer simulations of problem-solving of Newell, Shaw, and Simon. Using the term *heuristic* ". . . to denote any principle or device that contributes to the reduction in the average search to solution," they go on to define two such heuristics—planning and functional (or means-end) analysis.[82] As with the art strategies, the one heuristic is defined as working backward, the other as working forward. (Interestingly enough, Duncker[83] refers to the former as "organic," the latter as "mechanical.") Perhaps the reason the planning heuristic, like the spontaneous strategy, has become associated with problem-solving is that most problems in the literature have one end in view with many starting points; and for this the planning heuristic is superior. For the spontaneous strategy, the end in view is not a verifiable solution, but usually a strong feeling-based image rich enough, yet simple enough too, to generate process alternatives. As Newell, et al., maintain, image here means an internal representation which ". . . may mirror all the relevant properties of the external representation without being a 'picture' of it in any simple or straightforward sense."[84] That this characteristic is applicable to the person using

the spontaneous strategy is visually apparent by examination of Figure 6, for the end image is implicit in the beginning stage of the drawing. That the image is not fixed, nevertheless, is shown by the repeated hindsight of students using this strategy (when observing time-lapse process photographs) that they went too far, that they should have stopped sooner. The "relevant properties" are qualities that apparently must be sufficiently wed to still-open processes for them to be communicated. My hunch is that they must be sufficiently arrested to make the "search" relivable, i.e., the process is the image.

Let us try to give more content to the basic heuristics defined by Newell, et al. *Means-end analysis* (equivalent to the divergent drawing strategy) classifies things "in terms of the functions they serve" and oscillates "among ends, functions required, and means that perform them." It has three basic methods:

1. Transforming one object into another (desired one) by detecting the difference and producing a new or modified object which can be transformed into the desired one.
2. Application of an operator to eliminate differences between objects to which they are applied and desired ones. Some operators make more changes than others, but all are likely to leave some features unchanged.
3. Some differences between given and desired states are more difficult to bring about than others. "Difficult" differences are eliminated even if this results in new differences of lesser difficulties, and so on, as long as progress occurs.

Interestingly enough, the diagrammatic structure of means-end analysis creates a series of horizontal transformational chain images.

The *planning method* (equivalent to the spontaneous strategy) is designed to:

construct a proposed solution in general terms before working out the details. It acts as an antidote to the limitation of means-ends analysis in seeing only one step ahead. It also provides an example of the use of an auxiliary problem in a different task environment to aid in the solution of a problem. This . . . method consists in (a) *abstracting,* (b) forming the corresponding problem in the abstract task environment, (c) when the abstract problem has been solved, using its solution to provide a plan for solving the original problem, (d) translating the plan back into the original task environment and executing it. The power of this method rests on two facts . . . because of the suppression of detail there is a simpler problem (having fewer steps) than the original one. Second, the subproblems that make up the plan are severally simpler (each having fewer steps) than the original problem. . . . Like the other heuristics, the planning heuristic offers no guarantees that it will always work. It may generate no plan, a simple plan, or several plans. More serious, a plan may turn out to be illusory—it may prove impossible to carry out.[85]

There is but one method associated with the planning heuristic and this is given above. It proceeds to abstract properties of the problem, searches for a plan, specifies a sequence of operators, if successful applies these to the

original problem to arrive at the desired object. The diagrammatic structure of this strategy produces a single, vertical, hierarchical image.

The same authors point out how the planning heuristic is equivalent to laying out a cross-country trip. The general path from major city to major city comes first; then these cities become subgoals and we "solve the sub-problem of reaching each from the previous one."[86]

In their use of "problem," Newell, et al., utilize the maze, a dendridic structure, as their abstract model. Again, the fit to art behavior is far from exact. In their examples, the choices not taken are internally specifiable, for the number of elements in the bounded context, though frighteningly large in most instances, is known. Further, the number of alternatives within what they call the "task environment" is further reduced by the definitions, rules, operations, and so forth, made available to the problem-solver. The point is that all of these are known or definable in various formulations.

In a drawing context, such delimitations seem impossible for the human, problem-controlling agent. (I do not rule them out for a future generation of computers.) Here the image itself is qualitatively significant, for the most part. Even in a bounded context where we can learn to see what a given person is after in his drawings, the good moves he has himself established are quite often abandoned as new qualities emerge from the process or from even some freak or accident. Thus getting "warmer" or "colder" have different connotations in drawing than in problem-solving. Even so, the kinship between these heuristics and our strategies is presented as evidence of their commonality as thought processes or search processes.

Berlyne's usage of "diversive exploration" takes on deeper meaning for art in this context. It has always seemed to me that the maze generated in a given drawing "could have been otherwise" and still terminate in interesting pervasive qualities. Plenty of arguments have already been given in this book for this characteristic of art, so I will not belabor them. Experimentally, it would be of interest, using computer storage or immediate mechanical reproduction possibilities (such as xerography) to allow a subject to take a beginning drawing maze into other branches by giving him the chance to generate several "ends." This seems less appealing, however, than the uncertainty of rebeginning, of using theme-and-variations behavior, and so forth; for the quality of this drawing, of this pot now being made is all important in providing the sensory feedback that the problem-controlling agent both directs and follows.

But Newell, et al., effectively stimulate one's thinking about the art process and call to account the vagueness in which we habitually clothe it. I agree with their general conclusions on "learning by hindsight," a method by which past successes or principles learned in action are brought to bear in new contexts. As experience proceeds, the subject has more at his disposal (as we have already suggested), but this makes his selection process also more difficult. He therefore must constantly change set and strive to learn. The authors usefully describe change in set as "a modification of the heuristics that are actively guiding search, by replacing them with other heuristics in

the problem-solver's repertoire; learning is change in the repertoire of heuristics itself."[87] Since I am here using strategy in a more inclusive sense than heuristic, it would seem possible to refer to change in set and change in heuristics within a single strategy. This book maintains that a powerful facilitation of learning is effected by maximizing the hindsight potential of process feedback and by urging the artist to try to communicate to another (so that he himself may grasp it) just what he did or was trying to do, how it felt in process, what qualities *were* achieved (as well as intended), and like probings, set in a value-neutral field. These maximize the artist's problem-controlling power. As one girl put it at the end of a ten-week period in the drawing-feedback laboratory, "I feel I know more and am more sure of what I am doing even though my method requires me not to know ahead of time. Before I was truly at the mercy of my methods, and the drawings were mostly alike."

It is highly likely that the heuristics, principles, and so forth, utilized by an artist are both general and highly idiosyncratic. Both, however, are assumed to be accessible, by feel and hindsight, if not for direct specification, at least for utilization in increasingly dynamic ways. And the process of being understood—even vaguely or nonverbally—about these, appears to be greatly liberating and facilitating to those we have worked with. Description of these findings must await case histories, for the tangible suggestion of what occurs. These will appear later.

For now, suffice it to say that there is no clear answer on how much drawing strategies and processes can really match the creative problem-solving literature. Instead, let us take a different point of departure and talk about the utility of the strategy concept from the point of view of observations and findings it has permitted us to make. If we cannot take the strategy signs as they now exist and illustrate the drawing process efficiently, we can nevertheless observe, through controlled situations, changes reflected in strategy signs attributable to definite conditions and treatments. This will be the task of the next chapter.

NOTES

1. Rene Huyghe, *Ideas and Images in World Art* (New York: Harry N. Abrams, Inc., 1959), pp. 394–96.

2. Johannes Itten, *Design and Form: The Basic Course at the Bauhaus* (New York: Van Nostrand Reinhold Company, 1963).

3. Klara G. Roman, *Handwriting* (New York: Pantheon Books, Inc., 1952).

4. Herbert Read, *Education through Art* (New York: Pantheon Books, Inc., 1952).

5. C. G. Jung, *Psychological Types, or the Psychology of Individuation.* Translation, H. G. Baynes (New York and London: 1923).

6. Henry Schaefer-Simmern, *The Unfolding of Artistic Activity,* 3d ed. (Berkeley: University of California Press, 1961).

7. June King McFee, *Preparation for Art* (San Francisco: Wadsworth Publishing Co., Inc., 1961).

8. H. A. Witkin, et al., *Personality through Perception* (New York: Harper & Row, Publishers, 1954).

9. Viktor Lowenfeld, *The Nature of Creative Activity* (New York: Harcourt Brace Jovanovich, Inc., 1939).

10. Anneke Prins Simons, *"Viktor Lowenfeld: Biography of Ideas"* (Ph.D. diss., The Pennsylvania State University, 1968).

11. Manuel Barkan, *Viktor Lowenfeld: His Impact on Art Education,* Research Monograph no. 2. (Washington, D.C.: The National Art Education Association, 1965).

12. Huyghe, op. cit., n. 1 chap. 4. The reference is cited in Huyghe, but is from F. Minkowska, "De Van Gogh et de Seurat aux Dessins d'Enfants." (Paris, 1949).

13. Witkin, op. cit., n. 8 chap. 4.

14. Jerome Kogan, "Impulsive and Reflective Children: The Significance of Conceptual Tempo," in *Learning and the Educational Process,* ed. John D. Krumboltz (Skokie, Ill.: Rand McNally & Company, 1965), pp. 133–61.

15. Dale B. Harris, *Children's Drawings as Measures of Intellectual Maturity* (New York: Harcourt Brace Jovanovich, Inc., 1963).

16. Gordon W. Allport and Philip E. Vernon, *Studies in Expressive Movement* (New York: Crowell Collier and Macmillan Inc., 1933).

17. See Robert C. Burkhart, *Spontaneous and Deliberate Ways of Learning* (Scranton, Pa.: International Textbook Company, 1962; and Kenneth R. Beittel and Robert C. Burkhart, "Strategies of Spontaneous, Divergent and Academic Art Students," *Studies in Art Education* 5, no. 1 (Fall 1963): 20–41.

18. For an overview of this literature, see Kenneth R. Beittel, "On the Relationship between Art and General Creativity: A Biased History and Projection of a Partial Conquest," *The School Review* 72, no. 3 (Autumn 1964): 272–88. See also Malcolm R. Westcott, *Toward a Contemporary Psychology of Intuition* (New York: Holt, Rinehart and Winston, Inc., 1968), pp. 189, 199–200.

19. E. H. Gombrich, "Meditations on a Hobby Horse, or the Roots of Artistic Form," in *Aspects of Form,* ed. L. L. Whyte (Bloomington: Indiana University Press, 1961), pp. 209–28.

20. Meyer Schapiro, "Style," in *Anthropology Today,* ed. Sol Tax (Chicago: University of Chicago Press, 1962), pp. 278–303.

21. James S. Ackerman, "Art and Evolution," in *The Nature of Art and Motion,* ed. Gyorgy Kepes (New York: George Braziller, Inc., 1965), pp. 32–40.

22. Heinrich Wolfflin, *Principles of Art History* (original ed., 1915; reprint ed., New York: Dover Publications, Inc., 1950).

23. Lincoln Rothschild, *Style in Art* (New York: A. S. Barnes & Co., Thomas Yoseloff Pub., 1960).

24. Ibid., p. 53.

25. E. H. Gombrich, *Art and Illusion* (New York: Pantheon Books, Inc., 1960), pp. 360, 358.

26. George A. Miller, Eugene Galanter, and Karl H. Pribram, *Plans and the Structure of Behavior* (New York: Holt, Rinehart and Winston, Inc., 1960).

27. A. Newell, J. K. Shaw, and H. A. Simon, "Report on a General Problem-Solving Program," in *Proceedings of the International Conference on Information Processing,* Paris, 1959, pp. 256–64. See also, by the same authors, "The Process of Creative Thinking," chap. 3 in Howard E. Gruber et al., eds., *Contemporary Approaches to Creative Thinking* (Chicago: Aldine-Atherton, Inc., 1962), pp. 63–119.

28. R. C. Anderson, and D. P. Ausubel, eds., *Readings in the Psychology of Cognition* (New York: Holt, Rinehart and Winston, Inc., 1965), p. 11.

29. L. S. Vygotsky, *Thought and Language,* ed. and trans. Eugenia Hanfmann and Gertrude Vakar (Cambridge: The M.I.T. Press, 1962).

30. Ibid., pp. 17–19.

31. George Boas, *The Cult of Childhood* (London: The Warburg Institute, 1966).

32. W. Grözinger, *Scribbling, Drawing, Painting* (London: Faber and Faber, Ltd., 1955).

33. David E. Berlyne, *Structure and Direction in Thinking* (New York: John Wiley & Sons, Inc., 1965).

34. Susanne K. Langer, *Mind: An Essay on Human Feeling,* vol. 1 (Baltimore: The Johns Hopkins Press, 1967).

35. David W. Ecker, "The Artistic Process of Qualitative Problem-Solving," *Journal of Aesthetics and Art Criticism* 21, no. 3 (Spring 1963): 283–90.

36. Karl U. Smith and Margaret F. Smith, *Cybernetic Principles of Learning and Educational Design* (New York: Holt, Rinehart and Winston, Inc., 1966), p. 443.

37. Berlyne, op. cit., n. 33 chap. 4, p. 244.

38. Robert M. Gagné, *The Conditions of Learning* (New York: Holt, Rinehart and Winston, Inc., 1965), pp. 58–59.

39. J. W. Getzels, "Creative Thinking, Problem-Solving, and Instruction," chap. 10 in *Theories of Learning and Instruction,* ed. E. Hilgard, 63rd Yearbook, N.S.S.E. (Chicago: University of Chicago Press, 1964), pp. 240–67.

40. Harry A. Simon, "Understanding Creativity," *Carnegie Review* 2, (1964–1965).

41. Langer, op. cit., n. 34 chap. 4.

42. Anton Ehrenzweig, "Conscious Planning and Unconscious Scanning," in *Education of Vision,* ed. Gyorgy Kepes (New York: George Braziller, Inc., 1965), pp. 27–49.

43. Jerome S. Bruner, "What Social Scientists Say About Having an Idea," *Printers Ink Magazine* 260 (1957): 48–52.

44. Monroe C. Beardsley, "On the Creation of Art," *Journal of Aesthetics and Art Criticism* 23, no. 3 (Spring 1965): 291–304.

45. James J. Gibson, *The Perception of the Visual World* (Boston: Houghton Mifflin Company, 1950).

46. Konrad Fiedler, *On Judging Works of Visual Art,* 2d ed. (Berkeley: University of California Press, 1957).

47. Anton Ehrenzweig, op. cit., n. 42 chap. 4.

48. William James, *The Principles of Psychology* (New York: Holt, Rinehart and Winston, Inc., 1890).

49. Michael Polanyi, *The Tacit Dimension* (original ed., 1966; reprint ed., New York: Doubleday & Company, Inc., Anchor Books, 1967), p. 34.

50. P. McKellar, *Imagination and Thinking: A Psychological Analysis* (New York: Basic Books, Inc., 1957).

51. Berlyne, op. cit., n. 33 chap. 4, pp. 310–11.

52. B. F. Green, *Digital Computers in Research* (New York: McGraw-Hill Book Company, 1963).

53. Langer, op. cit., n. 34 chap. 4.

54. Smith and Smith, op. cit., n. 36 chap. 4, p. 353.

55. Ibid., p. 353.

56. Ibid., pp. 441–42.

57. Ibid., p. 443.

58. Harris, op. cit., n. 15 chap. 4.

59. Gombrich, op. cit., n. 19 chap. 4, p. 224.

60. Wellington J. Madenfort, *"A Phenomenology of the Esthetic and Art Education"* (Ph.D. diss., The Pennsylvania State University, 1965), p. 133.

61. Jean Piaget, "Art Education and Child Psychology," in *Education and Art,* ed. Edwin Ziegfeld (UNESCO, 1953), p. 22.

62. Jean Piaget and Barbel Inhelder, *The Growth of Logical Thinking* (New York: Basic Books, Inc., 1958).

63. Berlyne, op. cit., n. 33 chap. 4., pp. 123, 117.

64. Beardsley, op. cit., n. 44 chap. 4, p. 299.

65. Ibid., p. 297.

66. Paul Valery, *Collected Works,* Jackson Matthews, ed. (New York: Pantheon Books, 1956). V. 7, *The Art of Poetry,* trans. by D. Folliot.

67. Curtis Bradford, "Yeats' Byzantium Poems: A Study of their Development," *PMLA* 75 (March 1960): 110–25.

68. Vygotsky, op. cit., n. 29 chap. 4, p. 17.

69. Beittel and Burkhart, op. cit., n. 17 chap. 4. See also Beittel, op. cit. (1964), n. 2 chap. 1.

70. Robert C. Burkhart, "An Analysis of Individuality of Art Expression at the Senior High School Level," in National Art Education Association, *9th Yearbook* (1959), pp. 90–97; Robert C. Burkhart, op. cit., n. 17 chap. 4.

71. Gloria D. Bernheim, "The Dimensionality of Differential Criteria in the Visual Art Product," *Studies in Art Education* 5, no. 1 (Fall 1964): 31–48.

72. Beittel, op. cit., (1964), n. 2 chap. 1, p. 7.

73. Ibid., pp. 25, 30.

74. Beittel, op. cit. (1966), n. 2 chap. 1; and Kenneth R. Beittel, "Manipulation of Learning Set and Feedback in the Teaching of Drawing," *Studies in Art Education* 10, no. 1 (Fall 1968): 17–32.

75. Langer, op. cit., n. 34 chap. 4, p. 124.

76. Burkhart, op. cit., n. 17 chap. 4. See also Beittel and Burkhart, op. cit., n. 17 chap. 4; Beittel, op. cit., n. 18 chap. 4; Beittel, op. cit. (1964), n. 2 chap. 1; J. W. Getzels and M. Csikszentmihalyi, "Creative Thinking in Art Students: The Process of Discovery," U.S. Office of Education Cooperative Research Project No. S-080 (University of Chicago, 1965).

77. Beittel, op. cit. (1966), n. 2 chap. 1 and op. cit. (1968), n. 74 chap. 4. See also J. W. Getzels and M. Csikszentmihalyi, "The Value Orientations of Art Students as Determinants of Artistic Specialization and Creative Performance," *Studies in Art Education* 10, no. 1 (Fall 1968): 5–16.

78. Beittel, op. cit. (1964), n. 2 chap. 1. See also Stephen P. Klein, Rodney W. Skager, and Charles B. Schultz, "Points of View about Preference as Tools in the Analysis of Creative Products," *Perceptual and Motor Skills* 22, (1966): 83–94.

79. Beittel, op. cit. (1966), n. 2 chap. 1 and op. cit. (1968), n. 74 chap. 4. See also Stephen P. Klein, Rodney W. Skager, and Walter Erlebacher, "Measuring Artistic Creativity and Flexibility," *Journal of Educational Measurement* 3, no. 4 (Winter 1966): 277–86; and Stephen P. Klein, "A Description of Points of View in Esthetic Judgments in Terms of Similarity Dimensions," *Studies in Art Education* 10, no. 1 (Fall 1968): 33–42.

80. Beittel and Burkhart, op. cit., n. 17 chap. 4, p. 20.

81. Charles S. Peirce, *Collected Papers,* vol. 5, ed. Paul Weiss and Charles Hartshorne (Cambridge: Harvard University Press, 1935, 1963), pp. 84–85.

82. Newell, Shaw, and Simon, op. cit. (1962), n. 27 chap. 4, p. 78.

83. K. Duncker, "On Problem-Solving," *Psychology Monograph,* Vol. 58, No. 5; Whole No. 270. Washington, D.C.: The American Psychological Association, Inc., 1945.

84. Newell, Shaw, and Simon, op. cit. (1962), n. 27 chap. 4, p. 99.

85. Newell, Shaw, and Simon, op. cit. (1959), n. 27 chap. 4.

86. Newell, Shaw, and Simon, op. cit. (1962), n. 27 chap. 4, p. 91.

87. Ibid., p. 105.

5

Conditions Affecting Drawing Strategies

Thus far the point of view has been emerging that the person drawing is a problem-controlling agent, operating by means of abstract symbolic transformation of process feedback. Further, to be self-rewarding, his activity is akin to blind-search in that, by allowing diversive exploration and autistic thinking to enter, idiosyncratic meaning (the self, as becoming) is achieved— the interesting, the innovative, and the aesthetic (seen as a pervasive quality). The whole is engineered by an intelligence attentive to part-whole organization that is largely situational or contextual. "This" organization, "this" context now in shaping discloses (and encloses) its peculiar emerging.

The conditions facilitating such a process cannot, in my opinion, be limited to those which have an impact upon the drawing strategies discussed in the last chapter. Nevertheless, since these strategies are assumed to be at work when a drawing is made, conditions affecting the strategies may further enlighten us about the mind-context-drawing phenomenon that is our chief concern.

Findings from research are not as easily extrapolated from their own context as we would like to believe. Certainly this is likely to be so especially where there is no underlying theory or paradigm common to an array of studies. There is some advantage to the continual buildup of one study upon another that helps to offset the aforementioned intractability. It is for this reason that I will draw primarily upon experiments which I and my associates have completed, for in addition to the findings there is a kind of tacit knowledge which prompts the organization and interpretation of what is found. It is perhaps unnecessary to point out the danger of overdetermination that may thus creep in. I can only urge others to both replicate and extend these beginnings. This is already happening, as later references will show.

EVALUATING DRAWING STRATEGIES

First, however, there are some problems to take up concerning our scrutiny of strategies. In the first experiments we performed,[1] two of our findings relating to judgment procedures remain unresolved. In the first of these, it was found that detailed differential criteria, developed by Bernheim[2] and located in three domains termed (1) spontaneous, (2) divergent, and (3) formal, were not as sensitive as dependent variables in experimentation as were global or gestalt judgments of products. (Only one out of 16 main effects, on the average, occurred on the detailed differential criteria and on the three summed domain totals. One out of two main effects were significant, however, on the global judgments.) This finding suggests that when we eventually succeed in analytically separating out criteria, seen as parts of art objects, we lack the knowledge of how to synthesize them. To me, this is a suggestion that elements have slight invariant meaning from one configuration to the next. Their real meaning, that is, is locked in the configuration into which they are articulated. Their value may reside in the vocabulary, the labels, they give us for that in-context look. In such usage, they give rise, of course, to higher order abstractions (organizational principles) that do generalize to a degree across art objects although we must willingly admit that many contextual properties are still left out at these levels of abstraction. We are still left with the suspicion that aesthetic qualities, being contextual, can best be grasped as structural systems through a unified, not an analytical, act of perception. Put in simpler terms, it is likely that the discrete or differential or analytical criteria we can isolate are seldom in any sense pervasive qualities in themselves and therefore do not emerge as values for attainment in the drawing process. It would be, for example, a rare case where "ragged borders of shapes" (a criterion of the spontaneous domain of Bernheim's differential criteria) is the quality pervading an art object.

Before leaving the differential criteria, however, it is well to indicate how they were isolated. Nitschke's "Multiple Purpose Drawing Experiment"[3] provided the drawings which permitted their development. In this procedure, a neutral stimulus, in the form of a black and white still-life drawing (bottle,

jug, flower pot, cup, cloth and table top) is given the subject on a printed page; and he is asked to draw four thumbnail sketches, in sequential order, from the stimulus. Examples of these drawings readily suggest attributes of the drawing strategies (see Figures 15 and 16). In this procedure, we have a bounded context and a series of drawings—conditions necessary for conceptualizing strategy and change.

It is time to introduce the second finding relating to judging procedures mentioned above. Simply stated, the problem is that of the difference between intrasubject and intersubject perspectives of judgment. The objectivity and consensual validation honored in science inclines one toward analytical criteria, applied by independent but qualified judges, who work with one criterion at a time, over the whole range of objects from an experiment. The order of the criteria and the order of the objects are randomized for each judge. Appropriate and useful as this procedure is, it has missed, thus far, the range of insights provided by a look at the work of one subject at a time. In our earlier experiments,[4] the internal or intrasubject perspective, like the global judgments earlier alluded to, were more sensitive as dependent variables—that is, they were more helpful in ascertaining conditions affecting strategies and quality of drawings.

I intend to go on using, nevertheless, both kinds of judging perspectives since the issues are far from resolved. It is also possible that fruitful syntheses of the differing perspectives can still occur. An example might be that of having independent judges apply one criterion or sign at a time to the complete work (bounded series) of a subject. Thus some accommodation between the two perspectives might lead to generalizations of greater power than presently. Even so, as later discussion will affirm, such a synthetic process will remain procrustean within the foreseeable future, for idiosyncratic meaning, intentionality, and the very qualities a subject acquires sufficiently to direct his future actions will elude the judge using such methods as described. Much will remain below his threshhold and beyond his criteria. Later examples will show that this is true for even the most sensitive intrasubject perspective when all one has to go on is the series of products and time-lapse process records, but lacks communications established with the subject and bolstered by more than one participant-observer. In a later chapter, I will attempt to speculate on the basis for a method of inquiry which will both facilitate the drawing process and increase insight into the thinking processes and the situations producing drawings.

FIRST EXPERIMENTS

Our first experiments[5] were dubbed as using "self-reflective training" and looked at outcomes not only within the art and the art strategies, but also at what was called "the capacity for creative action." By "self-reflective" we meant simply that we assayed to provide the subject variations of "good" means (from prior research) for evaluating and directing his own drawings. These means related to "depth" as opposed to "breadth,"[6] that is, con-

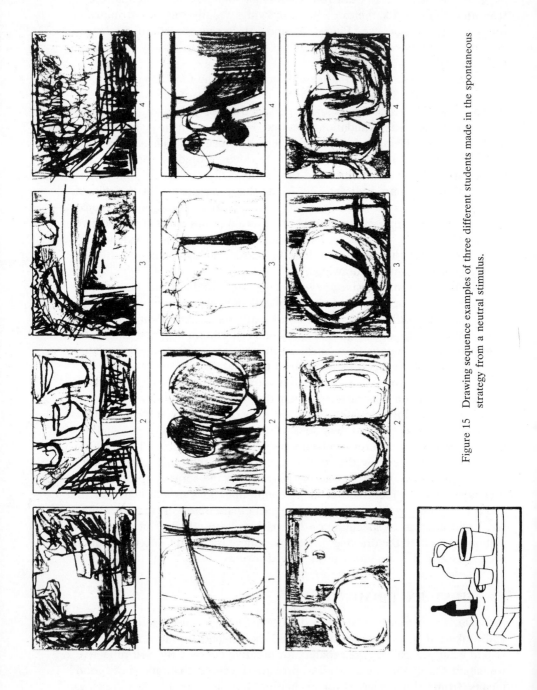

Figure 15 Drawing sequence examples of three different students made in the spontaneous strategy from a neutral stimulus.

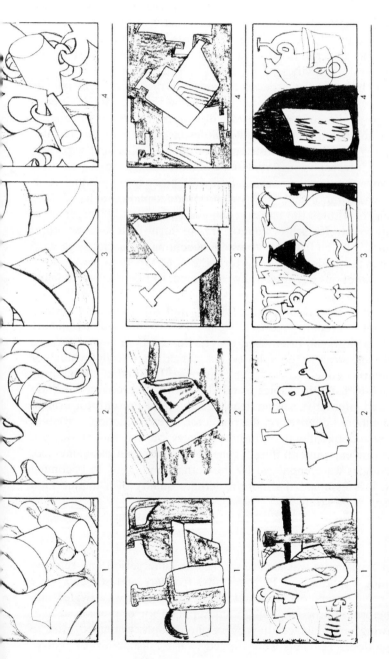

Figure 16 Drawing sequence examples of three different students made in the divergent strategy from a neutral stimulus.

tinuity in medium and stimulus (or theme) from one drawing to the next (the stimulus was the still-life of Figure 5). They also established regular and standard methods of evaluation,[7] as mediated in an interactive and supportive or an independent setting.[8] The "capacity for creative action" was operationally represented by a battery of "predictor" tests, eight in number, which correlated with the art criteria used in the study and also related to the literature on general creativity.

This is not the place for a detailed report on the experiment and its findings. The general findings, however, need to be reported for they have guided my ongoing inquiry. "Expected" directions on the independent variables (for which the literature cited in notes 6, 7, and 8 of this chapter give some support) were largely confirmed. The chief independent variables, in brief, were (1) internal vs. external self-evaluative locus (in the form of subjective or "given" criteria for evaluation); (2) process vs. product form of feedback (in the form of time-lapse or end product photographs of prior drawings, which constituted the basis for self-evaluation); and (3) interactive vs. independent setting for self-evaluation (in the form of a teacher representative who acted much like an interested, accepting counselor vs. a written form on which the student was to perform the same functions for himself). The "expected" directions were generally confirmed, so that the best possible mix of conditions in the experiment was (1) internal locus of evaluation (self-discovered criteria), (2) process feedback, and (3) interactive setting. Of these outcomes, process feedback alone directly affected art quality improvement; but both self-discovered criteria for evaluation and process feedback increased strategy complexity (as judged by intraindividual or internal judgment), defined as noticeable increase in number or intensity of strategy signs (as listed in Tables I and II). Both self-discovered criteria for evaluation and interactive setting (teacher moderator present) for evaluation effected significant changes on the predictor "creative action" variables (and thus suggested likelihood of future changes on art and strategies).

From this first experiment, thus, a general direction and base emerged. Here, *both* strategies were enhanced by the better conditions. In becoming more complex, it is assumed the more a definite quality of a unique kind can be expressed via a strategy.

SECOND EXPERIMENT

A second experiment was carried out at this same period and referred to as a "teaching experiment." In this study, teachers and students were classified according to their art strategies. Process feedback was divided into immediate (Polaroid in-process photographs supplied for evaluation at midpoint of a drawing) and delayed (in-process photographs evaluated prior to each drawing period). Teachers were trained to use "sustaining" or "entry" questions, and students worked in an "interactive" (teacher present during evaluation) or "independent" setting (no teacher during evaluation). Although a lesser experiment than the first reported on, this study attempted to extend findings from the first one.

The results of the teaching experiment suggested that delayed process feedback was generally superior to immediate process feedback, as defined. This was the clearest finding, and it has reinforced my decision to intrude minimally on the drawing process while it is going on. Sustaining questions were also generally superior to entry questions, and the interactive setting (teacher present) likewise aided both strategies. Here, again, is the suggestion favoring an interested, open communication between the teacher or teacher surrogate and the person drawing.

Even though some treatments were generally superior in the teaching experiment, subsidiary findings revealed a tendency for "opposed" and dissimilar elements to facilitate drawing strategies. Divergent teachers, for example, were associated with student gains in spontaneity, and the reverse was true with spontaneous teachers. Entry questions (new topics) were associated with gains in spontaneity, sustaining questions with gains in divergency. In this study, at least, unlike mixes of treatment and classification factors facilitated slight gains in drawing strategies.

In general, I feel the teaching experiment to be less conclusive than the first experiment reported. The teaching experiment is more important for the kinds of questions it raised and provided first answers to. It also led to other studies, as in Jones's analysis of teacher-student evaluation dialogues.[9]

The issue of the placement and form of feedback for evaluation is not closed. Bradley[10] has conducted several experiments pertinent to this question. Although he does not look directly at drawing strategies or judge process samples or products, he has helpfully focused on the important role of verbalization within the art process. His findings suggest there may be merit in having verbalization take place during the formative stages of a drawing (this is especially true for what he calls "Plan-Oriented" students, not to be confused, in my opinion, with those who use "planning heuristics"). I am inclined to feel, with Hyman,[11] that such approaches will be most effective where we carefully study induced changes to a beginning "cognitive map," or step, in a solution chain to a problem. It is apparently early in and during the process that the "map" can be externally influenced the most.

CONDITIONS AFFECTING ART STRATEGIES

Let us return to the focus of this chapter: conditions affecting art strategies. As already suggested, the identification of art strategy over a series of drawings, as in the first experiment[12] reported on, is to a degree dependent on how strategy is judged from the in-process material. Stability of one's strategy is therefore a complex concept, for in addition to the method of judgment there are the influences acting upon the subject within an experiment even when the treatments do not intend to create a change in one's kind of strategy. Here, where such an induced change was not at work, consistency of strategy from beginning to end of the first experiment and within the teaching experiment was 74 percent and 90 percent respectively.

Subjects were able to judge their own strategies relatively well. For

one-half the subjects from the first experiment (48 of an N of 96), a self-judgment of strategy agreed 73 percent with the intraindividual or internal judgment made by judges. Using the multiple discriminant function technique and seven predictor tests, Burkhart predicted strategy (as classed by internal judgment) with 83 percent accuracy.[13] An undergraduate research assistant (Stewart) was able to achieve 87 percent accuracy with the same criterion by means of blind analysis of statements which students wrote on their evaluation forms. Stewart says:

> The Divergent student often wrote of his work as "changing from one viewpoint to another, but with the same subject matter," or, "seeing it as it builds," or "having fine detailed lines from the beginning." The Spontaneous student wrote of "using the whole space at once," "suggesting much with less, particularly less line," and "overlapping mass shapes." . . . Personal ways of working (if they were explained in the writings) also led to determination of strategy . . . [The] Spontaneous often wrote of "splashing ink on the page," or "working faster and wetter," or "loosening up, not concentrating on detail." The . . . Divergent papers included statements such as "I don't know where to stop adding detail," and "keep adding until one sees something one likes." Expressions such as, "Be bolder, have more confidence," "Break rules," "Discipline yields freedom," and "Be more careful," show a marked personality difference in the papers.[14]

A still closer look at statements appearing in individual protocols may be valuable. Here the contention is that the self-reflective conditions of the first experiment affected drawing strategies by generally moving them toward both clarity and greater complexity. Written verbal statements suggest this effect. A sampling is presented in Table V. It is instructive to sense the kind of large, schematic goals, qualities and directives an undergraduate art education student sets for himself. Here we can see that the student using a spontaneous strategy or "planning heuristic" is relatively vague and open, whereas the student using a divergent strategy or "means-end heuristic" is by no means overcome by minutiae before the process. Rather this written residue of inner speech is only in global terms oriented toward inner drawing, a fact lending support to the situational, in-process determinants of a drawing. The statements sampled are like problem-controlling criteria—before-the-act descriptions of desired states, what not to do, and what to get "more" of. They are also curiously like the learning by hindsight discussed in the

TABLE V STATEMENTS TAKEN FROM STUDENTS' SELF-EVALUATION FORMS
WHICH INDICATE CLARIFICATION OF STRATEGY AND SELF-DIRECTION

Divergent	Spontaneous
30.* Change order of parts	32. Use the whole space at once
Change viewpoint	Good shades within larger state-
New experience	ments
Definite lines from the beginning	Get more down sooner
22. New viewpoint	Big feeling, more successful
More definition	46. Slopped water on page

Use finer lines of separation

43. See it as it builds
Different view
Take what emerges as a composition
Use positive-negative

60. Experiment
Concentration helps freedom
Fill more space

34. Approach one form in different ways
Change all the structures
Realize freedoms

35. Contrast very important
Form controlled by line

33. Work looks busy
Vary lines more
Use positive and negative

47. Keep experimenting
Find new devices
Integrate
Off balance

14. Use negative, positive
Repetition of line
Picture expands to edges
Plan more
Vary lines

48. Can't decide what to do with it
Take a section and use it
Don't have big square thing in the middle
Change size relationships
Move focus point
Start smaller

57. Go on with one form
Stay controlled
Add lines for meaning
Organize forms more

53. Unusual viewpoint
Find one part with interesting areas
Use positive, negative
Too simple
Use detail, shading
Be more careful

Work larger
Freedom and experimentation

2. Suggest much with less, particularly less line
Use mass shapes, overlap
Free organizations, more abstract
Form more nebulous

11. Work larger, looser, bigger strokes
Remain flexible
Use less definite line

61. Do not limit to one part
Be bolder
Work on the whole

44. Simplicity
Clarity of thought
One idea
Vagueness in pictures
No unnecessary details

36. Start loose, study, do secret things
Work quickly, but not sloppily
Put new objects in each picture
Experiment freely
Work fast and direct

5. Fast, free
Break rules
New procedures
See whole thing at once
Work as if it's independent work

3. Freedom, spontaneity important
Splashy ink good
Make the center bring parts together
Strengthen unity of parts to whole
Use more large, dark areas

12. Freedom first, then composition
Work faster, wetter
Confidence
Think more at beginning
Keep the whole thing simpler
Loosen up, don't concentrate on detail
Conclude strong, work faster

*Number of students in experiment. See op. cit., n. 1 chap. 5.

last chapter. They appear to be labels capable of evoking and controlling smaller and less verbalizable drawing operations. They thus possibly constitute the kind of abstract symbol which transforms feedback subtly toward its ends.

I would like to digress momentarily to discuss the problem of labels for drawing strategies. *Spontaneous strategy* and *planning heuristic* may on the surface sound like logically opposed terms, and the case may be the same for *divergent strategy* and *means-end heuristic*. The computer simulation language stresses the program which controls the selection and application of transformational operations whereas the drawing strategy label emphasizes the visual impact of a chain of such operations. The linkages are thought to be thus:

Spontaneous Strategy: State A → ? Operation → Desired State B
 (the Planning Heuristic emphasizing
 Transformation-Selection)
Divergent Strategy: State A → Desired Operation → ? State B
 (the Means-End Heuristic emphasizing
 Transformation-Application)

The labels in themselves are meaningless without the strategy signs and visual qualities that go with them, and without an effort to invoke the feel of the thinking processes accompanying them in action.

A SECOND SET OF EXPERIMENTS

To continue, strategies of drawing are much more open to environmental and treatment induced effects than I earlier supposed. In a second set of experiments,[15] my assistants and I set out to correct some of the conditions of our earlier studies. To begin with, we moved to a more controllable drawing laboratory or neutral studio, in which a subject could work alone, except for the researchers, and in which time-lapse process photographs could be accumulated with a minimum of interference. An electronically operated *Robot* 35mm camera capable of taking up to 3,000 photographs without reloading and of operating at any set interval from .25 of a second to three hours was mounted behind a partition. On the other side of the partition was constructed a drawing table and a fixed place for drawing a horizontal or vertical picture on a 12″-by-18″ white pad. The camera picked up the image of the drawing through a small window opening and off of a front-surface mirror mounted at a 45° angle over the drawing (see Figures 17 and 18). The same still life used before (see Figure 5) was placed on a table with rollers so that it could be positioned easily and moved out of sight when not in use.

A carefully constructed experimental design attempted to secure comparable samples for treatment conditions by controls on participating subjects. The design required an equal number of undergraduate males and females, art majors and nonart majors, divided evenly before treatment

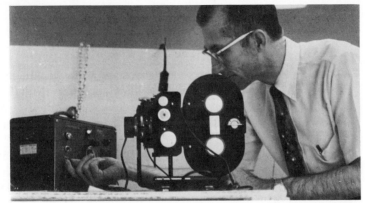

17.1

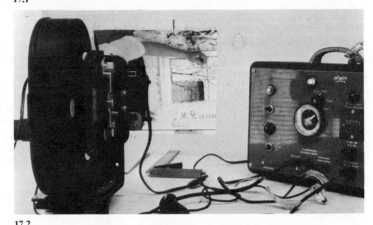

17.2

Figure 17 Electronically activated robot time-lapse camera and timer.

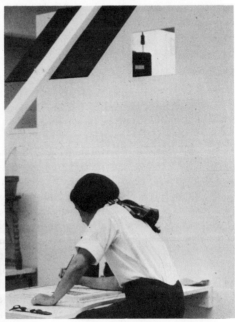

18.1 **18.2**

Figure 18 Drawing table with overhead front-surface mirror, student at work.

into those beginning in the spontaneous and those beginning in the divergent strategy. The time period for experimentation was extended over the 1964 study,[16] four to six or seven weeks. Subjects worked two times (hourly, once each for two weeks) in the studio before any treatment began so that they felt at ease in the setting.

Although this is not the place for detailed statistical analyses, it should help the reader to see the layout of the design of the two experiments which were conducted under these general arrangements. Table VI shows the

TABLE VI EXPERIMENT I (1966): DESIGN OF THE EXPERIMENT

Problem:	The effect of variation of stimulus set (drawing theme) and amount of process feedback on the art strategy and aesthetic quality of drawings of classified college undergraduate subjects in a sequential drawing setting.
Duration:	Seven consecutive weeks, one hour weekly (each subject averaging about 18 drawings over 7 weeks). Time line as follows:

$$\text{Week: } \frac{\text{A} \quad \text{B} \,^*\text{C} \quad ^*\text{ D } ^* \text{ E} \quad \text{F} \qquad \text{G}}{\text{Pre} \qquad \text{Treatment} \qquad \text{Transfer Switch strategy}}$$

and Post

* = feedback prior to drawing series

Design: The independent variables are as follows:

FACTOR	NAME	LEVEL I	LEVEL II
A	Sex	Male	Female
B	Art Training	Art Major	Nonart Major
C	Pre Strategy	Spontaneous	Divergent
D	Stimulus Set	Still-Life	Mental Theme
E	Feedback	Plus: 2 picture process strips	Minus: 1 picture process strip

Note: N = 32. Because this places only 1 S in each cell, all 4-factor interactions are incorporated into the error term (giving it thus 6 instead of 1 d.f.). The experiment is a $2 \times 2 \times 2 \times 2 \times 2$ balanced analysis of variance.

Dependent variables:

1. Spontaneity (9 criteria singly, and as a total score, 3 factor scores, as judged from process photographs)
2. Divergency (9 criteria singly, and as a total score, 3 factor scores, as judged from process photographs)
3. Aesthetic quality (judged from final products)

Procedure: Materials: pen, India ink, brushes (4 sizes), standard 12×18 white pad, choice of V or H format; water available for washes.

Records: Drawings are photographed by a *Robot* electronic 35mm camera which is out of sight and operates off an overhead front-surface mirror. During week A all S's were exposed to both stimulus set conditions and a fast and slow camera setting. Approximately 12,000 process photos were printed (minimum = 20 per drawing; week A not printed). Subjects chose the camera time setting from an available chart, basing their choice on a minimal time prediction.

design of Experiment I (as we will refer to it); Table VII shows the design of Experiment II; and Table VIII describes the instructional condition applied in Experiment II. For further detail, the reader is referred to the final report[17] and to a briefer summary in a professional journal.[18] Here we will concentrate on conditions affecting drawing strategies.

Among the first of these influences is that of the "implicit set" created by the drawing stimulus conditions manipulated in Experiment I. The stimulus conditions were simply the still life (Figure 5) or no external stimulus ("mind" condition). The impact of these simple conditions was observed by comparing the strategy position of the subject during the treatment period (weeks C, D, and E of Table VI) with the transfer period (week F), for on the latter the stimulus set built up over three weeks was reversed to the opposite condition. When the 18 strategy criteria of Table III were applied to the

TABLE VII EXPERIMENT II (1966): DESIGN OF THE EXPERIMENT

Problem: The effect of direct and indirect strategy instruction on the art strategy and aesthetic quality of drawings of classified college undergraduate subjects in a sequential drawing setting.

Duration: Six consecutive weeks, one hour weekly. Time line as follows:

Week: $\dfrac{\text{O} \qquad \text{A} \quad *\text{B} \quad * \quad \text{C} \quad * \quad \text{D} \quad \text{E}}{\text{Screening} \quad \text{Pre} \qquad \text{Treatment} \qquad \text{Post}}$

* = feedback and instruction occurs prior to drawing series

Design: The independent variables are as follows:

FACTOR	NAME	LEVEL I	LEVEL II
A	Sex	Male	Female
B	Art Training	Art Major	Nonart Major
C	Pre Strategy	Spontaneous	Divergent
D	Strategy Instruction	Spontaneous	Divergent
E	Teaching Method	Direct	Indirect

Note: N = 32. Because this places only 1 S in each cell, all 4-factor interactions are incorporated into the error term (giving it thus 6 instead of 1 d.f.). The experiment is a $2 \times 2 \times 2 \times 2 \times 2$ balanced analysis of variance.

Dependent variables:
1. Spontaneity (3 factor scores corresponding to instructional periods, and a total of these, as judged from process photographs)
2. Divergency (3 factor scores corresponding to instructional periods, and a total of these, as judged from process photographs)
3. Aesthetic quality (judged from final products)

Procedure: Materials: pen, India ink, brushes (4 sizes), standard 12×18 white pad, choice of V or H format; water available for washes.
Records: Drawings are photographed by a *Robot* electronic 35mm camera which is out of sight and operates off an overhead front surface mirror. Approximately 8,000 process photos were printed. A standard time setting was used (3 shots for the first minute, 2 shots for the second and third minutes, 1 shot per minute thereafter).

TABLE VIII EXPERIMENT II (1966): FACTOR D, STRATEGY INSTRUCTION[1]

1. Process Dialogue	2. Spatial Continuity	3. Big Central Attack	4. Controlled Detail	5. Elaboration and Pattern	6. Segmented Form and Space
(a) Diversity of line (1)*	(a) Medium variation (6)	(a) Early statement (3)	(a) Fine line control (2)	(a) Abrupt medium changes (5)	(a) Formal distortion (10)
(b) Suggestion (7)	(b) Recession (12)	(b) Organic development (18)	(b) Single element, off-center (4)	(b) Pattern (8)	(b) Plane (11)
(c) Action gestures (9)	(c) Broken lights (13)			(c) Solid black-white	(c) Size manipulated (16)
(d) Process emphasis (15)					(d) Theme and variation (17)

Instructional Schedule

Week	Spontaneous Strategy	Divergent Strategy
B	1 vs. 5	5 vs. 1
C	2 vs. 6	6 vs. 2
D	3 vs. 4	4 vs. 3

[1] The six clusters are the result of a factor analysis of the 18 strategy criteria judged in experiment I and shown in Table III.
*Numbers in parentheses refer to the original 18 criteria of Table III.

drawings, it was apparent that, in all instances but one (of 18), the still life caused a shift toward the divergent strategy, the mind stimulus toward the spontaneous. This sudden change was most pronounced for these spontaneous criteria (from Table III):

(1) Diversity of line; open or broken contours (process-related) (a "type of line" criterion)
(7) Suggestion (a "detail" criterion)
(9) Direct, flowing movement; action gestures (a "movement" criterion)

For the divergent criteria, these reflected the change most clearly (also from Table III):

(10) Concern for contour, formal distortion (a "movement" criterion)
(11) Plane: eye travels path of forms; frontal plane; position in space affirmed; floating; lateral tension; transparencies and overlapping of flat planes (a "space" criterion)
(16) Size relationships manipulated (a "theme" criterion)

Also associated with this drawing stimulus effect was the finding that those working from the mind condition had, on the average, a shorter working time per drawing, whereas those working from the still life took longer (suggesting they had more information to process or transform). A further and unexpected corroboration of the tacit connection existing in the minds of the subjects between drawing stimulus condition and the strategy employed occurred during the last week of Experiment I. At this time, subjects were given rating scales and photographic examples of the two strategies and asked to rate their own way of working. They were then instructed to try to "switch," or to simulate the opposite of their self-perceived strategy. For this purpose, a choice of drawing stimulus condition was permitted. Eleven of 16 subjects classified as working in the spontaneous strategy chose the still life switch, while twelve of 16 classified in the divergent strategy chose the mind condition. Thus, in 72 percent of the cases, subjects chose the stimulus condition unlike the one facilitating their base strategy when they were asked to switch. Figure 19 shows examples of their ability to change.

The clear way in which one's preferred working strategy is amenable to an intentional reversal was a finding not completely expected. Further, the better and more trained the student, the more he was able to switch. This finding was later verified in a comparable way by Klein,[19] working with students at the Rhode Island School of Design.

In our experiment, it was apparent that untrained subjects had difficulty in simulating the spontaneous strategy. Indeed, untrained subjects seem to fall most frequently into a means-end, step-by-step heuristic, but without the openness for change and formal development found in the mature, complex, divergent strategy. Despite our earlier reference, children also more commonly evidence a piece-by-piece "separation," emphasizing "immobility and precision," rather than "joining or connection" and its

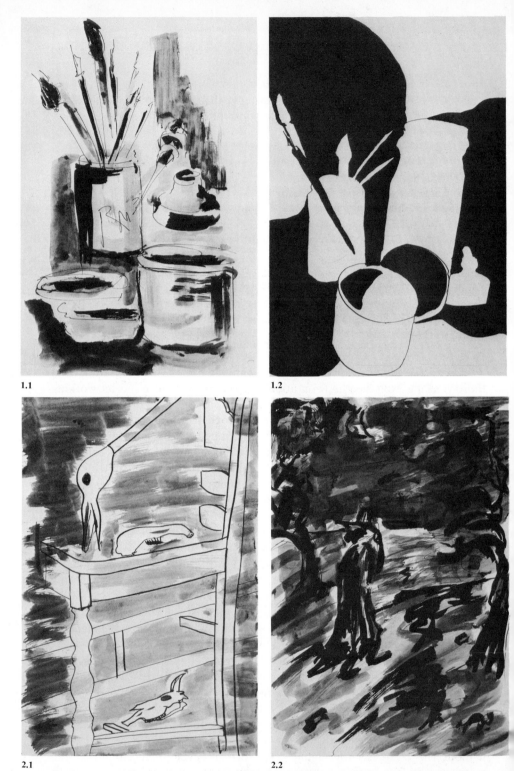

1.1

1.2

2.1

2.2

Figure 19 Drawings by a student classified as spontaneous and a student classified as divergent showing strategy change when asked to simulate the opposite of their perceived strategy.

concomitant "movement and impreciseness of form."[20] Perhaps this is partially the basis for Schaefer-Simmern's insistence that children's drawings and those of untrained adults are ". . . artistically realized by the . . . stage of visual conceiving of figure and ground combined with single relationships of directions."[21]

It is also the basis for the association of poorer quality work with the divergent strategy, above and beyond any possible bias of judgment. There is just more low-level means-end work in existence. This is not unlike the finding that the younger the child the less able he is to perceive movement in ambiguous stimuli, as in the Rorschach blots. In this sense very few rudimentary planning or spontaneous strategy examples are available in children's drawings. When they do occur, we may tend to identify the child, as Lowenfeld did,[22] as "potentially gifted" (a term which, indeed, he applies to all children) for the examples which he chose would rate higher on spontaneous strategy signs. The imbalance persists into adulthood and until "confidence," "creative attitudes," and "esthetic concepts" appear.

But even before I was prepared to admit to the plasticity of drawing strategies brought on by the experiment in switching, there was ample evidence of strategy mobility. In our earlier self-reflective training experiment,[23] there were some clear cases of strategy transitions within the four-week period of the study. Figure 20 provides an example of change. Such a transition, it should be emphasized, came out of a context where there was no instruction toward such changes.

Perhaps one of the reasons why the divergent strategy was hard to perceive in its full potential was that our earlier studies were cross-sectional and thrown off by the imbalance in which much low-level divergent strategy work was present. Under more optimal conditions, the upper reach of the divergent strategy could emerge and be identified.

One of the rarer signs of the divergent strategy in our earlier study was theme and variations within a picture. The simple ground for perceiving this sign was established by: same medium, same stimulus (complex still life), and time (repeated occasions). The reason for this is deducible. It takes familiarity with the theme, built up by repeated experience, to lead to its confident, even playful, compositional variation. That the still life stimulus (Figure 5) permitted this can be seen by observation of some examples, given in Figures 21 and 22. In the first of these figures, process examples are given to show the ingenious thematic variation as it builds in space. The second gives further end examples. In theme-and-variation thinking, common in all the arts, we have a clear example of an aesthetic end not typically deducible from the planning or spontaneous strategy. It appears that a chain must be forged from element to element, or from one variation to another. Perhaps we could conjecture that the spontaneous strategy might envision a series of drawings as variations on a theme. In any case, only 23 percent of the subjects in our first experiment gave evidence of this sign sometime during their four weeks of drawing, and then it was later in the series and inevitably by a student achieving high complexity on total divergent signs.

20.1

20.2

20.3
20.4

Figure 20 Drawing series show-
ing strategy change
over a four-week pe-
riod: spontaneous to
divergent transition.

By now it must be apparent that most of the concepts being presented are only readable through bounded contexts. We do not deal with essences or set up criteriality for qualities of drawings. Rather, we find traces of mind in drawings and processes occurring in known contexts. In this point of view we concur with Arnheim: "a work of visual art . . . is not an illustration of the thoughts of its maker, but rather the final manifestation of that thinking itself."[24] And for even the kind of abstract grasp of that thinking and the conditions affecting it which is the theme of this chapter, we need to know something of the subject, of the setting, and of the process.

We have seen how the drawing stimulus subtly deflects the strategy. Related to this finding, also from Experiment I,[25] was the strengthening of stimulus effect as combined with process feedback (all references to process feedback are to delayed feedback in the form of in-process time-lapse photographs). The mind stimulus condition, together with more process feedback, was associated with increased signs of the spontaneous strategy. The drawings also took less working time. Conversely, the still life stimulus condition, coupled with less process feedback, was associated with increased signs of the divergent strategy, and the drawings took more time to complete.

In terms of self-ratings (using Osgood[26] type scales), under more process feedback, students classified in the spontaneous strategy saw their work as more "active," whereas divergent subjects saw their work as more "active" under less process feedback. In general, subjects working from the mind stimulus condition saw their work as "good" (or better) under more process feedback, whereas subjects working from the still life more often saw their work as "good" under less process feedback.

INSTRUCTION IN A STRATEGY

In Experiment II,[27] moving off the knowledge obtained by noting how well subjects could switch strategies, we set out to instruct directly our balanced group of subjects (see Table VII) in either the spontaneous or the divergent strategy. For this purpose, we used the strategy criteria clusters emerging from a factor analysis of the revised set of 18 criteria (see Tables III, IV, and VIII). One factor cluster of criteria became the instructional content for each of the three treatment weeks. Instruction was given by three instructors, a different one each of the three weeks, by means of verbal labels and pictorial examples (obtained from Experiment I). Application of the instructed strategy cluster to the student's own process samples (of the previous week) was pointed out by the instructor (direct mediation of learning feedback) or led by the student (indirect mediation of learning feedback, under the instructor's opening and sustaining questions).

Strategy instruction was overwhelmingly effective. The graphs in Figure 23 plot the gross differences related to the instructional condition (induced learning set or strategy instruction) by showing the three measures used in the experiment (spontaneous signs, divergent signs, and art quality) compared on base, treatment, and post-treatment periods. An examination of these graphs is instructive in several ways. Not only does a pervasive

21.1 21.2 21.3

21.4

Figure 21 Process examples of theme and variation drawings.

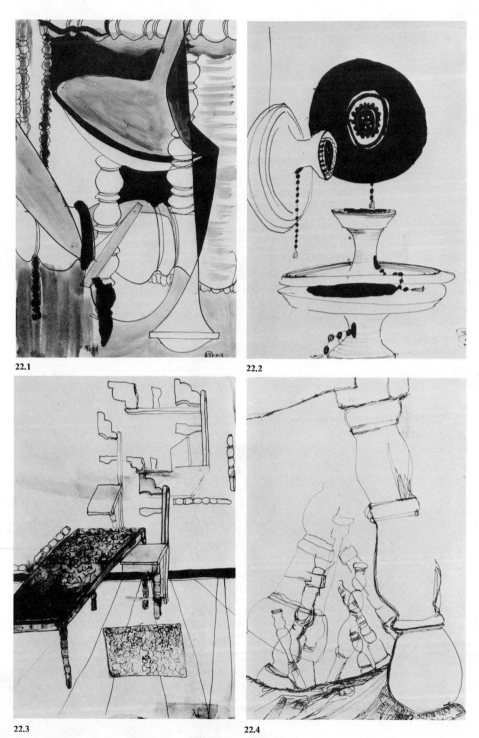

22.1

22.2

22.3

22.4

Figure 22 Further examples of theme and variation drawings.

116

1.1

1.2

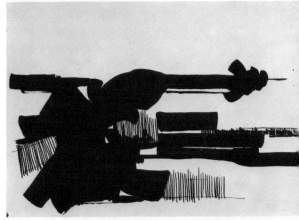

1.3

Figure 23 Effects of strategy in-
struction from experi-
ment II on spontaneous
strategy signs, divergent
strategy signs, and art
quality.

These effects are shown pictorially
in 1.1 to 1.4 by a student who changes
gradually from spontaneous to diver-
gent, and in 2.1 to 2.4 by one who
does the opposite. They are also
shown for groups in the statistical
graphs.

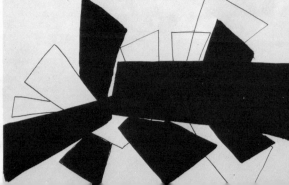

1.4

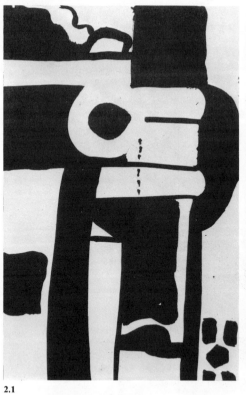

2.1

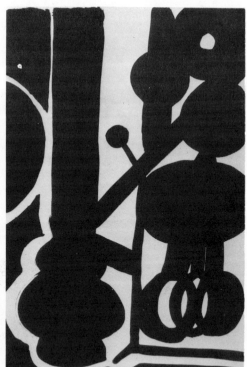

2.2

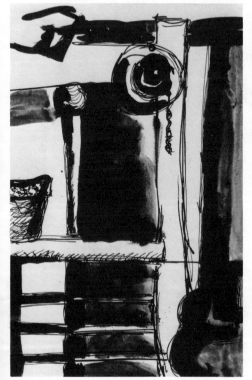

2.3

2.4

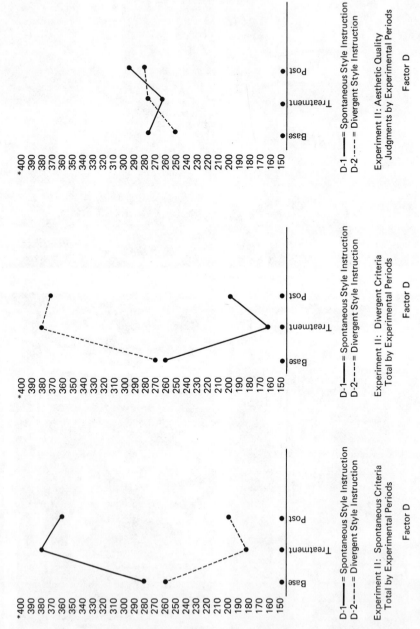

D-1 ——— = Spontaneous Style Instruction
D-2 - - - - = Divergent Style Instruction

Experiment II: Spontaneous Criteria
Total by Experimental Periods

Factor D

D-1 ——— = Spontaneous Style Instruction
D-2 - - - - = Divergent Style Instruction

Experiment II: Divergent Criteria
Total by Experimental Periods

Factor D

D-1 ——— = Spontaneous Style Instruction
D-2 - - - - = Divergent Style Instruction

Experiment II: Aesthetic Quality
Judgments by Experimental Periods

Factor D

*Means (decimal omitted) on a scale on which 500 = high, 250 = average, 100 = low.

change in strategy occur, but it persists (with only slight decline) after instruction ceases. Also, the differences between strategies on art quality is almost nonexistent, for under instruction virtually all subjects instructed to do so changed strategy. Over the six weeks of the experiment, the correlation between the spontaneous strategy sign total and art quality was .194, and between the divergent strategy sign total and art quality it was $-.041$. (Comparable figures for Experiment I were .662 and $-.538$ respectively.) This leveling is attributable to closer screening of subjects in Experiment II and to the fact that some of the better students changed strategies as a result of the experimental conditions, while the poorer students received ample strategy instruction that they also changed styles (especially important here is that relatively rare change of untrained subjects from low divergent to low spontaneous).

In Experiment II, direct mediation of learning feedback (information of how the instructed strategy related to the subjects' drawing processes, led by the instructor) was associated with gains in spontaneous strategy signs, whereas indirect mediation of learning feedback was associated with gains on the divergent side.

In general, connections observed between strategy classifications or gains on strategy signs and experimental conditions suggest congruency between thinking processes and their environmental counterparts. It appears, for example, that the spontaneous strategy is nurtured by flow of information and internal stimuli (operationally represented by more process feedback, direct mediation of learning feedback and mind stimulus), while the divergent strategy responds to bits of information and is set going by external stimuli (less process feedback, indirect mediation of learning feedback, and still-life stimulus).

There is still further empirical evidence on the congruency between drawing strategies and environmental conditions. Wise[28] found that college subjects could achieve expressive qualities better which were conceptually linked with their strategies. Students classified as using the spontaneous strategy did better in expressing "interaction"; those classed as divergent excelled on the theme "isolation." These themes are deliberately general and somewhat vague so as to allow subjects freedom to explore their own imagery and means. Interaction arouses associations of movement, conflict, complexity, mixing, and the like, and suggests both subject matter and graphic characteristics of medium related to these—for example, more than one person, with actions and connections between them. Isolation just as readily evokes images of a single person or object, and qualities of bareness, starkness, stillness, and so forth. Naming signs from each of the strategies shows form-content expressive equivalences: for interaction, movement within shapes and across contours, action gestures, direct motions, central attack; for isolation, elimination of nonessentials, single element focus, static suspension in space, floating without base line, fine-line control. As Gombrich has maintained, first we "make" and then we "match."[29]

More recently, Rutkowski[30] has found that simple manipulation of time limits strongly affects drawing strategy. Brief time limits of several minutes'

duration force untrained college subjects to resort to a planning heuristic and to pick up descriptive qualities having much in common with spontaneous strategy signs. The mere imposition of a two-minute limit on a drawing of a still life made students move toward suggestion, sweeping lines, blurring of contours, interrupted lines, abrupt motion, broken darks and lights, movement within shapes, action gestures, etc. While there is an artificiality about the outcome, nevertheless the transition is undeniably toward the spontaneous strategy.

In summary, this chapter has attempted to discuss in general terms empirical evidence on conditions affecting drawing strategies. Our earliest formal experiment indicated that art quality, creativity tests, and drawing strategies were facilitated by an environment organized to make self-evaluation and self-direction possible. These conditions were such that they encouraged self-evaluation (via one's own criteria) of process feedback in an interactive but supportive setting. A smaller study, attached to the above experiment, indicated support for delayed process feedback, again in an interactive setting, with generally sustaining questions from the teacher surrogate.

The second set of formal experiments indicated that the drawing stimulus condition, especially in conjunction with process feedback, molded drawing strategies one way or the other. The mind drawing condition, with more process feedback, increased spontaneous strategy signs; the still life drawing stimulus, with less process feedback, increased divergent strategy signs. Subjects, when asked to rate their own strategies at the end of Experiment I, and then to simulate the strategy opposed to what they perceived theirs to be, were able to do so with apparent ease. In Experiment II, direct instruction of one or the other strategy was undertaken, with changes which were pervasive and apparently persisting. Direct mediation of learning feedback was associated with gains in spontaneous strategy signs; indirect mediation of learning feedback was related to gains in divergent strategy signs.

Drawing strategies thus appear to be extremely plastic, but there is a logic discernible between a chosen or instructed or otherwise influenced strategy and the environmental conditions to which it is responsive. Although such evidence as here presented is far from complete, it lends credence to the position that the person drawing is a problem-controlling (or exploring) agent, actuated by process feedback and its subsequent symbolic transformation in terms generally congruent with one of the two drawing strategies presented, sensitive to gross or relatively minor influences on his drawing situation. The facilitating conditions generally desirable stress the "internal locus of evaluation" and the self as active, seeking, exploring. The thinking processes (strategies) can be drastically or subtly influenced at their outset, but thereafter remain faithful to the chosen course.

The following quotation from Collingwood here seems pertinent:

... what a student learns in an art-school is not so much to paint as to watch himself painting: to raise the psycho-physical activity of painting to the level of

art by becoming conscious of it, and so converting it from psychical experience to an imaginative one.[31]

The nurturance of such an activity, however, is more delicate and idiosyncratic than our discussion of abstractions on the level of strategies alone can hope to suggest. We next turn to that issue: that of converting psychical experience to imaginative experience. For this, we will resort to the case method. The kinds of lawfulness observable in drawing processes, over a drawing series, in a bounded context, and occurring in a given single case are of a different order from drawing strategies, yet coupled with them yield unmistakable insights into the role of mind and context in the art of drawing.

NOTES

1. Beittel, op. cit. (1964), n. 2 chap. 1.

2. Gloria D. Bernheim, "The Dimensionality of Differential Criteria in the Visual Art Product," *Studies in Art Education* 5, no. 1 (Fall 1964): 31–48.

3. Earl Nitschke, "Some Advantages of Using Multiple Drawing Behavior Samples in Lieu of Regular Classwork" (Ph.D. diss., The Pennsylvania State University, 1963).

4. Beittel, op. cit., n. 2 chap. 1.

5. Ibid.

6. E. L. Mattil, Robert C. Burkhart, H. B. Burgart, and Kenneth R. Beittel, "The Effect of a 'Depth' vs. a 'Breadth' Method of Art Instruction at the Ninth-Grade Level," *Studies in Art Education* 3, no. 1 (Fall 1961): 75–87.

7. Bernard Schwartz, "The Effect of Working Time and Instruction in Art Upon the Process Characteristics and Aesthetic Quality of Art Performance" (Ph.D. diss., The Pennsylvania State University, 1964).

8. Carl Rogers, "Toward a Theory of Creativity," *ETC, A Review of General Semantics* 11, no. 4 (Summer 1954): 249–60.

9. Layman H. Jones, Jr. "Student and Teacher Interaction During Evaluative Dialogues in Art," U.S. Office of Education Cooperative Research Project No. S-050. (The Pennsylvania State University, 1964).

10. William R. Bradley, "An Experimental Study of the Effects of Three Evaluation Techniques and Personal Orientation on Aesthetic Preference," mimeographed (Minneapolis: University of Minnesota, 1968); see also William R. Bradley, "A Preliminary Study of the Effect of Verbalization and Personality Orientation on Art Quality," *Studies in Art Education* 9, no. 2 (Winter 1968): 31–37.

11. Ray Hyman, *Creativity and the Prepared Mind.* (Washington, D.C.: National Art Education Association Viktor Lowenfeld Memorial Fund, 1965). Research Monograph No. 1, pp. 13–14.

12. Beittel, op. cit. (1964), n. 2 chap. 1.

13. Ibid., p. 61.

14. Ibid., p. 59.

15. Beittel, op. cit. (1966), n. 2 chap. 1.

16. Beittel, op. cit. (1964), n. 2. chap. 1.

17. Ibid.

18. Kenneth R. Beittel, "Manipulation of Learning Set and Feedback in the Teaching of Drawing," *Studies in Art Education* 10, no. 1 (Fall 1968): 17–32.

19. Stephen P. Klein, Rodney W. Skager, and Walter Erlebacher, "Measuring Artistic Creativity and Flexibility," *Journal of Educational Measurement* 3, no. 4 (Winter 1966): 277–86.

20. See n. 12 chap. 4.

21. Henry Schaefer-Simmern, "The Mental Foundation of Art Education in Childhood," in *Child Art: The Beginnings of Self-Affirmation,* ed. Hilda Present Lewis (Berkeley, Calif.: Diablo Press, 1966), p. 62.

22. Viktor Lowenfeld and W. Lambert Brittain, *Creative and Mental Growth,* 4th ed. (New York: Crowell Collier and Macmillan, Inc., 1964), pp. 381–94.

23. Beittel, op cit. (1964), n. 2 chap. 1.

24. Rudolf Arnheim, "Visual Thinking," in *Education of Vision,* ed. Gyorgy Kepes, (New York: George Braziller, Inc., 1965), p. 4.

25. Beittel, op. cit. (1966), n. 2 chap. 1.

26. Charles Osgood, et al., *The Measurement of Meaning* (Urbana: University of Illinois Press, 1957).

27. Beittel, op. cit. (1966), n. 2 chap. 1.

28. James Wise, "The Effects of Sex Differences, Working Conditions, Style and Art Process Strategy on Ability to Incorporate Expressive Qualities into Drawings" (Ph.D. diss., The Pennsylvania State University, 1966).

29. E. H. Gombrich, *Art and Illusion* (New York: Pantheon Books, Inc., 1960).

30. Walter Rutkowski (untitled Ph.D. diss. in progress, The Pennsylvania State University, 1969).

31. R. G. Collingwood, *The Principles of Art,* original ed. 1938 (reprint ed., New York: Oxford University Press, Inc., Galaxy Books, 1958), pp. 281–82.

6

Idiosyncratic Meaning, Inner Drawing, and Forbidden Procedures Observable in a Bounded Context

In Chapters 2 and 3 I made reference from time to time to concepts borrowed largely from Piaget, Pribram, Gombrich, and Langer which were transmuted into what I called idiosyncratic meaning. It is defined as meaning which is essentially covert and private, a movement from the lone center outward, but it is not a thing at all. Rather it is the impulsion, the first phase of a situation. As such it has no reality separate from its history, although its denial indicates the possibility of what Collingwood calls the "corruption of consciousness," in which the conscious work necessary to the clarification and objectification of the feeling base is not confronted.[1] Our concern here, however, is to give more flesh and blood to the concept itself.

From the point of view of the perceiver of a work of art, Anderson speaks of a process leading to the "disclosure of content."[2] This is a gradually advancing, never-ending transaction. From the agent's side, we do not even have this "open puzzle" for our probings. Instead, the situation (process in context) itself "leaves its mark." We see the thinking as the traces of a de-

cision-system operating through symbolic transformation of its own feedback (even when feedback is given, it is the recipient's own). There is an "enclosure of content." The point made is that *idiosyncratic meaning,* as impulsion, as image for analogical or abductive reasoning, as uncertainty or ambiguity or the source of the interesting, is an important part of the enclosure of content in the drawing situation. It is important not to confound this concept with the so-called "propulsionist" or "finalist" views of the art process, for we have rejected both the expressionist and problem-solving oversimplifications of that process as verbal traps restricting observation of the thought-action taking place in drawing.

Why do I often go to my pottery shop intending to make something but do something completely different once I set to work? I think it unlikely that it is because I am just generally distractable or that my shop is a mess. Why will a subject I am observing say one thing and do another, or why will he resist structured problems, even when they are possible solution routes toward clarification of his self-announced difficulties?

Preordained ideas and problems lack cohesive power and energy potential when compared with idiosyncratic meaning as the impulsion phase of a drawing situation. In fact, even when we carry ideas foreign to us, or of an abstract nature, to the drawing setting, they are immediately transformed into idiosyncratic meaning *in situ* or we feel we cannot proceed as exploring decision systems. (The connotation of "meaning" in my usage is, again, all on the artist's side. It refers to the full experiential reality of his immersion in the art process. This usage of "to mean" is akin to a complex of words, among which are "to intend, to purpose, to plan, to guide from within." A reviewer has pointed out that this will confuse psychologists and critics who associate "to mean" with "to signify, to refer to, to be interpretable as.")

The drawing process itself, reflexively, enters into idiosyncratic meaning, for this concept is not meant to refer to a vague feeling out of nowhere. At the close of Chapter 5 we quoted an important principle from Collingwood concerning the desirability of converting psychical experience into imaginative experience through enlargement of consciousness, by way of the power to watch oneself drawing.[3] This watching and consciousness are by no means verbal, although verbalization (as language in communication) can play an important role. The transformations from past situations become reversible, recombinable, manipulable, and projective components of envisioned and on-going situations. Collingwood has said it more simply: they go over from the physical and psychical into the imaginative. They become part of images and plans, or of organized structures into which a hierarchy of acts of execution are already integrated.

CONVERSION INTO IMAGINATION

Figure 24 exemplifies how this conversion via consciousness into imagination occurs. The drawings are by a girl in our first experiment.[4] The first drawing was early in her series, the second late. In between she observed her

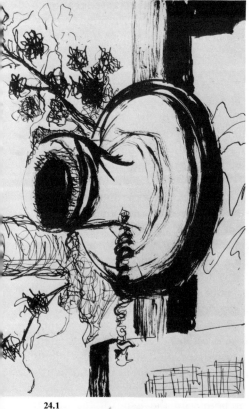

24.1 **24.2**

Figure 24 An example of conversion via consciousness from the psychical to the imaginative:
an early and late drawing of a girl who set herself the task: "stop scratching over."

drawings via process-feedback (time-lapse photographs taken in-process),
and she also specified criteria meaningful to her for their evaluation (self-
discovered criteria). The criterion she set for herself was more like an
admonition to refrain from overworking her drawings. It was: "stop scratch-
ing over." The phrase is itself interesting, for it reflects a growing conscious-
ness of her own drawing processes. She did not speak of directness, medium,
suggestion or other signs abstractly associated with the spontaneous strategy.
She came at improvement from the inside and from knowing more what she
did not want than what she did. The results, however, are unmistakable.

We can now suggest that there is a close connection between what in
the chapter heading is termed "idiosyncratic meaning" and "inner drawing."
Perhaps those who talk of visual conceiving and visual thinking mean some-
thing comparable, but I find it unwarranted to stipulate special psychological
processes and aesthetic or stylistic features as necessary to the concepts of
idiosyncratic meaning and inner drawing. The latter concepts are most
clouded over, in fact, when we get hung up on instruction, evaluation, and art,
seen as organization and expectation in the environment which we bring to

bear on the person drawing. These are necessary constituents of educational experimentation, but it is my hunch that they all too often confound inquiry into the role of thought and context in the drawing process and the drawing series. I do not separate them completely, as the discussion on conditions affecting drawing strategies in the last chapter testifies. But I have had to go over to case studies and temporarily set aside experimental design and standard statistical procedures to move closer to thinking-drawing behavior. Moreover, I have had to set aside any theory of art or art education (that I am conscious of) to move forward. Later in the book I will speculate on implications for art education and tentatively project a theory of learning in art based on my explorations. These will be a by-product, not the aim, of this book.

In our present discussion, however, we come to something of a contradiction. As training and experience in art increase, the connection between idiosyncratic meaning and inner drawing is enhanced. But training which ignores idiosyncratic meaning seems progressively to usurp its place, leaving us with art as technique, with the academic and not the imaginative. Then the artist must struggle to overthrow what is irrelevant in his habits and what does not produce sufficient uncertainty between desired and remembered conditions to keep his own processes alive. He must find his way back to a personal base.

Lowenfeld, in his mural classes, would often have a graduate student in art beside a rank novice, working on a wall. He would state to his students that the untrained person had an advantage over the trained, insofar as the struggle for meaning was concerned.

While this is also a partial truth, it points up the issue of the proper tension between the egocentrism and the submission to reality (or the collective) of which Piaget spoke (as earlier described).[5] With the novice, we often observe unproductive conflict between idiosyncratic meaning (as well as collective) and his concept of what art should be, especially as regards standards of technique and realistic representation. With few transformational habits at his disposal from past experience, virtually no inner drawing is possible for him. Provided an environment that encourages him to watch himself drawing, that is, to build into imagination what he can bring within consciousness, he is almost guaranteed improvement. He will learn to accommodate idiosyncratic meaning to his slowly enlarging imagination, concerning what he can and might draw, and his unrealistic criteria and expectations will be viewed with more tolerance during the actual drawing process. I am speaking here of adult or college-age subjects, with whom I have largely worked.

Just what is a bounded context? Is not every context bounded? Just as, in reality, there is no figure and ground, but only figures with nearer and further boundaries, making the one more ground-like, so there is no context without its limits, though they be fuzzy, shifting and impermanent. In the case here in point, a bounded context is one in which the observer of the drawing process and drawing series sets certain constraints on the environment in which the subject draws. Since there are always boundaries, the chief dif-

ference here is in their being consciously known by the person trying to describe drawing behavior. In this way, he can sift out some observations as tentatively relevant or irrelevant.

The person doing the drawing accepts the boundaries without needing to be conscious of them. They are just "the rules of the place," and he adjusts to them and seems to forget them. They continue to affect his drawings, to be sure; but this effect in some form or another, usually unknown, is always present, for every situation has its boundaries, including all that the agent brings in.

In the drawing lab, as we call it, the environment is private, neutral, and generally oriented toward bringing processes, decisions, discoveries to consciousness. The assumption is that so doing will increase imagination, confidence, self-direction, and the general power of the subject as a problem-controlling, exploring decision-system actuated by its own feedback.

Some of the methods by which this is accomplished have already been suggested and are those which developed out of past experiments. We provide time-lapse in-process photographic records as process feedback. This means that we record drawings, by the method shown in Figures 17 and 18.

CONDITIONS OF OBSERVATION

Our subjects know that our task is to observe and describe, that is, to understand their drawing and thinking processes. This is a component in the neutrality of the environment. We are not "teachers." Thus their explorations must be self-initiated and not external problems or "sets" given or induced. Our questions (usually not intruded into the drawing process itself) are accepted as part of *our* orientation and as free of the threat of external evaluation. (Some subjects must learn that this is the case, often over a period of several weeks.)

We, as observers, must back off eventually, by having our interactions impartially analyzed. Herein lies some problem, but we will not get lost in that labyrinth presently.

In addition to the above conditions, every several weeks we put up a one-man show of the subject's drawings, which he can study, if he finds it helpful (and he usually does), in addition to the process feedback with which each session begins (that is, he observes his drawing processes as recorded the week before). He spends as little or as much time on this as he likes. If, as has been occurring on the average toward the middle of a ten-week series, he wants to spend the entire period talking about drawing (or anything related to his life, the world and drawing), this too is permitted.

As interlocutors of thinking and drawing, we try not to project our evaluations on his work. Any such evaluations as enter in, we typically refer to *comparisons* of drawings within a series, or to *similarities* and *differences* in sensed qualities. Even so, these occur *after* the subject takes a lead, under questions or without, in such evaluations. And these are not what are usually termed evaluations, for they are open, exploring, tentative. Their function

is also to increase consciousness, imagination (inner drawing), confidence and self-direction.

As observers, we strive to be "congruent." This is a term of Rogers,[6] by which he means that what is in the "gut" is also in consciousness and in our communication. But we have our job which establishes priorities under which our congruence is made manifest. The subject is to be active, exploring, deciding.

Communication between humans over a period of time like this, despite roles and constraints, is also communion, the "I-Thou" of which Buber speaks[7] (and of which communication models do not). True "listening" is as crucial in such a relationship as speaking, and both draw upon the tacit dimension of earlier discussion. The desire to understand without judgment (or with suspended judgment, more probably) encourages the desire to "communicate"—to be understood and to render the self understandable. That these are dynamic, interactive forces is undeniable. They are the stuff of human action.

Some have argued about my use of the word *neutral,* but I persist in its use. The setting is not clinical nor therapeutic in purpose, whatever its effects may be. It is not, strictly speaking, educational, since changes need not be "better" by preordained criteria. Thus the setting is not for *discovery learning,* in the educational usage of that term.

It has been argued that the lab is so structured as to be "acceptant, clarifying, and problem-structuring," and certainly "learner-centered," to borrow terms from Withall's[8] "climate index." But these terms come from educational and clinical settings, not from where the effort is to describe thinking, decisions, and processes as they emerge. We are operating somewhere between the experiment, the classroom, the clinic, and the studio, with methods akin to those of the anthropologist and the ethologist. We are participant observers in a bounded context.

Let me now introduce the remaining concept from the chapter title. In this setting, subjects feel free to use forbidden procedures. Here we are closer to psychological counselling, since we accept the subject's initiative on his own basis. The most common procedure used by untrained subjects is that of drawing from photographs or other printed images. These are known to be "off limits" in the standard art studio and are widely acclaimed to be uncreative methods, leading to stereotyped thinking, and so forth.

Similarly, certain subjects, cute or sentimental, are implicitly or explicitly forbidden in other contexts. Such prohibitions are perfectly proper if they function positively, but we do not set them up in our lab. By such acceptance (I'd call it neutrality or absence of prohibitions) we have come to realize how important and meaningful these forbidden procedures often are within a particular subject's development. Note that the subject must take the initiative. We have available only the complex still life (Figure 5), an item of continuity and aid to our insight from earlier studies. If the subject wants other objects, photographs, sitters, his own "studies" and sketches, he must bring them in or ask for them.

The same is true of the medium. We have India ink, an assortment of

brushes, pens, mixing pans, wax and oil crayons, charcoal, dark pencils, Conté crayons, acrylic paints—a range of black and white media. If the subject wants others, he must ask for them (we require them to be black and white at this point). There is a standard 12″-by-18″ white drawing pad (in sufficient quantity not to seem precious, but of such qualities of stiffness and surface as to be compatible with the media mentioned). Though this is the effective limit (up to 18″-by-18″) of our photographic surface, we would respond to requests for some change, even if it meant photographing the work in sections or changing our camera location.

This setting I consider neutral and responsive, foremost. The terms that others may apply may equally fit phases of the ten-week-long sessions with a particular subject, but these two qualities are always present. This is not yet the place to ask whether the approach can in any sense be called scientific. The reader needs, however, to know what our bounded context is like. (He could really only know by becoming a subject or an observer— but he is asked to suspend judgment as to whether this is a criterion such as used in psychoanalysis: we have no clear analytical method or theory.)

Finally, more than one observer is advantageous. I personally prefer one of these to be less an authority image (that is, not a professor, but a graduate assistant or an undergraduate art or art education major). Such a combination also removes the environment from the clinical image. Moreover, it more likely achieves suspended judgment on the part of observers and removes the potential for "one-person effect" in any interaction occurring. All observers must take notes and otherwise be functionally busy in the lab (there are always technical, procedural, and housekeeping functions).

INFLUENCES OF THE EXPERIMENTER

Still, as the continuing observer and authority figure in the environment (also as the trainer of observers) I must acknowledge the influences I bring into the lab. Some of these I am only now bringing to consciousness. I will try to discuss several.

Treatment is not a part of the case-study perspective. I have come to experience directly what before was an academic or abstract issue. In the lab as described, an ethic of relationships is established which precludes treatments beyond the bounded context shared by subject and observers from the start. A treatment condition would have to be introduced as an explicit contract. As such, it could be related to the boundaries of the context. For example, part of the subjects could take their own process photographs and label them, others might be regularly sampled and not label them (we are experimenting with this). Once under way, we could say to a subject: "You average about six process shots per drawing. We would like you now to try to take twice this number, so that you, and we, can see more taking place within your drawings." To others, we might suggest less photographs, bigger units. The main point is that these conditions operate upon the boundaries of the context or that they are explicitly acknowledged.

In experiments (at least those I have done with such complex processes),

subjects know they are being treated, that a set, for example, is being implicitly or explicitly manipulated and that it differs from one subject to another systematically. They thus envision these surrounding conditions and an unknown degree of reactivity creeps in. From our experiments we learn something, to be sure, but something different from what we learn from the case studies. Further, the means of analysis constrains what our experiments can be as opposed to our case studies. The well-known abstractness of the one is balanced against the intractibility of the other when it comes to generalizations. The only way to span the gap from the precise but possibly superficial to the vague but profound is to engage in both over extended time, so that the tacit is rendered overt, and the design and analysis of experiments is kept open.

Yet there are several assumptions underlying the work I have done which it is best to acknowledge openly. They may well be viewed as unparsimonious, or even mystical, by a stern, scientific critic. One has already been mentioned, still another hinted at. The drawing process has been called a dialogue between the artist and the emerging work. We have tried to intrude upon it minimally—for example, we have not given instructions nor have we entered actively into discussion with the artist during its progress. When we do interact, we often enter into relation—into what Buber calls an I-Thou relationship.[9] If it is said that as professionals this is improper, the reply is that as humans, openly responding, it is at times unavoidable. Further, it is to be welcomed, for communion is assumed to be integrative.

So, in effect, we experience the subject on several levels: as observers we see him as a phenomenon to be explained, both before he draws, during his drawing, and thereafter (while we write our summary of the occasion); but we are fellow human beings when we talk together about his drawings and anything else brought into that meeting, for there are no limits. Insofar as the subject can do so, we assume he treats his drawings in a similar way during their development. Of course, what can occur and what does are not the same, but to neglect the former for the latter seems contrary to my notion of both man and his art. I will leave this difficult subject after asserting that in experiments there is the danger that if we treat subjects like objects only they will respond to the experiment like an object—as though it lacks reality for them. I readily admit that these ideas are beyond my powers of philosophical and operational justification. I therefore present them for what they are, assumptions tacitly held, a priori, which slowly come to consciousness.

INDIVIDUATION

Let us further delineate the emphases found in the chapter heading. Malraux[10] speculates that had El Greco not left Venice for Toledo, he might well have ended up a second-rate Tintoretto. He also says that an artist may say many things about art, but he will paint what he can. In this vein, what I have termed idiosyncratic meaning is meant to arouse a dynamic image. It

is an individuation drawn from art and life—more like the impulsion phase of the drawing process (actually there would be many impulsions, for there are innumerable acts in a drawing process, but feedback enters in at once to add enormous complexity). It might be variously thought of also as the desired state of affairs projected upon the existing and emerging state.

One of our subjects defines imagination as what she "wants to see," but adds that she can't want to see just anything, but only certain things she can do or get to. As the slang goes, they must be "her bag." Such a notion checks well with Gombrich's gradual advance through "schema and correction," through "making and matching"[11] and through the conquered part entering into consciousness and imagination.

This long quotation from Eisely[12] will give our meanings a turn into depth:

> "A person too early cut off from the common interests of men," Jean Rostand, the French biologist, recently remarked, "is exposed to inner impoverishment, like those islands which are lacking in some whole class of mammals." Naturally there are degrees of such isolation, but I would venture the observation that this eminent observer has overlooked one thing: sometimes on such desert islands there has been a great evolutionary proliferation amongst the flora and fauna that remain. Strange shapes, exotic growths which, on the mainland, would have been quickly strangled by formidable enemies, here spring up readily. Sometimes, the rare, the beautiful can only emerge in isolation. In a similar manner, some degree of withdrawal serves to nurture man's creative powers. The artist and scientist bring out of the dark void, like the mysterious universe itself, the unique, the strange, the unexpected. Numerous late observers have testified upon the loneliness of the process.

I would like to follow this statement with an equally long one:

> How do we read a human life? As a series of disconnected accidents or as the unfolding of a drama with an inner unity? Anyone we know appears to us at some instant of time with a history we do not know and may never know, or know only in fragments, and in most cases disappears from our view into a veiled future. Moreover, much that is of great personal concern occurs secretly, in wishes and dreams that are never expressed. Biographies fascinate us because they promise a more sweeping panorama of an individual life than our ordinary day-to-day contacts permit. Yet a biography does not necessarily provide us with a meaningful, comprehensible unity; it may seem to confirm the opinion that life is a series of accidents. For the unity of a life, if it exists, is a matter of an individual myth, to borrow a phrase from Thomas Mann; and we may not know this myth. To know it, we have to start far back in the individual history and know those things which children know and do not as a rule articulate very fully, and we have to be in at the death. Act One in a good drama enables us to understand Act Five, it prepares us for it, but riddlingly: not because the foreshadowings of Act One are vague, but because we do not perceive them clearly for what they are, or do not believe them, until Act Five has clarified and confirmed them. And so we need Act Five to comprehend Act One.[13]

These two statements convey something of the import attached to idiosyncratic meaning. It is the stuff out of which that "individual myth,"

"the unity of life," is constructed. And the series of works symbolically limns, if ever so faintly, the possible outline of that myth. Paradoxically, though works of art add "durability" and therefore continuity to life,[14] they also render the self, as Yeats admitted, progressively more of a mystery.[15] I do not, therefore, believe the concept of idiosyncratic meaning and its contribution to and derivation from the individual myth is hard to defend, if, as Pribram[16] maintains, all of our imagery begins in our minds as a configuration implicit with a meaning that we cannot share and apart from its incorporation in art (by analogical or abductive reasoning) do not even dare trust.

Thus there is a kind of "reafferent stimulation," that "comes from the environment as the result of the system's own motor outputs" that applies equally to the symbolic transformations of the art process as well as to the early visual learning of animals and humans.[17] As Platt, the author of the preceding citation convincingly says, we do not deal with an environment and a system as separate terms, but with the "flow processes that connect them across the boundary, the flow-entities of 'awareness' on the input side and of 'action' on the output side." We are, in short, plunged into a situation where all perception is a kind of "participative interaction."[18] This is why we have stressed a cybernetic point of view of the drawing process and the drawing series.

> To overstate it a little, physics is the science of weak-interaction, on *that* side of the boundary; cybernetics is the science of strong-interaction, of will, of human purpose, of applied knowledge, on *this* side of the boundary.[19]

This digression is a reaffirmation of our dynamic point of view, but it is also an enlargement of the traditional one. The self, the individual myth, idiosyncratic meaning, the image itself, are elements of process realities, existing only in relation and not in themselves. The subjective emphasis which they reintroduce into the psychology of art is a special one—the "subjective as participant," "the subjective as manipulant," as Platt calls it.[20] They exist in the realities we study, but they are not separate from the "objective" aspects of these realities.

Dewey states the issue squarely:

> No mechanically exact science of an individual is possible. An individual is a history unique in character. . . . But constituents of an individual are known when they are regarded not as qualitative, but as statistical constants derived from a series of operations. . . The tangible rests precariously upon the untouched and ungrasped.[21]

I rather suspect, however, that no mechanically exact science can grapple with phenomena as complex as these, and that the kind of science Dewey speaks of is being superseded by another more willing to entertain the untouched and ungrasped. But Dewey's words bring us away from the danger of overstressing the subjective (a tendency to which I am prone). It is well to recall Buber's words. In thinking of art, he says, "I do not behold it as a

thing among the 'inner' things nor as an image of my 'fancy', but as a thing which exists in the present." And again: "In art the act of the being determines the situation in which the form becomes the work."[22]

By extension, I would state that the subjective phenomena we have discussed are merely more subjective, that they are shaped by the drawing process and the drawing series as much as they shape these. As such they relate to the "individual myth" that constructs the possibility of a form to one's life. The series of drawings discloses this content. Milner, in her self-report *(On Not Being Able to Paint*[23]*)* gives us a hint about how the construction of idiosyncratic meaning and the individual myth occurs. Drawings do not of themselves, I maintain, disclose psychoanalytic content nor personal and abstract symbols such as Milner finds in her "free" drawings. But when one is a psychiatrist undergoing psychoanalysis while the drawing series is occurring, the making and matching, leveling and sharpening, the symbolic transformation of feedback, disclose this kind of content. Unlike Peckham's position that extra-art forces shape art,[24] I would say that art more likely slowly shapes itself toward these forces—it explores their potential for embodiment in the present.

CASE STUDIES

Case studies reveal some of the ways this happens. The first example comes from 1964, when I had two small groups of subjects, the one working from the still life (Figure 5), the other from personal themes. Each subject was supplied with process-feedback photos, and these were evaluated prior to each drawing session on a form developed for the earlier, self-reflective experiment.[25] Each subject also chose, from a pool of over 100 black-white nonrepresentational exercises, five which exemplified qualities he wanted in his drawings. The subjects were otherwise uninstructed. At the beginning of the fifth and last drawing session, subjects looked over their entire series to that date and wrote about them without using a form. When the sessions were over, I interviewed each, recorded this interview, and subsequently transcribed it.

The case we will focus on will be called "Ellie." Figure 25 shows her drawing series over a five-week period. She begins by drawing trees which by her own description were "stereotypes." She observes trees during one of the middle periods. She ends trying to "correlate movements of trees in respect to figure movement" (statement written before fifth drawing session on an idea which emerged during the fourth session).

In her self-evaluations she used only four different criteria (subjects specified three criteria for the evaluations preceding periods two, three, and four). These are, simply: form, simplicity, motion, and feeling or mood (feeling appeared during the second evaluation but was changed to mood in the third). Ratings of her process-feedback photos showed form going down from first to second period, then it dropped out. She writes:

25.1

25.2

25.3

25.4

25.5

25.6

25.7

Figure 25 Ellie's series: disclosure of idiosyncratic meaning.

I have not been concerned with form in the last two periods. Having never at-
tempted any art to this point in my life, I don't really think form is my largest
problem, or should be, for it will be one that would only arouse more frustration.
Since I have stopped worrying about form, I have enjoyed doing these sketches
much more. What I am aiming at now is movement and feeling between nature and
the human. [Statement preceding last drawing session.]

"Motion" as a criterion goes up in her ratings and persists. "Feeling-Mood"
enters in at the second evaluation period, persists and goes up. "Simplicity"
remains a desired quality (it had dropped down in her second period draw-
ings). Her self-ratings on "Motivational Interest" kept up (above average),
but her ratings on "confidence in my working process" only came up to aver-
age (from the lowest) in her last evaluation.

In projecting how to improve the quality desired, she writes about
motion:

Use more singular sweeping lines that give a more unified idea of motion. Mine
were a little too choppy. [First evaluation.]

Have lines of motion more flowing. Even though curving, these were too rigid.
[Third evaluation.]

On the criterion of Feeling, she writes:

I completely lacked any expressiveness or feeling while doing these. No personality
of mine was displayed. I just made trees—too stereotyped.

I could improve by picking a topic that I have a real personal feeling or attitude
towards. My topic does not draw out any feelings within me. Need self-confidence
also. [Both from second evaluation.]

On her stereotyped tree schema:

I began with my same stereotyped trunk. No form really. Was disgusted and hur-
ried—a poor finish.

I must make a closer study of trees—come to recognize marked differences and
similarities rather than trying to drum up a tree. [Both from second evaluation.]

In the first period, Ellie had drawn a tree which, while stereotyped, had more
motion and feeling for her than the "still scene" of the second period. It was
in the third period, however, that she made an accidental breakthrough. The
following excerpts come from my interview with her at the close of the
drawing periods:

E: I think the changing point was between periods two and three. I knew that the
 motion is what appealed to me, the gesturing, and I had to reject the rest. I
 couldn't use trees actually the way I wanted to. When I first began I just wanted
 to use different kinds of trees.

B: What did you pick up that made you feel like you were on the track with the
 movement?

E: Well, actually, when I came in the third period I was very tired, very discouraged that day, and I wasn't doing what I wanted to do, I knew that, but I still didn't know what I wanted to do; so I made one line coming up the back of the first figure.

B: Was it a figure in your mind when you made it?

E: No, just a line. I knew from looking at the Period One photos that I still wanted to do something with motion.

B: The line represented motion without any content?

E: That's right. I just made a line. I think exactly what I did was to try to depict myself. I was tired. I felt bent myself and that is the way I did that, and you can actually see the frustration lines in Photo Number Four, up in the corner.

B: Do you think this tiredness and not knowing exactly what you are doing but having a feeling is like a discovery?

E: I think it is: I think it's important because before I had been trying so hard to think. I kept saying: "Ellie, please think of something." [Both laugh.] This day I just didn't care anymore, and I thought I would just do what I feel, and that is what I felt. . . .

B: How about the last period?

E: Well, surprisingly, the last period I felt more free, more relaxed, and, actually, more confident in what I was doing, because by this time I knew the direction I wanted to pursue. All I had to do was capture the feeling. So I began again with the random line—the bend that was the first line of the tree. It was a random line and I decided that I didn't care any more. I had been very careful about my branch formation before. And this time I decided it was not the branch formation and it wasn't the form that I was interested in any longer, it was just the feeling and so I made my branches sketchy to pick up the motion. . . .

B: I know one more thing I want to ask you. If this studio were redone and if you wanted any outside help or interaction, what kind of thing or things do you think would help you?

E: You mean outside help with what I'm doing?

B: Suppose you wanted someone to act as teacher. . . . Now, there was no one doing this directly. I think it was a framework for learning; but there was no teaching—using this as a transitive verb.

E: Actually, I think it would almost stint any person to have a teacher there.

B: Why?

E: In the type of work that we were doing . . . because I know that I was so starved for criticism, and I know that any criticism you would have made, I would have followed; and that wouldn't have been me.

B: You feel that what you have done here has been you?

E: If nothing else, it's me. [Laughs.] I wanted direction at the beginning—the first two or three periods. It was actually much better in the end that you never said anything to me.

Figure 26 shows the crucial drawing processes in which Ellie discovered

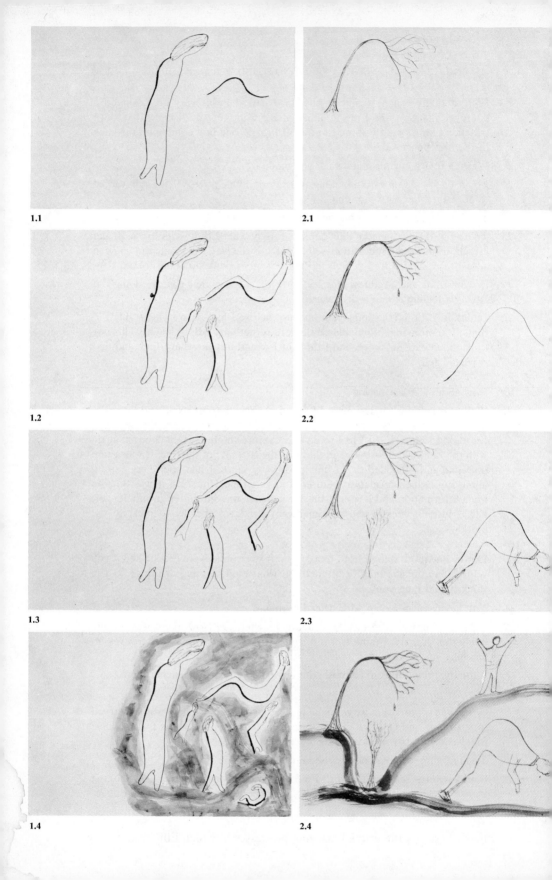

1.1

2.1

1.2

2.2

1.3

2.3

1.4

2.4

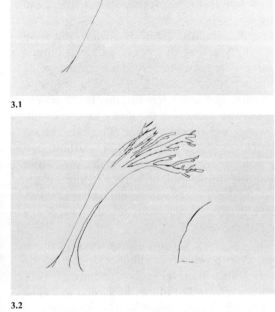

3.1

3.2

3.3

3.4

Figure 26 Ellie's series: The crucial
processes.

the connections between feelings in herself and in contentless lines, which subsequently became gesture and motion in human forms and in trees, and led to an interest in correlating the two.

The next example is much more complex. "Dot" is an art education senior. She has a developed sense of style, and she works within a limited range of forms. She is fast, productive. The material before me consists of 31 drawings done during eight working periods, along with 14 outside drawings, of the same size and in the same media. The latter were done after the first, fourth, and eighth working sessions. She made no drawings in the eighth session, but talked about her drawings and related topics. The last session was a recorded discussion between Dot, my graduate research assistant, and me, with her 45 drawings on the wall. In addition there are the time-lapse process shots of all drawings done in the drawing laboratory, and the weekly notes made by my assistant and me. As these notes will reveal, she was simultaneously doing independent study in silk screen with another professor whom she did not see until the end of the term.

Interestingly, all 45 of Dot's drawings are vertical. They are very much of the same family; and since she is so productive, changes appear to be gradual and, at first, hard to discern. Since there is such a volume of work to attend to, only the specific examples referred to in the discussion to follow will be illustrated. So that these can keep their place in the sequence of events, a time diagram of Dot's art work in and out of the drawing laboratory is shown in Figure 27. The numbering system appearing in this figure will be used to identify the chronology of the drawings. Numbers preceded by the letter O refer to the 14 outside drawings.

Two kinds of descriptive material will be sampled to give the feel of this series. The first will consist of excerpts of observations and inferences from our weekly notes. The second will come from the discussion held during the last week, when all 45 drawings were on display.

From the weekly notes:

W-1. Dot doesn't like to have a preconceived idea. Prefers some uncertainty, even in class assignments. If she has a preconception and her work doesn't turn out as envisioned, she is frustrated, even if the work is good.

During drawing #2 she yelled "stop" to herself. Feels she overworks.

In drawing #3 she introduced wash earlier than before and is leaving more spaces (not cutting them up as in #1 and #2).

In drawing #4 she began completely with wash and tried to leave center ("nexus") out at first. Feels she always starts or comes to central network (as a "tree" or as a "river network of tributaries"—dubbed "tree" and "river"). Is trying to "resist tendency pulling me."

Drawing #5 is preferred. It's like a bigger form (blow-up) of parts of #3 and #4. Nexus is off-center. Began bigger, off center. Still too much "fill-in," but said she tried to simplify with dark. She likes, however, forms closed, not open. Less self-conscious than in #3 and #4. When half finished she felt there were too many lines. Forms are "like two giant bugs." [See drawing W-1:5, Figure 28.]

Figure 27 Time diagram of Dot's art work in and out of the drawing laboratory. Note: 01, 02, etc., refer to drawings done outside the drawing laboratory. In like manner, the week number with the decimal, as in 1.5, means the drawings were done between the laboratory sessions so designated (in the example, between the first- and second-week laboratory sessions). The drawings are numbered consecutively, those done in the laboratory 1 through 31, those done outside 01 through 014. All drawings were vertical in format. In the text, a drawing is indicated both by week and drawing number: thus W-5:21 means drawing 21 done in the laboratory in week 5.

Not sure of next week. Said she did something similar in watercolor before, but the problem is different in black and white. Felt a "run" or sequence makes a direction occur.

W-2. Reviewed time-lapse negatives on viewer. She found forms, on the average, most vital around 5 to 6 minute point. She set the conscious goal of stopping earlier and of freeing the sequence faster (before the last drawing in a run).

Dot brought in 7 outside drawings (4 in black and white, 3 in watercolor). Both sets went, as in W-1, from tighter, closed forms to softer, freer, more organic. Discussed how black-and-white could not depend on fusion without some change in values, as color watercolor can. Felt that later works in and out of class were less like pieces of something continuous (off-the-page), more like organic forms on a ground, but still attached to it.

Did 7 drawings in rapid succession. Latter drawings were as short as 3 minutes. Liked #1 the best; mentioned its "square" form feeling, that "black counted as black," and that it both had forms and was part of continuous form. What she did wrong in #1 was to have a continuous black enclosure. [See drawing W-2:6, Figure 28—note that drawing numbers are continuous, as on the diagram in Figure 27, to show their order in the total sequence.]

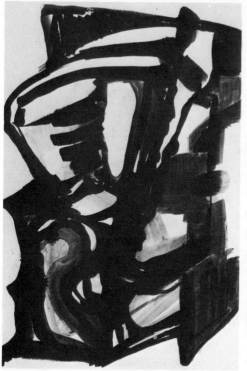

W-1:1

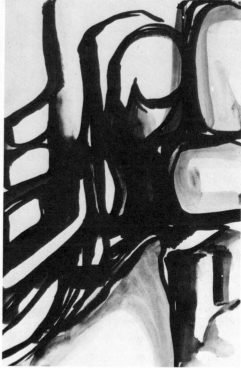

W-1:2

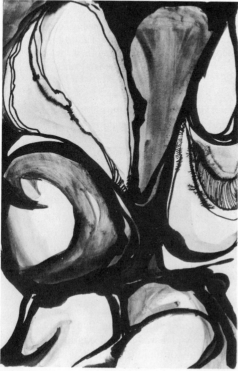

W-1:3

Figure 28　Example of Dot's drawings referred to in text (identification numbers are those given in Figure 27).

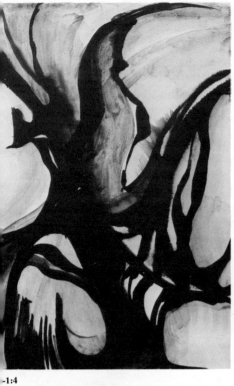

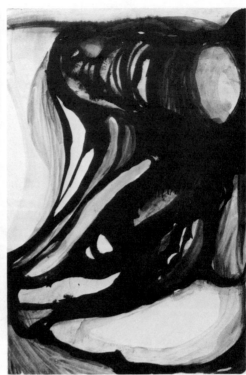

-1:4

W-1:5

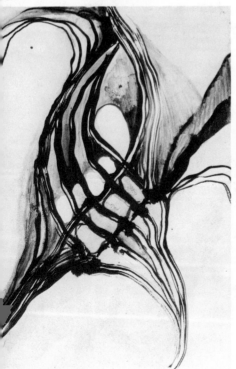

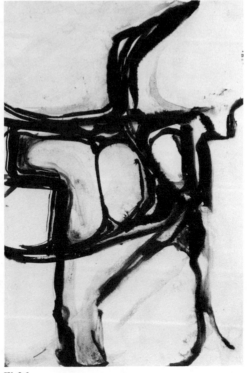

-1.5:03

W-2.6

143

Figure 28 (continued)

W–2:10

W–3:14

W–3:16

W–3:17

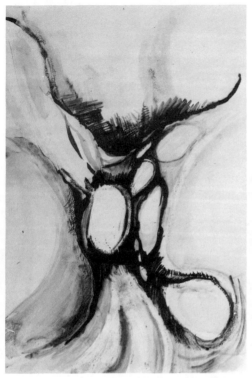

W–4:18

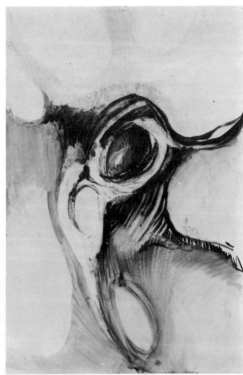

W–4:19

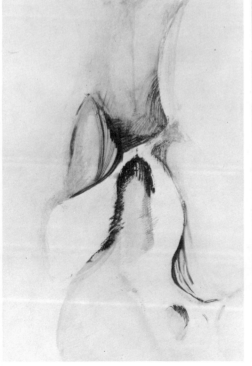

W–4.5:05

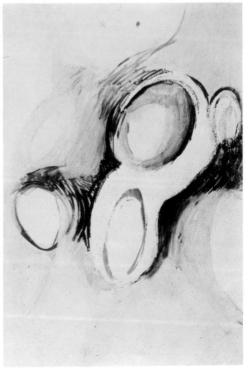

W–4.5:09

Figure 28 (continued)

W–5:22

W–6:24

W–6:25

W–8.5:010

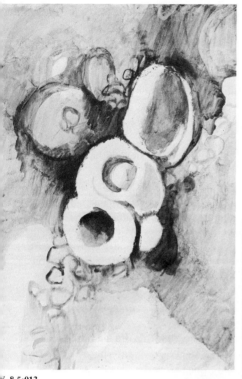

W–8.5:013

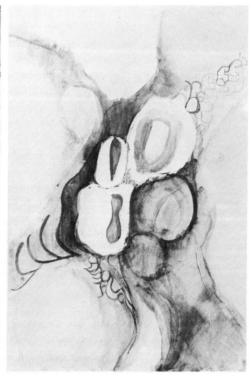

W–8.5:014

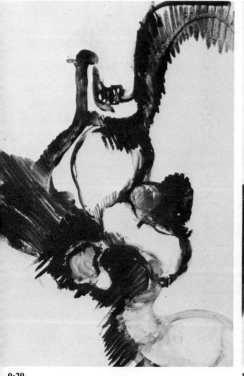

–9:29

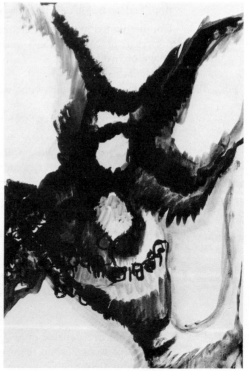

W–9:31

147

W-3. Still preferred first drawing of W-2, in looking at negatives. Saw that wetting whole page at beginning did not seem to contribute to end qualities. In first drawing this time, she wet only parts of the paper.

In second drawing, switched to litho crayon and black oil-crayon ("craypas"). With mix of two crayons, could feel "black as black" difference better than in ink (she seems to mean black as a "color," not just as dark shading).

Found change of medium stimulating. In drawing #3 she combined some ink wash with crayons.

Drawings #s 2, 3, and 4 evoked her training associated with media. She associates the ink and wash with past watercolors ("organic abstracts"), but crayons were used for real or representational subjects. Drawing #2 became "still-life like" (hadn't started so), whereas #3 became eventually like a clown's head. Drawing #4 she deliberately aimed toward a figure. In drawing #5 she was able to do her first "organic abstract" in crayons. The sequence, thus, is:

1. Medium change.
2. Into "conditioned" representational subject matter, unsought.
3. Purposely into such subject matter.
4. Into organic abstract for the first time with this drawing medium.

Interestingly, used similar structural schema ("tree" and "river") even with representational subject matter. (See drawings W-3:14, W-3:16, W-3:17 in Figure 28 for examples of unsought representation, conscious representation, and conscious abstraction in crayon medium.)

Dot mentioned many teachers made her work the whole composition. She prefers a "process schema"—really more the "feel" of the process, than an image of overall form.

W-4. Dot brought in previous large watercolors (from a class 2 terms ago) and some current silk-screens done in independent study. Dot said the silk-screen was an attempt at a "tree" type (center to branch) process in a much different medium.

Did two drawings, added the white-oil crayon as a resist device and returned to ink and wash (she got this idea from seeing several negatives of another student's work, by chance).

This mixed media approach stimulated her and she felt she was getting a synthesis of qualities of her watercolor, crayon, and ink works.

At this point in her series, a variety of tonalities, of open and closed contours, of holes and solids, and a simplified nesting of forms and contrast occurs, with extensions of these merging variously with continuous background forms (off the page). Thus focal and continuous emphases, and maximal variation of value and contour occur (see drawings W-4:18 and W-4:19, Figure 28).

W-5. Dot brought in 5 outside drawings. She felt *all* achieved the level of W-4 drawings or went beyond them. She left off using the white oil crayon as resist in one deliberately, to see whether she could obtain the same quali-

ties with ink only. Leaves much more unresolved and suggestive (see drawings W-4.5:05 and W-4.5:09, Figure 28).

In checking W-4 negatives, said sequences now seemed alive and not overworked, the whole way.

She did 3 drawings today. Said she would like to destroy the second. I said: "If you like." But she said: "No. It's part of the series." She felt the form was too flat and split the focal point, yet accepted it as a new kind of form.

Said she is more "aware" and "conscious" of her way of working, but "in a helpful way." She thought her early things were spontaneous because she worked without knowing what she was doing, but said they look less spontaneous now than later ones, which are more conscious and disciplined.

W-6. Did not know where wanted to go. Negatives and old pictures not needed today. In second drawing, got the idea to bring in "calligraphy." In third drawing tried this out, self-consciously. White oil crayon resisted too much, so she couldn't overlay forms adequately. We will get her acrylic white and black (see drawing W-6:25, Figure 28).

W-7. Dot continued calligraphy addition to her more open organic abstracts. Calligraphy becomes more complex. In drawing #1, instead of being superimposed as in W-6, it becomes part of the border of a form (around a "hole"). Felt shape at bottom right disturbing: too firm and hard, too much overlap. Holes too regular (she now gives detailed self-criticisms).

Drawing #2 is preferred; it has a soft and "fuzzy" tonality. Calligraphy becomes "symphonic"—i.e., complex, subtle, suggestive (I compare it to Tintoretto's disintegrating heavenly hosts). Dot said the forms were "like holes when stretching bubblegum apart"—(laughed) a definite feeling of stretching. She couldn't think of laying calligraphy in first. It had to be "grafted on" but become organic. She didn't like definiteness of 3-fingered form, but liked the total, and changed values and definiteness within calligraphy.

W-8. Did not draw but talked whole period. Said she tried to take forms from her drawings into her silk screens but they didn't work. "Jumped" into the medium out of despair, found her way, then brought in "bits of richness" like the calligraphy.

She was sure she did 3 drawings last week (W-7)—one of which (nonexistent) got around two problems she was conscious of. Said this hadn't happened since she was a young girl. She thought her mother had bought her a large doll and was hunting it in a trunk, but it hadn't really happened.

W-9. Dot brought in 5 outside drawings and some matted silk-screen prints. Pushed calligraphy into texture and atmosphere—back into the forms (see drawing W-8.5:013, Figure 28). Seemed pleased with all outside drawings. Was also very happy with many matted silk screen prints (which were not organic abstracts so much as more geometric and random complex spatial overlaps, suggesting light planes of color at times).

She spoke of her drive currently to "do—move—take command," as a kind of finding of self. She needs to work alone, or as in the lab. Felt less successful in a mural she's painting, where she compares herself with others. Does not do so in drawings and silk screens.

She said she now does black and white pencil drawings also.

Today did 4 "black" drawings using acrylic paints (for the one she likes best, see drawing W-9:29, Figure 28).

The following excerpts come from the recorded discussion at the last session (W-10), when her 45 black and white drawings were on display. (Identification symbols: D = Dot, B = Beittel, RA = Research Assistant.)

D, B, and RA summarize what they see:

> The logic gets less complicated; learned to simplify, leaving a lot out; lighter quality comes in, especially after the crayon (starting with W-4:18); spatially, more of a flowing quality; more of an atmospheric quality; in one sense simplified, in another more complex—or at least enriched; forms seem to be coming out of the paper; one form "grows" from the other.

RA: You do more pictures than the others, so the changes are less apparent than if we skipped every so many.

B: Where do the "jumps" occur for you?

D: One is at #10 (W-2:10, Figure 28) where I become more linear. Another is at #09 (W-4.5:09, Figure 28), with the crayon. Even into calligraphy was not a big jump.

B: More of an enrichment?

D: Right. In #010 (W-8.5:010, Figure 28), the form is again getting broken up, toward the end. Before there was one main form. Also in #014 (W-8.5:014, Figure 28). Before the forms were more continuous. In the last week (W-9), they're getting heavier. It's a different medium. I got interested in #29 (W-9:29, Figure 28). It has different shapes and treatment (brush strokes and texture). Back in #24 and #25 (W-6:24, W-6:25, Figure 28), I tried to introduce new shapes, yet there seems to be a repetition. . . .

D: One thing I learned is when to stop—how to control myself.

B: You learned that quite early. [W-2]

D: When I set my mind to it.

B: Did the process shots help in this?

D: They did definitely.

B: How about after that?

D: Up to a point. I tried to think back to where a picture worked, and stop. And then after a while it just became natural. The ones at home, I made myself stop, even when I didn't think it was finished.

RA: Do you still do that?

D: Yes.

B: At first, the drawings seem both more complex and more confused.

D: That's a good word. I never know what I'm doing, but I later felt more control. Like I can direct myself. The brush wouldn't take me. I'd take the brush and move it. At first I didn't know what I was doing, but I also didn't know what I was *going* to do.

B: How's that?

D: I knew the process I was going through but I didn't know the product that was coming. The first ones are more like sections of something bigger. The end ones are more separate, in themselves.

RA: At first you were concerned about color and minded the restriction to black and white.

D: Yeah, but I don't know why, but after I got the white [oil crayon and acrylic], I sort of changed.

B: Did you then develop an atmospheric feeling?

D: True. The values can take on atmosphere, like color. . . .

RA: You could have done this on your own, couldn't you?

D: I don't know if I would have. In watercolor, in silk screen, and in here, I feel like I achieved something. In watercolor I got negative crits. And I thought I was good. I slowly overcame the gap. In silk screen, I did it on my own. I wouldn't have done this series on my own. I get frustrated so I would quit. I've never worked under this no-criticism atmosphere where you're just, like, helping indirectly. And I feel that what I've produced is more of my own than, like under a coaching.

B: What were we doing?

D: Making me think more about what I was doing—raising questions that I never would have thought of before. In silk screen I was really frustrated for a while—ready to give up the whole thing. It was an accident that got me going.

B: Here you got no direction, but "feedback," is that it?

D: But I did get direction in a way. Sometimes it would bother me that I didn't get anything like "this area is good," but yet it helped me because it made *me* think more about my own work. It made me more independent, not leaning on somebody else's ideas, which I've done. Even all through college, you're almost made to lean on your teacher's criticism, to always take this as valid and never reflect on your own ideas. In this, I could look at a piece of work and say something about it and not worry you'd say, "no, that's wrong." You helped me reflect, being more independent about what I think of my own pictures.

One of the questions you almost always asked was, "How do you feel about this?" And that really made me think. Instead of letting a teacher think of my work, I thought about it.

RA: What could we have done that would have helped you more?

D: It sometimes bothered me you didn't give me criticism. I think I should have opened my mouth and said, "What do you think of it?" Because it sort of produced a little anxiety in me. But it wasn't your fault you didn't give it because I didn't ask you to give it.

B: If you had asked and we'd have answered, would it have helped?

D: No. That's the funny thing. I always reflect back on my courses, what I learned. Usually I don't learn anything. Here . . . it produced an anxiety in me but the anxiety was good. I always get scared when I have to think about a problem for myself.

RA: Did anything else happen to hinder you?

D: No. Not at all. Sometimes I was conscious of your being here. Like, if you hadn't been around, I might have worked freer. *Like if I felt I wanted to change, I felt I couldn't. I was already on a path.* (Author's italics.) . . .

D: It was good to be able to come in and just talk, too. If I didn't know what to draw at first.

B: What function did that serve?

D: When I'm teaching, I want my students to always be free to talk, because I think it gives them a lot of insight into their own ideas—having a free atmosphere where you can talk about anything you want, helps ideas come out.

 I'm free other places too, but get no "feedback" or way to see what I've learned. This is more of a continuing process, because I can look at the beginning and end and see that I have improved, where in most courses, I can't say whether I've improved or not. I've got some new information, but . . . I don't feel I've learned anything satisfying.

Let us turn to one more series in this chapter. I do this to keep before myself and the reader sufficient examples to guard against premature generalizations.

This case is also a girl, a senior, who is an English literature major. She has not had art training. We will call her "Louise." Following the procedure used for Dot, in Figure 29 is given a time diagram, showing the drawings Louise did in and out of the drawing laboratory. In all, there are 28 drawings, 17 in the laboratory, 11 at home. The material which follows is drawn completely from the weekly notes which I and my graduate research assistant wrote.

W-1. Louise did three drawings. Drawing #1 was from the still-life. Started with dead branch. Said she likes growing things. Next did bedpost and cow's skull attached to it. Skull greatly exaggerated in size. Said she didn't realize it was so out of proportion. Added another bedpost to right to "balance." She feels free to rearrange from the still-life. Has the concept of not needing to copy.

 She said she draws whenever she has time. "Plants are prettier than solid, inanimate objects." She propped her drawing up to study it from a distance. "The skull looks like a huge bird holding by claws to the bedpost."

 In drawing #2 she selected the flower pot out of still-life and put flowers in it in her drawing (there were none in it in the still-life). Focus exclusively on pot and flowers. B. asked if she had any idea what she would do on the rest of the page. She said: "No idea at all. It's not important yet."

Figure 29 Time diagram of Louise's drawings in and out of the drawing laboratory. Note: Positioning of rectangles shows whether the drawing was vertical or horizontal in the format. The numbered sequences are explained in the note to Figure 27.

Added chair as support for pot. The drooping flowers did not seem alive, so after studying the drawing from a distance she added leaves. The idea for the flowers came from seedpods in the still life.

Drawing #3 was a "rearrangement." She enlarged the flower seedpods and put them into a pot.

To Louise, W-1:1 was "heavy, dark, lumpy, masculine." She is after "light, airy forms; a feminine, organic, growing quality." These are qualities she wants to work toward. She is not clear how to get them, apart from plant forms. She is very conscious of balance. She finishes one object at a time, usually without knowing what else she'll add later. She said she doesn't need to have things physically present. (For examples of the drawings mentioned, see Figures 30 and 31.)

W-3. Louise asked to have still life removed and selected potted plants from the building to work with. Said she "picked the nicest branch to make sure I get it in and then fit the other ones around it." She found it "difficult to distinguish leaves from branch, so I must fill in something." Filled in soil to help. She studied W-1 drawings and decided "things look better if they don't run off the page." She held to this in her two drawings this week.

In drawing #2, she said she was tired of flower pots, so she combined shapes she likes: a stoneware teapot (in the room) and the best geranium branch from the potted plant used in drawing 1. She worked on the teapot by itself, then on the branch coming out of the spout, then put a table under the teapot. She said she prethought the relations of forms and lines in this drawing, and that therefore "it's less like art; more like a math problem." She selected the one branch again, but even so rearranged the leaves "to get a better pattern" (more decorative or just clearer?). She was conscious of the repeating curves. She blackened the table top last, but was not pleased with this. She said she thought she would study leaves outside the laboratory. (For W-3 drawings see Figure 30.)

W-4. Louise changed to landscapes after trying some home drawings of leaves and flowers from a flower book. Landscapes are of trees and a wishing well (she got the idea from a picture in a store window). She likes to balance a living thing with a solid, and sees these as feminine and masculine. "Even a dress is masculine, if it's solid—unless there's a flower design sewn on it." "The sky is neuter, but clouds are feminine."

She liked both of the drawings done this time. Said she learned to shade with pen and ink on the wishing well, as suggested by the print she saw in the store window. No overlapping, no horizon shown in either drawing. She wants to put more in her drawings next week.

W-5. Louise tried a landscape at home, with a path in it. The path didn't work; "it shot up in the air." The flowers and grasses in the middle distance seemed to be "floating" to her. The idea came from the stonework on the new Lutheran church. She studied trees outside and "brought spring" to these by fuzzing out the twig ends. The trees looked "wierd" so she added a moon and made it a Halloween type drawing. The road was meant to be hard and lumpy, but it looked soft. She capitalized on this discovery and used the road texture (ink treatment) for a soft, evergreen tree texture in her second outside drawing (W-4.5:02). Unlike last week's drawings, this shows conscious overlap. The brick wall texture came from the wishing well of last week.

Louise put W-4.5:02 on the wall. In her first drawing (in laboratory) today, she put the brick wall on an angle—the first diagonal thrust into space. She studied arch lines first on scrap paper, to show the inside's visible thickness. The tree on the left was enlarged and made to hang over the wall. She had me cut off bottom inch of paper. If she did it over, she'd put the tree in right foreground out further from wall to balance the tree behind wall. She seems thus to have extended "balance" consciously into space and off of the horizontal.

In drawing #2, Louise rearranged the same theme. The page is now vertical and the depth balance is made clear (although back to frontal planes). She is again conscious of masculine (wall) and feminine (tree) elements. The tree is moved forward and centered (this idea came from her first drawing today, she said). The wall bricks are laid in with a fine brush (drawing #1 with pen "looks like it's in the sun" and "all detail seems the same"). A transitional gray is added to the arch on the wall to "relate the hard and soft." Louise said her home drawing (W-4.5:02) is "like inside the wall looking out." W-5:8 is "like a wall along a road," whereas W-5:9 is "like outside the wall looking in." The latter drawing clarifies three planes: foreground, middle ground, distance.

W-6. Louise got an idea while in her class on Milton, which she sketched out at home with magic marker (W-5.5:03) and put on wall while making drawing #1. She concentrated on shading, solidity; and made the tree feathery ("spring-like and feminine"). The drawing seemed "heavy" to her. She would like it better if the building through the window in the distance had windows in it and if she had objects on the near window sill. Space was still part of the exploration in this drawing.

In drawing #2, she said space was a secondary theme. She was interested in

W–1:1

W–1:2

W–1:3

Figure 30 Examples of Louise's drawings (identification numbers are those given in Figure 29).

Figure 30 (continued)

W-3:4

W-3:5

W-4:6

W–4:7

W–4.5:02

W–5:8

Figure 30 (continued)

W–5:9

W–5.5:03

W–6:10

W–6:11

W–6.5:04

bringing back the airy, light, feminine feeling she crowded out of draw-
ing #1. I observed there didn't seem to need to be a solid-object feeling in
this drawing, but she contradicted me, saying that was the window sill and
frame. She connected the flat decorative quality of this drawing to the
teapot and branch drawing (W-3:5).

W-7. Louise continued the window, tree, pots and flowers theme. She did three
 outside sketches in magic marker. Usually she puts these "unfinished"
 sketches on the wall, but apart from the first drawing in W-6 does not follow

W–6.5:05

W–6.5:06

Figure 31 Further examples of Louise's drawings (identification numbers are those given in figure 29).

W-7:12

W-7:13

W-7.5:07

W-7.5:08

Figure 31 *(continued)*

W–8:14

W–8:15

W–8.5:09

W–8.5:010

W–8.5:011

W–9:16

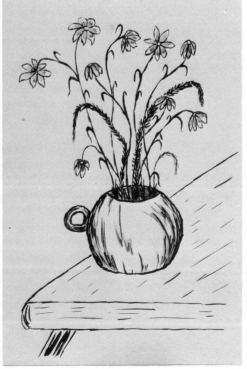

W–9:17

them closely. The "formality" of the laboratory, camera, my assistant and I make her want to do a "finished" drawing. She did two drawings in W-7. In the first, she brought more "solidity" to the drawing (darker tones) as compared with the second drawing in W-6, which was "too light through-out." She seems to waver in search for a balance between "too light" and "too heavy."

In drawing #2 she carried the idea of wall pattern from her sketch to her finished drawing. Since I had commented on the pattern in the sketch, I asked if I influenced her. She said I drew her attention to it, but that it is okay to do so. But she was unhappy with the weight of the pattern.

W-8. Two outside observers came in to take notes while Louise drew. I feared they would affect the atmosphere, but Louise ignored them and worked as usual. Again, the window theme. She had two outside sketches which she put on the wall. These relate directly to her two finished W-8 drawings, although changes in the plants occur. I say "plants" because they seem to be a cross between her trees and flowers. She is working on some synthesis, apparently. The tree-flowers are both inside and outside the window. This is conscious and deliberate, because she leaves spaces open when drawing the bottom window frame and the sill, in preparation for the branch and flowers thrusting through. At the end of drawing #1, after studying it from a distance, she added one last branch (the smallest and lowest). This is of interest because it is a conscious effort to thrust back into space, by means of foreshortening and angle, a device not in her other drawings and sketches.

Both drawings have a shaded upper glass portion, above the open window frame, to show the open and closed parts of the window. Her drawings differ from the sketches today in degree, not kind. (Shading of the closed part of the window was not in the sketch.) She left shading out right next to flower hanging inside to try to make it hang in space.

As in prior weeks, the second drawing is more decorative. It repeats the basic concept of the first drawing, but horizontally, and with several plants, not just one.

W-9. Louise did three outside drawings with magic marker—all of a vase of flowers on a table, seen from above. In the first, the table was too big, the vase too small, she said. In the second, the table was too small, the vase too big. In the third she achieved the proper balance of table and vase. She liked the vase in this sketch, and the sketch was put on the wall.

Before drawing, she commented on the negatives from W-8 process shots. The first drawing of W-8 (vertical window) was "too balanced." She likes more subtle balance than obvious (right-left balance). The second was "like a design—wierd, not real." It was "not a problem of balance, but decorative."

In W-9 drawing #1, she departed considerably from her sketch—vase, flow-ers, table, tones all change. She works within subtle balance (not right-left), containment (not off edge of paper), and what is real (not "design"). Empty spaces not meaningless here, but part of subtle balance, she said. Masculine-feminine aspects again in her thinking. She mentioned finding recently an article in a psychology journal dealing with masculine-feminine aspects of

drawings. (Is this the source of this focus? She is also recently married.) In this drawing she said the gray of pot and flowers makes them more feminine, as contrasted with the table (meant to be hard and rough). She said she was tired of the windows and remembered she likes the balance of chair and flowers in W-1 and W-3 drawings. Found her coffee table at home a good substitute.

In W-9 second drawing, she consciously made the table smaller and the flowers bigger for better balance. This drawing is also vertical (unlike the alternating vertical-horizontal drawings done weekly since W-3), because she *knows* this idea is not one which would work horizontally. She called us over to see the drawing with just twigs and pot. She liked it this way, but she felt she should experiment at home, but do a finished drawing in the laboratory. She made the vase round to balance (contrast with?) the vertical emphasis of the flowers. She didn't like the fact that both were vertical in her first W-9 drawing. She "filled in flower stems to make them heavy enough to hold up the flowers." She found the shape of the vase affected the (cluster) shape of the flowers. The table leg was black in her last two outside sketches. This was okay because the pots were black. But it wasn't right in her first W-9 drawing; better in the second, because it was in between. She added ferns last, "for refinement."

We have now looked at three individuals in some detail, over a bounded series of drawings. The method used may be described as one of observation, interview, interaction, and introspection. More will be said of method later. At this point it is important to try to reflect further on these cases with regard to the title of this chapter.

Certainly an individual myth is created by both the drawing laboratory context and by our exclusive focus on an individual's series of drawings. It is our focus because it includes not only my assistant and me, and any observers who may enter, but also the artist himself, who comes to see himself differently because he is perceived differently. He comes to see himself as the controlling agent, the source of action, evaluation, and direction. His limitations, skills, and misconceptions do not thereby go away. They are the constraints, in addition to those in the immediate environment, through which he as a decision system moves. His secrets come out precisely because he has no reason to conceal them ". . . in order to maintain some given perception of one's self in others,"[26] or, rather, the perception of himself he reads in those around him reinforces the idea that he is an "origin" and not a "pawn."[27]

In a sense, the three concepts in the chapter title are all one. "Forbidden procedures" are in essence prohibitions from the environment (usually from others) that move against the release of idiosyncratic meaning—that peculiar blend of meaning and method locked in the individual history. It matters little that the prohibitions are meant, at least on the surface, for the other's good. Even the mystique of creativity resurrects an idealized notion of behavior at variance with how a given person is able to behave. As such, it creates guilt and undermines self-confidence. Perhaps this is why Lowenfeld is so insistent about the far-reaching ill effects of imposition, copying,

and so forth, on not only the art but the personality of the young child.[28] Under such conditions, the secret of what one really feels and wants is protected or even repressed. This chain of events leads to images that fall apart, to techniques that feel foreign, and to the feeling Milner had about "not being able to paint."[29] In turn, since the individual cannot watch himself drawing effectively under such conditions, he cannot meaningfully bring his processes to consciousness, which means that inner drawing does not occur.

Inner drawing is not meant to be an esoteric concept. At its simplest level, it merely means that there is an ongoing stream of artistic consciousness fed by numerous and unexpected tributaries. As such the concept differs little from any consuming and productive focus of an individual, except that in art we deal with that hard to verbalize and deep and complex situation I have tried to reason about in earlier chapters. It is likely that the productive thrust of other driving passions and motivations is not as appealing, personal and yet real as is art, and certainly not as seemingly unimpeded by external forces. The artist feels he is the means in an open process the end of which must contain surprise. When, as in the series of drawings, directionality emerges, all sorts of influences, accidents, fact and fantasy are transmuted into the next possible link. This is all that inner drawing is about—the symbolic transformation of experience through the life of the mind into potential drawings. Even, as rarely happens, when a person comes to the drawing lab not knowing what to draw, the merest doodle, word, or chance object is enough to start the flow. And the streaming direction behind one shapes the new, often small, bits being processed in the present drawing situation into the next segment of that course.

I have already mentioned that for this process we do not need to invoke "visual conceiving" or any special mental process. It stands to reason that we will imagine *in kind*—that is, if we are drawing we will be inclined to translate into and think in terms of drawings. Certainly, as a potter I can evoke both feel and process of potential forms present in my mind as an image, or a composite of images, which includes pots of mine and of others with whom I identify, as well as the emergent form. As we saw with Dot as compared with Louise, this process differs with the amount and kind of art experience we have had. The difference is both one of complexity and of transformational operations accessible to the artist. It would appear, however, that the abstract artistic or aesthetic concepts discussed in the previous chapters are a very real thing. They are the hidden shapers behind the molecular or tactical medium transformations. Such concepts influence the direction and emphasis of the artist's coding of his imagery, a process reflecting one of the ways in which idiosyncratic meaning accommodates itself to socialized aspects of expression. On the other side, there is an interaction with the image base which renders the artistic and the aesthetic a part of a personal equation. The personal, the artistic, and the technical color each other as part of one integral process, one situational history of acts. A boy currently working in the drawing lab who is not an art major has, nevertheless, highly developed knowledge about art. His technical skills are primitive, but

I expect sudden and comparatively large changes to occur in his work as his medium transformations are enlarged because he has strong personal and artistic forces already at work in his mind. I am continuing him into a second ten weeks partly to check out this prediction.

I had not originally intended to move deeply into case studies. My experiments have always been preceded by pilot ventures and case studies, and I still have the opinion that there will be later experimentation. But it seems wiser to shape one's methods to one's subject of inquiry rather than the other way around, current practice in psychology notwithstanding.

The reader has doubtlessly noticed that in the case studies there is little direct concern with artistic merit. This does not mean that art quality is unimportant to the subject. Far from it. But it is the dual factor of the drawings clearly being one's own plus whatever their qualities may be, especially as compared with one's past qualities, that renders them valuable to the subject. And from our side, trying to understand the thinking and the changes unfolding before us, any a priori notion of quality seems patently out of place. In terms of learning in art, at least, the proper criteria for evaluation in any kind of depth look had better be hewn to the individual case. I rather suspect that "art quality at large," if there is such a thing, or at least in an expanded context, had better be left to that larger context. I believe, but cannot yet give firm evidence for the belief, that quality improvement (by expert consensus) does occur in the cases I have observed. I will one day put it to the test, through both intraindividual and interindividual judgments in which time clues are withheld from the judges. I am more excited, however, about an emerging sense of method of inquiry and what it yields in terms of insights into the thinking processes and their role in learning in art. On the assumption which the clinician must make that "we are all pretty much alike,"[30] I have a hunch that generalizations concerning learning and change in the drawing series will be forthcoming, and that these will subsequently point to experiments and applications in other settings. Now we are too close to individual lawfulness as observed in the single case to do more than speculate on what these generalizations will be like.

The kind of focus we have in the cases above is not meant to be earthshaking. These are unique but not unusual cases. They hint at the roots to the three admittedly unfinished concepts heading this chapter. The thought processes observed in the persons of our focus are far removed from the usual writing on art. They show how our ordinary workaday thought processes can move into depth and include those which we keep somewhat secret, even from ourselves, to come to grips with the problem of art and of learning in art. If it be urged that these cases miss the idea of art altogether, the burden of proof will be on the claimant. As a trained artist and as an amateur potter of professional pretensions, I do not sense the break. The case is more like that of the judge of Old Bailey mentioned by Somerset Maugham, who kept a roll of toilet paper on the bench to remind himself that he had much in common with all other men. But I will confess that the case perspective has drawn me away from strategies and the internal trans-

formational chains and symbolic manipulations taking place in any one drawing process to the concepts, decisions, yes, and accidents shaping the drawing series. As the next chapter will indicate, so far we can only come to understand these forces a posteriori. Now our repertoire is not wide enough to predict or even want to.

NOTES

1. R. G. Collingwood, *The Principles of Art* (original ed., 1938; reprint ed., New York: Oxford University Press, Galaxy Books, 1958), p. 217.

2. John M. Anderson, *The Realm of Art* (University Park: The Pennsylvania State University Press, 1967), p. 23.

3. Collingwood, op. cit., n. 1 chap. 6, pp. 281–82.

4. Beittel, op. cit. (1964), n. 2 chap. 1.

5. Jean Piaget, "Art Education and Child Psychology," in *Education and Art,* ed. Edwin Ziegfeld (UNESCO, 1953), pp. 22–33.

6. Carl R. Rogers, "Learning to be Free," in *Conflict and Creativity,* ed. Seymour M. Farber and Roger H. L. Wilson (New York: McGraw-Hill Book Company, 1963), p. 275.

7. Martin Buber, *I and Thou,* trans. Ronald Gregor Smith (Edinburgh: T. & T. Clark, 1937).

8. John C. Withall, "The Development of a Technique for the Measurement of Social-Emotional Climate in Classrooms," *Journal of Experimental Education* 17 (1949): 347–61.

9. Buber, op. cit., n. 7 chap. 6.

10. Andre Malraux, *The Voices of Silence* (New York: Doubleday & Company, Inc., 1953).

11. E. H. Gombrich, *Art and Illusion* (New York: Pantheon Books, Inc., 1960), 29–30.

12. Loren Eiseley, *The Mind as Nature* (New York: Harper & Row, Publishers, 1962), p. 29.

13. H. Follett and H. G. McCurdy, *Barbara: The Unconscious Mind of a Child Genius,* (Chapel Hill: University of North Carolina Press, 1968), p. v.

14. Hannah Arendt, *The Human Condition* (original ed., 1958; reprint ed., New York: Doubleday and Company, Inc., Anchor Books, 1959), p. 118.

15. William Butler Yeats, *The Autobiography of William Butler Yeats* (New York: Crowell Collier and Macmillan, Inc., 1938).

16. Karl H. Pribram, "Meaning in Education" (Paper presented at the meeting of the American Educational Research Association, Chicago, 1960).

17. John R. Platt, "The Two Faces of Perception," *Main Currents in Modern Thought* 25, no. 1 (September-October 1968), p. 10.

18. Ibid., pp. 14–15.

19. Ibid., p. 14.

20. Ibid., p. 15.

21. John Dewey, *Experience and Nature* (LaSalle, Ill.: Open Court, 1925).

22. Buber, op. cit., n. 7 chap. 6, pp. 10, 14.

23. Marion Milner, *On Not Being Able to Paint* (New York: International Universities Press, 1957).

24. Morse Peckham, *Man's Rage for Chaos* (Philadelphia: Chilton Book Company, 1965), p. 72.

25. Beittel, op. cit. (1964), n. 2 chap. 1.

26. David Bakan, *On Method* (San Francisco: Jossey-Bass, Inc., Publishers, 1967), p. 105.

27. Richard de Charms, *Personal Causation: The Internal Affective Determinants of Behavior* (New York: Academic Press, Inc., 1968), p. 273.

28. Viktor Lowenfeld, *Creative and Mental Growth,* 3d ed. (New York: Crowell Collier and Macmillan, Inc., 1957), p. 5.

29. Milner, op. cit., n. 23 chap. 6.

30. Bakan, op. cit., n. 26 chap. 6, p. 92.

Accident, Counter-Intervention, and Locus of Control

In the simple case studies in the last chapter, one may observe how minute and chance-like are the events that may deflect or set a course of learning. Thus with Ellie we saw the random, tired line which was eventually recognized as isomorphic with a feeling state and projected into a theme "correlating gesture in man and nature." With Dot, the accidental observation that a fellow student was using a white oil crayon led her to solve some of her difficulties by incorporating this slight change of medium. Louise, dwelling on her concern with space, solidity, and femininity, fixed on the window in her English literature classroom, with the solid building and lacey tree observable through it, and carried on variations of this theme for the following three weeks.

In a sense, such events are only chance-like from the point of view of the casual observer. Certainly in each case they fall upon a prepared mind — that is, a mind preoccupied but unknowing about what will provide a push toward the synthesis of the separate pieces of that preoccupation. In each

case the determining event seems unpredictable to us, even as informed observers, but the subsequent course of the drawing series, while not predictable strictly speaking, is certainly congruent with the antecedent course of drawings.

What is hard to comprehend is the arousal value of the particular catalytic event. I can only speculate on how this occurs. It appears that persons have a partly conscious representation of the actual or desired directionality of their ongoing drawing series. What would to an observer be a chance adventitious event leaps to importance for the artist because it can effect a chain of other events leading in some desired direction. This is true even if there is a large element of discovery or surprise in the ramifications of the prepotent occurrence. In fact, this surprisingness may in itself be the desired ingredient. It permits the person to undergo an unexpected transformation. If it does this, the source of the departure is immaterial, for it is only important for what it gets in motion. The fact that such events so often seem incidental and accidental should be properly humbling to anyone hoping to organize the art experiences of another. I take this repeated happening as a further indication of the necessity for acknowledging that the control and guiding center of the process and series lie within the individual artist.

Smaller learnings more closely parallel Gombrich's principles,[1] as when Louise finds her hard, lumpy road really looks soft and uses the same texture in the next drawing to represent a soft fir tree—an example moving from making to matching to redefinition to a new making and matching. The former yields a principle applying to the whole drawing or series of drawings that will follow, the latter is a lesser part, more like a minor technical discovery.

The directionality of the drawing series creates a kind of mild anxiety—a desire to discover what one will do next. The more the drawing series is tied to deeper idiosyncratic meaning and personal metaphor, the greater this anxiety and greater the arousal value of whatever the event, accident, or stimulus that sets up the next drawing situation. The forcible impact of the event is close to its source most often; subsequently it subsides or is disciplined. Thus Louise's window series picks up aspects of prior drawings and after a few later discoveries (in-and-out-of-the-window tree-plant flowers) runs its course. Dot discovers she can get the needed effect without the oil crayon. Ellie works again on simplicity and clarity in the presentation of her discovery.

When the directionality of the series is blocked or misconceived, instead of mild anxiety there appears to be despair or despondency. (An example will shortly follow.) One is reminded of the depression clinicians report as a prelude to a client's insight.

As further illustration of this and related concepts, let us turn to another case study. This example we'll call "Larry." Larry is a junior-year English literature major, with no formal training in art. As before, the initials will stand for the subject (L), the writer (B), and his graduate research assistant (RA). The information will be sampled from the week to week laboratory

notes and from the recorded interview at the tenth week, at which time Larry's entire series of drawings was on the wall. The reader is referred to Figure 32 for the time diagram and numbering system identifying Larry's series. Examples of the drawings themselves are given in Figure 33.

From the Weekly Notes

W-1. Drew from the still-life (W-1:1). Took liberties: changed sizes (made screen smaller to fit it in), showed line of drawer which was not visible to him, adjusted forms to page, was conscious of choosing simpler elements.

He mentioned he has read Dewey's *Art as Experience* and Joyce's *Portrait of the Artist as a Young Man;* also mentioned a philosophy professor at Hazeltown campus who taught him Humanities.

He sees a connection between literature and art. Seems careful, thoughtful, but not overly tight or dependent on stimulus. Said he is trying to get used to pen and ink.

W-2. Spent 15 minutes on process negatives. Interested in translation of visual impressions into pen marks. He is conscious of relating things on the page.

Today he worked out problems of light and shade on a sphere, using a round pot. Interestingly, he used black lines for both light and shadow on a spherical form. He became aware of the effect of changed pressure and broken outline on a spherical form.

He then spent considerable time on a careful drawing of the shoe (W-2:3) from the still life. His exploratory drawing was very primitive compared to his finished drawing ("like a cave man's," he said).

W-3. In looking at negatives, he became aware of the effect of different weights of line and how these relate to light-shade and "perspective" (his word for form).

On the shoe (W-2:3) he worked on texture ("what the material is") and light-shade, the latter more or less superimposed on the texture. Both concepts are translated into pen and ink language—what he calls "pen figures"—to be built into the drawing. He felt the "figure" for texture had to be different from that for light and shade, but then found they seemed to interact confusedly.

He appears to work both on concept (the pen language level, away from

Figure 32 Time diagram of Larry's drawings in the drawing laboratory. Note: In the text, a drawing is indicated by both week and drawing number: thus W-8:14 means drawing number 14, which occurred in week 8.

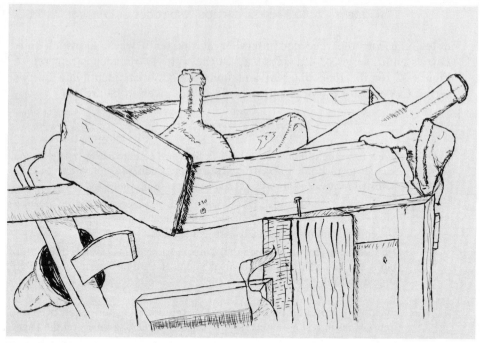

W-1:1

W-2:2

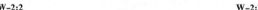

W-2:3

Figure 33 Examples of Larry's drawings (identification numbers are those given in Figure 32).

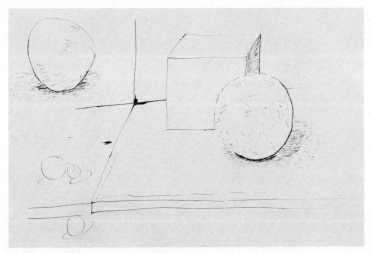

W–3:4

W–3:5

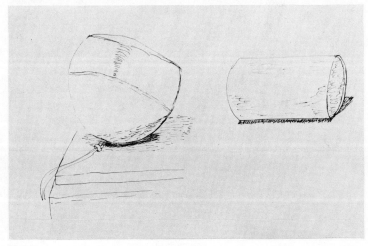

W–3:6

Figure 33 (continued)

W–4:7

W–4:8

W–4:9

W–5:10

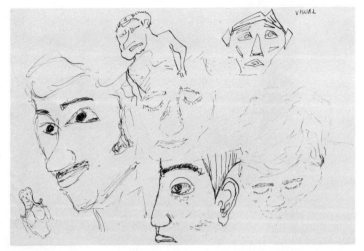

W–5:11

W–8:13 **W–7:12**

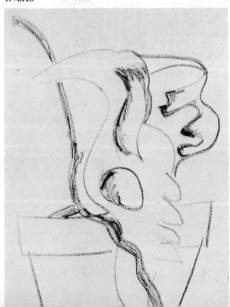

W–8:14

Figure 33 (continued)

W–8:15

W–8:16

W–9:17

W–9:18

W–9:19 W–9:20

objects) and also directly from objects, but conscious of the difference between what he does in the drawing and what's "out there."

Today, he is drawing from a sphere, cube, cylinder set-up in the corner of the room (white, textureless forms from a doctoral candidate's perception experiment). In his sphere sketches (W-3:4, 5, 6) he worked out the light-shade problem (still using dark lines for both high light and shadow) and discovered that a sphere has an "elliptical shadow" (his words). He carried these principles into the drawing of a tree, but was unhappy with the shadow, an ellipse which did not hold its place on the plane.

On the same drawing (W-3:5) he used different weight lines on the tree trunk to *simultaneously* show bark texture and light-shade—a problem he had not been able to resolve in his shoe (W-2:3). He was not aware of this solution when he was drawing, because he was focusing on the spherical tree and its shadow. He became aware after doing it and drew additional lines to illustrate the discovery and show it to us.

He said at the end of the period that he wants to master such means and methods so he can arrive at "lifelikeness" and "feeling," as in drawing a face. He said: "Now I'm like a person learning to use the hammer and saw so he can build something."

W-4. Made several outside sketches in his notebook: Beatles, a section of Guer-nica, and his own pipe. He liked the in and out spatial quality of the Beatles' photograph and had a free feeling in copying the Guernica (said: "My kind of man—no perspective!"). He had studied Guernica earlier in art history, said: "It really blew my mind."

179

Today he asked for the large photograph earlier apparent in the room (portrait of a girl), but which we had concealed. He made three rather free drawings (W-4:7, 8, 9), the first two in crayon, the third in pen and ink. He found the difference between the photograph and the drawings more disturbing than between objects physically present and drawings.

W-5. Studied negatives. I was humbled by what I could *not* see he had accomplished until the process shots stimulated his recall. In W-4:9, in pen and ink, he continued his conquests of prior weeks. He began with the hair, but without outline, at the forehead, and varied the light-shade and texture simultaneously by *direct* pen strokes ("not by going over"), thus clinching what he had discovered on the tree trunk (W-3:5). Lines appear loose and open. He says he visualizes the whole first pretty much. He treated all the features by his open concept except the lips, which he said were "out of place." He still had a problem, he said, with showing the projection of a rounded form.

Today is drawing an art education senior, W_____, from life. He liked the first drawing (W-5:10) until he added features. Felt chin was wrong. In second drawing (W-5:11), he drew a series of heads, side by side.

W-6. In viewing negatives, he pointed out the gestural correctness of W-5:10 before he added the features. Said he "avoided" the features. Was struggling with foreshortening (he didn't use this word, but "angle"). "Couldn't get the right chin-forehead line." Moved his thumbs with touching forefingers like a tilting plane to demonstrate his meaning. Got everything in line but features. In one of the W-5:11 sketches of heads he achieved the right combination. On this same drawing there appear some schematic, semi-abstract heads. He mentioned how he both flattened and formed the nose in the upper right schematic head. He had written the word "visual" beside it to tell us something important (perhaps on the relationship between the visual and the schematic?) but he couldn't recapture it. He discussed "expression, which is the main thing in a face," and how this differs from realism.

No drawings were done in W-6. Instead Larry and W_____ talked the remainder of the period, after reviewing the negatives. We did not monitor the talk, which seemed spontaneous and a good dialogue. W_____ said later that they were both amazed how easily they could talk with each other. W_____ said he pushed the importance of "confidence in his own thing"—whatever it seemed like, and they talked about drawing as compared with literature. The talk was apparently stimulating to both W_____ and Larry, both of whom seemed to think such occasions uncommon.

W-7. By a kind of tacit understanding, Larry went to drawing at once, but wasn't sure what he would draw. He studied the still life. Focused on the window screen and the moiré effect of its fold. He worked out two pen "figures" (≡≡≡ and ╪╪╪) to signify the lighter and darker patterns. He placed the whole form carefully on the page (with respect to page edges; see W-7:12). Put in all light units first, then all dark ones, varying both figures

in weight and density of placement. He deliberately gave no context to identify the form as screen, landscape, or whatever. He later connected his desire to leave it open to the feeling he got at the Flavin light exhibition and the Montenegro exhibition he had recently seen. When questioned, he saw a virtue in the drawing's ambiguity. Said his approach was under a different attitude, not bringing to bear as many rules and technical requirements before beginning, and relaxing his first-the-tools-then-the-building theory.

W-8. During this hour, Larry made four drawings. One, W-8:14, paralleled the screen symbol (W-7:12) in concealing its origin and remaining direct and ambiguous, without context. It was in charcoal, freely attacked, representing a section of wood from the still life. He also drew freely from the still life, changing placement of parts (skull, flower-pot and branch, in W-8:13), made a "doodle figure" (something he had done when a child, W-8:15), and experimented with pen and brush (W-8:16). Said he enjoys people who take themselves, him, and their work seriously.

W-9. W_____ posed again, for first drawing, a pen portrait, using only fine lines. Felt it didn't succeed too well. He had in mind a pen portrait a friend, an art major, had drawn. Said he got some of the quality he wanted. Finished the head and other parts with the brush. W_____ later remarked on the free handling of the collar. Larry said "thanks" with feeling.

W-9:18 was pure brush experimentation (dry brush, wet, dark, light, big stroke, small stroke). He made dividing lines abstractly, then applied different strokes, values, textures.

W-9:19 was direct and free brush work off the still life. He said later he liked the feel of release after the slow, scratchy pen lines.

W-9:20 was a "Giacommeti man" (at first he couldn't recall the sculptor's name), done with the large, one-inch brush. Tall, thin, with a large base. Larry felt it should have been still taller and thinner but was obviously pleased with it. Since it was Larry's last drawing, we stated our feeling that it was expressive and successful to us too. A discussion ensued on brush versus pen.

The following excerpts are from the recorded interview during the tenth and last week of the series, with all of Larry's 20 drawings on the wall. (Identification symbols: *L* = Larry, *B* = Beittel, *RA* = Research Assistant.)

B: What do you sense in looking them over? Suppose you take the lead.

L: There's a divide that happens at #12. You can see that before that I was attempting realism all the time, and my studies were mainly trying to get perspective and control the pen.

B: That was a break because you used the means, the various pen strokes you developed, for a new kind of purpose.

L: Yeah. It wasn't an attempt at being realistic.

B: Did you feel like you were preparing for this before?

L: Yeah, I noticed in the last studies [W-5:11] a kind of freeing,

RA: There were 2 weeks in between—the one before was a discussion period.

L: Yeah, and I saw a few works of art—different shows: the light show and the one in Chambers Building Gallery. I guess I sort of thought about them. I guess I loosened up a bit. I was getting really frustrated trying to present things realistically.

B: Even though you made some headway mastering realistic problems, like shading translated into pen lines, and shading plus texture. Then you set yourself harder problems, like the foreshortening of a tilted head, and learned to free up a bit through several trials on the same page.

L: I really was tight. It was getting really depressing.

B: You felt tight?

RA: Did you feel depressed or did you feel tight? Or are they the same?

L: They're not the same. In my drawing I felt tight, but I was depressed because I wasn't doing as well as I wanted. I thought I had made some gains. It's not that I didn't feel I wasn't getting anywhere. But trying to do it on my own I thought I had about come to the point where I wasn't going to get any better, unless maybe if I learned some techniques—say, if one of you would sit down and work with me. I didn't think I could go any further just exploring on my own.

B: At what point was that?

L: Numbers 10, 11; that week [W-5].

B: There you would have welcomed some direct instruction?

L: Yeah.

B: Up to then it didn't matter as much?

L: No I was moving along. I was still exploring up to then. But when I tried to do W_____ (posing), that really put me down for a while.

B: You were trying to free up even back in #7 and #8, when you drew from the large photo portrait in the room.

L: Yeah. I was exploring the crayon in the one, charcoal in the other.

B: Then in #9 you went back to pen. You really did learn to vary pen strokes. Earlier, you learned almost by mistake about representing texture and light and shade at one time [W-3:5].

L: Yeah, I think you'll see on the side how the lines, just the little scribbling lines, were thinner or darker showing the shading and the texture on the tree trunk. I was fooling around, even before, with all kinds of squiggly pen lines, trying to get different effects.

B: That makes #12 more understandable, in a way, because you were doing this kind of thing but tying it down to realistic portrayal, but here you freely translated something that was a stimulus (the screen of the still life) into pen strokes that had a different meaning. Kind of like a transformational leap, in a way.

L: Yeah. Using the same techniques but using them to a different end.

B: Is it fair to say that this becomes more symbolic to you? Don't ask me what I mean by that. If you can accept it, without my telling you, because I can't. It means something else, more than just representation?

L: Yeah. It's more of an effect. A feeling rather than just representation.

B: Do you feel you have to know what it means?

L: Not really.

RA: Did you think about it before you did it? I mean, when you put the pen lines down did you know what it was going to mean? Or did it come as you were doing it? Or after?

L: The pen lines—I don't know just what you mean by pen lines.

RA: Well, you knew it was a screen, but did you know it was going to be an abstract form?

L: Yeah, I did. I had that in mind when I started out.

B: You did mention some of the things that might have led to that—the art shows, and possibly the discussion with W⎯⎯. These helped to prepare the way, along with your exploration in 10 and 11?

L: Yeah.

B: And in #14. Is this a similar type of thing to #12?

L: Yeah, only it's a little freer. It wasn't taken from any model. It was a little more playful.

B: Do 13 and 15 retain some of that playful quality too?

L: Yeah.

B: What does the playfulness do for you?

L: It gives a different feeling when you're doing it. I'm not sure whether it's important in the result or not.

B: When you came to 20, that's your favorite, you said, you felt pretty good about that. Is that playful? Is it different from, say 15?

L: It's different from 15. In 15, I filled the paper with lines, then I—kind of free association, doodle technique. For 20, I had the figure in mind, after I had been playing with the brush strokes. A completely different feel. I did that, and it just worked.

B: It was like a coming together of things? You had an image and like a synthesis?

L: A synthesis.

B: And 18 and 19 were preparations?

L: Yeah. Because prior to that I had hardly used the heavy brush at all.

B: This [W-9:18] is a different tactic from when you were learning to use the pen.

L: No, I didn't do it then.

B: There your pen was tied to the problem of representation, but here you were willing to use the brush texturally and freely to see what it would do, then put it to use. You said you used the biggest brush at 19, and you didn't think you could, and then you carried that over into 20.

L: Number 18 was definitely seeing how the brush worked and it was, as you said, divorced from any representation.

B: What's the difference between your doing that and, say, if back at #2, we had said, "Larry, we'd like you to do a page of pen textures, and exercises, playfully—just do them."

L: I might have tried to be a little more finished about it.

B: If we had set the problem?

L: Yeah.

B: As you'd try to think more about what we had in mind for you to do?

L: Exactly.

RA: Is there a difference between #14 and #19?

L: Number 14 is just something that struck me—a dark piece of wood. I had the charcoal, and I liked putting all the darkness down—just an effect that I liked after playing with the scratchy pen. Number 19 was just parts of the still life taken, just very cursorily. The shoe's in there, the horn—(laughs) maybe W_____'s in there too. Don't tell him.

B: In #17 did you find out as much about the brush as in #18?

L: Number 17 led to #18. Number 17 was more deliberate. I realized that the brush was used very artificially in #17.

B: This feeling of freedom—is that fairly important to you? Freedom of handling?

L: Yeah.

B: Yet there's a kind of discipline in #12, but it doesn't seem not free.

L: It was carefully put down, though it was a free feeling that I had doing it.

RA: Suppose, back in #10 and #11, you had asked us for help—you didn't—and we had said yes. Do you think #20 would have happened? I mean, you were forced into a change just through not being able to draw. Do you think you could have arrived at as good a solution as some of these, through the technical proficiency?

L: I guess it would have depended on you and what you would have told me as to the way I'd have gone. As far as the outcomes—I don't know.

RA: Suppose we had taught you what you thought you didn't know in #10 and #11.

L: You'd have taught me perspective and foreshortening. I probably would be hung up yet on that.

B: We would have been inclined to read your direction up through #11 as not including #12 on, because you weren't struggling with these latter things. If you had said, "How about some help with drawing tilted heads," and we'd said, "We'd like you to do some abstractions." (All laugh.) We wouldn't have been apt to do that.

L: Yeah. I guess I would have ended up with another drawing of W_____. Maybe a little better.

B: It would have been a different history. We don't know how it would have worked out.

L: There would have been no #20.

B: We developed the image of you as a kind of agent finding his way. It's hard to express these things. Do you know what I mean? Our role is to try to understand what you've found and are trying to find, but not to set the path. We'd like to help you find a path, by trying to communicate with you, trying to understand what you're doing.

L: It helps to jell your thoughts.

B: By circulating ideas around?

L: You're a little more aware of what you're doing.

B: We probably would have resisted—begged out. We'd have tried to get you to say what it is you need to learn and maybe talked about possible strategies or asked you where you felt you succeeded better at it. We might sometime want to study interpolating instruction, when a person asks for it only. Past experience has shown us that if a person isn't too self-critical, he'd want our criticism early, and feel funny if he's not getting any.

RA: You didn't feel this? If it had been a class, we might have critted your first drawing and told you what was wrong or how you might increase this or that quality. But we didn't. You went on to other drawings and we didn't tell you how to get more of this or that. But that didn't bother you. Or did it?

L: No. Not until #10 and #11.

B: We learned that those who wanted crits and felt some anxiety at not getting any, later would say they thought it was better if they had none. It's not that, in your case, we'd not be interested in your facing the problem, if you felt one. But we'd try to get you to talk about it and probably not suggest a solution or give direct instruction. That's what we did back here. You said you wanted some round things to study light and shading, so we said there are some in the room. But you had to bring the problem out. . . .

RA: Do you remember at #7, 8, and 9 whether they were sketches or drawings just done fast?

L: They were just fast drawings in themselves. It was the first time I used the crayon, in the one, and the conté in the other.

B: That's when W_____ and K_____ first came in to observe. Did that have any effect on you?

L: No. I was just sorry I picked up the crayon. No. Everyone was friendly and interested. It might have even helped.

RA: Did this environment have any effect on you? Should it be changed in any way?

L: I thought it was pretty good. That old still life is pretty important.

B: Is it something to fall back on or depart from?

L: The white surroundings are kind of bare. I don't know if it had an effect or not.

B: Taking the pictures, etc., did that bring a certain seriousness to it all? Good or bad? One girl said probably she'd have been freer in her dorm room. Wilder, as she put it. Also, she'd have drawn things she's more used to. Did you feel this?

L: Not very much. If I were at home, I'm sure I'd have drawn different things. I don't know if it was that big a thing, though.

RA: How about looking at the negatives?

L: I think it's helpful. It helps you make more progress because you can get warmed up and feel for what you've been doing. I guess it helps you keep on the track somewhat.

B: Kind of like going back a little before you go forward?

L: Yeah.

RA: Was any time more important than another in this?

L: I think the middle part, and the first half, were the most significant, because that's when I was most concerned with the processes; and we could go from point to point and look how it came about.

B: It helped us, because in looking back, you were able to recreate the thing for us and share the process.

L: Yeah.

RA: But the camera feedback wouldn't be as important for these end ones? Why was that?

L: It was just done more quickly, so I knew there were less pictures taken, so I didn't tend to rely on them as much. I don't know why they were more important earlier—whether I relied on them or just knew I'd have them to rely on.

B: In these later ones, would you say you had a stronger image of what you wanted beforehand?

L: Umhmm. Yeah.

B: I don't mean like a picture in your head, but kind of like drawing without drawing.

L: Sort of a feeling. It's more prominent in the end result. I think it is, really. I'm closer to these than those, in time, but if I were to come back in a few weeks, I'd still get that feeling.

RA: Is it because the criteria earlier were more from outside, later more from inside? For example, if you were to continue the ideas before #12, would the feedback have helped more?

L: Yeah. When I'm trying to hit the technical aspects, they're not as easy to keep in mind. The image isn't as vivid.

B: These, if they went on after #20, might get more complex, they might go too far. This often happens to art-trained people, who'll say it was good up to a certain point—especially if they like to work freely.

RA: Where will you go from here?

L: I don't know. I was thinking of buying some supplies. I think I'd like to try some color. I like the idea of the brush. I don't know what I would do with it, though. I guess I would like to do some kooky things just now. Big pieces of paper.

A LOW POINT

With Larry, as earlier with Ellie, we see a low point, close to depression, preceding a marked change in the drawing series. In both instances there was evidence of learning having occurred up to the turning point, but apparently it was the wrong kind of learning—too close to one's expectancy to seem significant. It is as though in the absence of an active teacher the student artist's superego takes over and supplies the problems, the goals for what one ought to learn. But even when these succeed, disillusionment sets in. There is no arousal value in them for the artist. Having achieved them, they seem all too predictable.

In a sense, this is true even with a goal a person is doubtful of achieving. Here is a brief excerpt of an interview with another student, whom we'll call "Paula":

RA: Is there any point in the series that was significant—not just a picture, maybe, but a session?

P: I remember when I did that pot over there, I thought: "Well, now I know I can do a pot, and I can draw anything—anything sort of like that, so that it means nothing." I know I can draw it so it doesn't mean anything to me.

B: No more a challenge?

P: Yeah. If I can do it, then it couldn't be very hard—anybody can do it. So I thought, "I'm bored."

In this same vein one could refer again to Marion Milner's book *On Not Being Able to Paint.*[2] Milner apparently had to give up her problem-oriented and instruction-directed efforts and turn to doodling, to "free-association" drawing, to relax her overtight expectancies and allow drawings to occur which aroused her interest and, she felt, probed deeper levels of meaning for her.

We often seem to meet this fearful, unconfident, tight syndrome which moves toward a low point of discouragement, even when progressing toward avowed goals, which is then reversed by some seeming accident or relaxation during the drawing process, springing like a discovery into the series. As Ellie put it: "I just didn't care anymore, and I thought I would just do what I feel, and that is what I felt." With Larry we see a sharp departure from complete mastery of realistic representation in favor of an accommodation of his pen figures, to his free feeling, which meant for him something open and ambiguous enough to have symbolic overtones. Quite a number of the untrained people we have studied emphasize the importance of the achievement of what they call feeling in their work, thus lending credence to Langer's equivalence of form and feeling, or of shaped and objectified feeling.[3]

I am not suggesting, however, that discouragement and depression are in themselves important in sparking a learning spurt. They are more

likely symptomatic of an accumulating awareness that one's chosen direction doesn't have its base in idiosyncratic meaning or personal interest. Terms like *accident* gain their definition from contextual properties of the series which is their ground. It is this which makes the mind prepared to make something of their unexpectedness. And they are often little things, like the white oil crayon Dot used. Another brief excerpt from the interview with Paula illustrates this.

 B: What are the things you learned in your series?

 P: I think I've learned . . . it seems like little stupid things; like about the eyes, that they get real dark in here. And, like the shoe. I just drew lines. I'd make straight lines but I didn't know how. I still don't really, but at least I can feel sort of some way to make them.

 RA: Where in the shoe don't the lines run right?

 P: Oh, they're bad.

 RA: Where are they better?

 P: In #9, I think—the ones around the mouth and the chin. I like the chin. I think I've gotten better.

 B: What did you have to learn to do with the lines in #9?

 P: I learned you couldn't make them straight and you couldn't make them with crayon (laughs). . . .

 B: We have a person who likes his drawings incomplete, who claims he leaves things incomplete out of fear. He'll begin, say, with an eye and go on to the nose if it's good. If it's not he'll stop. So he goes on to the point where he can't risk anymore.

 P: I do that some. I feel like I'm going to wreck it if I make another line.

 B: That's one of the reasons you like a more plastic medium, like charcoal, I gather.

 P: Yeah. I like to feel it with my fingers.

 B: And you did learn to incorporate what you called errors in #10 and #11.

 P: Yeah. I found, like when I draw, if my first lines are good, and I keep going on and they get ugly, I get discouraged; and if I keep on working on it, pretty soon it'd better again—you know, good, bad, then good. Sometimes I won't do it because I'll get too sick of the thing and think it's really ugly. But usually if I stick to it, it comes out okay.

 The first part of the excerpt from Paula's interview indicates the kinds of "little stupid things" connected with learning in drawing, as seen from the agent's side. The second part demonstrates how a person learns to accommodate himself and his feelings to the dynamic aspect of the drawing process and series. Even when the person is more fluent, when more inner drawing can take place, this constantly occurs. Another girl put this very well:

> I like to draw from imagination. I've done this for some time. Imagination is drawing what you want to see. When there's a model right in front of you, you can't do this. It directs you, and you forget what you want to see. Imagination will correct for what you can't do, because you know whether you can do it, or change it to what you can do. You have to make a compromise.

In the earlier examples, it appeared that the artist often had to abandon his self-imposed learning disciplines if feeling were absent from them. At other times some event occurred in-process which was sufficiently different from his expectancies to have strong arousal value for him. When such an event or accident happened during a low point of discouragement, the person felt elation.

At this point it is appropriate to make some connections with other literature. When a person in a drawing series learns to give up his tight hold on certain outcomes, largely pseudo problems dictated by his inadequacies and his conception of what drawing should be, he approaches drawing as something intrinsically rewarding. He allows his feelings to live in the process. He participates and contributes to a movement, to a path, as Anderson[4] puts it, which leads to an aesthetic occasion. Under these conditions, certain discrepancies from expectations are likely to be pleasurable. Such a formulation has much in common with the so-called discrepancy hypothesis, which may be stated thus:

> Small discrepancies of stimulus intensity from the adaptation level of the organism produce positive affect: large discrepancies produce negative affect.[5]

This hypothesis, though vague in many ways, is thought by many psychologists to have relevance for aesthetic experience. We have seen possible use of such a principle in some of the criteria isolated within drawing strategies (in Chapter 4), "theme and variations," for example. As de Charms, the author from whom the definition was quoted, points out, we deal here with "expectation level" rather than "adaptation level," that is, with learned and often conscious behavior, in which case we must define whatever expectation the discrepancy hypothesis is referred to ". . . relative to the past experience of the perceiving organism."[6]

DEPARTURES FROM EXPECTATIONS

We have earlier referred to Berlyne's work with its explicit mention of the "arousal potential" of "collative variables," that is, those which ". . . depend on the collation, or comparison, of information from different sources," such things as ". . . *novelty, surprisingness, change, ambiguity, blurredness,* and the power to induce *uncertainty*."[7] Here, too, there is an expectation

level and some degree of departure from it implied. Thus Berlyne suggests some of the kinds of expectation levels that can function within any given person's drawing process and drawing series. To make such an application, however, as I hope the case histories demonstrate, it is essential to define what is ambiguous or novel to a particular person in a particular process or series.

Berlyne has introduced another concept useful in this context—that of the "arousal jag."

> We are far from being in a position to characterize in detail the conditions in which increases in drive are sought and to differentiate them from those in which they are avoided. But as far as we can see at present, the important ones are (1) that the drive is aroused to a moderate extent, and (2) that the arousal is promptly followed by relief.
>
> Both of these conditions have been cited by Hebb (1949, 1955) as those in which arousal or emotion will be pleasurable, and they are implied by Meyer's (1956) hypothesis that emotion is pleasurable when we feel that the situation is under control.
>
> Some psychoanalytic writers might be inclined to assume that if fear, pain, or other forms of distress are actively courted, it must be for the sake of self-punishment as a means of assuaging guilt feelings. This may conceivably be a contributory condition at times, but the evident importance of quick relief in most of the pertinent cases argues against this view.
>
> . . . There is, however, another psychoanalytical interpretation of apparently self-persecuting behavior that is closer to ours. This is the theory of "belated mastery" (Fenichel, 1945), according to which experiences that originally produced anxiety are repeated as a means of gaining control over them. As Fenichel puts it, "An expenditure of energy is associated with anxiety or the fearful expectation felt by a person who is uncertain whether he will be able to master an unexpected excitation. The sudden cessation of this expenditure brings its relieving discharge which is experienced by the successful ego as a "triumph" and enjoyed as functional pleasure. . . . When a child is tossed in the air by an adult and caught [and] is certain that he will not be dropped, he can take pleasure in having thought that he might have been dropped; he may shudder a little, but then realize that this fear was unnecessary. To make this pleasure possible, conditions of reassurance must be fulfilled. The child must have confidence in the adult who is playing with him and the height must not be too great."
>
> This is precisely the kind of process that we shall assume to occur in connection with arousal. In fact, we shall assume that it is at work whenever a momentary rise in arousal potential . . . is rewarding in the absence of a previous and independently produced spell of severe supraoptimal arousal. Such slight and transitory jumps in arousal will become pleasurable as a consequence of the drop in arousal that quickly terminates them. Consequently, behavior that is regularly followed by such *arousal jags,* as we shall call them, will be learned.[8]

Despite the long quote from Berlyne and the previous mention of the discrepancy hypothesis, these concepts are presented only as plausible partial explanations for what we observe during the drawing process and series. The discrepancy hypothesis and the arousal jag theory, dealing as they do with learned expectations and a particular sequence of events, offer solace in the

form of theory at a very abstract and empty level, for the most that they do, in our observations, is to give a name to a history taking myriad forms. It is true that we might be able eventually to predict in a given case, given a sufficient longitudinal base, the general kinds of expectations and departures therefrom that would stimulate a given person during his drawing process. Even here, some caution is suggested, because we deal with *perceived* discrepancies from expectations.

The arousal jag concept fits very poorly what we sense during a drawing series when accidents, "stupid little things," chance juxtapositions, and general relaxation deflect a course of events which was becoming progressively painful. For one thing, the painful sequence, cumulative and seemingly irreversible to the agent, was not sought after. Rather let us say that the direction was self-imposed, but its punishing aspects were unintended. They were to have led to mastery. Still the relief that comes from the deflection or change has something of this notion attached to it. It is as though unconsciously the student artist has given himself this frustrating beginning in order to be eventually relieved of it. The chief merit of the concept is that it is dynamic, idiosyncratic in its workings, and context-bound, and these are the very conditions operating in the drawing series.

To be sure, the people drawing in the bounded context of the drawing laboratory are provided "psychological safety" and encouraged toward an "internal locus of evaluation" which Rogers finds conducive to creative action.[9] We have already given evidence that the drawing laboratory allows persons to face their anxiety and to work at belated mastery on the fearful idea that they can direct their own learning in drawing and arrive at some experience of art and at a kind of personal identity related to it.

The writer must confess that he is all too ready to *believe* in self-identity, as in idiosyncratic meaning and in like concepts, a belief which a skeptic would be quick to attack. It is closer to the truth to believe in the human *search* for these concepts than in their bald existence. David Hume reminds us that we are

> . . . nothing but a bundle or collection of different perceptions, which succeed each other with an inconceivable rapidity, and are in a perpetual flux and movement. Our eyes cannot turn in their sockets without varying our perceptions. Our thought is still more variable than our sight, and all our other senses and faculties contribute to this change; nor is there any single power of the soul, which remains unalterably the same, perhaps for one moment.[10]

He later informs us that ". . . identity is nothing really belonging to these different perceptions and uniting them together, but is merely a quality which we attribute to them because of the union of their ideas in the imagination when we reflect upon them."[11] Only on the relations formed by resemblance, contiguity, and causation, he says, can the concept of identity be built up.

> We only *feel* a connection or determination of the thought to pass from one object to another. It follows, therefore, that the thought alone finds personal iden-

tity when, reflecting on the train of past perceptions that compose a mind, the ideas of them are felt to be connected together and naturally introduce each other.[12]

SEARCH FOR SELF-IDENTITY

It may still follow that the penchant to conceive of self-identity is encouraged under one set of circumstances and impeded under another. In a time when alienation is a common word, when many feel manipulated by the very conditions making their lives comfortable and secure, the search for self-identity reveals the absence of any cementing myths. The "individual myth," discussed in Chapter 6, then becomes none other than the search for, or the forming of, self-identity. The bounded context of the drawing laboratory, the self-reflective process feedback, the effort at communication and understanding, the cumulative thrust of the drawing series—all of these underscore resemblance, contiguity, and causation, those principles which Hume admitted worked toward relating the "distinct existences" which compose the mind. It is in this emergence, this drift, that the observed therapeutic aspect of working in the drawing laboratory undoubtedly resides. Perhaps it is also common to all complex learning involving cognition, thinking, and insight. And much more so does it seem to adhere to learning that feels close to the self and under one's own direction.

Of the individuals we have observed in the drawing laboratory, each in his own way has come to view himself in his drawing activity as the locus of causation. In some instances, it could be said that an individual has come to this view *in the course of* his work in the laboratory. In almost all cases a strengthening of this perception of the artistic self as an active, determining origin has been observed. By the term "locus of causation" we mean exactly what de Charms means by "personal causation":

Personal causation is the initiation by an individual of behavior intended to produce a change in his environment.[13] . . . Personal causation is . . . the knowledge of oneself as a causal and motivated person, and, in addition, personal causation forms the basis upon which all men learn to attribute motives to other people and ultimately to attribute causes in the physical world.[14]

Except for the last sentence above, in which, following Piaget, de Charms points out that our notion of physical causation stems from our knowledge of ourselves as loci of causality, the concept of personal causation offers very little difficulty to the artist, whatever problems it may pose for the psychologists and philosophers. Anderson points out that the artist's response to his medium ". . . is an act involving causal agency, but also guided by a heightened sense of possibility."[15] Certainly our emphasis on cybernetics, on the artist as a problem-controlling decision-system transforming feedback toward desired states, leaves no doubt on this score.

Still we are plunged into seeming contradictions. We set out to study

mind and context in the drawing process and the drawing series, we do not intend to teach, and we end up increasing a person's motivation and sense of personal causation. We leave off seeing the person as subject or object, and instead know him through stirrings in ourselves. It is small wonder that most psychologists gave up the study of mind for behavior. The contradiction rests at base in Titchener's formulation: ". . . the mind which we study is the mind by which we study, or the intentional experiences which we seek to know are the intentional experiences whereby we know."[16] But the difference is that I now take Titchener's statement, intended as negative, positively. If, as Anderson insists,[17] we accept art as an ultimate beyond which we cannot go, it is only as participant observers, or rather as *observer participants* that we can enter into its human study. As in Polanyi's interpretation, we use ourselves as probes to understand, and thus ". . . we know more than we can tell."[18] De Charms feels that we can learn to discipline this kind of knowledge, through a search for ". . . techniques of validating personal knowledge and making it reliable as an adjunct to, not as a substitute for, the techniques we have already devised for obtaining knowledge of objective facts."[19]

As Bakan observes, we have much to learn from psychoanalysis and introspection, two oft-maligned emphases in psychology. Psychoanalysis creates a depth image of what is "intimately personal." But whereas the major objective of psychoanalysis is therapy, "the major objective of the classical introspectionists was the acquisition of knowledge."[20]

More crucial, perhaps, is our tendency as observer participants "to look ourselves in the eye" as we strive to understand each other. As Buber[21] and Bakan[22] both put it, when we try to describe what man is, we are involved with statements about what man ought to be—the descriptive is entangled with the normative.

We are in need of a process psychology and a process philosophy. While we are no less men as artists (whenever "arting" occurs), it is the bounded character of ourselves as men that makes us reach out toward art. The series perspective in a bounded context forms our concept of the emergence of learning in art in a dynamic fashion. It is quite like the "exfoliation," the "flowering into a variety of meanings," the bursting "into multiple emotions and a plenum of images" of which Anderson poetically speaks in describing the role of symbols in art.[23] A process philosophy means precisely that we cannot settle for invariant contents but must look to the shape and pattern of the movement, the emergence, itself. The movement of the suggested meanings (symbols) in an art work, for example, Anderson says reveals the nature of the movement itself:

> Its nature is to be found not in the meanings which are suggested, but in the movement toward them; a movement which—as developing toward these meanings in disclosing content—testifies to the accessibility of this disclosure to man, and to the effectiveness of man's participation in the disclosure. Participation in an aesthetic occasion is not only accident; those activities leading into it are not entered upon merely by chance—this becomes clear when they are seen as an expression of human nature in their efflorescence into a myriad of meanings.[24]

I would like to claim for the aesthetic learning series what Anderson does for the aesthetic occasion. The notion is so pervasively abstract that I cannot present it well. It points toward a process psychology of learning in art. There is, in the individual's drawing series, an efflorescence into a myriad of artistic occasions, which is an expression of human nature operating as it *both does and ought to* in learning in art. These artistic occasions or achievements are not to be comprehended or judged in any absolute sense or even comparatively, intersubjectively, because the nature of the learning resides in the very movement toward these flowering achievements, and not in the achievements themselves. This alone constitutes learning to learn in art from the perspective of the open drawing series. Mastery is nothing other than the readiness, even as Anderson[25] claims for the aesthetic occasion, to enter into the process as a participant and a contributor. The drawing series is then approached in much the same mental attitude as the creative process conceptualized by Ehrenzweig[26] and earlier discussed in this book—as a path with unexpected branchings opening up into unforeseen possibilities. Though we approach our work feeling that we are the locus of causality, we are hopeful that we will arrive at what is other than ourselves in the process. In this respect our artistic self-identity is something of a contradiction in that it stands for a constant search for renewal and extension. We are helmsmen but want a true dialogue—that is, feedback diverging from our expectations but having the character of development.

ARTICULATION

Various terms I have coined or adopted echo the depth image and the dwelling upon what is "intimately personal" which above I said was associated with psychoanalysis. It would be unfortunate, however, were these to be seen as synonymous with psychoanalytic usage. In one sense both the terms I use and those of psychoanalysis are metaphors for what otherwise eludes expression in discourse. To refer again to the quotation from Gombrich quoted in Chapter 4:

To the artist the image in the unconscious is as mythical and useless an idea as was the image on the retina. There is no shortcut to articulation.[27]

It is the last sentence which is crucial: *there is no shortcut to articulation.* By stressing the necessary ambiguity of our symbols in art, we did not mean either that their meanings were fixed or that they were inaccessible to us. Following Anderson,[28] we would say it is the exfoliation brought about by symbols that counts—the movement in and out of consciousness which leads us into art through the experience of art.

Articulation, however, here has the connotation of forming as an open, dynamic process. Kubie[29] helps immeasurably on this concept if one accepts his models showing the interaction of conscious, preconscious, and unconscious processes in creativity. It is that province between the clearly con-

scious and the repressed (or unconscious) which is the seedbed of creative thought. If our images in art are to be vital, it is on the fringes of consciousness that this work of articulation takes place. Earlier in this book we talked about "abductive reasoning" and "thinking by analogy" as the method by which we create forms to match our images and feelings. It is the merit of Kubie's theory that it so clearly points out the dangers to creative thought in our traditional educational methods:

> . . . they either tie our preconscious symbolic processes prematurely to precise realities, or leave them to the mercy of distorting influences which arise around areas of unresolved unconscious conflict.[30]

It would do art education much good to underscore the idea that the intimately personal terms we have used are not off limits, nor do they refer to the clinical, but to the healthy functioning of creativity in the normal. We did not use the term *preconscious* in our earlier discussions. I am not particularly happy with it, except in its explanatory power within Kubie's theory. It is apparent, however, that whatever our terms we deal with something not capable of discipline and expression completely in the coded symbols of words, powerful as the latter are for logical and objective communication. Art is, indeed, a reality and ultimate of its own.

The articulation of which Gombrich speaks occurs within a "universe organized by the images of a life without fear."[31] Fear cuts off openness to the dialogue which transcends our expectations. Whether we call it preconscious activity, or-or structures, diversive exploration and autistic thinking, free association, symbolic play, regression in the service of ego, or by some other name is perhaps mostly a function of vocabulary and group identification. We deal with the creative mind at work.

> Cogitation and intelligence: *"cogito"* to shake things up, to roll the bones of one's ideas, memories and feelings, to make a great melting-pot of experience: plus the superimposed process of *"intelligo":* i.e., consciously, self-critically but retrospectively, an after-the-act process of choosing from among unanticipated combinations those patterns which have new significance.[32] [Kubie]

We have been saying that this kind of process is nurtured by the process, series perspective and by feedback, communication, and strengthening a person's self-knowledge and self-direction. To formalize the arguments of this chapter, the following motivational hypothesis and definitions are given:

> . . . when a man perceives his behavior as stemming from his own choice he will cherish that behavior and its results; when he perceives his behavior as stemming from the dictates of external forces, that behavior and its results, although identical in other respects to behavior of his own choosing, will be devalued.

> [The words Origin and Pawn are used] . . . as shorthand terms to connote the distinction between forced and free. An Origin is a person who perceives his behavior as determined by his own choosing; a Pawn is a person who perceives his

behavior as determined by external forces beyond his control the distinction is continuous, not discrete—a person feels *more* like an Origin under some circumstances and *more* like a Pawn under others.[33] [de Charms]

To stress the artist as active agent, as the locus of causality, is to move from the experiment to the case-history perspective, from the weaker side of interaction, to the stronger, cybernetic side, or so it would appear. This was not the intention, since we are concerned, experimentally and theoretically, with optimizing the conditions under which such self-perceptions occur and within which the "images of a life without fear" can arise and free creative processes. We will try to reconcile these apparent discrepancies in our research when theory and method are discussed in the next chapter. The solution to the dilemma will rest on whether we can separate the teaching and researching functions, the normative from the descriptive, and on whether we conceive it desirable to try to do so.

Feeling not sufficiently in touch with the thought and action that guides a drawing process and a drawing series from the vantage point of the controlled experiment, we moved toward the study of single individuals, drawing over an extended period of time in our drawing laboratory. This shift is serving its intended function—we *are* closer to mind and context in drawing. We have changed from researchers applying treatments to subjects to observer-participants trying to communicate with persons who see themselves as Origins. We understand more, but we can predict less. How can this be? Perhaps it is simply that in our experiments the grounds for prediction are narrow and highly specific, while in our case histories the grounds for our understanding are broad and general.

The person making a drawing knows, or can be stimulated to recall, much that an observer will miss. Furthermore, since symbolic transformations occur, the observer may miss entirely the mental grounds for what has been articulated, either because it is idiosyncratic or only partially embodied in the drawing. Furthermore, the range of meanings fluctuating around symbolic behavior in art is rarely likely to show complete overlap between observers, or observer and artist. There is a sense in which what is articulated is open for proper probing by both artist and observer.

William James conceives of thought and action as two aspects of one thing. The observer sees one side better than the other, and is thereby likely to err in separating thought from action.

A behavioral act or sequence is the basic phenomenon. The outside observer sees overt manifestations of it; the actor may see the overt manifestations of his act, and he is also privy to his own mental and emotional experiences. The observer can share these only if the actor can translate them into some overt behavior that communicates to the observer. What the actor experiences forms his personal knowledge; and, since he is privileged to withhold some of this experience from being overtly expressed, he may experience thoughts and emotions that are not observed by the onlooker. On the one hand, it should be clear that a complete psychology should include the experience of acting or inhibiting an act as well as the observa-

tion of it; but, on the other hand, a direct line to the thoughts of a person would not give us a perfect instrument for the prediction of behavior. As things stand at present, prediction from one series of specific overt acts to another should be much more reliable than prediction from acts that communicate thoughts to other more specific overt acts. The value of attempting to gain samples of thoughts (through communicative acts such as writing) is not in increasing the predictability of specific other acts, but in arriving at a broader picture of the actor's predisposition to act over a period of time and under many different circumstances.[34] [de Charms]

THE PARTICULAR SITUATION

It is this latter value, that of a particular mind operating in a particular context, that we have sought to explore in these last two chapters. Only thus is it possible to suggest, however dimly, that quality of thought which directs a given drawing situation, and to indicate how that situation is further situated in the drawing series. We have argued for the need for this closer look to understand some of the ways feedback is symbolically transformed during the drawing process. To earn this point of view we have had to risk ourselves and give up the separation and the different language associated with the researcher-subject tradition. The people we study are persons, individuals, not subjects or objects; and we come to know their thoughts through communication. The basic method is stimulated recall—recall that is set going by in-process records and by products, the latter functioning like in-process records on the ground of the drawing series.

Our interaction with the artist in the communication sessions requires the cultivation of a special frame of mind. Although it is not our intention to teach but rather to observe how learning or, at the least, change and directionality occur, it is nevertheless true that the assumptions underlying our approach to the artist at work, as outlined at the beginning of Chapter 3, constitute an implicit set concerning how an artist *should* behave. It is in this sense that our own ground rules and procedures "teach" the person working in the drawing laboratory. But this is also how we can study man and his drawings—that is, by attempting to enclose the normative and descriptive in the same frame. By treating persons as we believe artists should be (and want to be, by and large) treated, we can describe something of the artistic process and its dynamics. Wherever this is not done, it is questionable whether what is described will relate to the artistic process under its typically broad range of circumstances.

Admittedly, what we have done is a compromise since our entry into the series, the bounds and constraints of our environment, and the communication process itself influence what we study. Purity and objectivity, however, are relative virtues, and their significance pales before the kinds of phenomena we seek to grasp.

The implicit set communicated cumulatively by our environment and procedures requires that we *actively and consciously strive not to interfere* with the individual's perception of himself as an Origin, as the locus of

causality. This means that we refrain from instructing him, directly or in-directly, to the best of our ability. It means that we do not take the lead in evaluation. Instead we seek to press for details and clarification, for com-parisons that evidence the artist's perception, for stimulated recall of process sequences, for the individual's feelings, for his hunches and intuitions, his possible influences, his evaluations, memories, and so on. Although we often fail (in particular, we say too much, as a study of transcripts will reveal), this is the general tone of our interaction. Since, however, we have our own per-ceptions, hunches, feelings, and intuitions, we also take the individual outside himself through the nature of our questions.

In terms of any instructional posture, I have developed the concept of *counter-intervention*. The chief dialogue is the drawing itself. Our communi-cation is toward comprehension, which means partially exploration, bringing to consciousness, entertaining multiple hypotheses, and the like. I have chosen not to use the word nondirective and its equivalents: client-centered, learner-centered, and the like. To some degree all of these apply, but they are found in operation where art work is not being formed and thus smack of the classroom or the clinic. Ths atmosphere here is of the studio and the lab-oratory combined—a peculiar hybrid of what the laymen would take to be the embodiment of subjective and objective orientations. We find this opposi-tion unnecessary and unnatural. It is rather a functional difference: one person chooses to think and act as an artist; another chooses to study that thought and that action. The *functional separation of roles* permits honest interaction, when it occurs, without discomfort and distrust. The artist does not need to worry about our roles (although most of the people working in the drawing laboratory have shown empathy for the difficulty of what we are attempting to understand—especially toward how we will ever share it with others).

It is the separation of functions which requires active counter-interven-tion on the observer's part. The observer, further, probably needs a fair amount of experience as artist, scientist, and teacher to function effectively in this setting. Without these, he cannot sift his own responses for relevance. The most difficult role to restrain is that of teaching, and from our insights thus far it is the most in need of restraint. Hence the birth of the term counter-intervention. It would be humbling to any teacher used to organizing classes and classrooms, regardless of the climate typical of that organization, to play the observer participant's role in the drawing laboratory. Thought has not ceased because little is observable, and experience soon confirms the sus-picion that when little is observable it is partly deficiencies in the observer, on the one hand, and partly the covert and incomplete or faulty disclosures of the artist on the other. Nothing need seem to happen for something sig-nificant to be occurring or forming, perhaps to become clear several drawings or weeks hence. So patience and acceptance of the undefined, or even the void, is part of counter-intervention. The stronger part of the notion of counter-intervention, however, has to do with who is to be active, who the agent, who is to feel like the artist. Without active counter-intervention, the observer cannot be prepared for the likelihood that art and change will occur.

The case history of Larry presented earlier in this chapter suggests a strong additional argument in favor of counter-intervention. Had we followed up the base laid down in the first eleven drawings and had he requested help, a different history would have undoubtedly occurred. In all likelihood, it would not have delved as deeply into Larry's need to arrive at symbolism and feeling as what transpired without our instructional intervention. In this context, even diagnosis from a base is shaky.

We did not directly set out to achieve any insights into art instruction at this level of maturity, but the results have been such that it is hard to resist them. Counter-intervention, coupled with the emergence of the individual's confidence in himself as locus of causation, and with the self-knowledge resulting from communication with an observer fully intent on understanding, without judging, what has taken place—these, taken together, and interacting as one system, provide a powerful learning environment. It is not suggested that these are the only functions of the teacher, but theories of instruction in art would do well to take them into account and test them out. It is as though when we relaxed our search for the teacher, he suddenly appeared.

Perhaps in the study of the events significant in the drawing process and drawing series we have learned that they are such that they cannot be preordained or prearranged—not for the artist or appreciator, so certainly not for the teacher. The teacher is no deity. Neither is the observer participant. We merely set a bound, a context, which does not make art or change happen, but which allows us to cognize what does happen. The criteria of learning in art, as process realities, are not now specifiable, but only disclosable in the passage or movement of which they are a part.

In a sense, the first experiment ("self-reflection"[35]) operationally tested out the concepts I still hold to be important. I cannot help but wonder what would have happened had they not received even the kinds of confirmation they did. Self-discovered criteria for evaluation and goal-setting: that is the person as causative agent, as contributor, participant. Process feedback: that is the focus on emergence, on not just intention, certainly not on problem-solving in its usual sense, but on discovery, disclosure, possibility, and on interiorizing of the feel of these. Interaction with an interested other: that is the goad to consciousness, to communication, interest, motivation—the feeling that I am understood through making myself understandable, a process requiring an extension of myself to merit disclosure.

There is, in short, a realm of learning in art, much as Anderson[36] has shown there to be a realm of art. If art is an ultimate beyond which one cannot go, so, perhaps, too is learning in art. Learning, or learning to learn, in art may have something to say about other areas of man's existence, not properly studied or acknowledged through our current technological, methodological, control-oriented culture.

Our second set of experiments[37] showed the ambiguity surrounding intervention in instruction. Drawings can be easily influenced and deflected toward external criteria by subtle or direct methods of shaping. But we have developed the feeling that that shaping which proceeds from the self as Origin, nurtured by a climate calling forth openness and adventure within

process and emergence, leads to the effective interaction of conscious and preconscious levels of thought, to the beginning and sustaining of the creative process and to the proper ambiguity attending the attempted articulation of one's images and intentions through the work of imagination and the resistance of medium.

NOTES

1. E. H. Gombrich, *Art and Illusion* (New York: Pantheon Books, Inc., 1960), p. 358.

2. Marion Milner, *On Not Being Able to Paint* (New York: International Universities Press, 1957).

3. Susanne K. Langer, *Mind: An Essay on Human Feeling,* vol. 1 (Baltimore: The Johns Hopkins Press, 1967).

4. John M. Anderson, *The Realm of Art* (University Park: The Pennsylvania State University Press, 1967).

5. Richard de Charms, *Personal Causation: The Internal Affective Determinants of Behavior* (New York: Academic Press, Inc., 1968), p. 74.

6. Ibid., p. 76.

7. David E. Berlyne, "Motivational Problems Raised by Exploratory and Epistemic Behavior," in *Psychology: A Study of a Science,* vol. 5, ed. S. Koch (New York: McGraw-Hill Book Company, 1963), p. 290.

8. David E. Berlyne, *Conflict, Arousal, and Curiosity* (New York: McGraw-Hill Book Company, 1960), pp. 198–99.

9. Carl Rogers, "Toward a Theory of Creativity," *ETC, A Review of General Semantics* 11, no. 4 (Summer 1954): 249–60.

10. David Hume, *A Treatise of Human Nature* (New York: Doubleday and Company, 1935), p. 351.

11. Ibid., p. 357.

12. Ibid., p. 379.

13. de Charms, op. cit., n. 5 chap. 7, p. 6.

14. Ibid., p. 11.

15. Anderson, op. cit., n. 4 chap. 7, p. 82.

16. Edward Bradford Titchener, *Systematic Psychology: Prolegomena* (New York: Crowell Collier and Macmillan, Inc., 1929), p. 254.

17. Anderson, op. cit., n. 4 chap. 7, p. 3.

18. Michael Polanyi, *The Tacit Dimension* (original ed., 1966; reprint ed., New York: Doubleday & Company, Inc., Anchor Books, 1967), p. 4.

19. de Charms, op. cit., n. 5 chap. 7, p. 357.

20. David Bakan, *On Method: Toward a Reconstruction of Psychological Investigation* (San Francisco: Jossey-Bass, Inc., Publishers, 1967), p. 102.

21. Martin Buber, "What is Man?" in *Between Man and Man* (Boston: Beacon Press, 1955), pp. 118–205.

22. Bakan, op. cit., n. 20 chap. 7, p. 128.

23. Anderson, op. cit., n. 4 chap. 7, p. 67.

24. Ibid., p. 78.

25. Ibid., p. 68.

26. Anton Ehrenzweig, "Conscious Planning and Unconscious Scanning," in *Education of Vision,* ed. Gyorgy Kepes (New York: George Braziller, Inc., 1965), pp. 27–49.

27. Gombrich, op. cit., n. 1 chap. 7, p. 358.

28. Anderson, op. cit., n. 4 chap. 7, p. 63.

29. Lawrence S. Kubie, *Neurotic Distortion of the Creative Process* (Lawrence: University of Kansas Press, 1958).

30. Ibid., p. 142.

31. Herbert Marcuse, *One-Dimensional Man* (Boston: Beacon Press, 1964), pp. 238–39.

32. Kubie, op. cit., n. 29 chap. 7, pp. 50–51.

33. de Charms, op. cit., n. 5 chap. 7, pp. 273–74.

34. Ibid., pp. 226–27.

35. Beittel, op. cit., (1964), n. 2 chap. 1.

36. Anderson, op. cit., n. 4 chap. 7, p. 48.

37. Beittel, op. cit., (1966), n. 2 chap. 1.

chapter

On Theory and Method

8

For years, in all seasons, weather and light permitting, I have loosed my dog and taken a daily walk in the woods adjoining my home and studio. These woods are not part of my real estate, but certainly they are mine in proportion to the use to which they are put. It is a walk, ordinarily, of only fifteen or twenty minutes. Without reasoning about it, until now, I have always veered to the right where the path forks and begun through the lighter, hardwood forest of oaks, hickories, maples, and wild cherry trees and circled back through the darker, hemlock woods via what would be the left fork in setting out.

Today, for no premeditated reason conscious to me, I took the left fork first. The territory was the same, but I scarcely recognized familiar landmarks. My reasons for walking daily over the same route are many, and it is a habit from youth, when I wandered along the Susquehana River banks. For adequate perception, one must be alone although I enjoyed sharing the walk then and still do. Yet, perception of nature's changes can hardly be the

motive, for I am often lost in thought or have a problem tucked away in my mind. It is as though the solitude, the familiar path with its change in constancy, sets ideas freely circulating. The unexpectedness of sights like mayflowers pushing up, three-score jack-in-the-pulpit plants, several deer or grouse, the miraculous unfolding of the hickory bud, or a new kind of mushroom is not lost because of this state of consciousness. Rather it seems symbolic of the discovery my mind is preparing for. And moving from the lighter woods, into an open stretch of park-like grounds, then to the darker, hemlock woods where I must duck and twist among rocks and branches, symbolically seems like the security and protectedness I associate with a return to childhood. The cycle done, I return refreshed.

To reverse the path today seemed strangely appropriate and symbolic. The territory, I repeat, is the same, but my experience and the meaning of what I meet along the path are changed. True, these change even if I follow the same path habitually. They lead me on and I ordinarily have no desire for reversing directions. But now that I have, the issue will be upon me each day at the fork. I will doubtlessly take the left path for a while, to probe its strangeness further. But then I will likely fluctuate.

I hope the reader will forgive this personal reference and the extended figure it projects. Like all metaphors, it will suffer at any effort at explanation, so I will leave it unexplained.

ATHEORETICAL RESEARCH

Originally, in Chapter 1, I had mentioned the idea of computer simulation of drawing strategies as a method for clarifying language and specifying operations. While it seemed like one of the routes promising and possible out of the study of drawing strategies, my siding with cybernetics, with the symbolic transformation of feedback, with idiosyncratic meaning, inner drawing, accident, personal causation, and counter-intervention have drawn me further and further from such simulation. In honesty, I like the feeling and what I am probing, feeling no less of a researcher but much more in touch with the phenomenon of drawing behavior. Perhaps the computer would be more properly used as "sensuous technology," as another tool and medium properly approached through a radical materialism and in terms of its own logic and potential. The symbolic transformation of feedback is what threw me, plunging me deeper and deeper into the realization that human meaning is locked into the context in which forming takes place, especially where our concern is with the articulation of the essentially inarticulate. Furthermore, I find myself presently giving a clearly negative response to the question of whether we can separate the teaching and researching functions in the study of learning and change in art.

My own research has been primarily atheoretical. To the artist, theory is associated pejoratively with the past, the academic, and even the dogmatic. Exhortation by philosophers to view research into art behavior as "the verification of aesthetics"[1] have merely revealed their fundamental inability to grasp the meaning of empirical inquiry in all its uncommitted skepticism.

Yet a contradiction was always present. This is that it is through personal knowledge and commitment that the grounds and operations for empirical inquiry and experimentation are laid.[2] As a believer and practitioner of the research experiment, I can report with what soul-searching the operational methods are finally set; and there is a continuing lack of closure as to what the chosen manipulations and the criteria for evaluating them really meant. This "objective ambiguity," however, was something one could cognize, evaluate, and improve upon, as compared with the unfathomable complexity I feel when I create art and must therefore imagine when I observe others do so. And interacting with a phenomenon seemed, and still seems, one of the best ways of getting to know something about it. Disinterested observation, in contrast, plunged me into unending and largely fruitless speculation. On the other hand, where there is no compelling theoretical model to work from or against, the personal knowledge and commitment guiding an experiment may seem arbitrary or irrelevant.

Perhaps in a search for my own identity, I feel that my experiments and the more recent case histories in the drawing laboratory are related. Without reviewing their history in detail, the first experiments (self-reflective learning studies[3]) were based on scattered findings and assumptions concerning (1) the kind of open and supportive climate conducive to creative thought, (2) the learning potential of depth or continuity in artistic theme and medium (as opposed to breadth or the scattering of energies across largely unrelated themes and media), (3) the desirability of encouraging self-evaluation procedures in one's own language style and related to one's goals, (4) the importance of delayed process feedback and its resultant stimulated recall, and (5) the motivation arising from open, supportive interaction with a teacher figure.

Findings from these experiments have been discussed already. Here it suffices to recall that they were largely supportive of the assumptions just enumerated. In addition, they led to the delineation of the two strategies discussed in Chapters 4 and 5, and to an emphasis upon them as plans, heuristics, and mental operations freed bit by bit from their earlier direct association with style and personality.

For greater control, a drawing laboratory was established and persons were studied one at a time, with adequate means for recording drawing processes and manipulating feedback. Relevant sample characteristics were controlled, and two related but different experiments carried out.[4] Implicit and induced learning sets both were shown to shape drawing strategies, the former in subtle, the latter in severe ways amounting to complete reversals often persisting beyond treatment periods.

The two sets of experiments fell apart in my mind, however, because I had assumed, with Monet, that all one had to do to learn to draw was to draw. Yet little change or movement had been observable in the drawings of those in the weaker of my two last experiments, where only an implicit set from the drawing stimulus was at work and where subjects were left largely on their own so we could take a closer look at their drawing processes.

We collected thousands of time-lapse records but seemed no nearer

to grasping how the mind works in the drawing process. We did, of course, learn something from the experiment, but the "learning automaton" which I thought would operate locked within its own action-feedback system did not appear to be readably functioning. Other conditions or other perspectives on individuals were necessary.

At this point, we left our experimental frame, with its subjects, treatments, and perhaps too quickly frozen interpersonal criteria of change and achievement and began to look at persons as individuals following unique paths. We also began to try to describe these paths. To do this we had to communicate with each person within the context of his own works and processes, and through the world he brought with him.

PERSONAL ARTISTIC DEVELOPMENT

This change was great enough in itself, but attendant upon that change were still unforeseen ones. We found that although we did not intend to teach, the bounded context with its feedback-communication components did so. We found further that we "understood" a given person's history without explicit process or product criteria being necessary or seemingly possible. And as we strove to arrive, through communication, at the meaning of what took place, we participated in the subsequent development of the person.

My malaise at my later experiments at first puzzled me. They were more controlled and yielded useful information, but they left me feeling that art somehow slipped out. I came to conclude that *the human use of art,* wherein art is seen as an ultimate, a discipline, a move toward the expression of feeling through the work of imagination and the resistance of medium, *requires a normative frame in which the "prescription" is self-chosen and self-monitored.* Without centering on his own imagery and intentionality, and the uniqueness of each encounter as process, all aborts for the artist. This is why I say his value grounds and their subsequent development or change must be in his own hands.

Let me make clear that I am not setting mind or self off from context. Left on their own, even with the myth of creativity about, I would guess that very few arrive at the self-selecting prescription and self-monitoring mentioned. Very many are ready to do so, I feel; but they cannot handle the anxiety that their own methods or instruction foreign to their imaginations creates. Consequently, they do not enter into the production of art although, hopefully, they may enter into appreciative experiences where these same causative principles are operable for them.

Our bounded context has as its goal a number of interrelated objectives: to study learning in art through the process of a person's constructing an image of himself and of art simultaneously. As Bruner puts it: "Man's image of himself, perforce, is not independent of his image of the world. *Weltanschauung* places limits on and gives shape to *Selbstanschauung.*"[5] We provide a world-view which, while not neutral, is only weakly normative. It says to the individual: "You are the artist, whatever that means, and we will treat you like

a person trying to find his way in art. Nothing is irrelevant that takes place here. We will try to understand what you do, and we will make records of what you do. We will share the process records with you and ask questions about what you did. Beyond that we will attempt not to instruct or judge you. We have no hidden agenda."

There is irony in the fact that instruction in art occurs most effectively, to our view, when all conscious desire to instruct is withdrawn. One is reminded of Freud's feeling that psychoanalysis, originally constructed as a therapeutic method, would hold more future significance as a science of the unconscious. Our concern was the opposite. In our desire to study mental processes involved in drawing we have unintentionally drifted toward educational and therapeutic implications. No doubt this is because of the global viewpoint with which we have constructed a significant setting for such study. It became obvious that people can be directly influenced to change their drawings, but it was equally obvious that their drawings underwent change without this direct instruction and intervention. Furthermore, the kinds of change we sense ourselves and other practitioners of the arts to be making did not appear to be traceable to specific achievements on levels of mastery, but rather were related to the recirculation and reorganization of processes operating on many levels, to motivational states common to the arts (but not peculiar to them), and to abstract concepts about the artistic, the aesthetic, and the creative which are active in the culture. It was further obvious that, although we could detect severe and even subtle changes which we had influenced—detect them, that is, in terms of external criteria related to drawing strategies primarily, and to qualitative achievement to a lesser degree and with less certainty—the kinds of change we could feel taking place, but could not assess, had to do with mental processes, concrete skills, abstract concepts and a motivational mix largely idiosyncratic to a given person.

We therefore withdrew our intent to instruct or influence persons and provided the freest neutral environment we could, within which we could record and observe drawing processes and communicate with the person concerning his drawings. The mentioned neutrality turns out to be only a temporary lack of structure which the person drawing and we as observer-participants bring values to. The artist brings his world and motivations; we bring our research functions and a set of accumulated values concerning how artists behave. These sets of values perforce interact, verbally and nonverbally, but especially in dialogue about what the artist has drawn. We have chosen to strengthen the person or artist side of the equation, weakening the experimenter's side with its tendency to treat persons as subjects or objects, thus largely cancelling out the very kind of human role we want to study. We have come back to mind, away from what Bakan calls "a philosophy of epistemological loneliness" (inherited from the British empiricists) and the language of the behaviorist "modelled after the language among strangers."[6] Only thus did it seem likely we would move closer to what the artist does in his selecting, monitoring, and transformational acts.

Some of the people with whom we work in the drawing laboratory are

both highly introspective and communicative. One young girl, a freshman, has become conscious of three value systems at work in her thinking as she draws. There is a "hierarchy of values" in which she has been taught that those things have significance which are done with care and consummate skill. In drawing, she has never excelled on this scale and recalls some painful experiences in her schooling and at home (where she competes with a sibling "talented" on this level). Secondly, there is a spontaneous enjoyment she experiences, for her related to not caring, abandon, instinctual exploration and discovery, as with fingerpainting, wet-on-wet ink washes, and the like. She also "picks up cues" from us and all of her art acquaintances concerning a third value system which we will call aesthetic, in which a person perceives openly, intuitively, delaying judgment—a kind of attention which can be turned upon anything and everything for whatever it might hold in immediate experience. She would now like to jettison completely the value hierarchy associated with care and skill and explore the other two kinds of value. It is apparently the third, however, the "aesthetic attitude" she senses in her art acquaintances, which allows her to explore her more instinctual enjoyment values without feeling guilt for what she might otherwise interpret as self-indulgence.

The environment in the drawing laboratory does not prescribe which of these value systems she should select (although it is true she has detected one of these as operating within us as within her other art acquaintances). It allows her to select and to monitor her behavior according to any or all of these. Care and skill are themselves concepts changing their meaning at various levels of process, not precluding what she now calls enjoyment nor what she senses as the aesthetic attitude.

It should be more apparent now why so-called process criteria of achievement are far from our being able to master them as research tools. The most our studies might lead to in this regard would be likely paths for certain kinds of persons given a specified value system espoused within an instructional or research setting. The arts seem to argue, however, for a multiplicity of value systems, the important ingredient being that whatever the value system, it is ultimately entwined with the motivation, the skills, and the symbolic behavior of a given person. For this kind of functioning, other individuals around the artist should counter-intervene if they want to understand the artist as a dynamic, changing system. Beyond this, others could represent identification models (which is the way we are probably perceived at times), strong alternative or even opposed value systems actively functioning, or forces potentially or actually inimical to one's own self-direction (the way authority figures and formal instructional efforts often seem to be perceived by persons we have studied).

CONSCIOUSNESS OF VALUES

From the vantage point of the individual cases we have observed, the fruits of our labors are histories of change. At this point, we would not call them histories of learning or development, except from the perspective of the

explicit normative base we have laid down. In this latter case we might present evidence that a person had brought to consciousness a set of values he felt personally identified with. This selected value base would be relatively absent from his early work. It would increase in evidence through transformation of existing skills and symbols into different usages or through discovery of new skills and symbols. Its personal relevance would be established through self-evaluations, increased motivational signs, its spread into diverse aspects of the person's life, a reduction of fears, an increase in free-associations, positive regression to childhood memories and feelings, greater sensitivity to art and to environment, and so forth.

It is my own feeling, however, that we have not observed enough to give firm evidence relative to even the kind of open value base we prescribe. The task of observing change (not learning or achievement) must go further first, so that our repertoire of kinds of change and the thinking associated with them is increased.

If we refer back to our first exploration of the literature on art education (in Chapter 2), some differences between our approach and earlier ones appear. A temperamental or personality basis for our observations, as Read or Jung suggest, seems unnecessary. Lowenfeld's admonition that we think of nothing the artist does as a "mistake" or a "failure," from some other (adult, artist, or whatever) point of view, seems well taken. A prior definition of what is creative, what not (such as copying), however, would be detrimental in some of the histories we have observed. In addition, motivations and experiences do not need to be the concern of the researcher although they are properly the concern of the artist. Lowenfeld, of course, talked as an art educator, largely for the child level; but even so, these latter emphases appear overdrawn to us now. An example of this has to do with subject matter. To Lowenfeld, the art educator dealt with the "who, what, where, when" aspects of direct experiences (in their concrete aspects undoubtedly suited to child levels). He did not stress "how" things were to be done. That was personal. On the contrary, our communications dwell on the "why" and the "how" aspects of drawing. And it is not true that the subject matter is the same for all and that we differ only in our relationship to it. Rather, it is only partly true. The skills and the subject matter are both locked into idiosyncratic meaning and inner drawing. Beyond this, their actual meaning has to do with their entry into the very process and situation of articulation itself.

Schaefer-Simmern's essentially one-dimensional theory of how drawings unfold now appears to reinforce surface skills and perceptions. Perhaps it is closer to the mark to say that his approach restricts the potential and multiple value systems to one. The artist, therefore, does not select or construct a set of values during his drawing series. This anxiety producing necessity is taken care of beforehand, but to do so is to disenfranchise the artist.

The various formalist and process-formalist theories, such as those of Christopher Alexander or Desmond Morris, operate at far too high a level of abstraction to be of great use in explaining a given drawing process or drawing series. Principles describing changes in drawings such as modification through repetition and random variation, through leveling and sharpening,

or such as calligraphic differentiation, thematic variation, optimum hetero-geneity, or universal imagery, are useful but apply in only a very limited sense to the complex phenomena we study. These principles still smack of product-comparative viewpoints, of differences in qualitative dimensions from work to work.

PROCESS LANGUAGE

The strategy criteria which we have developed can likewise be criti-cized. Apart from the problem that these more detailed criteria are highly intercorrelated within the two strategy domains, they, too, are product-linked. Like Alexander's and Morris's terms, however, they too are essentially value free. And at least a number of them require process data for proper judgment. Still, all of these approaches, while furthering our search, seem to leave mind and context out, so that they seem close to irrelevant when faced with the very phenomenon they try to explain.

Perhaps a more proper language will evolve. Bradley's[7] recent argument in favor of intrinsic reinforcement and feedback, with its emphasis on pro-cess evaluation as opposed to product evaluation, moves in the right direc-tion, although his emphasis is upon the effect of these upon aesthetic growth —a criterion problem likely to continue to haunt us. Another difference lies in the fact that I have not, even in my experiments, manipulated treatment variables *during* the drawing process. They were always placed *between* drawings or drawing sessions. Burkhart and others,[8] along with Bradley,[9] have done so.

Langer provides a clue to the kind of language appropriate to works in progress. She says that artists

> . . . are likely to speak of tensions and resolutions, and all their language shifts to dynamic metaphors: forces in balance and imbalance, thrusts and counterthrusts, attraction and repulsion, checks and oppositions. Different arts favor different metaphors, but tension and resolution are the basic conceptions in all of them.[10]

I would only add that, in addition to dynamic metaphors, there are personal metaphors.

At the present, we have not tried to construct a process language with which to record what we observe for the simple reason that what we can ob-serve is by far the smaller part of what is going on. We have instead resorted to personal communication to extend our power of comprehension.

Let us look again at the role of language in this process. In the last chapter we quoted from de Charms concerning the problems and advantages connected with communicative acts. These, he said, are not so much likely to predict "overt acts" as to reveal "mental and emotional experiences" which an observer cannot otherwise share, to give us the feel of "acting or inhibiting an act," and, in general, help us in ". . . arriving at a broader picture of the actor's predisposition to act over a period of time and under many different circumstances."[11]

But what of the role of language in our effort to construct this broader

picture of the drawing process and the drawing series? It is in the process that we know experientially; it is in the effort to reflect and communicate that we know consciously, cognitively; and it is in the perspective of time, of the series, that we know change and are led to evaluate that change. The preparatory work of changing takes place in the middle passage, where we reflect, communicate, plan, and sort things out into a seemingly unbounded consciousness. The unshaping "other" is here of extraordinary importance. He is the midwife at the birth of art concepts relating to process, change, symbolic transformation, and that myth of self-identity so motivating in the creation of art. Developing art concepts, explored and circulated through reflection and dialogue, like contemplation of delayed process feedback, intervene to prevent premature structuring of the creative process[12] and caution one concerning the less conscious tendency to repeat habitual working processes automatically.

Art concepts and insights thus conquered, dealing as they do with the concrete stuff of one's own dynamics, become part of the working repertoire. Tucked just out of mind, they nonetheless constitute the flexible *ad hoc* rules and evaluative tests that guide the symbolic transformation of process feedback. Just as certainly, they must become in part the source of intrinsic reinforcement, and their effective actualization must relate to the growing sense of self-identity. Within the series perspective, they lead the artist into depth as opposed to surface perception, away from the easily obtained "good gestalts" which Ehrenzweig[13] says obstruct our path through an open creative process. They contribute to the build-up of "or-or" structures, funding in with other free-associative elements of all kinds, allowing one to monitor himself more openly and less fearfully along a path experienced essentially aesthetically—i.e., in its own immediacy and as its own reality.

According to Kubie,[14] what is conquered in consciousness may drop out of active consciousness when we are fully functioning. We are again back to the "proximal" and "distal" terms in knowing-parts of "personal knowledge" as Polanyi[15] defines it; and to his example of the hand which forgets the stick when it becomes a probe. It is, then, the "sensation" relayed by these concepts to the mind during the process which counts, not the concepts themselves, for they are after all only sticks by which we cognitively probe what is being disclosed as we create. This is why the categorization of the kinds of working concepts, and their spread and number, which a person can bring to consciousness is not meaningful in itself.

But we had best drop the stick analogy. There are hierarchies of concepts. The hardest art concepts to acquire for the artist relate to process phenomena, to change, and to the problem of a dynamic self-identity. In a sense these are extra-aesthetic. They prepare the ground from which the aesthetic aspects of process can spring.

THE ROLE OF LANGUAGE

It would seem that these key terms are functionally nested in each other in some such fashion as this: (the myth of self-identity [change {process

(the aesthetic)}]). The latter is immediate, sensuous, primarily noncognitive, but open for diversive exploration. In spreading fashion, it prompts the utilization of process and medium characteristics "as a set of temporarily drafted signs"[16] for the constructive embodiment of its meanings—thus the importance of process concepts. These in turn gain their relevance to some degree from ends and developments seen as progressive or valued (related to change and learning), and together they build into the myth of self-identity which is based on the motivating conditions of self-confidence and personal causation. In fact, the system is reflexive and the enclosures could be rearranged so that the aesthetic aspect would be the most inclusive term. I did not put it thus because first it must occur, then the terms rearrange themselves. This is, of course, figurative and speculative speech. But it leads me to continue to use *the artistic* and *the aesthetic* as two terms whose overlap cannot be completely specified. I placed the myth of self-identity in all this first, because there it operates as myths have always done ". . . to effect some manner of harmony between the literalities of experience and the night impulses of life."[17]

With Dewey, we see experience as both immediate and meditated. The pervasive quality which holds us in all experience makes us "resonate." Exploration through our mediated thought processes, tied in their significance to the conditions inspiring their resonance, expands our future capacity to experience the immediate. A genuine dialogue, when it occurs in our effort to communicate about our experience, has its own pervasive quality, but it is as a situation situated within the self-identity-learning-process-aesthetic art complex that is the bounded drawing series that it gains functional meaning.

The role of language in this process cannot be overemphasized or underemphasized. Even in dialogue itself nonverbal forces play a high part. In the perspective of the drawing series, the context in which the effort at communication occurs is as important as the dialogue itself. The meaning of the communication lies at a still more abstract, discursive level, where the concern is about the role of language itself in its relationship to other factors within the total structure or series. But at its very simplest, language reveals to us much that would otherwise be lost to us; and for the artist it brings his processes to consciousness and aids him in the construction of art concepts.

Then there is the relationship between language and working techniques. As for techniques themselves, anything can go. There are, as we said, no forbidden procedures. All is determined by the way techniques enter into a given situation. The virtue of verbalization, of communication, is that it brings conquered techniques (or operations) to consciousness, lifting them out of context so that they become transformational possibilities. Experienced artists often speak of "rediscovering" skills and processes they have used before. They are apparently evoked only *in situ.* Our impression is that conscious verbalization (being understood) concerning their meaningful role in one context does tend to make them imaginatively accessible in another. As such, they help produce "images that can be made"—that is, they lead to inner drawing. The method described reminds one of Freud's oft-

quoted phrase, "where id was, there shall ego be," except that we deal with material not so much beyond the limen of consciousness as of an enactive and iconic nature, standing thus in need of verbal exploration for its economical storage, retrieval, recombination, and so forth.

Yet how can we arrive at any grasp of how the pivotal concepts of our research and speculation can be drawn into a total perspective? Without intending to do so, we have slid from an experimental to a descriptive to a normative-descriptive framework; from a more surface, object-centered perspective, to a depth, cybernetic one; from intersubjective product and process criteria to knowledge gained through self as instrument (observer-participant) and the person (artist) as communicant, where intrasubjective interpretations of change and direction occur within the dynamics of a series.

During a panel discussion with experts from the disciplines surrounding art education which took place during a ten-day funded seminar,[18] the art critic and artist present offered a spontaneous description of art as a special kind of work which transformed the worker. The artist added a qualifier: "critical self-transformation." Without belaboring their open definition, I suggest we accept it for the moment, admitting as we must that it could not be restricted to art nor might all activities termed art noticeably have this effect.

DEPTH ANALYSIS

We might have turned away from depth analysis, feeling, with Arnheim,[19] that it was unfortunate that the "psychologist who came to dinner" in the early days of art education was the psychoanalyst. For years I had been inclined to agree with him. Now I think it more likely that the visit was merely premature and erroneously linked too closely with the visitor's namecard and therapeutic calling.

I will doubtlessly be criticized, among other things, for not centering my studies on children or on developmental analysis. Earlier I tried to get at some of my reasons for studying at levels beyond childhood. Simply put, the clearest reason is that the entire confused notion of that undefinable brace of concepts, art and the aesthetic, as a cognitive function which directs affect and imagery along a self-chosen line is a later development. So saying does not detract from the importance of experiencing the aesthetic and the artistic from the earliest years onward. In many ways Malraux[20] is right: the child is not an artist, childhood (almost inversely to level of development, I would add) is the artist. The drama and tragedy of the genesis of art activity in the life and thought of the child is far from described. It doubtlessly awaits the kind of description of the path toward the humanities and social studies that Piaget has given toward the sciences, mathematics, and logic.

In a time when it is more than a joke to aver that a person over thirty has little of significance to say to a youth, the passive normative frame (stained at most with an open "aesthetic attitude") is more than a scholar's luxury. (By *passive normative frame* I mean the same as value neutral frame.

The passivity and neutrality are conscious efforts to put the selection and utilization of values in the artist's hands. Only thus can his own imagery and intentionality freely operate in the art process.) Several arguments from Bruner's essays are germane to this point. The first is that the "scientific cosmogony" that has replaced the myths of creation lacks "metaphoric force." The myths of creation are driven inward thereby, producing anxiety rather than leading to expression. Then comes his key point:

> . . . perhaps between the death of one myth and the birth of its replacement there must be a reinternalization, even to the point of a *culte de moi.*[21]

His second point is a functional one. Technological advance and the social organization essential to it have expanded what we can do, but with the result that:

> . . . the sense of potency—the idea of the possible—increases in scope, but the artificer of the possible is now society rather than the individual.[22]

A further dilemma is thus added to the first one. The myth of creation is driven inward, possibly even out of reach, signalled only by the malaise and anxiety associated with it. Outside us, however, more and more things are possible, but they are inaccessible to us as individuals.

Thomas Mann has said that the myth ". . . is the foundation of life; it is the timeless schema, the pious formula into which life flows when it reproduces its traits out of the unconscious." Further, when this ingredient enters into life, the artist's powers are heightened, bringing

> . . . a new refreshment to his perceiving and shaping powers, which otherwise occurs much later in life; for while in the life of the human race the mythical is an early and primitive stage, in the life of the individual it is a late and mature one.[23]

If, as I have come to believe, we are all heirs of the "myth of science," the "scientific cosmogony" of which Bruner speaks, and if with this comes an involution and repression of affect and imagery associated with our own effectance, competence, potency, causation, will, confidence—whatever the words of this motivational family we may use—and if the possible is increased by technology but further fenced off from our pitiably shrunken *culte de moi* (an almost vestigial remnant), then instruction in the arts, and any study of art behavior or learning of any depth, skirts the territory of what we lump into the therapeutic. But this is an accident, not a necessity.

The contact between therapy and instruction, between the *culte de moi* and the varied prescriptions called art, between the generations (or institutions and persons), is the institutionalized passive normative frame wherein the concrete stuff of action is experienced, abstracted, experienced in new particulars—i.e., where the *culte de moi* yields to some myth of creation and to the self-identity which picks up form along a path of change. The motivational forces released by the unintended instructional frame resulting from

our bounded series with its process-feedback and periodic open communications, would seem to constitute an institutionally manipulable base for a theory of instruction in the visual arts. Where artistic values are pluralistic and in constant flux, there is no theory of art that could constitute a viable normative frame and attach itself meaningfully to a given person's affect and imagery other than that prescription which is self-selected (or stumbled upon, forged in action, or what have you) and self-monitored throughout a history of change wherein the means for evaluation, reflection, reworking are maximized.

We have stressed language within this process, but would underscore that it is as *within this setting* that language so functions. Our effort to understand the workings of the mind in context as drawings are made led us into the crisis of the meaning of what we observed. A fair proportion of that meaning (it must always be less than complete) is within human grasp, we are now convinced (note that I did not, at this time, say "scientific grasp").

OPERATIONAL ANALYSIS

But it leads one to the kind of inquiry which Bridgman described in his mature years, when he came to the conclusion that "introspectional words in the private mode" can be submitted to operational analysis.[24] By this construction he apparently refers to the way we describe our personal knowledge. He further demonstrates that there is an "operational dichotomy" holding between private and public modes, asserting: "The class of operations performable by only one person may very well have a calculus of its own, and part of the task of the behaviorist is to investigate what this calculus may be."[25] Bridgman crosses the gap between "my consciousness" and my knowledge of "your consciousness" by what he calls the "operation of projection." By this he means that he imagines himself in the position of another. "If I can imagine that I myself would be using the same word in that position, then I understand the meaning of your word and you have been successful in your communication."[26] Personal knowledge gained from imagining another's experiences is the raw material, the "introspectional words in the private mode," for operational analysis.

In our later work, we depend on our knowledge of the artist's consciousness and upon the artist's own consciousness, as these are gained on several levels through observation, accumulated history, and primarily through communication, wherein that subclass of operations only the artist can perform is shared and to it is added the operation of projection, our effort to imagine the artist's experiences. The scientific task is that of describing the calculus of the single artist's operations.

A valuable suggestion about how this can be done is offered by de Charms. He interprets Bridgman's aim as that of assigning communicable meaning to introspectional words in the private mode through operational analysis:

Operational analysis, then, means an attempt to specify in what activities I must engage in order to arrive at the situation described by the word under consideration, the result of the question, "What do I mean when I use it?" In short, what are the conditions for its use.[27]

De Charms says that psychology has made some progress with a method for doing this, namely content analysis. In this technique communications are submitted to analysis for occurrences of words or meanings. A manual is developed for what is to be counted, and it is the work of putting together the definitions for this task that is most difficult and most important. Apparently something like Bridgman's operational analysis is what goes into the making of the manual. The manual ". . . adds two crucial elements, namely (a) specificity, and (b) a technique for testing the reliability of communication."[28]

Content analysis would thus seem to be one of the methods we might use. But all of the models provided (e.g., McClelland, et al.[29]) deal with communications highly structured by the researcher as compared with ours occurring as they do within the context of the drawing series, where the stimulated recall is usually the process photos of drawings or the drawings themselves of a particular individual. A more global content analysis shaped to the drawing series as a whole and to the communications concerning it would seem more appropriate. The material presented in this book is evidence enough that we are not yet at this point.

I would like to point to a further proof of the essentially atheoretical path to our present position. We are led to Bridgman and other writers like him by our immersion in our studies—that is, by problems of description and analysis we cannot solve. It is not the other way around.

It needs to be reiterated that our major concern is the acquisition of knowledge about the drawing process and about changes occurring within a drawing series. We have turned toward "introspectional words in the private mode," toward imagining the experiences of another, and toward personal knowledge as obtained through observation and communication because these were the readiest and often the only means for obtaining this knowledge. We thus confront the dilemma to which de Charms gives a more general setting in his study of the concept of motivation:

> . . . it has become clear that *the concept of motivation has no place in a strictly objective science of behavior.* This is so because, try as we may, *we can never completely objectify the concept of motivation.* . . . Either we pursue the goal of a completely objective science of behavior and renounce the concept of motivation, or we pursue the concept of motivation and renounce the goal of complete objectivity. The first alternative has been admirably set forth by Skinner, although other less pure behavioristic approaches have muddied the water with compromises . . . Spurred by some recent discussions by scientific philosophers, notably Bridgman and Polanyi, [we have] tried to consider the case for a science of psychology that accepts personal states and personal knowledge as prime data and faces the fact that they can never be completely objectified.[30]

De Charms goes on to say that all we have to go on presently is the effort recommended by Bridgman, the operational analysis of "introspectional words in the private mode." De Charms[31] and Bakan[32] both urge us to study "the first-person subject" as an enlargement of a psychology (a strict behaviorism) of "the third-person as object." To follow the latter route exclusively forces us to rule out our personal knowledge and to disregard the obvious assumption that "other people are like us"—a position untenable when we study inanimate objects, but, these authors argue, a necessary first assumption in the recommended study of the "first-person subject."

This argument, then, is not for some essence, or mind, or ghost that guides the human organism. If the foremost aim is the acquisition of knowledge, regardless of the nature of the phenomenon into which we inquire, this then falls within the concept of science. "What is needed is an adequate means of communicating about so-called subjective states, not the rejection of them," and again: "the problem with personal knowledge is to convert it from the private realm to the public realm" (de Charms[33]).

CONFLICTING THEORIES

Certainly, the art process is within the midst of conflicting psychological theories which seek to explain motivation, affect, and perception. They are at the crossroad of the crisis of the meaning of meaning. The platform we are erecting is high and shaky. Bridgman himself, after trying his method out on a seminar composed of seven doctoral candidates from a number of different fields, says:

Neither does the tool of operational analysis put agreement on an almost automatic basis, as I had hoped. The situation revealed by detailed analysis is so complex and individuals differ so widely that agreement is to be expected, even with the aid of this powerful tool, only after long and serious effort. In particular, seven people is by far too large a group to permit a sufficiently detailed analysis of what each has in the back of his head to justify the expectation of agreement in the time available. Moderate success might be hoped for with only one other member, but even with one, I would never be sure that I had caught all the implications of his ostentions.[34]

In some ways, however, our task is easier than were we studying verbal communications about art objects other than those of the artist himself. Having constants of place and procedure, of medium, possessing photographic in-process records, accumulating our notes and tape recordings from one occasion to another, our focus is narrowed to the task of attaining communicable meaning about how drawings get made and how they change. This communicable meaning is obtained through an attribution process whereby we test out personal constructs we have formed concerning an artist and his work for confirmation or disconfirmation. Because much that occurs in art, for both artist and viewer, has to do with affect and meaning stimulated by

departures from expectancies, *it is mismatching in the attribution process that leads to revision of the personal constructs we use to imagine the experiences of the artist which relate to change and discovery.* Of course, this requires laying down a workable base for imagining what the artist is doing before we become involved in his history of change.

Bakan[35] projects methods appropriate to the attribution process and the place of logic within it. As other sources have also maintained, he says that we refer to our own experience to obtain knowledge of the other. These must be conscious experiences on our own part, and we must have, preferably, a large repertoire of our experiences available to us in our consciousness. As in psychoanalysis, it is equivalent to having overcome many repressions so that we can maintain in consciousness ideas usually shocking. Although Bakan is here discussing the role of logic in clinical psychology, his reasoning seems to be applicable more broadly.

> . . . The task involved in understanding the other person essentially involves the attribution of one or another of his experiences with a probability value indicative of the likelihood that this is the experience in the client to which the client is referring. It should be evident that whereas our view in general calls for a clinician in whom the appropriate experiences are conscious, it does not necessarily call for the same in the client.[36]

Bakan further suggests that there must be a logic probabilistic in nature applicable to such knowledge.

> However, it is indeed a special kind of probability. It cannot be probability in a relative frequency sense since, without stretching a point, there are no samples or populations sufficiently homogeneous from which a sensible ratio may be made. . . . The probability notion with which we might have some business has more to do with degree of certainty than with objective states of affairs.[37]

In passing, de Charms[38] feels that certainty is a will-of-the-wisp notion, but that we can concentrate on conditions where experimenter and subject have confidence in their judgments. Interestingly enough, such conditions have much in common with mismatches in the attribution process which cause us to revise our personal constructs, excepting that in judgments there is the notion of some criterion which does not move toward revision when it encounters a departure, which does occur, however, in the attribution process. To return to Bakan's earlier statement, and try to relate it to our effort at imagining the artist's experiences, we might say that we have more confidence when we attribute experiences within our own consciousness to the artist in those instances where our expectations are not fulfilled, that is, where detectable change is occurring. This is akin to saying that in an experiment where no differences are registered on our dependent variable we do not know what to say about this state of affairs, so numerous are the possible reasons why nothing happened.

In the context of his earlier discussion on probability, Bakan speculates on the usefulness of the following ratio:

$$\frac{P\ (B_o\ /\ E_o\ h)}{P\ (B_o\ /\ \overline{E}_o\ h)}$$

"The probability of behavior B_o an experience E_o, over the probability B_o on not E_o, all under conditions h." These probabilities can be ascertained by the individual only on the basis of some kind of self-observation, for behavior and experience together are available only to a person himself.[39]

He suggests a definition of the relevance of an item of behavior to a person's experience:

. . . an item of behavior B_o is relevant to an experience E_o if the probability of E_o is modified with the introduction of B_o.[40]

These formulations are highly speculative and as yet untested, but it was comforting to find affirmation from Polanyi, Bridgman, de Charms, and Bakan that the intent and direction of the methods of our inquiry are in keeping with the phenomena themselves and with the ways we can acquire knowledge about them. Bakan says we need not have had all of the experiences we seek to encompass in our effort to understand the other. We "have" these experiences only

. . . in the way in which all yearning is the same, and all pain is the same, and all fantasy is the same, etc.—only in this way need we have had these experiences. And the method whereby we may become aware of the relationship between experience and behavior is through the use of systematic self-observation.[41]

He therefore urges us to reconsider introspection, not as Titchener utilized it, but more as Bridgman does. We thus approach psychological phenomena perhaps impossible to elicit in the laboratory.

Introspection has its maximum value on those very experiences for which there may be no conspicuous physical stimuli, such as grief, joy, anxiety, depression, exhileration, anger, etc.[42]

The method recommended is that of ". . . an oscillation between a free expressive mood and an analytical mood, with the free expression being the subject of the analysis." And the free expression is subjected to continuous scrutiny as to its meaning to a given topic or focus.[43] That there are sources of error in this procedure Bakan readily admits:

We know about the stimulus-error. We are aware of the tendency to suppress data (repression), of the tendency to supply socially acceptable data (distortion, rationalization, displacement, etc.). But insofar as we are aware of these error tendencies, we can take precautions against their commission. In this respect introspection is no different from any other set of methods in science.[44]

There is this difference in our reference to introspection—it is primarily a device for imagining what the artist is experiencing, the route toward the

forging of personal constructs and their open application in the attribution process.

We have spent time and space on the work of de Charms and Bakan because they move toward the dilemmas of theory and method we face in our own research. They urge us to retain our identity as scientists despite the amorphous state of our theory and the stocks and stones that are our tools.

Directly pertinent to this discussion is a paragraph from a recent letter to the author from Dale B. Harris,[45] well known for his research on the art of children:

> I still cannot escape the notion that for the scientific study of phenomena such as art we may need to evolve somewhat different techniques than the highly analytical one we are wedded to presently. At least this was the opinion suggested to me years ago by one of the best scientists and one of the most brilliant men I ever knew. He definitely felt we had overextended our analytical procedures without developing appropriate synthesizing procedures to parallel them. Or just possibly we have not evolved the appropriate analytical procedures; the history of measurement has shown again and again that gross judgmental activities can be refined with appropriate scales into finer techniques, but even they reach a point of diminishing returns. Or it may be that we must use ultra-fine analytical procedures and fall back upon computer techniques to put back together the many variables into which we sort our zillions of pieces. For the fact remains that any artistic product, or any artistic behavior for that matter, is a highly organized whole of many composite parts which are themselves correlated in intricate ways. They simply do not break apart neatly as do chemical formulae. The learning psychologist solved this problem by defining his task so narrowly that the learning he studies interests chiefly himself!

Earlier in this chapter we suggested that the process and context of our inquiry related to instructional and therapeutic overtones. These have been such that at times we must take a firm grip on our own identity, that is, on the function of acquiring knowledge as our main goal. We admitted that there is an instructional component to our context, identifying it with a basically contentless normative base (also called a passive normative frame) that we conceive to be the minimal assumption about "acting like an artist" which allows us to describe a person so doing. The second and third chapters of this book attempted to present some of the literature describing how art is made, as seen from broad philosophical and psychological perspectives.

When we found in one of our last two experiments that most of the people involved did not change much when we left them alone, even though we provided them with process feedback and with a limited type of self-evaluation, we moved to more in-depth study of individuals. It might have been that the changes were there earlier but that we could not experience them. In any event, we engaged people where no treatment conditions were applied, but we did suggest a set toward learning—we said (1) that we wanted to watch how people learned on their own in drawing, and (2) that we would question them about what they were doing but would not offer them instruction. Both of these assertions are part of the normative frame. While they do

not suggest what will be learned, *they suggest that learning will take place and that the person can direct himself in this process.* They leave open the matter of contents and working method, so that any lack of relevance experienced by an individual will seem to be of his own choosing. We have discussed motivational and quasi-therapeutic effects of this context in Chapters 6 and 7. We have also come to regard our separation of functions, our openness to the full range of the person's interests and concerns, our empathy and use of ourselves as instruments of knowledge, and our own active counter-intervention as contributing to an unintended instructional climate. In short, we have encouraged the person's imagination to spread out and open up; through our dialogue concerning what has occurred we have established a climate of community and sharing; and through our effort to describe changes we have elicited communications amounting to an internal reinforcement of the person's perceived mastery. These are the very conditions which Jones[46] says define instruction, the goal of which is creative learning.

His model is so clear, as he parallels it with a model of psychotherapy, that I would like to present it here, since it helps clarify our procedures:

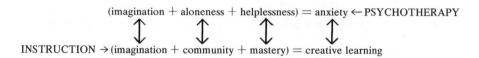

It is only the absence of criteria and the conditions for meeting them[47] that make me refer to "change" instead of "learning" in our descriptions, yet it is entertainable that criteria may yet be deduced to fit this kind of frame (and thus it would become one kind of "theory of instruction" in art). Jones's model suggests the differences but also the bridges between psychotherapy and instruction. Thus it matters little that we did not set out to instruct or to increase community and mastery. What matters is that our very methods of inquiry have the cumulative effect of doing so. This is perhaps why I cannot escape the conviction that for the first time in the research into creativity and art with which I have been involved for more than fifteen years the present work has direct implications for instruction in art. Intended or not, this is an outcome. I will not, however, venture to suggest its direct application to schools. It would be ironic if its effect were related to this very lack of intention. This is not as far-fetched as it may sound. De Charms, in a section on "The Personal Aspects of Motivated Behavior" reviews research on "The Effects of an Extrinsic Incentive on Intrinsically Motivated Behavior" and describes "A Paradoxical Effect of Withdrawing an Extrinsic Incentive."[48] In these discussions he stresses the motivational increment arising from specific conditions supporting personal feelings of control. It may well be that the conditions which foster our methods of inquiry are an excellent way to stimulate such feelings. Here is an issue which I feel can be approached experimentally.

The reader may question whether our position is not just an elaborated

rationalization of soft procedures. On the basis of only the firm evidence we can present thus far, such a conclusion may indeed be justified. Our commitment to our studies, however, makes us claim it is much too early to come to any final conclusion on them. I would ask the reader to note that it is the very decision to comprehend more which makes us continue to observe and question a person, and which ultimately increases the sense of community and mastery which shapes conscious imagination into creative learning.

THE THERAPEUTIC FUNCTION

Not only has Jones helped to clarify the relationship of instruction to psychotherapy, he has also effectively argued that a qualitative difference separates the physical sciences from the social sciences in terms of the way they are grounded in a person's self-interests and, therefore, as they function in learning. He says that the symbols of the physical sciences have "enactive and iconic referents" which are largely "*objective* with respect to the child's ego." The opposite is true with the social sciences, where the enactive and iconic referents are "ultimately *subjective* with respect to the child's ego."

> Success in the physical sciences is more likely to lead to experiences of discovery, and failure, to experiences of helplessness. In the social sciences success is more likely to lead in [*sic*] experiences of revelation, and failure, to experiences of isolation.[49]

Jones then carries these distinctions still further and offers his own extension of the Brunerian model for a theory of instruction:

> Success and failure are a function of informativeness; are pertinent to the short-range experience of discovery, and to the long-range experience of competence —all of which figure prominently in the processes of accomodation, mastery, and the attainment of concepts. Correspondingly, reward and punishment are a function of need reduction; are pertinent to the short-range experience of revelation, and to the long-range experience of self-confidence—all of which figure prominently in the processes of assimilation, invention and the *formation* of concepts.[50]

These distinctions are crucial to the assumptions underlying the context of our latter studies. We have shifted toward the "formation of concepts," toward "revelation" (or disclosure), toward "self-confidence"—in short, to a concept having more to do with organic than cultural evolution.[51] Perhaps this is the more basic, passive normative frame, wherein the feel of forming art is consciously wrestled with. Later, specific cultural styles and technologies can be sought out and attained, given this ground, meaningful in terms of its symbols with their more personal enactive and iconic referents. The fact that the few art-trained people whom we have studied intensively found the same motivation and meaning as the untrained persons in the setting of the drawing laboratory suggests, however, that these capsule models of evolution might not work as well the other way around.

In our last experiment we demonstrated that signs associated with strategies of drawing could be directly taught in such a way that they severely affected the appearance of drawings. This is equivalent to saying that stylistic concepts could be attained and included in one's drawings. When this occurred, however, the formation of concepts, the processes of assimilation and invention of which Jones spoke above were either absent or interfered with—hence our feeling that this was not sufficiently art. We did demonstrate how easily drawings could be changed from the outside-in. Perhaps what we became uneasy about was the fact that the personal enactive and iconic referents to the symbolic aspect of the drawings was further removed from individuals by this means—not that they embodied these well to begin with, but rather that we may have unwittingly further impeded their entry.

In this connection, I would like to refer to an insightful correction to the earlier model comparing instruction and psychotherapy, brought to my attention by my research assistant.[52] It is his feeling that aloneness and helplessness before an activated imagination are among the essential conditions for art. The anxiety thus aroused, however, can be coped with, as it yields to the work of forming, of articulation. Situational factors within which reflexive abductive reasoning (discussed in Chapter 3) take place determine the unique process leading to any art object, so that the process itself disperses and utilizes the attendant anxiety. The crucial point is that unless the artist or artist-student copes with the anxiety contingent upon his aloneness and helplessness before his own imagination we do not have the conditions where art is possible. This is merely another way of stating the requirement of prescription selection and monitoring on the part of the artist. The observer participant, we have learned, is not a therapist, but his function of communication with the artist for the acquisition of knowledge has the side effect of helping to dispel the artist's aloneness and helplessness, or at least that residue of these left from the operation of insufficient means upon the thrust of imagination. The observer participant's dispassionate desire to understand "introspective images and acts in the private mode" (to extend Bridgman to the visual arts) renders relative coping accessible for evaluation and direction, while the cumulative effects of choice and initiation strengthen the feelings of personal causation and control, relative to the paucity or richness of means, solidifying the potential for inner drawing—in short, simultaneously disciplining the imagination and extending the means.

Perhaps we can put to rest the entangled issues of knowledge, instruction, and therapy. The less a person we observe can cope with his aloneness and helplessness before his imagination, the greater his anxiety and the more we are apt to serve (temporarily) therapeutic functions even though this is not our intent. Progressively, the bounded series will serve an instructional function, particularly as it helps the less trained or more naive artist to form the concept of himself as an artist in action. Finally, the full focus on knowledge about the process and series will lead progressively to a dialogue among equals clearly separated by functional roles. The effect of exploring meanings, it is our impression, will continue even here to further release imagina-

tion and means for the artist. A rhythm of action-synthesis and communication-exploration is the likely outcome.

But our goal and role priority is clear. We are intent upon knowledge about the drawing process and series. We acknowledge that the setting is of necessity instructive and that our means of gathering knowledge contribute to the setting's instructional impact, but this is not our purpose; thus we adopt a value neutral frame and counter-intervene. We also acknowledge that before the setting can be grasped as plastic and instructional, many persons will have to learn, remedially or therapeutically, to face their own anxiety, assess their limited means realistically, and select and monitor value orientations related to their own imaginative experience.

KNOWLEDGE, INSTRUCTION, REMEDIATION

Thus the knowledge, instruction, remediation (therapy) continuum has been made explicit as well as our functional and value priorities upon these three positions. The knowledge which we seek is that of the drawing process and series seen from a perspective taking into account changes within an observable and traceable context. We would call it "learning" or "learning to learn" were our criteria further developed. Once we have a sufficient base in accumulated histories of change and further information on how we function within them, knowledge-getting and instructional conditions can be more clearly separated in future research. Table IX attempts to summarize the varying ingredients of our studies as these function along this hypothesized continuum.

It is important to stress that knowledge, instruction, and remediation all operate within one system. As the dynamics of this system become known, conscious variation within it may be possible. At present, my research assistant and I are hard pressed to monitor our own behavior and to describe what transpires. As with Bridgman, I feel "moderate success" with the description of one person at a time, but, as he put it, ". . . even with one, I would never be sure that I had caught all the implications of his ostentions."[53] What Table IX does indicate, however, is where next energies must flow, namely, into point 3 under "Knowledge," or into "Synthesis and Analysis." Right now we have only dealt with points 1 and 2 under "Knowledge," as the material within this book will testify.

A kind of "program" is thus suggested by Table IX. It would be a mistake to suppose that it was explicit from the start. The route has primarily been inductive, synthetic, empirical. Since the emphasis is primarily upon knowledge-getting and knowledge-interpretation, we have not, to reiterate, espoused a theory of instruction. It would be nearer to the truth to call our middle column a theory for implementing self-instruction. Nevertheless, a close parallel to our operational representation of instructional conditions is at hand in Kaelin's recent "existential-phenomenological account of aesthetic education."[54]

Since his analysis proceeds from philosophic inquiry, it may be en-

TABLE IX COMPONENTS OF CASE-HISTORIES AND THEIR FUNCTION ALONG THE KNOWLEDGE-INSTRUCTION-REMEDIATION CONTINUUM

Knowledge ⟵⟶	*Instruction* ⟵⟶	*Remediation (Therapy)*
1. Knowledge-Gathering (R) a. Products b. Time-lapse process photos c. Written notes on observations, communications d. Recorded communications e. "Personal Knowledge" as it functions within communications f. additional (neutral) observers 2. Knowledge of change: Mismatches in Contextual Expectancies over Time (R) 3. Synthesis and Analysis (R) a. "Operational Analysis" of Communications b. "Content Analysis" of Communications c. Delineation of process criteria of evaluation for "expert" judges (for interindividual and intraindividual evaluations)	1. Value Neutrality (R) 2. Prescription-Selection and Monitoring (A) 3. Counter-Intervention (R) 4. Self-Reflective Environment a. Process Feedback (R) b. Bounded Series (R) c. Consciousness through Communication (R & A) 5. Motivation: Increased Self-Confidence and Self-Identity (A) 6. Change and Directionality (A)	1. Value Neutrality (R) 2. Self-Acceptance: Preparation for Prescription-Selection and Self-Reflective Environment (A) 3. Counter-Intervention (R) 4. Consciousness through Communication (R & A)

Note: R = primarily role of researcher; A = primarily role of artist; R & A = role shared between researcher and artist

lightening to note how his account parallels ours and wherein it may help to clarify ours. What we have called "prescription-selection and monitoring," that is, the need for the artist to adopt, direct, and modify his own value premises, Kaelin calls the "projectional principle."

Education must be considered a dialogue between the educator and the educatee, and the dialogue must be initiated by a gesture of the latter. . . . Existentially con-

sidered, where one wants to go, and not where one has been in the past, determines what and where one is at any given moment of decision. But this is only to say . . . that a human being is ontologically defined by his own projects of existence; and, ontologically, this is what is meant by "transcendence."

. . . Man is in some fundamental sense what he is to become, i.e. a projection toward some as yet undetermined future; this future, moreover, can be actualized only by a free decision or commitment of the individual.[55]

Here, then, in the "projectional principle" (a different meaning from Bridgman's earlier use of this term) we have a philosophical position supporting one of the underlying assumptions of our later studies. In passing, it should be pointed out that Langer in her recent work has spoken of the artist's "projection" in a similar vein.[56]

Where we cannot follow Kaelin's argument is also instructive. It must be remembered that he is presenting an account of aesthetic education based on the method of phenomenology, ". . . whose empirical adequacy is guaranteed by the fact that the categories it uses to describe aesthetic experiences are derived from our everyday contacts with works of art, both in and outside the classroom."[57] So far so good. Where we cannot follow him completely is in his assumptions about "aesthetic communication" and in his postulates coming after his projectional principle, namely, the "autonomy principle," the "relevancy principle," and the "completeness principle."[58] In our setting we do not directly attack the problem of justifying aesthetic judgments, as is done under Kaelin's "completeness principle." We are not critics of the artist's work. Instead this task is reflected back to the artist. But we do give "readings" of how we perceive a given work. These are offered as tentative hypotheses, and they follow the lead taken by the artist as he perceives his own work and reconstructs the situation from which it emerged.

It is instructive that Kaelin says the latter three principles are established through phenomenological analysis of aesthetic objects, whereas only the projectional principle is established through existential analysis.[59] The place of departure is not in method, however, but in his assumptions limiting aesthetic communication. He says:

Besides the actual making and appreciating of individual works of art, only the descriptions of art works and their embodied values as mediating the consciousness of the student and that of the teacher are relevant to the aesthetic procedure.[60]

But we have found that "embodied values" is a misnomer, for we do not deal with individual works alone, but within a series we experience an expanded context where many other factors serve to mediate the consciousness of artist and researcher. This does not mean that we thus fall prey to the so-called intentional and affective fallacies, wherein we must know what an artist meant to do or wherein we assume that any interpretation is legitimate. It rather suggests a delimiting effect of Kaelin's account of aesthetic education and one which we need not accept to make use of the merits of the phenomenological method, more broadly conceived.

But then, too, our setting is not one for aesthetic education. It is more radical than that. We cannot draw lines on what is autonomous (centrally aesthetic), relevant (issuing only from so-called embodied values), or complete (in which an "adequate perception" of the work of art already implicitly judges its worth[61]), and I know of no criteria that would demonstrate that this could issue from phenomenological analysis. We cannot draw lines because forces which are not centrally aesthetic, values which are not fully embodied, and perceptions which are tentative and of unknown adequacy are active and shaping what occurs within the drawing process and the drawing series.

Kaelin is helpful in opposing the Platonic model of communication—idea, work (artistic vehicle), idea—with another:

> Since the artist is working to clarify his vague notions and feelings stemming from his prior relations to his environmental situation, and does so by creating a work which is the meaningful projection of the old into the newer situation, artistic communication may be schematized as work $\left\{ \begin{matrix} \text{reaction}_1 \\ \text{reaction}_2 \end{matrix} \right.$, where the reactions are those of the artist and his audience.[62]

This latter model of artistic communication, as the description leading up to it, perfectly fits our setting. Disagreement comes later on, for unlike Kaelin, we do not have the notion of what successful communication can mean following this model. Since by his own argument, following Kant, aesthetic judgments are founded on "indeterminate concepts,"[63] the problem of successful artistic communication, established between two reactions, artist and teacher, or artist and researcher, is problematic to say the least.

Yet there is no disagreement with Kaelin's "postulates for the interpretation of aesthetic significance".

P 1. All aesthetic significance is context bound.

P 2. An aesthetic context is composed of counters and their relations, either surface only or surface and depth.

P 3. No aesthetic counter has absolute significance; i.e., each has only that significance which is made apparent by a relationship to some other counter within context.

P 4. The significance of the context is the felt expressiveness of all the counters as they fund or come to closure in a single experience.[64]

These postulates check with our experience, but we are sensitive to the many influences entering into a given context. Perhaps what Kaelin means is that the reactions of the "audience" must be to the immediate, the sensuous, the nontransparent—i.e., to the aesthetic—in order to "educate" the artist. This may well be so without recourse to any justification of aesthetic judgment. Even so-called failures, from some given point of view, may be attended to aesthetically. The issue of justifying judgment, in short, is presently beyond us, except through the common operational definition as consensus of defined experts.

The difference is no doubt precisely that of purpose. We give no account of aesthetic education. Instead we seek to describe process and change where the "projectional principle" operates and where feedback and communication give the artist the opportunity for extension and directionality as he conceives these from his value base and his reaction to his "work." In this sense, the "self" of the artist is the "other" who reacts, and our exploration for understanding gives him first opportunity as "audience." Seldom is artistic communication seen as outright successful or unsuccessful under these circumstances. Rather the artist (and we with him) comes to experience what *seems* to be embodied, through open exploration of what he perceives.

In short, Kaelin's account is a very appropriate parallel to ours, hence we have dwelled upon it. The difference is one of what is admitted within the account. Given the bounded series and context, we exclude nothing deliberately. Only in the existential sense do we deal in prescriptions—we assume the artist *ought* to select and monitor his own value base. From there on we try to trace what in effect is the artist's reaction as audience and how this relates to his reaction as artist, and what this may mean in his next transcendent projection, into artistic work. We also react, but after the artist has done so, and in an exploring, not a critical manner. I am led to speculate that our aesthetic response is to the larger context of which the work and the reactions are only parts.

It is also true that in our usage communication has a different meaning from Kaelin's, the latter being operationally equivalent to confirming overlap in aesthetic response between artist and (informed) audience. Our usage is more like Bridgman's, that is, search for "communicable meaning" concerning a work of art, a derivative of exploration (and perhaps of operational analysis) of introspectional images and acts in the private mode, as these can be grasped in verbal communications.

MODEL

It should now be obvious to the reader that I am not going to arrive at theory in this chapter and only partially at method. In any case, I cannot do what philosophy and psychology are now incapable of doing. I have had to come to the conclusion that my work is prescientific, but defensibly and necessarily so. Following Langer,[65] I might maintain that I work largely from an image of the drawing process and the drawing series in a context of defined boundaries. That I dare head this chapter "On Method and Theory" indicates that I have ambitions of arriving at a model, but the time is not quite ripe for this. That I deal with an image at this point is revealed by my confession that the process and series and the mind and context character of my studies, as "created semblance," confronts me like the feel of these phenomena themselves. As Langer points out:

A model . . . need not share any personal traits with its object, but symbolizes its structure or function and is true to the original in every proportion and represented

connection, to a stipulated limit of accuracy. A model is usually based on a single systematic abstraction which can ultimately be expressed in mathematical terms. Consequently it is a model, not an image, that one works with in science.[66]

Thus comes my conclusion that our studies are prescientific. Even so I have dared to use the forbidden word *mind*, again, undoubtedly made bold by the stand Langer has taken in the recent book from which the above quotation is drawn. Our work is gradual and unsystematic to a degree. We do not have the "single systematic abstraction" upon which a model can be built. Thus we chip away at our assumptions, flesh out our regularities of observation, and make sketches of our methods. When we present a pseudomodel, a postiori, as in Table IX, it is done more as a sketch, an exercise, a summary.

But this is not to be construed as defeat or apology. It is an admission of the state of the art of inquiry into such phenomena, and it is an admission which the psychology of art, aesthetics, and art education would do well to acknowledge. Let me quote Langer once more, as she speaks of the value of images in early phases of scientific study:

> . . . they, and only they, originally made us aware of the wholeness and over-all form of entities, acts and facts in the world; and little though we may know it, only an image can hold us to a conception of a total phenomenon, against which we can measure the adequacy of the scientific terms wherewith we describe it. We are actually suffering today from the lack of suitable images of the phenomena that are currently receiving our most ardent scientific attention, the objects of biology and psychology.[67]

We thus acknowledge that we are in what Langer calls "a sort of intellectual gestation period," wherein we have "turbulent notions about things that seem to belong together." Langer, further, comes close to the conclusions earlier drawn from de Charms:

> It is even conceivable that the study of mental and social phenomena will never be 'natural sciences' in the familiar sense at all, but will always be more akin to history, which is a highly developed discipline, but not an abstractly codified one. There may be a slowly accruing core of scientific fact which is relevant to understanding mind, and which will ultimately anchor psychology quite firmly in biology without ever making its advanced problems laboratory affairs. Sociology might be destined to develop to a high technical degree, but more in the manner of jurisprudence than in that of chemistry or physics. Were that, perchance, the case, then the commitment to 'scientific method' could be seriously inimical to any advance of knowledge in such important but essentially humanistic pursuits.[68]

Langer, then, like de Charms, leaves the issue open, even hanging and unreconciled, for if our inquiries build toward "a highly developed discipline, but not an abstractly codified one," then the earlier use of model loses its relevance, for we no longer speak of "natural science." We can only acknowledge this dilemma and continue to work toward the advance of knowledge,

whether this eventually moves toward natural science or humanistic pursuits. Not being a psychologist, nor having any definite psychological persuasion, I can afford to live under the ambiguity attendant upon our "incunabular stage."

It is close to the time, then, to leave off wandering through diverse literature and put aside the necessarily heteronomous writing this has forced upon me and the reader. I have tried to move across ideas not always comfortable together. Quotations have been lengthier than I would like, but this has wittingly been done to preserve the intractability of ideas for combination into larger issues once drawn from their respective contexts. Some of my own less fortunate neologisms undoubtedly were encouraged by this state of affairs. Were such constructions to prove workable, their function would be that of applying to the drawing process and series in such a way as to span several disciplines.

Were I to have a theory, or even the start of a model, I could be much less eclectic and much more parsimonious. There is, then, a sense in which I can be proven neither right nor wrong, and even a charge of inconsistency will have little cogency. The projection I now make would be a continuation of the general plan described in Table IX, the effort placed upon elucidation of the therapeutic, instructional, and knowledge-gathering and -synthesizing operations in which we engage.

I find myself returning to my intuition that the artistic process tends toward the state of a learning automaton, or, to match Langer, toward the organism analogy. At its most naive, I mean: forming is changing is growing is learning. Holding down environmental noise and our own will to shape the artist, we see him selecting, constructing, and adapting to a path, in which his means, his plans, and his cumulative acts are necessary but not sufficient explanatory factors. As observer participants, intent upon knowledge but necessarily obtaining this through our own experience in communicating with the artist, we affect as we describe, we reflect as we inquire, and we release as we explore. We do not intrude during the artist's projection, and we do not appropriate any part of his plans or usurp his feeling that he is an origin. Above all, we do not prescribe nor monitor a value orientation, for these belong to the guiding or nascent image and the working mind as a system.

Our earlier "search for the teacher" has succeeded even as we abandoned it. It came back as we strove to counter-intervene, and as we totally reinvested the artist with his power as locus of causality, as monitor and transformer of feedback, and as lead explorer in the stimulated recall of his own mental processes.

As befits our image of the phenomena of study, we have no schedule or category system to apply across individual artist's processes. Our means of abstracting for stimulated recall and for delayed process feedback are a time sample via photography of the history of the process itself. If the whole work is a symbol, we can only grasp it, morphologically, in the evolutionary sense. Thus our handling of process material is noncategorical. Its full intent is to move it from the operationally subjective (the covert, "whatever is felt

as action") to the objective (the overt, "whatever is felt as impact").[69] Thus we try to see the print of the "wraith-like character and mysterious coming and going of images and thoughts,"[70] the acts, the transformations, that have projected "a whole held together only by activity."[71] Further, our viewpoint of the "learning automaton" is nothing more than the same frame of mind applied to that larger process, the series, which reads the artist's path also as a projection.

At our present stage of knowledge, I cannot be sure of the third point under "Knowledge" in Table IX. Synthesis, as historical interpretation, we have attempted. And perhaps we are moving toward a kind of operational analysis of introspectional images and acts in the private mode in which any fair-minded judge would arrive at congruent communicable meaning. But I cannot be sure for some time to come whether we can develop a "manual" with "operational definitions" that will permit some equivalent of "content analysis" with these data. And I have the hunch that judgments and criteria will fare as badly applied to the process as they have to the product, except as they can operate through trained and sensitized human judges, whose judgments, I submit, will yield but little to atomistic analysis. At present I cannot specify judgments that would not seem like an untimely intrusion upon these data. In short, I am affirming that knowledge can be advanced, but willing to consider that it may have to be arrived at through the development of a discipline which is not "an abstractly codified one"—or better, that a fair portion of knowledge may have to be so arrived at.

Other investigators, at the present prescientific stage, may not want to hold on to as large an image as we have. Paradoxically, it has been much less frustrating to do so. I have never found my research as exhilarating, as compelling, or as enlightening as these last, methodologically simple studies. Without benefit of a model or of statistical tools or even a special language, I nonetheless feel full commitment to this route.

I can think of no better way to close than with the issue open:

> Whatever the future, let us not jeopardize it any further by denying to our re-searches the free play which belongs to brain children as well as to animal and human infants. The philosophical phase we have missed lies at the very inception of research; if we would build a sounder frame of psychological, ethical and social theory, it is to that incunabular stage that we must return.[72]

NOTES

1. Edmund B. Feldman, "Research as the Verification of Aesthetics," *Studies in Art Education* 1, no. 1 (1959): 19–25.

2. Michael Polanyi, *Personal Knowledge* (Chicago: University of Chicago Press, 1958), p. 300.

3. Beittel, op. cit. (1964), n. 2 chap. 1.

4. Beittel, op. cit. (1966), n. 2 chap. 1.

5. Jerome S. Bruner, *On Knowing: Essays for the Left Hand* (Cambridge: Harvard University Press, 1962, p. 159.

6. David Bakan, *On Method: Toward a Reconstruction of Psychological Investigation* (San Francisco: Jossey-Bass, Publishers 1967), pp. 81–83.

7. William R. Bradley, "Intrinsic Feedback and Its Effect upon Aesthetic Growth," *Studies in Art Education* 10, no. 2 (Winter 1969): 41–49.

8. Robert C. Burkhart, *Spontaneous and Deliberate Ways of Learning* (Scranton, Pa: International Textbook Company, 1962).

9. William R. Bradley, "A Preliminary Study of the Effect of Verbalization and Personality Orientation on Art Quality," *Studies in Art Education* 9, no. 2 (Winter 1968): 31–38.

10. Suzanne K. Langer, *Mind: An Essay on Human Feeling,* vol. 1 (Baltimore: The Johns Hopkins Press, 1967), pp. 157–58.

11. Richard de Charms, *Personal Causation: The Internal Affective Determinants of Behavior* (New York: Academic Press, Inc. 1968), pp. 226–27.

12. Barbara Biber, "Premature Structuring as a Deterrent to Creativity," *American Journal of Orthopsychiatry* 24, no. 2 (April 1959): 280–90.

13. Anton Ehrenzweig, *The Psychoanalysis of Artistic Vision and Hearing,* 2d ed. (New York: George Braziller, Inc., 1965).

14. Lawrence S. Kubie, *Neurotic Distortion of the Creative Process* (Lawrence: University of Kansas Press, 1958).

15. Michael Polanyi, *The Tacit Dimension* (original ed., 1966; reprint ed., New York: Doubleday & Company, Inc., Anchor Books, 1967), p. 13.

16. Monroe C. Beardsley, Review of *What Happens in Art,* by Matthew Lipman, *Journal of Aesthetics and Art Criticism* 26, no. 3 (Spring 1968): 411–12.

17. Bruner, op. cit., n. 5 chap. 8, p. 31.

18. Edward L. Mattil, "A Seminar in Art Education for Research and Curriculum Development," U.S. Office of Education Cooperative Research Project No. V-002 (The Pennsylvania State University, 1966).

19. Rudolf Arnheim, *Toward a Psychology of Art* (Berkeley: University of California Press, 1966), pp. 337–42.

20. Andre Malraux, *The Voices of Silence* (New York: Doubleday & Company, Inc., 1953).

21. Bruner, op. cit., n. 5 chap. 8, p. 41.

22. Ibid., p. 160.

23. Thomas Mann, *Essays of Three Decades,* "Freud and the Future" (New York: Alfred A. Knopf, 1937).

24. P. W. Bridgman, *The Way Things Are* (Cambridge: Harvard University Press, 1966), p. 216.

25. Ibid., p. 217.

26. Ibid., p. 220.

27. de Charms, op. cit., n. 11 chap. 8, p. 43.

28. Ibid., p. 44.

29. D. C. McClelland, et al., *The Achievement Motive* (New York: Appleton-Century-Crofts, 1953).

30. de Charms, op. cit., n. 11 chap. 8, p. 355.

31. Ibid., p. 357.

32. Bakan, op. cit., n. 6 chap. 8, p. 92.

33. de Charms, op. cit., n. 11 chap. 8, pp. 23–24.

34. Bridgman, op. cit., n. 24 chap. 8, p. 246.

35. Bakan, op. cit., n. 6 chap. 8, p. 88.

36. Ibid., p. 88.

37. Ibid., p. 89.

38. de Charms, op. cit., n. 11 chap. 8, p. 290.

39. Bakan, op. cit., n. 6 chap. 8, p. 90.

40. Ibid., p. 92.

41. Ibid., p. 93.

42. Ibid., p. 98.

43. Ibid., p. 104.

44. Ibid., p. 101–2.

45. Dale B. Harris, Personal communication to the author.

46. Richard M. Jones, *Fantasy and Feeling in Education* (New York: New York University Press, 1968), p. 77.

47. Jerome S. Bruner, *Toward a Theory of Instruction* (Cambridge: Harvard University Press, 1966), p. 40.

48. de Charms, op. cit., n. 11 chap. 8, pp. 323–35.

49. Jones, op. cit., n. 46 chap. 8, pp. 118–19.

50. Ibid., pp. 121–22.

51. Ibid., p. 123.

52. Charles S. Steele, Personal communication to the author.

53. Bridgman, op. cit., n. 24 chap. 8, pp. 245–46.

54. Eugene F. Kaelin, *An Existential-Phenomenological Account of Aesthetic Edu-*

cation, Penn State Papers in Art Education, No. 4. (University Park: The Pennsylvania State University, 1968).

55. Ibid., pp. 17–18; 14.

56. Langer, op. cit., n. 10 chap. 8, p. 107ff.

57. Kaelin, op. cit., n. 54 chap. 8, p. 5.

58. Ibid., pp. 11–12.

59. Ibid., p. 39.

60. Ibid., p. 11.

61. John Dewey, *Art as Experience* (New York: Minton, Balch & Co., 1934), pp. 308ff.

62. Kaelin, op. cit., n. 54 chap. 8, pp. 21–22.

63. Ibid., p. 22.

64. Ibid., p. 32.

65. Langer, op. cit., n. 10 chap. 8, p. 68.

66. Ibid., p. 68.

67. Ibid., p. xviii.

68. Ibid., p. 53.

69. Ibid., p. 30.

70. Ibid., p. 229.

71. Ibid., p. 273.

72. Ibid., p. 53.

Implications and Concluding Speculations

While possessing a constant theme, this book has openly changed, after its own personal history, from the empirical to the speculative and from the experiment to the case method. Details have not been laid into a neat and logical outline prepared beforehand. Moreover, a year has elapsed between the writing of the first eight chapters and the beginning of this one. It is my hope thus to leave the discussion of mind and context in the art of drawing even as I came upon it, problematic, even paradoxical, but open to continuing inquiry of all kinds.

My vantage point over the past two decades as a teacher of graduate students in art education, as a practitioner of empirical research in the study of artistic behavior, and as a believer in the possibility of a psychology of art, has produced a continuing internal dialogue concerning art education. Some of the brilliant younger minds it is my pleasure to work with seem able to come at the issues I address more directly through the discipline of philosophy. I look forward to their contributions. In my case, I have had to find

my way by a more empirical route. At the same time, I have had to acknowledge increasingly the importance of philosophy in my reflections, on the one hand, and the personal nature of my knowledge, on the other.

As I reread the literature of art education, I have come to believe, however, that the idea of a theory of art—at least of an "explanatory" theory of art—is a luxury unnecessary to art education. The work of Schaefer-Simmern[1] again comes to mind as an example of what I mean. He has a relatively explicit theory of art. At the least he has a firm grasp of what art "should" be (and an even firmer grasp of what it should not be).

In the course of a person's "unfolding," Schaefer-Simmern subtly (and honestly, for intentionality on the teacher's part is not dishonest but merely other than the student's intentionality) brings to bear matchings and parallels from folk and fine art, conceptions of stages of "natural" development in the conquest of representation, and working strategies of how a drawing is put together. These reinforcements, while external to the artist, attract rather than repel because Schaefer-Simmern utilizes a cybernetic and existential method in shaping the artist. How does this work?

The artist projects via meaningful personal subject matter, and does so through his own impoverished means. Familiarity, knowledge, and feeling (and what I have called idiosyncratic meaning and rudiments of symbolic transformation) are present from the start. Outputs are looped back, as in a regulated system, and the artist is kept at his subject and even urged to repeat his effort. This revision and retrial within a narrow range make possible the beginnings of internal drawing. The artist can begin to select, enlarge, accentuate, level, sharpen, rearrange, and take liberties. His obvious improvements are motivating.

Schaefer-Simmern's clearly formulated next steps in "unfolding" can now subtly be laid over this personal base. Wisely directed departures in medium, methods of criticism (structured by the teacher, in the Brunerian sense, so that the discovery, like that of quadratics or the conservation of matter, exemplifies a large, abstract concept concerning "visual conceiving" as related to artistic representational mastery consonant with the underlying theory of art), and repetitions with newness of a meaningful theme all come together to constitute a powerful didactic method. The teaching-learning and making-living relationships both become transitive, but the line along which the unfolding occurs is mostly a function of the teacher's intentionality projected upon this meaningful subjective base in the artist.

In contrast, Lowenfeld[2] offers us a theory of art education, not a theory of art. Actually, his was a theory of education *through* art. With him the teaching-learning relationship is still transitive, but teaching does not shape the learner toward art so much as toward a conception of the good life. And this good life has as its end increased sensitivity along many dimensions, the sum of which was a creativity which might operate in all life situations.

Undoubtedly we are closer to Lowenfeld's position, but not with respect to any assumptions about creativity and its transfer power. And the teaching-learning connection becomes intransitive. The experiential possi-

bility of art is protected through an emphasis on the values, the images, the intentions, the sense of personal causation and self-direction of the artist himself, whose entertainable myth of self-identity arises through his encounters within the art process and the art series.

FEEDBACK

To our observation, both learning and art reappear more strongly when their external structuring diminishes and when the learning environment holds down pressures and increases feedback usable to this one artist alone. If there is an end to the experiences of which we speak, it is not creativity, nor education through art, but more likely the continuing symbolic construction of the self. This end can apparently occur at any level of skill and within any of the disjunctive classes loosely comprising the realm of art. One comes to accept one's self, feelings, and skills, while at the same time the novel and the spontaneous arise as both responsibly under one's control and beyond it, a paradox within the finite realm of man's existence that lies beyond explanation.[3]

Let us look at this matter more closely. There is a subjective reality or set of test criteria which determines the rightness of an art experience. Whenever shaping occurs from an outside force and it is out of touch with this subjective rightness, it is doubtful whether we deal with art behavior at all. I use subjective in its commonsensical form. To the agent, this sense of rightness, of guiding criteria, is more objective than pressures from the environment although the latter are traditionally so-called.

Within my own life, I have only experienced willing withdrawal of will when I worked with the Japanese master who taught me porcelain-shaping methods. But then I had no internal model, image, or projection of plans (as though appearing unsought) to cope with the identification model provided me. My envelopment by him was complete. I trusted, and there was a living tradition and culture which supported this externalization of spirit. I temporarily became planless and emptied out my ego and past to become this new behavior, led on by the fact that it was humanly and masterfully held together in this artist's very being and every act. There was not an end to education and a beginning to life, and the spirit of this was reciprocal. I went to work on my own or he came to seek me out if I did not. The only requirement I can remember him specifying was not skill, not position, but what I can only translate as *zeal*.

Most of the teaching in art I have observed otherwise, however, misleadingly withdraws the ostensible desire to shape at the outset, but conceals a value realm which is not only projected nonverbally, but inculcated subtly or, more likely, indoctrinated by attachment to power and authority. The sincerity behind a teacher's values matters little, for the projection of his own tacit criteria on others, by our experience in the drawing laboratory, would predictively almost never match the subjective sense of rightness of the student. As such, it cannot help but sap self-confidence and motivation.

When I worked with the Japanese master potter, personal causation was not a problem—it was more like apersonal causation. Even technical matters were mediated with grace and timeliness. They never became a means of distancing me from the artistic and the human. Under such conditions, and at my stage of learning, an even balance between assimilation and accommodation existed. The criteria applied possessed rightness, objectively and subjectively.

Not blessed with continuity, tradition, and apersonality, American teachers of art often mistake their own subjective sense of rightness as a proper projection for shaping another. No match or extension of the student's subjective criteria is likely to occur. Instead, frustration, withdrawal, cynicism, duplicity of styles, and what Collingwood called corruption of consciousness results. This occurs typically in silent suffering, for genuine expression, which is all one can share, is out of order. It is a small wonder that the approach-avoidance conflict which I felt as a student in art school, and which many of our participants in the drawing laboratory have mentioned, occurs when we think of the formal study of art. The art student learns to survive through camouflage, double styles and values. And the academy becomes a no-man's land in which neither trust nor revelation is found.

Through such terms as subjective rightness, idiosyncratic meaning, and so forth, I merely sketch in concepts for extending discussion to covert aspects of art experience. My purpose is simple: I need some such terms to conceptualize the art dialogue. If the latter is dismissed, no expression takes place, and there is no communication back to the self, for it is in searching out potential meanings of expressive acts that I believe much conquest and construction of the self occurs.

IDENTIFYING WITH THE STUDENT

The exhortation to identify with the student in order to intuit what his sense of rightness would support and what would draw it out ("educate" it), is a well-meant but impracticable one. Buber[4] has indicated the only case in which such identification is genuine: wherein the intuition of the teacher leads him to bring within himself the student's need, an act which changes and educates the teacher as well (or else, he says, the relationship becomes a lie). Then the outside rightness and the subjective rightness (for the latter, there is a strong epistemological argument that the self is the only source of such information[5]) confront each other like attracting, not repelling, poles. This gift may not be so much rare as impossible to effect within our typical teacher behavior, for it requires more self-effacement and waiting than most of us can sustain in our roles. The ability is there. But we lack the habit of really hearing the other and we lack the habit of patience. Here is what one recent writer says about teachers' ability to wait:

It's really almost impossible for adults, and no doubt especially for adult teachers, to see any thing "constructive" going on in a bunch of kids shouting at each other. All the adults can see is just that: kids, all bunched together, yelling

at each other. You can't believe they are doing it for anything you'd call a purpose; they are simply creating a problem, something that shouldn't exist at all.

The adults also can't imagine that this problem is going to cease to exist unless they, the adults, make it cease. They feel that unless they issue orders and directions and threats, the kids will never stop making noise, never stop yelling, never get organized.

This feeling is wrong. The adults are wrong on both counts, not because they are stupid, not even because they lack . . . "insight" either. They are wrong because almost no one can stand to wait around long enough without doing anything, so that they can see what all the shouting is about, or what might happen when it eventually is over. They can't stand to, and so they never find out. Never finding out, they assume that there was nothing there. I don't think the quality of insight is unique or even rare. . . . What does seem to be rare is the ability to wait and see what is happening.[6] (Herndon)

I believe our experience in the drawing laboratory parallels Herndon's. All of the activity that goes on there—even what seems a lack of activity— is about something, and if we are patient listeners, chapter six will clarify and qualify chapter one. There is also a very personal satisfaction on my part from trying to practice this kind of patience. Rogers[7] expresses it well:

When I can really hear someone it puts me in touch with him. It enriches my life. It is through hearing people that I have learned all that I know about individuals, about personality, about psychotherapy, about interpersonal relationships . . . Hidden in all of the personal communications which I really hear there seem to be orderly psychological laws, aspects of the awesome order which we find in the universe as a whole. So there is both the satisfaction of hearing this particular person and also the satisfaction of feeling oneself in some sort of touch with what is universally true.

The strongest and most capable person I have known for "identifying" with the other was Viktor Lowenfeld. (I suspect his term *self-identification,* by the way, has been influential in my own struggle with the concept of the "myth of self-identity.") Yet I also recall that the power and presence of his personality, coupled with his sense of mission and authority, swamped many and made others dependent. But I confuse two issues here. He was properly a master, like my Japanese pottery teacher; not in art, but in art education. In art, he often projected himself instead of identifying or waiting. He was often uncanny at using art for some good in a person's life, and when this occurred, as in his case histories of work with the handicapped, he was at his best. In other art teaching relationships, he remained sensitive but became somewhat theoretical—which can also be read as impersonal and arbitrary. In my personal experience his sense of identification operated most fully when I did not follow him. Then his sensitivity revealed itself, for he would identify anew with the base I had laid, which was unlike his first projection of me. This showed me that he trusted my action, for he centered on what I was doing and not on what he thought I should be doing. In this regard I sense, again in keeping with Rogers's conclusions concerning psychotherapy,[8] that it is not a matter of what theory one holds but rather of the genuineness of the

relationship in the present moment that renders one effective. Indeed, in the drawing laboratory we have found that if our minds wander off the artist, if we had rather be elsewhere or doing something else, or if we are fearful or pressed, the artist senses this, and his dialogue with his work is marred.

Since I have skirted the issue of deepened interpersonal relations, let me seek to clarify a difference I have sensed in the drawing laboratory which sets it off from other situations. Despite the openness and presence which usually develops naturally in the drawing laboratory, there is one area of interpersonal relations where it seems proper to hold back as observer participants. I have mused on why a lack of response can seem right and natural and how this compares, say, to Rogers's criterion of "congruence" or genuineness[9] on the part of the therapist in psychotherapy.

First, however, let me describe the setting through an example. A relatively interactive young lady begins to draw in our laboratory. When she asks for help with technique, it is fairly simple to explain that we would rather not give such instruction because we wish to understand how artists overcome or tame technical problems in light of their own goals. But when she turns to us as fellow human beings and says, for example, "Do you feel I have enough dark and light to establish a mood?", or "Does it seem empty to you?", or "Does it lack a definite center of interest?", these are somewhat different questions. (All of these occurred to us in one session quite recently.) Now, I had feelings and perceptions concerning her questions, but it seemed right not to give them. At the same time, if I hold Rogers's generalizations in the back of my head, I am caused some conflict.

In my role in the drawing studio I am not relating to this girl only as a person in a person-person dialogue, but also, and foremost, to her relating to her work. That is the *primary* dialogue of importance. Around it circulates our secondary dialogue, through which alone we can ascertain, via first-person-singular statements of the artist, much that is privileged in the art dialogue. On our second level dialogue we do strive to fully accept and wait patiently for the person as an artist.

In many another setting, and certainly in most classrooms, revelation of my perception in response to such questions would be the expected feedback and doubtlessly a prime shaper of the student's perceptions. But in the drawing laboratory the most I might say might be: "You *do* want to know how I see it, don't you? I would rather like to try to understand how *you* see it and what action that might lead you to."

My only support for so doing is my intuition that it is better to turn the artist's perception back on itself. Such an action supports the autonomy of the drawing series through the agency of the artist and does not confuse our role with the finite conditions entering paradoxically into his creation. I suspect, moreover, that such an action is also important in facilitating the development of the other person as an artist.

A reformulation, then, would state that the observer, and the teacher, in my mind, should be genuine and honest in relating to the artist but should defer to the artist's perception. Thus I can use my responses as a source of

open questions concerning the artist's perception, freed of the possibility I may influence or instruct.

Of course, information is conveyed by any interaction. If I ask, "What is happening beyond the bridge railing?" the artist may have felt that it was obvious what was intended but now knows that some doubt may have preceded the query. (Better still to merely say, "How do you feel about this part?") But if I point out directly that there is a vagueness and what may cause it or how to correct it, thenceforth, as Cézanne was sensitive to note, I "have my hooks" in the artist, to the end that he is further socialized in his art (according to the tradition I represent), but possibly at the expense of some loss of self-identity, some shriveling of idiosyncratic meaning and transformational powers. But how can the correction of a simple and easily removed error squelch the artist, you may ask. I assume no errors, a priori, and I assume no skills or lack of skills are in themselves relevant to the art experience. Further, outside of willing submission to an artistic tradition, I doubt if there is much in favor of the mixing of perceptions into the making of art. It is not so much to be conceived as an invasion of privacy as the subversion of a potential communion. I well know this is a radical viewpoint and can myself envision other contexts where sharing "without hooks" could be confirming or clarifying. But in the climate I am trying to describe, I hold by the aforementioned intuition.

AESTHETIC THEORY

Above I have tried to discuss the problem of responding to a very human request for perception and value sharing. On the philosophic side, the matter can be put more bluntly. Neither a psychology of art nor an open art education can afford to espouse any single aesthetic theory. At any given historical moment, it may well be that a cogent case can be made for the emergence of some such theory (usually with its attendant antitheory). As I write, for example, there is a concerted attack on the object, on the art establishment, and on high or idealist art, and an emphasis on the gesture, the action, or life-action, of experiencing art. Art appears to be going through a demythologizing, a secularization, and a democratization.[10] It becomes radical and revolutionary, but attempts to insinuate itself into the public mind through mass media, working paradoxically even through the commonplace and the stereotyped for its unsettling impact. If a larger purpose is to be ascribed to it at all, it would appear to be along the line of Peckham's *Man's Rage for Chaos.*[11] It startles us into life by undermining our expectations, improving our adaptive behavior by supplying the disorientation, spontaneity, and surprise that is missing from our lives.

At this moment in history a good case can be made for the circulation of such values in the world of art, or so at least one might conclude insofar as, following Dewey,[12] these values will awaken our desires and render us more alive. The point begun in the last paragraph, however, is that no single aesthetic theory or set of values will suffice to do this. It is for this reason

that a pluralistic orientation and a value neutral posture seem most appropriate for the researcher (or the teacher) to bring to the study of art experience—I should say, to the study of the *emergence* of art experience.

In the trash barrel of aesthetic theories nothing is irrevocably finished. History seems to affirm their reincarnation in startling and unexpected forms. In terms of the experience of any given person, it matters but little how he comes to art. By taking such a position, I confess that I further democratize art and am happy to do so.

Similarly, we might ponder whether we should not give up drawing as our focus. Is it not similarly outmoded? True, in one sense any interface with art might do, especially if it is a continuing one. In that sense, then, drawing will do, for even nondrawing in a drawing context makes such a shift meaningful. Also, I am partial to a focus which is simple, involves one's imagery and experiences, echoes back to early years, and spreads out through the debris of traditions. In such a setting, the very working out of the repressed myths and outmoded aesthetic theories in personal terms is both real and productive. It would be a highly original artist who did not draw at all in a drawing laboratory, and we would learn something from interacting with him.

I studied such a person not too long ago, not in the drawing laboratory but in his basement studio. Actually, his studio was not that localized. It also included various darkrooms to which he had access, newspaper printing rooms, and generally seeped over into the environment. I was not up to the descriptive task, for the rituals of interaction we can reasonably hold to in the drawing laboratory were not possible, and the situation was too fluid for me to cope with it at that time phenomenologically. In a sense, then, drawing and the context in which it occurs permit me to delimit a corner of the potential realm of art so that I can study it.

Several kinds of confusion adhere to this entire enterprise. One arises from the question: How can we know the emergence of the artistic and the creative in the life of a person? Another arises from a related question: What part does our knowing play in the emergence of the artistic and the creative in the life of a person? I have tried to speak toward both of these questions, but never to my satisfaction. I trust the reader will forgive me for still another, a last try. It is my assumption that unless these questions are faced, a meaningful psychology of art is not possible. To these might be added a third question, harder for me to face: what is the meaning of my emphasis on the construction of self, the so-called myth of self-identity?

PERSONAL DISCIPLINE

As we moved from a process perspective on the individual drawing to a process perspective on a series of drawings of a person, we sensed a path, or a network of paths, a history, in which finite conditions appear as unpredictable and irreversible and act upon the artist himself. The longer he works in our laboratory, the more his life is drawn in and the more his art counts in his life. What appears as creative is like an emergence, meaningful in the

context of its own articulation, seen within the enlarging stream of experience of a person who feels he is the prime author of his acts. His life-expanding, life-entrapping actions thread a network of paths encountering under responsibility but never full control the unpredictable and the irreversible, which are symbolically shaped even as they shape the maker.

I have suggested that what we have here is a discipline, undefined and self-imposed, which supports the myth of self-identity and creative potentiality, as an alternative to an ossified scientific cosmology and the political reality of an impersonal technocracy, for this is the cultural setting in which we now have our being in the world.

> The same fat surplus which burns in Viet Nam feeds us. Let the art armies be disbanded. In the wake of the anarch, all marches are up. . . . Art is what we do; culture is what is done to us.[13] [Andre]

And I am saying that any self-selected, self-guided aesthetic, new or from the old scrap-bag, will do for this action. The quality of art then correlates with a potential quality of life. It gives what our life lacks. This does not necessarily mean what should be in nature or in human affairs. Polanyi in a recent article offers another formation:

> The factual information content of art is slight, its main purpose being to evoke our participation in its utterance. [Works of art] . . . by the fusion of their contents with incompatible frames have a quality wholly detached from nature and from man's personal affairs.[14]

The experience of art, Polanyi adds, is "transnatural." The combination of flat depth of the older painting, for example, is something outside nature. And what is fused, what is held together by activity, are contradictory or incompatible features. Polanyi is right in saying that gestalt theorists such as Arnheim have ignored the fact that it is contradictions that are fused into a whole.[15] The sources of these incompatibles is vastly enlarged in the modern imagination. They encompass personal, technical, and anti-ideational dimensions.

In anti-idealist art there are no formal criteria for criticism. Were an individual in our laboratory, however, to deal with an idealist type of art where formal criteria are more applicable, that is fine. The main point is that in the traditionless setting, evaluation of products cannot proceed out of context. Further external evaluation is held to be misleading and deleterious to the individual and to his dialogue with art. We have found the artist himself capable of discriminating technique from expression, and quality in his life from talk of quality in a comparative context—that is, he knows what is existentially art within his life and that the meaning of this is always relative and problematic in the larger world. Every artist faces this crisis of meaning after the fact of creation.

I am convinced that we are in touch with the nether world of formative processes. This world is genuinely and irreducibly mysterious, and no degree

of objective-mindedness makes it any different. The assumption of the sufficiency of subatomic analysis or of behavioristic reductionism can change the researcher by the way of methodology but it cannot change the phenomenon. And the constructs it manipulates with its machinery, no matter how complexly or cleverly, are thin, pale shadows.

APPRECIATING AND UNDERSTANDING

Once we acknowledge that our purpose in knowing is more like appreciating and understanding than like controlling and predicting, a different range of human knowing opens up to us. Control and prediction have little meaning in reference to my own experiencing, where a sense of agency and intentionality guide my behavior just as meaning already exists within my perception.

My experiencing is "known" either reflexively through expression—a situation where I experience the articulation of felt experience into form— or reflectively through reflexive description. The former is art, the latter part of a "science of human knowing." An inevitable contradiction occurs in both: the experience which we strive to express must be subordinated to the experience of expressing; the experience which we strive to know must be subordinated to the experience of knowing. We cannot express our intention; we can only intend to express. We cannot know our experiences; we can only experience our knowing. We might reflect on another level concerning the attitude, the context of our knowing—a process which could be raised to ever higher powers without exhausting possible interpretations. Knowing (which can be read "the experience of knowing"), like expressing, is perforce personal, idiosyncratic. The expressing of the felt experience (the impulse) in the one moves back upon the initial experience, as its theme, as it were. The knowing of the experience in the other moves out from the experience which is its focus, to set a ground for perceiving it as a figure, as it were. To express an experience is really a misnomer since we can only experience our expressing, so that what is expressed is the articulation of expressing, the expressing situation or process itself. It is this situation or process that becomes the focus of "knowing expressing." What is further confusing is that both expressing and knowing can be termed forms of knowing and also forms of expressing, but the felt step "in" or "out" (or "down" or "up" in more somatic terms) suggests reserving the one usage for art, the other for science, as a not quite possible but useful operational distinction.

As with expressing, human knowing of this type is sharable or communicable in degrees. It is not, however, verifiable through public test even though parts of reports of such knowing could demonstrably be shown to be in error. An example of the latter would be the inclusion of erroneous facts into the fabric of biographical interpretation. In artistic criticism, history, biography, any report of human knowing could always be otherwise were one's attitude to shift ever so slightly. But then, of course, we have a different knowing, just as even slight changes in the process of articulating form produce different expressions.

It is not, however, the idiosyncracy or relativity of such knowing which should be stressed, but rather the understanding and insight occurring from the very proliferation of points of view. Thus several quite different biographies could be written from one pool of documents. Also, the various products of such knowing could be compared or themselves become the basis for further reflection. The concepts we form on the basis of such articulations of knowing are in themselves neither good nor bad, but just that: someone's classifications of diverse products of knowing.

Personal knowing is energized by its own intentional and purposive impulse. After fullness of expression we are often left with little desire to reflect on that experience, for the step out or up need not occur. With the effort toward that step, however, I can "describe" (that is, abstract from some attitude) my own consummated experience, often throwing into relief the poignant difference in feeling associated with expressing as compared with knowing my experience.

The whole issue of knowing and expressing, and especially that of knowing expressing (or articulating the knowing of expressing), is not one that can be solved discursively. One can only take up a position and work out from that. And any position is lodged in contradictions, as for example: we perceive generalities, in that meaning is always there, ready-made; we come already prepared, seeking; but we seem to refine and develop our generalizations by a progression from the more particular to the more general.

I linger on these contradictions because they afford still another way of formulating the problem of knowing expressing. From experiencing expressing, especially from engaging in art experiences, a dynamic concept of the forming process arises as a kind of primary abstraction. Part of its dynamic character resides in one's grasp of the situational uniqueness, the structural dissimilarity pervasively staining each such encounter. Were it not so, we would go on from art experience to something else. But there is nothing else to go on to, considering art experience *qua* art experience. It is what it is, and it is only that "what" when it is. In each experience, art, life and mind merge in lived expression.

Therefore, knowing expressing in art has as its objective not elucidating a static concept concerning what can be conceived as necessarily in it, in a public sense, but rather the extensionalization and clarification of its essential existential structure through proliferation of reports (from diverse points of view) of its unique and unitary character. By so doing, we work at extending our cognitive grasp of art, and actively contribute to enlarging its potential within human life.

I do not expect most artists to be concerned with such extensionalizations, even though all artists in varying degrees become informally reflectively involved with knowing their own expressive episodes. There are, however, good scientific, philosophic, and educational reasons for more formal pursuit of such extensionalizations. In so saying, we typically envision—although we need not—the agency of a person (a knower) other than the one who has undergone the forming experience (the artist). It is this problem that I wish to discuss next.

Privileged as is my access to my own art experience, my efforts to know it lead me most typically quickly into further art expression, or into that more concrete historical reflection called autobiography, or, more rarely, into the abstract expansiveness of science and philosophy. To the best of my knowledge there are many artists, a fair number of artist-autobiographers, but very few artists-philosophers of art. The effort to know my own art experience, apart from the general motivations toward autobiography, seems best directed toward my own future art experiences. One art experience gives rise organically to another, and reflection on a completed experience opens up the irreversible but unpredictable link with the next. Such reflection, that is, affects my artistic intentions (a fact which has many educational implications), and this constitutes in turn much of my motivation to know (of course, in addition to the generic, unceasing interest in any answer to the question: "What does it tell me of myself?")

The articulation of knowledge of expression, however, seems best directed away from myself, where, that is, my motivation to know is impartial to my own artistic intentions but deals centrally with the art experience of another person. Under the concern of the scientist and philosopher I become interested in the grounds of the experience, in how the other person utilizes his expressing *and* knowing within a concrete history separate from the problem of articulating knowledge of expression.

To know, in the old sense, is masculine, active, Apollonian. We have given up detachment and control for merging with the mystery itself. We await whatever will be. We are active and passive, even as is the artist. We desire to know but cannot conclude that our knowing and any conquest of consciousness for the artist are necessary or, of themselves, helpful. If we and the artist are essentially one, despite our role differences, our understanding is no more secure than the artist's expressing. We accept the unknowable; the artist the unexpressible. Our knowing moves into partial darkness even as the artist's expressing moves into partial light. This effort at conjunction between artist and researcher symbolizes the world of experience as undivided. No generalizations in the older sense flow from this kind of immersive understanding, but only descriptions and interpretations which extensionalize the inexhaustible import of each expressive situation. Sometimes, as in religious literature, I am inclined to say, "Behold, I *show* you a mystery"—that is, I may occasionally attempt expressive writing to symbolize that I know, through experience, more than I can say discursively.

What he is to make of an expanded consciousness, mediated at least partially through verbal interaction, is up to the artist; even as what I am to make of increased understanding is up to me. As in depth psychology, conquest through insight is thought to increase the artist's powers but not to guarantee surcease of difficulties. And on my side, an awareness of the emergence of the creative and the artistic in another's art processes transforms art education into a vital reality. I feel a genuine ecstasy in these conjunctions, for they provide insight into the creativeness—and it follows, the destructiveness—of life itself.

The artist's continuing search and conflict works toward expression in a way which can be shared in a setting of nurturant calm. It is as though he can push off from a known shore, return, reconnoitre, and push off again. Labor is blossoming, but it is also pain. It is success, but it is also failure. It hardly matters as long as the traceable and felt line moves on.

THE ARTIST AS SYSTEM

The artist creating is an open system with his own hierarchical structure of images, intentions, skills, feelings, plans, transformational operations, and so forth. He is a subsytem of a larger environmental system. In the case in point, we might refer to the drawing laboratory as the larger system. Within it, our intent is to focus on the wholeness of the art process as exemplified in the continuing acts of the artist, but we are forced to acknowledge that the art process system which is our focus is a part of the larger environmental system comprised of all participants, conditions, rituals of operation, and the like. We comprehend the wholeness of the artist as an open system only by perceiving his history of acts upon the ground of the pervasive quality of the drawing laboratory. And we can conceptualize the latter only by further moving back to the assumptions on which this environment is grounded.

I have sensed in myself, in my effort to comprehend the processes of abstraction into which I have fallen, a schema at work which it is difficult to verbalize. Let me try anyway. As I try to "analyze" the "other" and his art processes, I seem to fall back upon the ground of my own "self." This leads me, reflexively, to a concern with the problem of self, and I fall back upon philosophy. Here I might reside, but I am not a philosopher, and I find a movement toward what I can only term the undifferentiated status of "depth psychology." Out of this somewhat chaotic matrix my concern with the "other" and the "self" arises again. I am not prepared to say what this cyclical or spiraling schema signifies.

In any event, from our position twice removed from the art process, we perceive how the environment provides feedback for the artist. This feedback aids the development of what has been called "third-order knowledge" or "third-order premises,"[16] that is, knowledge about our knowledge about the world. Just what one's third-order view of the world consists of is thought not to be as important as that it provides a premise rendering one's acts meaningful.[17] It is my belief that art processes are under the guidance of such third-order premises: we have knowledge directly of our art processes; we have knowledge about our art processes; and we have knowledge about our knowledge about our art processes. It is on the latter that the drawing laboratory feedback and inquiry operate, both in a specific and in a pervasive sense. Perhaps the most meaningful communication to the artist on this level is: here's how we see you seeing us conceiving of you doing your art. In actuality we never come out with direct statements about our conception of how the artist does his art, for our conceptions are open and tentative, but the inquiry on processes does lay bare hypotheses about these, if only in the form of

questions—e.g., "Were you conscious of combining the wash over forms, under forms, and outlining chance wash edges, which you had done in your three earlier drawings, all in this one?" Through such questions, the artist cannot help but form concepts about what his progress is like.

What is educative in this setting, however, is not just the clarification of third-order premises about one's art processes, but the fact that through this clarification one may be able to change one's art processes. A beginning artist, as we have earlier indicated (see Chapter 7), may say that he sees himself like an apprentice carpenter who wants to master certain techniques so that he can later build something well. This viewpoint allows him to explore meaningfully his tools and their marks without too much worry about "expression" or "art." But his tools and techniques interact unintentionally, and he finds (as happened in the case mentioned above) that his separate pen techniques for showing texture and light and shade, for example, can be one and the same technique, an accidental insight into varied, tree bark lines (when he was actually studying light and shade on the sphere of foliage). This discovery he so much wanted to share that he made a notation right on the drawing. In so doing, he had moved from a summative notion of techniques toward an interactional one. From this kind of premise, he was soon to move toward one involving kinds of transformations—characterization, mood, black as black, physiognomic qualities from the nuances of tone through use of a large and loaded brush, symbolic power through ambiguity, and so forth. The account "from the other side" lacks force as compared to the account as given by someone changing his base of meaning. Then it is not an abstract principle. It is his world that is changing.

EMERGING INSIGHTS

These changes are genuine emergences, not conscious manipulations, although conquest of consciousness about preceding art processes prepare the way for them. I say conquest because what a person has done in previous art processes is usually grasped like a new insight, especially at the third-order level under discussion. It should also be clear why a series perspective on processes is essential to this grasp. As third-order premises come to light, one can only communicate or think about them at the fourth level, which ". . . seems to be very close to the limits of the human mind and awareness at this level is rarely, if at all, present."[18] The authors from whom the levels of knowledge argument has been drawn point out psychotherapy is concerned with change in third-order premises, and that a man can do this only from a fourth level.[19] Our focus is similar to that of psychotherapy. We are concerned about an individual's third-order premises about his art processes and with how change comes about in these. The inquiry inevitably seeks out the artist's concept of his knowledge of his art processes. In his projected work, the artist may discover, or there may emerge—nay, usually will emerge—conditions allowing for new insights, the intuition of fourth-order premises, usually inarticulable. (There are instances where the artist has "lost" his in-

sight and cannot later recapture it. In one case an artist even jotted a word down on the drawing while working but still could not recover it later.)

We are unable to attempt a rational explanation of emergences or changes, operating from the past events which are related to the conquest and exploration of third-order premises about the art process. It is tempting, I am sure, for the therapist or the teacher, because of his professional and ego stake, to assume that his functions have caused such changes. But the art process is not a person-person function, but a person-self-medium-process function. We have argued that transcendence or emergence can be conjointly experienced by an artist and a participant observer to whom the artist permits shared revelation of transcendence—or even the honest probing of whether transcendence was involved. This report is part of a changing open system and is not objectively verifiable, because it treats emergences outside the system of known operations describable categorically. In continuation with a single artist, third-order premises in the nature of hypotheses about how his transcendences likely occur, or how they can be categorized, are possible, but only in a post-dictive or historical sense. Such elucidations, however, are bound to move the artist also to treat his transcendences in a third-order sense, forcing him to eventually change them or render his next achievements technical and not artistic. In practice, I do not believe the latter happens, given an environment where the continuation of art processes is kept open. It is here that the ethic of the human dialogue is forceful, as is the ethic of the art dialogue; for both are critically transformative or else they are not "serious"—that is, they contain a lie about man and about art.

To repeat, we can only conceptualize how a person sees us seeing him doing his art by suppressing our likes and dislikes and our aesthetic evaluations, and by means of process photographs and revelations of the artist himself, all taken over time. This conjunction offers insights which the artist cannot possibly provide himself. True, a mature artist might productively remain lost in his own labyrinth, an open system effectively symbolizing and clarifying itself. My position on this is similar to that toward therapy, no man is beyond its educative function at its best. The beginning artist will most assuredly profit from such an environment. Children not at the level of such cognitions may need to operate more through imitation, contagion, and feeling, or, as Lowenfeld suggests, under the impetus of direct or recalled experience. I am not suggesting that "insight" is enough with the post-adolescent artist, for the insight here involved is not a thing but a feedback process operating on the artist-art process interaction. Changes occur there which are real, through emergence and transcendence. "Parts" brought to consciousness and elaborated into knowledge about one's art processes lead to emergence through the volatile and unpredictable consequences of combination and through the potent impact of unexpected symbolic overtones. A setting where the artist can bring parts of his art process to consciousness and safely risk their manipulation is art educative. "Safe" means, even as Rogers[20] claimed, that one is not psychologically vulnerable and that no external locus of evaluation is operative, so that so-called failures are ambiguous, instructive,

and accepted. "Risk" means that one gives up some control for acquisition of new powers.

Further symbolized in this setting is an escape from the circularity adhering to too great an emphasis on the self. Artists and art educators are prone to vacillate between the self-focus error and the art-focus error. The self and art are an interactional system. The drawing-laboratory context works toward feedback utilizable to this interactional system. Consciousness of that interactional system is the only way I, as researcher, can conceive of knowing about the art experience. This is the nature of the artist-researcher symbiosis, permitting the link between art behavior and art experience to be cognized by the researcher, and lived and expanded by the artist.

HUMAN ASPECTS

My position is now clear to me. There can be no quarrel with behaviorism nor with the general canons of public test prescribed by the methods of empirical science. These methods just will not touch in any meaningful way the emergence of the artistic and the creative in the life of any person. There may properly be a psychology of art or aesthetics that deals with generic abstractions about art, but the entities so described, having first to submit to objectification, idealization, formalization, and functionalization (usually toward logic and mathematics[21]), will scarcely shed much light on the highly contextual participative and experiential side of art.

Let out and left over will be what may be called the important, *human* aspects of art, which will not submit to the kind of formalization and objectification described above. These will, however, submit to description more akin to phenomenological methods and to efforts at systematic interpretation. For this effort, introspection, first-person-singular statements of the artist, projection of interpersonal modes of knowing on the part of an observer-participant, and interactive dialogues in recall of art processes are the major means. Such material is like a cross between autobiography and biography with a narrow focus (drawing) and a constant setting (the drawing laboratory). It seems more like a new kind of history than the psychology we are used to. Within my own field of art education, I feel the need for some good case books. We still need the empirical connections I felt we needed two decades ago, but then I looked via a methodology that shut out the greater part of what can be known. .

This is tantamount to saying that we can approach something like the calculus of the single case of which Bridgman talked.[22] Its form is open. It is a logical error, I assume, to state that we can "know" any entity, object, or event "in itself," but we can know ". . . the constant context of experience in which it will be found."[23] It is in this sense that we can speak of the artistic and the creative within the constant context of person, procedure, and place that is the focus of our later studies. Such descriptions, like those of traditional empirical science, are never finished or closed. But they have scarcely begun.

My answer to the first question then is that we can know the emergence of the artistic and the creative in the life of a person in a scientific sense, if we expand our concept of science to include the nonobjectified, nonformalized knowing and interpretation accessible to us as human beings describing ourselves and the other.

Barker has spoken of O-data and T-data.[24] Psychology is composed largely of O-data, operator-data, wherein the psychologist talks to himself through the constraints he has operationally imposed upon the phenomena he studies. The experiment epitomizes this orientation. T-data, or transducer-data, is that wherein the psychologist is a sensing agent, translating phenomena as they occur into signs. In this respect, our lab notes, the time-lapse process photos, and the transcribed interactive dialogues are T-data or the source of T-data.

But, to recapitulate earlier arguments, there is still a difference. First-person-singular statements, on which we so much depend, are epistemologically unique and autonomous. We grasp these possibly much as we grasp the fact that a person is motivated (following de Charms[25]), not by any infallible repetitive signs but by the fact that we have known ourselves to be motivated and make this inference all the time about others. And the artist knows what he has done only in an approximate way, for when he brings it to words he must explore and speculate about himself, and he must leave much out and distort other things by the very use of language. There is no direct route to such knowledge — only indirect, inferred, approximate. Yet to give up the study of the phenomenon because the only route is indirect and through the human instrumentality is irrational.

Introspection, as we earlier indicated following Bakan,[26] should be reconsidered as a valid method in psychology. It was not so much used as misused in the past. What it gives is material for further analysis. Its first-person-singular statements are public, although not replicable (behaviorism has tried to make these terms synonymous).

But our method is not just introspective. It is as though "mutuality and sharing" are added to the primary dialogue of art, and as such, one of Buber's dialogues is crossed with another.[27] Art is a genuine dialogue, but it does not occur between man and man. What we seek to do is simple and profound: we attempt to enter into human dialogue with the artist concerning his artistic dialogue. This goes beyond O-data and T-data. This is D-data, dialogue-data. We would be consumed in the holy fire if we did not have the man-art dialogue as its focus (for an artist's art dialogue need be existentially real only within his own experience), or we would dabble in therapy or education, both lesser world's often marred by man's interminable penchant for interference. There are indeed therapeutic and educational overtones, but they are by-products. The artist acts, proactively not reactively, in the real world of concrete things *and* imagination.

All knowing, even the most advanced in traditional empirical science as Polanyi affirms,[28] is personal knowing. My assistant and I are instruments of knowing. We know *from* ourselves *to* the art dialogue, as we reenter it out-

side the holy fire. I don't know why this kind of language should surprise us. If it seems unscientific, so much the worse for our notion of science. Although I entered these studies under what Roszak calls the "myth of objective-mindedness,"[29] I do not at the present time and after recent changes feel unscientific. I seem to know less than ever what creativity and art are, but I have touched them in direct observation and interaction in life, not in theory, and shall continue to describe their natural history.

CREATIVITY AND ART

How to describe it, and what interpretations, if any, one should make, are more difficult to answer. Despite his reflections on the use of personal documents in psychological science, Allport[30] gives us more a catalogue of troubles and questions than clear guidance on how to proceed. In a later work,[31] there is a first inkling of kinds of methods which may be appropriate to the single case—"morphogenic analysis" as he prefers to call it. Still, for all his persistent courage and loneliness in emphasizing the single case, I think we may eventually be led more afield from traditional psychology, at least American psychology, than he admits.

Something of the feeling near despair and impotence generated by the descriptive task is conveyed in the following statement:

> Few things are more difficult for a therapist then presenting "a case." It was a living, breathing, sometimes gasping, sweating experience. I seriously doubt that we can really picture each other's work this way. I know we cannot do it justice. Also, there is a natural reluctance to make public what was private, even though it is disguised. (I have always admired Freud's forbearance, waiting until "Anna O" was dead before writing about her.) How to present the material? The raw data are verbatim dialogues, but that would fill a book, a sometimes tedious book. Subtleties of gestures, unspoken thoughts, analyses, would fill a shelf. They play a part. Worse still, we are conditioned to look for journalistic answers—who did it, what was wrong, where are the points of insight and the hidden keys uncovered by the detective-therapist? It doesn't happen that way. Therapy is bigger (a whole atmosphere) and smaller (moments of internal experience) than can be conveyed by the synopses we can offer.[32] [Schlien]

This *is* the problem. Though I feel the situation may be more hopeful for the description of the art experience than for the description of therapy, I can offer little evidence until more work is done. There are, however, the concrete acts and changes in the environment brought about by the making of art to which we can attach our inquiries and speculations, though we must, to be sure, read these through the indirect means of the artist's recall and response to our probes. It is on this problem, that of description, interpretation, and analysis of the art process and series, that I hope to spend my next energies.

The second question I asked had to do with the role our knowing plays in the emergence of the artistic and the creative in the life of a person. I tried to answer it previously, in an earlier chapter. Our mode of inquiry importantly

affects the artist, I fully believe. Our study of shaping shapes the shaper. More figuratively, if we expect the holy fire and are patient, it appears. Not always, perhaps, and not in a way that is always accepted by the artist—as with the case of the young man in our studies who, in a follow-up interview by a neutral party,[33] said:

> I can't say I've really been excited about art. I'd rather have someone give me the dogma of the whole thing in orderly sequence and then I would sit down and learn this and then go and apply it. If I were totally interested—as in chem—it's part of a discovery. Still, they give you some postulates and you're allowed to learn on your own. I think in a lab, if it's a good lab, people will discover for themselves.

The same person also said the following in the same interview:

> The more and more I drew, it made me observe the object a lot closer. I did a lot of copying of real objects. I saw a lot of things I didn't see. That's what I got out of it—to observe better.

> One time I drew from a line and let it expand. The more I looked, the more I saw, the more I put on the paper.

> Something happened—maybe it's because I haven't picked up the camera that much. But whenever I do, I don't just snap shots anymore. I don't know if there's a causal relationship but I know that I'm more selective when I shoot. I look at a thing before I take a picture of it—whether or not it's worth a picture of, you know. I kind of place a value judgment on it where before I just took haphazard pictures.

This is the least spectacular follow-up. I mention it because here is a person who would prefer that someone give him "the dogma," yet he mentions other outcomes which I think the context leads to, and leads to frequently enough that they cannot be overlooked.

THE HUMAN DIALOGUE

Earlier in this book I have mentioned other consistent side effects. For example, the beginning artist will not believe for a number of weeks that he is really in an open lab. Usually, as I said, he gives himself, in good super-ego fashion, the task-master kind of instruction and objectives he thinks he "ought" to have. He postpones whatever for him constitutes art to develop skills, tools. His self-imposed regime brings him to grief, even to despondency, and some seemingly adventitious events lead him to explore the connection between, to borrow Freudian terms, the pleasure-principle and the reality-principle in his own art experience. He soon takes responsibility for being as creative as he can within his limited means. He dwells in the experience of the making process itself, often inviting what one girl called "chaotic starts," yielding up tight control, perhaps, but unworried about the outcome. (This same girl, when she later returned for a third ten-week period in the drawing laboratory, moved beyond this willing yielding to chaos. As she later expressed it, the process of drawing became more autonomous and more "nat-

ural." She had passed, as it were, beyond the risk of exposure to the chaos of the undifferentiated to a point where neither her intentionally imposed will-to-form nor her release of control needed to see-saw back and forth any longer. The brush, the wash, the forms and images had their own life, and she participated in the drawing process "like one of the elements," almost like in a dream. I am not suggesting that the drawing process "caused" this transformation. Other important changes were occurring in her life. It is likely, however, that the drawing series was involved with these other changes and also to a degree symbolized them.)

I believe such learnings have very little to do with art in any formalist, idealist, or comparative way. I also believe that much is learned about art despite the low levels of skill beginners may possess. Here is another excerpt from a follow-up:

Q: Did you feel that you learned anything?

A: Yes. I feel I learned a little about every aspect of art I can think of, except drawing.

Q: You mean skill?

A: Yes. But as far as subjective things are concerned, it got me started. Until I did this I never would have gotten into the subjective aspect of art.

From still another follow-up:

Q: You talked at the beginning before you started to draw. Did that period of questioning mean anything to you?

A: Yeah. I think it's pretty important. It made me get some things out. You know how you might think about things and never really clarify them in your mind, a kind of talking over. We'd always do that about the thing I did before and it kind of refreshed me as to what I did before. They asked some questions that would get me thinking about things. Just by talking with them I'd start thinking, kind of get me rolling a little, help me think, builds up involvement. You get more involved if you talk it over.

Q: Did you use what you'd talked about later that day?

A: I tried to keep myself open. I didn't try to catch any hints or anything. They never gave any anyway. They're good at that! I don't think they've ever given me any direction at all, so I haven't looked for any. I just kept going on my own. I guess the talk had something in that it maybe gave a little continuity to what I was doing. I got some things in my mind. How can I improve it, change it? Other than getting me rolling, or giving them some information that they needed, it didn't shape what I did.

Q: Would you say you were satisfied with the results of what happened in here? By results, I don't necessarily mean a picture, I mean maybe you, or what you learned, or anything.

A: Yeah. I'm satisfied. There's no question about it. Also it's strengthened my visual sense. I see things better. I think that's kind of developed a little bit, more aware. That's pretty important to me. I'm satisfied. It's a good thing you didn't mention just pictures. (Laughs).

Q: And you were satisfied with that?

A: Yeah. That was the exploration. I said before that we talked. That could refresh me. And then, I would, with the stuff in front of me, explore. Then I wouldn't do it step by step but there was still some kind of continuity, exploration. I tried to remember what I learned before from doing the stuff. For me that's the only structure I felt. Of course, coming in and talking, doing the painting and maybe talking afterward. Other than that, the only place I could look were the questions asked. But the questions were real . . . I don't know exactly . . . it was just "what were you doing?" Stuff like that, I'd ask myself. Because I just don't do something and come back tomorrow or next week and do something else. It's a searching, like maybe trying to come towards, to do a better drawing. And they'd ask questions relevant to the goal that I set up. And they were the kinds of questions that didn't impose anything on you, didn't strike me as being structured in any way other than what I was doing, or what was going on. They never really asked too much except if they were trying to get the process of drawing down or something. I don't even know what that means!

Q: In a way you've answered this question: "Do you feel you've learned anything?" And then "how?" But you've answered that too.

A: There's one thing that I don't think I said before, I think it's pretty important. It's aided me psychologically. Not as far as art goes, but just because you could talk to people that would listen to you, about things that aren't so conventional. You don't want to bother other people with what's on your mind because they won't understand and don't have the time. And here you could do that, kind of a good feeling about it. I think it loosened me up somehow, easier to talk about things.

Another artist corroborates this last feeling, also from the follow-up:

Q: Did the way you learned in here, did you use any of these ideas, say talking about your work and stuff like that, with other people in your outside work, or in school?

A: I think probably the main thing I can really think of right now is not the work itself but the involvement in here. I've never been subject to such a close relationship. You just sat around here. It was really friendly, a homey atmosphere. Now it does exist — and isn't that a rare thing? I feel at ease quicker.

The latter excerpts, especially, suggest how the human dialogue seeps over into the artistic dialogue. Without the one, it seems we cannot learn about the other; but the one also enhances and stimulates the other. This is a fact and needs to be so stated and accepted. The precise impact our dialogue-inquiry behavior has on the art experience is in need of much study. Apparently the artists with whom we have worked have felt this influence but, at the same time, have not felt any direct shaping from us.

The reader may ascribe limitations to these conclusions, as relative to the untrained character of our artists. There may be some such relationship, but we were pleased recently to learn that a professional artist could work comfortably under these same conditions. We did not know until the ten weeks were finished that he had confined his entire production for that period

to what he did in the drawing laboratory. He worked on three quite different pen drawings, reflecting fully on their origin and development. They were still incomplete at the close of this period, and he typically worked first on one, then on another, back and forth. The kinds of verbalizations and insights arrived at, though much more complex, seem to differ in degree, not in kind. And the methods of relating to the artist do not change. His ruminations were also broader than his work, encompassing critiques of the artist's role, of modern society, of modern education, and so on. The inner world of the advanced artist and the novice are alike autosymbolic; their lives flow in and out of their work, and their works flow in and out of their lives.

At this point, I would like to describe another kind of follow-up we have done. We have called back to the drawing laboratory four artists who had been there previously. In each instance several college terms (or quarters) or more had elapsed. These people all had elected to take other art courses, we learned, so we were anxious to see what effect this would have on their work. The readiest generalization I could make is that whatever they retained or assimilated into their own work was always *incidental* to the objectives of the studio courses as they were taught, but *central* to the idiosyncratic way of working of each of them. For example, a girl who had drawn her images as isolated figures on a ground, slowly allowed in environment and positioning (even sometimes deliberately ambiguous positioning) in space. These were not emphasized in her studio course, apparently. Otherwise, whatever she did for that course, her work showed great continuity with her previous work in the laboratory although she gave herself up more to "chaos" (while her studio course had taken an opposite tack into machine forms and hard-edge images).

Going in the opposite direction, we learned with interest of the fate of one young man who had worked in our laboratory for three consecutive terms (one school year). This artist preferred drawing with a "00" (very fine line) Rapidograph pen. He had developed a highly controlled but free manner of drawing figures and parts of figures, paying close attention to abstracted forms which with high precision suggested an array of details or forms. These drawings were never closed or completed, but each part would be elaborately and delicately fashioned so that it seemed both "real" and "designed."

When this young man took two studios, graphics and watercolor, he received advice which completely alienated him from his own base of seeing and forming. In watercolor, he would have worked small, with fused color within confined areas, moving toward but never touching similar adjacent areas. These, he said, would have been figures or faces. He was told to work large, use big brushes and lots of water, and the teacher said, "Why in the hell are you painting faces?" In graphics, he had abstracted down the form-shadow of an upturned face to the point where it was represented only by a shadow extending from chin tip to neck. This was to be placed just so on a large zinc plate for etching. It was too bare, would waste zinc, and should be "further developed." In addition, examples of famous etchers were assembled to show him that many scratchy lines fit the medium better.

I repeat what he told us, not to impugn these teachers, who were oper-
ating with good intent and good reasons, but to point out that they had neither
time nor means to find out what he was really like, how he came to his art
experiences. The young man had no ill feelings. As another put it: "I got
what I expected out of a course—not much!" My point is still different—
namely, that even under such conditions what is really assimilated may be
important but quite incidental to the learning goals of the teacher. Art stu-
dents may be less fortunate, for they may take on imprints they cannot as
easily throw off, or they may never examine the nature of their own images
and intentions.

This raises a question to which I know no good answer: how is the cul-
ture at large—what is done to us—related to what persons do in our labora-
tory, to art, that is, or what one does? It leads me to my next speculation,
having to do with the nature of true community. In these speculations I am
out of my depth—but onward!

COMMUNITY

In our concern with the human and artistic dialogue and with the emer-
gence of the creative and artistic, perhaps it is not too far-fetched to suggest
that our drawing laboratory setting is a microcosmic community. To be sure,
we emphasize the individual over the social side of the equation, but this is
because the art process, as we have presented it, is a movement, an existential
projection, from the active self outwards. Following Buber,[34] it does not,
however, lead to mutuality or sharing, or to the human dialogue. Yet, we have
maintained that we are always, in our inquiries, moving toward human dia-
logue in our effort to understand the artistic dialogue. It would seem, then,
that we have unwittingly set up a community sensitive to the emergent self,
as seen through its creative and artistic strivings. This trade-off is genuine,
for the larger aim of knowledge-getting can only proceed, I fully assume, by
way of admitting and encouraging the artistic and human dialogue. If, there-
fore, there is a transcendent aim or goal of the entire situation, it is that of
knowledge of the art process. But we have seen that all knowing is personal
knowing, so that my own self, as knower, is in like manner nurtured by the
exchange. If I deemphasize my self, it is nonetheless my self that gains by so
doing. If the artist reveals and probes his self, it is also his self that is enlarged
and known thereby; and the myth of self-identity arises as an organizing be-
lief.

The sense and fullness of being is enhanced, not diminished, by genuine
community. "Happiness, possession, power, authority, life can be renounced,
but sacrifice of being is a sublime absurdity."[35] Yet it would seem that all too
often our impersonal, institutional situation makes such an absurd demand
upon us and we flee to an equally unreal individualism to escape it or join
one of the many short-lived efforts at forging a "counter culture."

But community, growing community (which is all we have known so far), is the

being no longer side by side but *with* one another of a multitude of persons. And this multitude, though it moves toward one goal, yet experiences everywhere a turning to, a dynamic facing of, the other, a flowing from *I* to *Thou*. Community is where community happens.[36] (Buber)

It follows that community can happen even within our ossified, bureaucratized institutions. It is no mistake, however, that I did not set out to study the art process in the institutional school setting. Too many factors, too many rules, too many habits intrude between the self and the art process for any assurance that the art dialogue will occur. Among these the most intractable is the teacher-and-class tradition. It is hard to conceive what thirty collected students, on the average, and one teacher, addressing them usually in regulatory authority, can have to do with the art dialogue. It is not impossible for it to occur there, but why start there at all, at least to study it?

I believe, however, that such an unlikely setting, despite the oppressive weight of regulation and mechanization upon it, can spring into community. I also believe that what we are learning has implications for that setting, although it demands far more of student and teacher than tradition expects or allows them to give. It would nevertheless be a difficult setting in which to study or describe the nature of the emergent creative and artistic in the life of an individual.

Just recently I was fortunate in experiencing a class that sprang into community. It was a summer class, of eight weeks duration, in advanced ceramics, largely of graduate students. Intentionally, I began by urging the group to break the studio and institution hold. We went to the woods, dug our own clay, built our own kilns, cut and collected our own wood, and fired our own pots. The elemental struggles with fire and self and nature; the obdurate cussedness and hard physicality of "things"; the direct or unexpected relationships between effort, success and failure; and always the working "with" each other—these were the stuff of that experience in community. Released therefrom was a respect for the depth, reach, and tradition of a craft I could not have mediated in the usual academic setting. But it was the fact that community happened that was the greatest outcome. Again, the "testimonials" reflect this:

If there are any lasting qualities I've learned from my experiences they come from this atmosphere that permeated the summer class: the open-ended situation, the self-discovery, the individual goal setting, the achievement of the task, the learning in failure and the chance to correct it. These things I hope to make a part of my teaching. It takes a whale of a lot of work to get it but it's worth it. Now all I have to do is learn to be bright, interested, talented and giving. [Letter to the author from a participant.]

Another student spoke of "a new concept of self":

I feel the most important thing I gained this summer is a new concept of myself and how I relate as an individual to others. Through the years, I have isolated myself, partly out of natural desire, and partly for protection. Team work, com-

munal sense, etc. had become foreign concepts. This summer made me realize that it is possible to give of yourself, to become part of the community, to be accepted for what you are, and what you can do, and still retain complete individualism.

From still another letter, the following excerpts express part of what I am trying to say better than I can:

It's hard to pinpoint the sequence of events or the time at which it dawned on me that this was no ordinary class, but a "happening" in the best existentialist sense of that overworked word. I did not go to many evening sessions because of family ties, but sensed that there was growing up a group solidarity and mutual interest which is woefully lacking in ordinary classes.

And out of it all emerged, quite clearly two results for me. On the ceramics side a far deeper understanding of the complexity and fascination of the craft, and a respect for its versatility and depth. A completely new respect for "firing," which had always seemed like a tricky chore for someone else. An urge to learn about glazes and a determination to try again, sometime, somehow, the mad business of firing a wood-burning kiln. I developed a liking for the smoky imperfect products which made the pieces from the gas and electric kilns look tame. (I also found out a lot about what's wrong with my lousy wheel techniques!)

On the philosophical side, I recaptured that sense of the potentially transcendental nature of American society. (Wow that's high-flown.) I just mean that what attracted me to America in the first place was that sense of overcoming narrow chauvinistic, religious, national and social barriers to achieve a kind of zany but glorious creativity and vitality, a true echo of the sort of divine creativity that made pink-bottomed baboons and mad-beaked toucans, and platypus and all the crazy wonderful creatures of the earth, and which could be channelled here into the building of 'one World.' [Letter to the author.]

I have lingered on the topic of community because it receives short shrift in our present life. I have also had to acknowledge that it takes a kind of spiritual maturity and courage and skill of expression to reflect back on it. It is possible that it threatens some of the participants to do so—that it does not seem "real" in terms of our workaday "reality." If I meet any of these people, the feeling returns in the face-to-face encounter.

My main point was to acknowledge, first, that community occurs in the drawing laboratory, and, secondly, that it can occur also in the institutional educational setting though I believe that the latter must be well-nigh transformed and transcended to bring it about. On the other hand, the dual artistic and human dialogues occurring in the drawing laboratory constitute a natural platform for community. It is in this latter sense, and as an indirect outcome of our experiences, that I humbly submit that the drawing laboratory's atmosphere and procedures have direct implications for art education. These implications may even possess the rudiments of a crude theory of art education, but first I must return to that third, unanswered question I raised earlier in this chapter: what is the meaning of my emphasis on the construction of self, the so-called myth of self-identity?

THE PROBLEM OF SELF

I quoted Hume in Chapter 7 in his opinion that any sense of continuity, identity, and so forth, that we ascribe to the self is, as it were, a mental figment that we project on facts that lend such notions little support. I recall a clever criticism of Hume's position (the source of which I am uncertain of) which brings out the contradictions we must be prepared to face in the study of the self: Hume was likened to a man who went outside his house, looked in the window, and reported no one was at home, and decided therefrom that the house was vacant.

Nowhere have I found the opaque ideas circulating around the concept of self better handled than in a recent philosophical work by Johnstone.[37] As expressed in his preface, ". . . if there is a problem of the self, its solution is that the self is a problem."[38] It is Johnstone's contention that the "self" is the locus of contradiction in the person. He further feels that it is in philosophical argumentation itself that the self, as locus of contradiction, is most fully evoked.[39]

What is the nature of this contradiction? In taking a position, one sees it as the only one possible, he says; and the positions of one's rival will be seen as impossible. Yet the impossible cannot be conceived at all, so a contradiction arises.[40] The "verificationist" illustrates this dilemma.

> Whatever he will accept as evidence must already satisfy the public criterion. Hence all evidence that is possible is evidence for his own view.[41]

> The verificationist has contradicted himself. He has said, in effect, both "my position is not a view" and "my position is a view, which attacks a rival view." He both can conceive of an alternative to his position and cannot conceive of an alternative to it.[42]

> A view can be negated (that is, is logically impossible) only if it exists (that is, is logically possible) and it can exist only if it can be negated (for otherwise it is just a tautology or other analytically true statement, not a view).[43]

In the same sense, if any view of the self can be negated, it can only be because that view exists (is logically possible). Likewise, any view of a mode of inquiry into the process of art differing from the behavioristic, "verificationist" view, must accept responsibility for facing the contradiction inherent in philosophical argumentation, a stance made difficult because of the unquestioned power of the behavioristic view in our modern world (which view does not admit its contradiction openly). (The term "verificationist" is admittedly broader than "behaviorist," since the former includes many who could not operate within the confines of a strict behaviorism—for example, G. W. Allport, Bakan, Rogers, among those from whom I have quoted.)

As soon as I admit, as I have, "mentalistic concepts," introspection, first-person-singular statements, the possibility and desirability of dialogue and community, the emergence of the creative and the artistic as realities locked within the individual history and its being-in-the-world, I must go

further and argue, explicitly or implicitly, against the verificationist view. I thought for some time I could avoid taking such a position, but in this my feelings have been a better guide than my mind. And in this sense there is no real bridge between the earlier and later modes of inquiry I have included within my own history and within this book. They exist side by side in my world and in the same larger world, but they are, at bottom, opposed views, and the drift of my allegiance will be evident to the reader. While my self is ready to accept this, I have not been ready or willing to argue against the other view, though I feel clearly the existence of the juxtaposed, contradictory views. Perhaps under attack I will learn something of the art of philosophical argument. Meanwhile, however, I will proceed to describe, in my inquiry from this point forward, the art process, the art series, and the emergence of the creative and the artistic, as a kind of human history accessible for description under conditions approximating those of the latter part of this book.

Let us return to the issue, or the problem, of the self. Buber has argued that the relation to one's own self is not real, for it lacks "duality," which is present in every "essential living relation." The self does not reach completion or transfiguration in terms of its self, as it does in relation to things, men, and mystery, as evidenced in art, love, and religion. "The question what man is cannot be answered by a consideration of existence or of self-being as such, but only by a consideration of the existential connection of the human person and his relations with all being."[44]

I dwell on his view because there is a narcissistic aura about the art process which often deceives the artist into thinking he has dialogue with his self, whereas in actuality he constructs or forms anew his self-identity in his dialogue with things in creation. In the somewhat flowery and mythological language of the analyst: the soul is engendered in the psyche through eros.[45] This eros is a living relation with the world. It faces toward a contradiction within artistic experience that Johnstone does not mention: the self becomes other than self to *become* or *be* a self. It is thus that the self participates in its own myth of self-identity, or to use a still more difficult word, self-destiny. Less apparently than in philosophical argumentation but perhaps affectively even more cogently the self faces this contradiction. As Johnstone puts it:

> . . . The presence of the contradiction is felt as a burden, and the self emerges to take up this burden—or perhaps it is more accurate to say that the self *is* the taking up of the burden. . . . The self is the consciousness, unified for the first time, in which the contradiction appears. Thus the relation between self and contradiction is reciprocal. Contradiction, which calls the self into existence, presupposes that the self has already juxtaposed the contradictory poles.[46]

The acceptance of responsibility for the contradiction that the self is and is not the source of the artistic and the creative, signals, I believe, the emergence of the artistic consciousness. The artist will act *as though* he is the source. This is an inscrutable and difficult concept for any of us to learn, but

I believe I have watched people learn it. Anderson has argued ". . . that there is a self emergent in aesthetic responses different from the ordinary personality. And it implies that these extraordinary responses develop into equally extraordinary awareness."[47] This enlarged self is that consciousness in which the contradiction concerning the self itself appears. I may be forgiven if I can identify more closely with the artistic self that *is* the taking up of this burden of contradiction than with that which emerges in philosophic argumentation.

The myth of self-identity in art is locked within this self, not-self, newself, nonself dilemma. It is burden and responsibility of a most puzzling and exhilarating kind. Though I have privileged access to my thoughts, feelings, and recall concerning my art experience, I cannot fully share nor grasp, first of all in myself, secondly with another, my conception of that experience as a whole. But I can engage in a dialectic of exploration fruitful in my developing view of my artistic and creative self over against my ordinary self. It is this search process that can be shared and encouraged, and we can describe how it spreads ever anew into meanings beyond the mere recall of processes. Further, we can describe its positioning within the recorded images of the art series.

I must digress here to point out that I have found, to my amazement, that the writings of the psychologist Jung speak directly toward the attitudes and methods arising out of my own inquiries. When I was a graduate student minoring in clinical psychology, Jung was off-limits because he was tagged a nonscientific mystic. He is eminently readable now even though I feel no need to buy his psychology with its somewhat dated metaphors. What remains is the man's courage, breadth, and humility, along with a genuine feeling that he proceeded as scientifically as he could, given the phenomena of concern to him—and these were considerable: the dynamic wholeness of the self, its mythical and transcendent nature, its gradual conquest and enlargement ("individuation"); the way symbolic projections of man shape and portend his path; the role of vague feelings and images; the functional autonomy of parts of the self and how they are "democratized".

Without feeling in any sense Jungian, I believe I have located a sympathetic mind when it comes to method and purpose. He adopted the biggest and most inclusive look at man possible: a trust in his potential for organic growth and for regulatory processes within his self-in-the-world; humility before these forces and a willingness to be open to man's historicity and mythic inheritance; plus a method tainted with belief, interacting with man as a purposing and self-shaping creature, focusing on his forward projection. In his method, for example, Jung would never think of interpreting a single dream of an unknown person. Rather, he was inclined to work with the dream series,[48] and he treated it in much the same way we treat the drawing series (except for his reliance on interpretations based on "archetypes"). He considered the dream series like parts of incomplete manuscripts, which in the aggregate shed light on each other but are largely indecipherable in any one part. While interpretations remain conjectural, they have a way of fitting together into a matrix of evidence. Further, and this is the most important

part, the dream series was considered the context which the dreamer himself supplied. Also, interpretations, at least in the therapeutic setting, had only pragmatic and existential validity—that is, they had to be articulable into the consciousness of the dreamer and be useful in his self-direction. In addition, the dreamer practiced the "work of active imagination" on the dream, so that he was an active part of the interpretation process. Jung read from the continuing dreams themselves whether an advance or a regression was occurring in the therapeutic relationship, taking this pragmatic reality as a guide.

Now drawings, I realize, are not dreams. I also readily admit to great differences in beliefs between Jung and me; and I cannot hope to convey the excitement I felt in my rediscovery of Jung in these brief and superficial paragraphs. In addition, my willingness to identify with Jung in spirit leaves me somewhat vulnerable. Thus I feel a need to discuss several concepts.

It must not be assumed that I am making research into a purely consummatory experience. There is, to be sure, a sense in which all of our important, lived experience presses toward the consummatory, but to stop there would be to devalue its potential influence in the world. It would also suggest that the kind of "knowing" with which the latter part of this book has been concerned moves inevitably toward expressive form. I do not think this is so.

The series of drawings, like the dream series of which Jung speaks, is the context which the artist himself supplies. It furnishes a rich matrix wherein the reverberation of comparisons, meanings, interpretations can occur without strain—where, in fact, the explanation seems to arise of its own accord, if we are attentive and patient enough. This cannot be known beforehand, nor can it be sensitively described through any traditional research method which I know. To move into it, I must treat the future as history—that is, I must enter into inquiry, in closeness to the artist, of his privileged memory of the forming process, stimulated into recall through a feedback of that process as historically recorded. I must cross through "contamination" to a different world view and search for symmetry between phenomena and method, the former intuited as "flow," as behavior-with-experience, under a teleological view of man-in-the-world.

There is, I realize, a problem in the changed world of inquiry into which I have moved. Gombrich describes the nature of this difficulty when he speaks of the historian's desire to breathe life into the past, how he searches and sifts for evidence which he strives to fit into a meaningful context:

> There is much to be admired in this effort of the imaginative historian to "wake the dead" and to unriddle the mute language of the monuments. But he should never conceal from himself that his method is circular. The physiognomic unity of past ages which he reads from their various manifestations is precisely the unity to which the rules of his game have committed him. It was he who unified the clues in order to make sense of them.[49]

Perhaps this is true of all inquiry, especially of that probing complex phenomena. This charge could be laid upon Jung, upon Lowenfeld, upon Schaefer-Simmern, upon any number of explanatory efforts addressed to man

and his art. Several things give me some solace here. First, the data are of such a nature that they invite, at the least, several interpretations. Secondly, I lack firm explanatory concepts. In addition, the uniqueness of cases (so far, no two seem strictly comparable; no clear parallels, no unifying "archetypes" appear) works against the natural inclination to generalize. While a case seems to "explain itself," it does so in a largely unique way and within the arbitrary boundaries of time in which we experienced it.

Gouldner,[50] in the last chapter of a provocative recent book on the coming crisis of western sociology describes the requirements for a "reflexive sociology"—one turned back on the position, the contamination, the being-in-the-world of the inquirer into "human knowledge." In his courageous stand, Gouldner refuses to ". . . segregate the intimate or personal from the collective, or the everyday life from the occasional 'political' act."[51] Research into human affairs is a moral act, and he who would change his knowledge must change how he lives and his "praxis" in the world.[52] Here a researcher has seen how the stance of his discipline and of his own past research pursued as though above and apart from man, has led to unforeseen influences on the researcher and his discipline and upon the concept of man held by both. As a consequence, Gouldner now sees a central part of the historical mission of a reflexive sociology to be ". . . the task of helping men in their struggle to take possession of what is theirs—society and culture—and of aiding them to know who they are and what they may want."[53]

This recent viewpoint is not that far from Jung's prospective view of man. I realize that in singling out both Jung and Gouldner I have identified myself more with an "idealistic" than a "naturalistic" view of man. This has not been my intention, but if the drift of my inquiries make this appear so, then so be it. Somewhere there is a delicate positioning, a role difference, which still urges me to speak of "knowing" or of "gathering knowledge" of these phenomena without having to submit to a reductionistic, "underdimensionalized" view of man.

I have, repetitiously no doubt, given evidence through my own history of inquiry how I first studied, via research experiments, drawing strategies and conditions affecting them. Here the individual became lost in the process of formalization and abstraction. He was transformed into the "universal-formal." A change occurred, occasioned by the intuition that the art process had disappeared from the drawing strategy, as studied, and case studies of individuals threading their own paths were begun. The individual reemerged, transmitted into the "idiosyncratic-subjective-organic." The conditional, the causative, the verificationist gave way to the organic, the teleological, the largely unverifiable. I even dared to speak within this chapter of the group as community; of education as spirit transcending institution.

In looking back, some order now appears. It was, as the reader may agree, an exercise of "emotional philosophy" arising out of personal experience.

What does this add up to? It eventuates in a history, a biography, of how the hidden, the revealed, the real and the potential, the responsibility

for the burden of the contradiction of the self as ordinary and creative, participate in a given life. I am arguing that this is *human* knowledge, knowledge of the human, of a high order. And in so doing, I have had to face the burden of a contradiction in my own thought: we have to enter the dance to experience its mystery, but we have to leave it to describe it. In less figurative talk, I part now from my earlier verificationist, more narrowly empirical self, to confront it with a more human *and* phenomenal self. I can no longer vacillate between the two. The one cannot do what the other can, not just "not yet," as strict empiricists put it, but never.

I set out to do a research and ended by participating in a sacrament. I have tried to state and accept responsibility for this contradiction as essential to the study of man experiencing art. The psychology of art, from my present view, only deserves to be so-called insofar as it can admit the full human situation and the problem of art experience within its boundaries. The link between experience and behavior cannot be broken without breaking the link between psychology and art; the link between experience and behavior cannot be maintained without drastic revision to our conception of psychology. And inquiry into the *linkage* of experience (of the emergent art situation) and behavior (what one seemed to do, recalled one did, thought and felt one did) can only proceed by way of the inquirer's own participation in the construction (I prefer this to "maintenance of the fiction") of that bond. You may say I am invoking a kind of "aesthetic indeterminacy" principle for the empirical study of art; but that will not change my best intuitions as to "the way things are" and my determination to continue inquiry from this view. Actually, all I did was to give the drawing back to the artist; but once that was done, the methods and criteria I had used before no longer applied. And small wonder, for the structure they served fell asunder, while a new one arose which as yet we cannot describe very well. Thought, however, is unresistingly drawn toward such a problem. I invite other amateur artist-philosopher-psychologists to work on this side.

NOTES

1. Henry Scheafer-Simmern, *The Unfolding of Artistic Activity,* 3d ed. (Berkeley: University of California Press, 3rd Printing, enlarged. Orig. ed. 1948. 1961).

2. Viktor Lowenfeld, *Creative and Mental Growth,* 3d ed. (New York: Crowell Collier and Macmillan, Inc., 1957).

3. Carl R. Hausman, "Mystery, Paradox, and the Creative Act," *Southern Journal of Philosophy* 7, no. 3 (Fall 1969) 289–96.

4. Martin Buber, *Between Man and Man,* trans. Ronald Gregor Smith (London: Routledge & Kegan Paul Ltd., 1947).

5. Paul Weiss, "Love in a Machine Age," in *The Human Dialogue, Perspectives on Communication,* ed. Floyd W. Matson and Ashley Montagu (New York: The Free Press, 1967), p. 68.

6. James Herndon, *The Way It Spozed To Be* (New York: Bantam Books, Inc. 1969), p. 176.

7. Carl R. Rogers, *Freedom to Learn* (Columbus, O.: Charles E. Merrill Publishing Co., 1969), p. 222.

8. Carl R. Rogers and Barry Stevens, *Person to Person: The Problem of Being Human, A New Trend in Psychology* (Lafayette, Calif.: Real People Press, 1967), p. 186.

9. Ibid., pp. 90–92.

10. Barbara Rose, "The Politics of Art," Parts II, III, *Artforum* 7, no. 5 (January 1969): 44–50, and 7, no. 9 (May 1969): 46–51.

11. Morse Peckham, *Man's Rage for Chaos* (Philadelphia: Chilton Book Company, 1965).

12. John Dewey, *Art as Experience* (New York: Minton, Balch & Co., 1934).

13. Barbara Rose and Irving Sandler, "Sensibility of the Sixties," New York: *Art in America,* Jan.–Feb. 1967, vol. 55, no. 1, pp. 44–67.

14. Michael Polanyi, "What is a Painting?" *British Journal of Aesthetics,* 10, no. 3 (July 1970): p. 232.

15. Ibid., p. 230.

16. Paul Watzlawick, Janet Helmick Beaven, and Don D. Jackson, *Pragmatics of Human Communication* (New York: W. W. Norton & Company, Inc., 1967), pp. 261–66.

17. Ibid., p. 261.

18. Ibid., p. 267.

19. Ibid., p. 266.

20. Carl R. Rogers, "Toward a Theory of Creativity." *ETC, A Review of General Semantics* 11, no. 4 (Summer 1954) 249–60.

21. Joseph Kockelmans, "Lecture on Truth and Science" (Paper presented to the Two-Cultures Symposium, The Pennsylvania State University, October 7, 1970).

22. P. W. Bridgman, *The Way Things Are* (original ed., 1959; Cambridge: Harvard University Press, 1966), p. 217.

23. John Dewey, *Philosophy and Civilization,* "Conduct and Experience" (New York: Minton, Balch & Co., 1931), p. 270.

24. Roger D. Barker, *Ecological Psychology* (Stanford: Stanford University Press, 1968).

25. Richard de Charms, *Personal Causation: The Internal Affective Determinants of Behavior* (New York: Academic Press, Inc., 1968).

26. David Bakan, *On Method: Toward a Reconstruction of Psychological Investigation* (San Francisco: Jossey-Bass, Inc., Publishers 1967).

27. Martin Buber, *I and Thou,* trans. Ronald Gregor Smith (Edinburgh: T. & T. Clark, 1937).

28. Michael Polanyi, *Personal Knowledge* (Chicago: University of Chicago Press, 1958).

29. Theodore Roszak, *The Making of a Counter Culture* (New York: Doubleday & Company, Anchor Books, 1969).

30. Gordon W. Allport, *The Use of Personal Documents in Psychological Science* (New York: Social Science Research Council, 1942).

31. Gordon W. Allport, "The Unique and the General in Psychological Science" *Journal of Personality* vol. 30, no. 3, Sept. (1962): 405–22.

32. John M. Schlien, "A Client-Centered Approach to Schizophrenia: First Approximation," in Carl R. Rogers and Barry Stevens, ed. *Person to Person: The Problem of Being Human, A New Trend in Psychology,* (Lafayette, Calif.: Real People Press, 1967), p. 157.

33. Mary Corbett, "A Philosophy and Study of the Concepts of Personal Causation in the Feedback Environment" (Master's thesis, The Pennsylvania State University, 1970).

34. Buber, op. cit., n. 4 chap. 9, p. 29.

35. Ibid. p. 31.

36. Ibid. p. 31.

37. Henry W. Johnstone, Jr., *The Problem of the Self* (University Park, The Pennsylvania State University Press, 1970).

38. Ibid., p. xi.

39. Ibid., p. 150.

40. Ibid., p. 134.

41. Ibid., p. 136.

42. Ibid., p. 138.

43. Ibid., p. 139.

44. Buber, op. cit., n. 4 chap. 9, p. 179.

45. James Hillman, "On Psychological Creativity," *Art International,* 13, no. 7 (September 1969): 26–41.

46. Johnstone, op. cit., n. 37 chap. 9, p. 150.

47. John M. Anderson, *The Realm of Art* (University Park, The Pennsylvania State University Press, 1967), pp. 18–19.

48. C. G. Jung, *Psychology and Alchemy* (New York: Pantheon Books, Inc., 1953), p. 45.

49. E. H. Gombrich, *Meditations on a Hobby Horse* (London: The Phaidon Press, Ltd., 1963), p. 51.

50. Alvin W. Gouldner, *The Coming Crisis of Western Sociology* (New York: Basic Books, Inc., 1970).

51. Ibid., p. 504.

52. Ibid., p. 493.

53. Ibid., p. 509.

Index of Names

Subject Index